KB083907

우리는 원형을 찾기 위해 노력한다.
그것은 사물의 본질과 우리 이야기의
교집합을 찾는 것과 같다.

We strive to find the original
form. It is similar to finding the
intersection between the essence
of objects and our story.

일상에 영감을, SWNA
깨뜨리고 뒤흔들고 비틀어보기

Everyday Inspiration, SWNA
Breaking apart, shaking up, and tweaking

ISBN
979.11.6823.012.5 (03600)

2022년 6월 21일 초판 발행
2023년 8월 7일 2쇄 발행

지은이 이석우
옮긴이 이수경
펴낸이 안미르, 안마노
크리에이티브 디렉터 안마노
편집 김한아
디자인 옥이랑
인덱스 일러스트레이션 이윤재
영업 이선화
커뮤니케이션 김세영
제작 세걸음
글꼴 Sandoll 고딕, Helvetica

안그라픽스
우 10881 경기도 파주시 회동길 125-15
전화 031.955.7755 • 팩스 031.955.7744
이메일 agbook@ag.co.kr • 웹사이트 www.agbook.co.kr
등록번호 제2-236(1975.7.7)

1st published in 21 June 2022
2nd published 7 August 2023

Authors Lee Sukwoo
Translation Lee Sookyung
President Ahn Myrrh, An Mano
Creative Director An Mano
Editing Kim Hana
Design Ok Yirang
Index Illustration Lee Yunjae
Marketing Lee Sunhwa
Communication Kim Seyoung
Production Agency Seguleum
Tapeface Sandoll Gothic, Helvetica

Ahn Graphics Ltd.
125-15 Hoedong-gil, Paju-si, Gyeonggi-do 10881, South Korea
Tel +82.31.955.7755 • Fax +82.31.955.7744
Email agbook@ag.co.kr • Website www.agbook.co.kr

사진 출처
이석우, 김권진, 홍기웅, 나씽스튜디오,
대림e편한세상, SK브로드밴드,
라이엇게임즈, 로우로우, CJ, KT,
국립한글박물관, 문화역서울284, 장준혁

Photo Credits
Lee Sukwoo, Kim Kwonjin, Hong Kiwoong,
Nathing Studio, Daelim ePyeonhansesang,
SK broadband, Riot Games, RAWROW,
CJ, KT, National Hangeul Museum, Cultural
Station Seoul 284, Jang Junhyeok

일상에 영감을, SWNA
깨뜨리고 뒤흔들고 비틀어보기

Inspiration for
Everyday Life, SWNA
Breaking Apart, Shaking Up,
and Tweaking

이석우
Lee Sukwoo

안그라픽스

프로세스의 촉감

김상규
서울과학기술대
디자인학과 교수

2021년에 열린 전시 〈SWNA-ANWS〉를 흥미롭게 봤다. 10년을 이어온 스튜디오 활동을 기념하는 이 전시에서 이석우와 SWNA는 프로세스를 보여주는 데 공을 들인 것 같았다. 스케치부터 프로토타입, 생산품까지 펼쳐놓았고, 젊은 관람객 몇몇이 종이로 만든 스터디 모형을 유심히 들여다보고 있었다. 그 모습을 보면서 콘스탄틴 그리치치의 인터뷰가 떠올랐다.

> 1990년대 초에 독립해서 활동을 시작할 당시에 재정이 한정되기도 했지만 내가 손수 골판지로 모델과 프로토타입을 만든 건 재료를 다루는 일의 즐거움 때문이었어요. … 이제 어시스턴트들이 모델을 만들지만 누군가 골판지를 잘라서 뭔가를 만들고 있다는 얘기를 들으면 무척 즐거워요. 프로세스의 촉감이 손에 잡힐 단계가 되었다는 것이니까요.*

산업 디자이너이자 큐레이터로서 학제적인 면모를 보인 그가 여전히 모델 제작을 소중히 생각한다는 것을 알 수 있다. 비평가 알렉스 콜스는 그리치치가 이 말을 할 때 컵을 쥐고 있던 그의 손을 눈여겨보았다. 오랫동안 골판지, 목재 등을 다룬 흔적이 그리치치의 손가락마다 남아 있었기 때문이다. '프로세스의 촉감'을 입증하기에 충분한 장면이었을 것이다. 산업 디자이너라고 다 같은 프로세스를 적용하지는 않는다. 예컨대, 그리치치에 따르면 재스퍼 모리슨은 그리치치와 달리 머릿속으로 사물을 시각화해서 그것을 그려내는 '대단히 지적인 프로세스'의 소유자다.

어떤 프로세스든 디자이너와 디자인스튜디오의 프로세스에 주목하는 것은 각별한 의미가 있다. '그들'을 궁금해한다는 뜻이기 때문이다. 물론 프로세스는 그들이 어떻게 문제를 해결하는지, 그들만의 방법은 무엇인지 파악하는 중요한 정보다. 그리고 특정한 미션을 수행할 수 있는지를 가늠할 수 있는 정보이기도 하다. 하지만 그런 판단의 도구 차원을 넘어서 한 디자이너의 프로세스에 대한 관심은 그를 잘 알아가는 출발점이 된다.

이런 질문을 떠올려보자. '디자이너는 어떻게 성장하는가?' '새로운 상황에서 디자이너가 어떻게 대응하고 변화해왔는가?' 사실, 알 길이 없다. 현재 특정한 디자이너의 특정한 활동을 어렴풋이 알 뿐, 디자이너의 활동 추이를 알진 못한다. 먼 나라의 디자이너들에 관한 책을 자주 접하는 것에 비하면 우리 곁의 디자이너들을 다룬 번듯한 책을 만나기는 참 힘들다. 그들을 궁금해하지 않기 때문이다.

이 책 『일상에 영감을, SWNA』는 그래서 무척 반갑고 소중하다. 디자이너들과 전시를 하고 글을 써온 사람으로서 진작 이런 일을 도모하지 못한 미안함도 있다. 사실 디자이너들의 소셜 네트워크와 웹사이트를 둘러보면 어지간한 정보를 얻을 수 있다. 책보다 훨씬 빠르고 널리 공유되어서 클라이언트와 팬을 얻을 수 있다. 하지만 이 과정은 디자이

너를 소비하는 것이고 디자이너는 잠깐 눈요깃감으로 소모된다는 느낌을 받곤 한다. 반면 디자이너의 이야기를 책으로 편집하는 건 그들을 알아가는 노력이 뒤따른다. 그들의 생각을 담아내야 하기 때문이다.

스쿨 오브 비주얼 아츠의 프로덕트 디자인 대학원 과정을 책임지는 앨런 초치노프는 제품 디자인과 그래픽 디자인을 무엇으로 구분할 수 있냐는 질문에 이렇게 답했다.

'물건에 대한 애정'이라고 답하고 싶다. 전형적인 제품 디자이너들은 사물을 분해하고, 그 작동 방법을 알아내며 손으로 물건을 만드는 등의 일을 하면서 성장한다.**

메타버스와 NFT를 빼고 대화하기 힘든 오늘날에는 무척 고전적인 답변이지만 솔직한 이야기다. 물건에 대한 애정과 성장이라니 얼마나 와닿는 말인가. 『일상에 영감을, SWNA』는 우리의 동료이자 친구인 디자이너들의 애정과 성장에 관심을 기울이게 하는 의미 있는 시도다. 고백하건대, SWNA 스튜디오를 몇 차례 방문하고서도 이석우를 비롯한 디자이너들의 손을 눈여겨보지 못했다. 나와 독자들이 몰려가서 손을 보자고 할 수도 없는 노릇이니, 이 책을 통해 이석우와 SWNA의 '프로세스의 촉각'을 느껴보는 것이 어떻겠는가.

*
알렉스 콜스 지음, 『학제간 스튜디오』, 스턴버그프레스, 2012

**
스티븐 헬러·베로니크 비엔 지음, 문가용·이화경 옮김, 『기술과 디자인: 디지털 세계의 양손잡이 디자이너』, CABOOKS, 2017

The Tactility of Process

Kim Sangkyu
Professor of Department
of Design, Seoul
National University of
Science and Technology

I was intrigued by the *SWNA-ANWS* exhibition held in 2021. In this exhibition to commemorate a decade of studio activity, Lee Sukwoo and SWNA must have put in much effort into showing the process. Sketches to prototypes and even productions were displayed and young visitors were paying close attention to the study models made out of paper. Looking at this scene, I was reminded of an interview with Konstantin Grcic.

> Together with the limited financial means at my disposal when I started out on my own in the early 1990s, this enjoyment of working with materials informed why I made models and prototypes out of cardboard by hand. ⋯ Now my assistants make these models, but it still gives me great pleasure to hear someone else cutting into cardboard and constructing something—to know that the tactility of process is near at hand.*

We can see that Grcic, as an industrial designer and curator who possesses an interdisciplinary side, still values the production of models. Critic Alex Coles noticed Grcic's hand holding his cup during this interview. This was because traces of working with cardboard and wood for a long time remained on every finger. That image would have been enough to prove "the tactility of process." Not all industrial designers apply the same process. For example, according to Konstantin Grcic, Jasper Morrison goes through a "very intellectual process" of visualizing things in his head before drawing them, quite unlike him.

In any process, it is especially meaningful to pay attention to the process of designers and design studios. This means to be curious about 'them'. Of course processes are important information to understand how these people solve problems and what their own specific methods are. It is also information to determine whether they can perform a particular mission. However, beyond being a tool of judgment, interest in the designer's process becomes a starting point to get to know him well.

Let's think about these questions: 'How does a designer develop?' 'How have designers responded and changed in new situations?' In fact, there is no way to know. Currently, we only vaguely know the specific activities of a specific designer, but we do not know the process of the designer's activities. Compared to the frequent encountering of books about designers from far off countries (whether in the form of their works or the books they wrote), it is very difficult to find a decent book dealing with

designers near us. This may be because we are not curious enough about them⋯.

This is why the book *Inspiration for Everyday Life, SWNA* is so welcome and of value. As someone who has been writing and exhibiting with designers, I feel bad for not being able to do this sooner. In fact, it is possible to get a bit of information by browsing the designers' social networks and websites. This way is much faster and more widely shared than a book, so they can get clients and fans. However, this process means the designers are the product, and they often feel that they are consumed as a sudden attraction. On the other hand, editing a designer's story into a book entails an effort to get to know him or her. This is because the designer's thinking has to be fully expressed.

Allan Chochinov, who is in charge of the Graduate Program in Product Design at the School of Visual Arts (SVA), answered the question of what distinguishes product design from graphic design.

> I'd say a 'love of stuff.' Typical product designers grow up taking things apart, figuring out how they work, making things with their hands.**

These days when it is very hard to talk about anything besides the topic of Metaverse and NFTs, it is a very classic answer, but there is honesty to it. How touching is the love and growth of "stuffs." *Inspiration for Everyday Life, SWNA* is a meaningful attempt to draw attention to the affection and growth of designers who are our colleagues and friends. I must confess, even though I visited the SWNA studio several times, I did not observe the hands of designers including Lee Sukwoo's. Since it is impossible for me and readers to all go take a look at the designer's hands, why not experience the 'tactility of process' of Lee Sukwoo and SWNA through this book?

*
Alex Coles, *The Transdisciplinary Studio*, Sternberg Press, 2012

**
Steven Heller, Veronique Vienne, *Becoming a Graphic and Digital Designer: A Guide to Careers in Design*, Wiley, 2015

자기 갱신의 디자인

정다영
국립현대미술관
학예연구사

SWNA는 산업 디자인 회사다. '산업'의 사전적 정의가 '인간의 생활을 경제적으로 풍요롭게 하기 위하여 재화나 서비스를 생산하는 사업'이라 할 때, SWNA가 확장해 나가는 다양한 디자인 실천은 모두 산업의 범주에 포함된다. 이러한 영역 확장과 더불어 SWNA의 이석우 대표는 그 결과물을 전시, 출판, 워크숍처럼 산업 디자인이 날 것 그대로 적용하기 어려운 형식을 통해 기록하고 발화해왔다. 디자인 결과물인 내용과 그것을 가공하고 담는 형식은 SWNA가 끊임없이 자기 갱신을 해왔다는 증거로 작동한다.

SWNA는 좁은 의미인 산업 디자인 생산물인 제품부터 리빙 디자인, 환경 디자인 등을 모두 다루는 조직이다. 대량생산 가능한 제품을 만들기 위해 수많은 프로토타입을 만들고 그 안에서 최적의 안을 선택하는 산업 디자인 프로세스는 더욱 복잡해진 생산 조건과 산출되는 대량의 데이터 위에서 최적의 결과를 도출하는 데 적합하다. 산업 디자인 프로세스에서 누구보다 맥락의 힘을 강조해온 이석우 대표와 SWNA는 유동하는 사물의 위상을 오랫동안 연구해왔다. 이와 같은 직능의 토대 위에 SWNA는 시대와 기술의 변화에 따라 사물의 기능과 아름다움을 재배치해왔다. 빠르게 변화하는 현대 사회에서 사물은 고정된 값을 갖지 않기에 이들이 걸어온 길은 자연스럽다. 하지만 이는 단순한 분야 간의 통섭, 융합, 협업으로만 치부하기 어려운 그들만의 고유한 실천의 힘이다. 그 동력 안에 끊임없는 자기 갱신의 과정이 있다.

새롭게 하는 것, 갱신은 몸 전체를 전과 다르게 쓰는 일이다. 조직이라는 신체가 다른 생각과 행동을 하지 않는 한 획득되기 어려운 감각이다. 조직을 새롭게 쓰기 위한 SWNA의 가장 인상 깊은 최근 행보는 '리버럴 오피스'다. SWNA 구성원이 개인의 정체성을 드러내며 자기 이야기를 하기 위한 조직 내부의 디자인 플랫폼이다. SWNA는 10년이 훌쩍 넘은 조직의 오랜 관성에서 벗어나기 위해 전시와 워크숍을 중심으로 한 리버럴 오피스 활동을 선언했다. 산업 디자인계에서 선례가 없었던 이러한 활동을 통해 SWNA는 자기 갱신의 디자인을 개발한다.

물론 SWNA는 리버럴 오피스 이전에도 꾸준하게 새로운 실험과 실천을 축으로 자기 조직화 활동을 진행해왔다. 이 또한 그저 되는 일이 아니라 치밀하게 쌓아 올린 경험과 시간 위에서 작동할 수 있다. SWNA는 클라이언트뿐 아니라 일반 사회와 대중을 향해, 광고가 아닌 전시와 출판으로도 몸을 맞춘다. 저자성을 강조하는 전시라는 무대에서 그들의 작업은 결과보다 과정에 초점이 맞춰진다. 마지막까지 상품화에 성공하지 못한 것들, 프로토타입으로 남은 것들도 전시의 대상이 된다. 전시에 선보인 사물들은 SWNA가 평소에 다루는 최첨단의 장치와 거리가 있는 종이 출판이라는 전통적인 방식으로 기록된다. 2차원 지면은 아직까지 대다수 사람들이 어떤 기술적 장벽 없이 접근할 수 있고 멀리 퍼져나갈 수 있는 공적 매체다.

작가와 달리 디자이너에게 전시와 출판은 작업의 목적 자체가 아니다. 그렇기 때문

에 이런 방향으로 자꾸 몸을 쓰는 일은 관성에 함몰되지 않기 위해 스스로를 새롭게 강화하고 열어놓기 위한 조직의 의지를 반영한다. SWNA의 지난 작업 결과물과 그 이면의 이야기가 담긴 이 책에도 마찬가지 뜻이 담겨 있다. 전시와 출판은 디자이너에게 방향을 틀게 만드는 흥미로운 계기를 제공한다. 그렇다면 이 작품집 출간 이후 맞이할 SWNA의 다음 여정이 어떤 모습일지 무척 궁금하다.

Design of Self-Renewal

Chung Dahyoung
Curator of the National
Museum of Modern
and Contemporary Art,
Korea

SWNA is an industrial design company. If the dictionary definition of 'industry' is 'a business that produces goods or services to enrich human life economically,' then the various design advancements that SWNA has made are all included in the category of industry. In addition to this area advancement, SWNA's CEO, Lee Sukwoo, has recorded and proclaimed his results through exhibitions, publications, and workshops which are difficult formats to work with raw industrial design. The results of the design and the format in which the design is processed and contained act as evidence that SWNA has constantly renewed itself.

SWNA is an organization that deal with products from industrial design in a narrow sense to living design, environmental design, and more. The industrial design process, which makes numerous prototypes and selects an optimal plan from which to make a product that can be mass produced, is suitable for deriving optimal results from more complex production conditions and large amounts of data generated. CEO Lee Sukwoo, who emphasized the power of context more than anyone else in the industrial design process, and SWNA have been studying the status of moving objects for a long time. On the basis of this, SWNA has rearranged the function and beauty of things according to the changes of times and technologies. In the rapidly changing modern society, objects do not have fixed values, so the path SWNA has taken is natural. However, this is the power of their practice and cannot be dismissed as merely the outcome of consilience, convergence, and collaboration between fields. Within SWNA's power, there exists the process of constant self-renewal.

To make new, to renew, is to use the whole body differently from before. It is a difficult sense to acquire unless the body as an organization thinks and acts differently. SWNA's most impressive recent move to rewrite the organization is its 'Liberal Office'. This is a design platform within the organization for SWNA members to reveal their personal identity and tell their story. SWNA declared a Liberal Office activity centered on exhibitions and workshops in order to break free from the long-standing inertia of the organization, which has long been in existence for more than 10 years. Through this activity, unprecedented in the industrial design world, SWNA develops designs of self-renewal.

To be sure, even before the Liberal Office, SWNA had been continuously conducting self-organization activities based on new experiments and practices. This, too, is not something that just happens but can only

work through the careful accumulation of experience and time. SWNA caters not only to clients, but also to the general society and the public, not only through advertising, but also through exhibitions and publications. On the stage of exhibition that emphasizes authorship, their work focuses on the process rather than the result. Items that did not succeed commercially until the end, and those left as prototypes, are also a part of the exhibition. The objects presented in the exhibition are recorded in the traditional paper publication method which is far from the state-of-the-art equipment that SWNA usually works with. The 2D space is still a public medium that most people can access and can be disseminated far and wide without any technical barriers.

Unlike writers, for designers, exhibitions and publications are not the sole objectives of their work. Therefore, the continuous effort in this direction reflects the organization's will to strengthen and open itself up to avoid falling into inertia. The same meaning is contained in this book which contains the results of SWNA's past works and the stories behind them. Exhibitions and publications provide interesting opportunities for designers to change direction. If so, I am very curious to see what SWNA's next journey will be upon the publication of this design workbook.

차례
Contents

프로세스의 촉감 The Tactility of Process — 김상규 Kim Sangkyu

자기 갱신의 디자인 Design of Self-Renewal — 정다영 Chung Dahyoung

창의력과 산업 디자인의 맥락 The Context of Creativity and Industrial Design — 이석우 Lee Sukwoo

프로젝트&프로세스 Projects & Process ——— 023
289

음악을 비추고 빛을 만지다 Spotlight the Music and Touch the Light ——— 025
290

허들 조명 Hurdle Light ——— 029
291

사물의 일상 Ordinariness of Object ——— 033
292

촉감 폴더블 핸드폰 Tactile Foldable Mobile Phone ——— 037
293

한 송이의 꽃을 위한 꽃병 Vase for Just One Flower ——— 041
294

우뭇가사리 시리즈 Agar-agar Series ——— 045
295

무중력 조명 시리즈 Zero-G Light Series ——— 049
296

아파트 제품 아이덴티티 Apartment Product Identity ——— 053
297

물병 Water Bottle ——— 057
298

레그 퍼니처 시리즈 Leg Furniture Series ——— 061
299

노말 체어 Normal Chair ——— 065
300

오리가미 체어 Origami Chair ——— 069
301

윙 테이블 Wing Table ——— 073
302

도트 테이블 Dot Table ———————————————— 077
303

트로피칼 버드 Tropical Bird ———————————————— 081
304

오래된 미래 테이블과 벤치 An Old Future Table & Bench ———————————————— 085
305

프로토 벤치 Proto Bench ———————————————— 089
306

숨쉬는 타일 The Respirer ———————————————— 093
307

데스크 액세서리 시리즈 Desk Accessories Series ———————————————— 097
308

TV 리모컨 TV Remote Control ———————————————— 101
309

굴뚝 조명등 시리즈 Chimney Light Series ———————————————— 105
310

전자책 단말기 eBook Reader ———————————————— 109
311

잎사귀 트레이 Leaf Tray ———————————————— 113
312

TV 셋톱 박스 TV Set-top Box ———————————————— 117
313

스마트 밴드 Smart Wristband ———————————————— 121
314

오피스 가구 시리즈 Office Furniture Series ———————————————— 125
315

브랜드 스토어 Brand Store ———————————————— 129
316

아파트 인테리어 조명 시리즈 Apartment Interior Light Series ———————————————— 133
317

스마트 스피커 Smart Speaker ———————————————— 137
318

우산 Umbrella ———————————————— 141
319

4D 영화관 의자 4D Theater Chair ———————————————— 145
320

플록 벌브 Flock Bulb — 149
321

라이프 클락 재난 키트 Life Clock Disaster Kit — 153
322

스마트 충전기 Smart Charger — 157
323

플래그십 스토어 카페 Flagship Store Cafe — 161
324

그래피컬 조명 Graphical Light — 165
325

2018 평창 동계 올림픽 메달 2018 PyeongChang Winter Olympic Medal — 169
326

서클 피콕과 테일 버드 Circle Peacock & Tail Bird — 173
327

버클 조명 시리즈 Buckle Light Series — 177
328

문화역서울284 굿즈 시리즈 Culture Station Seoul 284 Souvenir Series — 181
329

아파트 브랜딩 및 마스터플래닝 Apartment Branding & Masterplanning — 185
330

리그 오브 레전드 트로피 Trophy LOL — 189
331

스테이션 지오메트리 Station Geometry — 193
332

백상예술대상 트로피 Trophy Baeksang — 197
333

콘크리트 커튼 The Curtained Wall — 201
334

한글 2.5 Hangeul 2.5 — 205
335

태극기함 Korean Flag Case — 209
336

화장품 용기 Cosmetic Bottle — 213
337

공기청정기 Air Purifier — 217
338

암 체어 Arm Chair ——————————————————————— 221
339

트롤리 Trolley ————————————————————————— 225
340

트레이 Tray —————————————————————————— 229
341

치약 패키지 Toothpaste Package ——————————————— 233
342

클러스터 오브 라이트 Cluster of Light ————————————— 237
343

LED 헤어 디바이스 LED Hair Device —————————————— 241
344

스마트폰 UV 충전기 Smartphone UV Charger ——————————— 245
345

온수 매트 보일러 Hot Water Mat Boiler —————————————— 249
346

노트북 파우치 Notebook Pouch —————————————————— 253
347

NPT 전동 킥보드 NPT Electric Scooter ——————————————— 257
348

음악의 패턴 Pattern of Music ——————————————————— 261
349

무선 전기 주전자 Wireless Electric Kettle ———————————— 265
350

10 퍼스낼리티 10 체어 10 Personalities 10 Chairs ————————— 269
351

대화 Dialogue ———————————————————————————— 273

디자이너의 사고 과정 The Thinking Process of a Designer ——————— 274

인덱스, 미주 Index, Endnotes —————————————————————— 352

창의력과 산업 디자인의 맥락

디자인 프로세스는 다양한 능력을 요구한다. 특히 프로젝트 초반에는 정보 사이에서 반짝거리는 통찰, 곧 창의력이 필요하다. 하지만 어떻게 창의력을 가질 수 있을까? 또는, 창의력은 무엇일까? 이런 질문을 받아도 논리적으로 설명하기 어려워 대답을 기다린 사람의 기대를 저버리기도 한다. 내 경우를 보자. 머릿속 이미지와 현실의 정보와 여러 이야기가 어느 순간 번개처럼 번쩍, 아이디어로 나타날 때가 있다. 글, 소리, 혹은 그저 느낌 같은 추상적 조각에 맥락이 생기며 한 덩어리가 되어 떠오르는 것이다. 나는 그때 창의력을 경험한다.

이 통찰이 이루어지려면 머릿속 이미지 창고가 가득할수록 좋다. 디자인을 전공하는 학생들에게도 일단 많이 보시라고 한다. 몸의 기초 체력을 기르려면 많은 시간을 들여야 하듯이, 뇌도 창의력을 기르려면 많은 이미지를 경험해야 한다. 게다가 정보가 넘쳐나는 시대다. 마음만 먹으면 고급 정보를 무한히 접할 수 있다. 그러나 그만큼 정보의 자본화 또한 가속화해, 있는 사람과 없는 사람의 차이가 점점 극명하게 나타나며, 무엇을 봐야 하는지가 더 중요해졌다. 무엇을 봐야 할지 막막한 사람에게 다시금 강조하고 싶다. 보고 또 보라. 조금 억척스럽게 들리더라도 가장 빠른 방법이다. 사람마다 자라온 환경과 자질이 다르기에 편차는 있을 것이다. 그때까지 개인이 노력해야 하는 시간이 필요한 건 분명하다. 그러나 많이 접하면 나름의 식견이 생기고, 보다 보면 일종의 마일스톤이 생긴다.

이제 우리는 창고를 채워가는 중이다. 그런데 이미지로 꽉 차 있더라도 이를 어떻게 해석하느냐는 다른 문제다. 막상 필요할 때 창고에서 어떻게 적절한 것을 꺼내올 수 있을까? 다시 말해, 갈고닦은 창의력을 어떻게 실제 산업 디자인에 연결할 수 있을까?

과거의 산업은 대량 생산 체제를 이용해 소비자에게 싼값에 양질의 생산품을 공급하는 것이었다. 그러나 격변의 2000년대를 맞아 메시지는 더 자연친화적이고, 미래지향적이고, 섬세한 것으로 바뀌어야 했다. 여기서의 창의력은 단순히 재미있는 상상을 넘어 혁신적 사고를 핵심 엔진으로 삼는다. 이런 시기에는 디자인도 생산 과정 중 어느 한 지점보단 전체 프로세스에서 다양한 방식으로 작용한다. 기획, 개발, 제조, 마케팅, 유통 등 여러 이해 당사자 간에 적절한 교집합을 이끌어내는 조율자로서의 역할 또한 커졌다. 소위 혁신적인 프로세스를 통해 나온 콘셉트는 문제가 많았기 때문이다. 특히 구현에 있어 난관에 맞닥뜨리곤 했다.

마침 산업 디자인의 기본적인 물음 또한 '어떻게 문제를 합리적으로 해결해서 최소한의 자원으로 최대의 효과를 볼 수 있느냐'다. 다소 딱딱하고 무거운 이 목표에 창의력은 윤활유 같은 역할을 한다. 내가 문제를 해결한 방법도 창의력이었다. 머릿속 창고를 풍성하게 채우고, 자신만의 조합을 통해 맥락을 발견하고, 이를 가시화하는 능력. 머릿속 창고를 동원하면 다양한 가능성을 실험할 수 있었다. 프로세스 자체를 디자인해보면 전체 맥락이 읽혔다. 유연하고 창의적인 사고는 콘셉트를 실체화해 문제를 기회로 만들어주었

다. 이렇듯 창의력은 산업 디자인의 근간이나 마찬가지다.

일부러 낙차를 만들어 둘이 서로 영향을 주고받는 프로세스를 선호할 때도 있다. 이 경우 프로젝트 의뢰가 들어오면 바로 접근해 추상적인 발상에 유실이 없도록 '만들기'를 시작한다. 붓이나 만년필로 그리기도 하고, 종이나 점토로 만들기도 하고, 글로 표현해 가시화할 때도 있다. 이런 창의성 실험 후 바로 사용성, 양산성, 소재 같은 산업 디자인 요소를 연결한다. 영감의 재료를 로봇이나 스마트폰, 건축물, AI 디바이스 등에 적용해보는 것이다. 여기서 생기는 낙차는 꽤 크다. 덤벨로 운동하다가 바로 자유형 100미터를 하는 것이나 마찬가지다. 모든 프로젝트를 이런 식으로 하면 몸과 머리가 남아나지 않겠지만 그만큼 새로운 가능성의 실마리를 많이 찾아낼 수 있다.

창의력의 기저를 이루는 건 유연함, 또는 엉뚱함이다. 연관성이 없어 보이는 데서 맥락을 찾는 유연함. '이렇게 해봐도 되지 않을까?' 하는 긍정적인 사고 바탕의 엉뚱함. 이들이 나만의 해석을 패턴으로 만들어주고, 패턴의 성격이 자기 개성이 되고, 개성이 모이면 철학이 된다. 그리고 철학이 공고히 형태를 갖추면 오래가는 디자인, 즉 고전이 된다. 수많은 세월을 이겨내고, 시대를 초월하고, 그 시대를 대표하는 레퍼런스로 남아 하나의 디자인 철학으로서 후대에 계속 영향을 주는 것이다.

체력을 갖추고 근력을 쌓듯이, 창의력에 맥락을 갖춘 기술과 기교를 쌓으면 산업 디자인으로 발전한다. 이 책에는 그 결과물을 담고 이해를 돕도록 직관적인 설명을 덧붙였다. 이것이 내가, 그리고 우리가 창의력과 산업 디자인의 고리를 연결하는 방법이다.

The Context of Creativity and Industrial Design

The design process requires a variety of abilities. Especially at the beginning of a project, it is necessary to have a flashing insight, that is, creativity, between information. But how can one gain creative? Or, what is creativity? Even when asked such questions, it is difficult to explain logically, so the person who expects an answer might be let down. Let's take my case. There are times when the images in my head, information from reality, and various stories flash like lightning at some point and appear as ideas. Abstract fragments such as texts, sounds, or just feelings create context and emerge as one mass. At that moment, I experience creativity.

For this insight to work, the more the image warehouse is full of images, the better. I tell students majoring in design to go see, observe a lot. Just as it takes much time to develop the basic physical strength, the brain needs to experience many images to develop creativity. Besides, we live in an era of information overload. If one puts their minds to it, they have infinitely access to advanced information. However, the difference between those who have capitalized on and accelerated information and those who have not becomes increasingly clear, and the importance of what to look for has also increased. I want to emphasize again to those who are not sure about what to see. Observe and keep observing. Even if this sounds a bit forced, it is the fastest way. There will be variations as each person grew in different environments and has different qualities. Until then, it is clear that individuals need to make time for effort. However, as interaction increases, they will gain their unique insight, and as they keep observing, they will reach their own milestone.

Now we are in the process of filling the warehouse. However, even if it is full of images, how to interpret them is another matter. How do you get the right material out of the warehouse when needed? In other words, how can we connect our sharpened creativity to real industrial design?

In the past, industries used mass production systems to provide consumers with high-quality products at low prices. However, in the turbulent 2000s, the message had to be changed to more eco-friendly, future-oriented, and detailed. Here, creativity goes beyond simple imagination and uses innovative thinking as its core engine. During this time, design also acts in various ways throughout the entire process rather than at a specific point in the production process. Its role as a coordinator to bring out the appropriate intersection between various stakeholders such as planning, development, manufacturing, marketing, and distribution has grown larger.

This is because the concept born through the so-called innovative process contained many problems. In particular, implementation difficulties existed.

Right at this time, the basic question of industrial design is also "how can we rationally solve problems and get the maximum effect with minimum resources?" Creativity is the lubricant for this rather technical and heavy objective. The way I solved the problem was also through creativity: filling the warehouse in my head, discovering the context through my own combination, and visualizing it all. By utilizing this warehouse in my head, I could experiment with various possibilities. By designing the process itself, I could read the entire context. Flexible and creative thinking turned the problem into an opportunity by materializing the concept. In this way, creativity is the foundation of industrial design.

Sometimes I prefer a process in which things influence each other by deliberately creating a fallout. In this case, as soon as a project request comes in, I approach it quickly and start the process of "making" so no abstract idea is lost. Sometimes, I draw with a brush or fountain pen, mold with paper or clay, and other times I concretize in writing in order to visualize it. Immediately after this creativity experimentation, I connect my thoughts to industrial design elements such as usability, mass production, and materials. The idea is to apply the material of inspiration to robots, smartphones, buildings, and AI devices. The fallout here is quite large. It's like attempting the 100 meters freestyle right after working out with dumbbells. If you do all your projects in this way, your body and brain will be shaken, but you can discover many clues to new possibilities.

The source of creativity is flexibility or even ingenuity. The flexibility to find context in seemingly unrelated things… The ingenuity of positive thinking that asks, "why not this way?"… These turn my interpretations into a pattern, the character of the pattern becomes individuality, and when individuality gathers, it becomes philosophy. And when philosophy becomes a form, it becomes a long lasting design, that is, a classic. It overcomes countless years, transcends time, remains a reference that represents the era, and continues to influence future generations as a design philosophy.

Just as you build physical and muscle strength, industrial design develops when you build skills and techniques that contain creativity. In this book, subjective explanations are added to aid understanding of designs. This is how I, and we, bridge the link between creativity and industrial design.

프로젝트
Projects

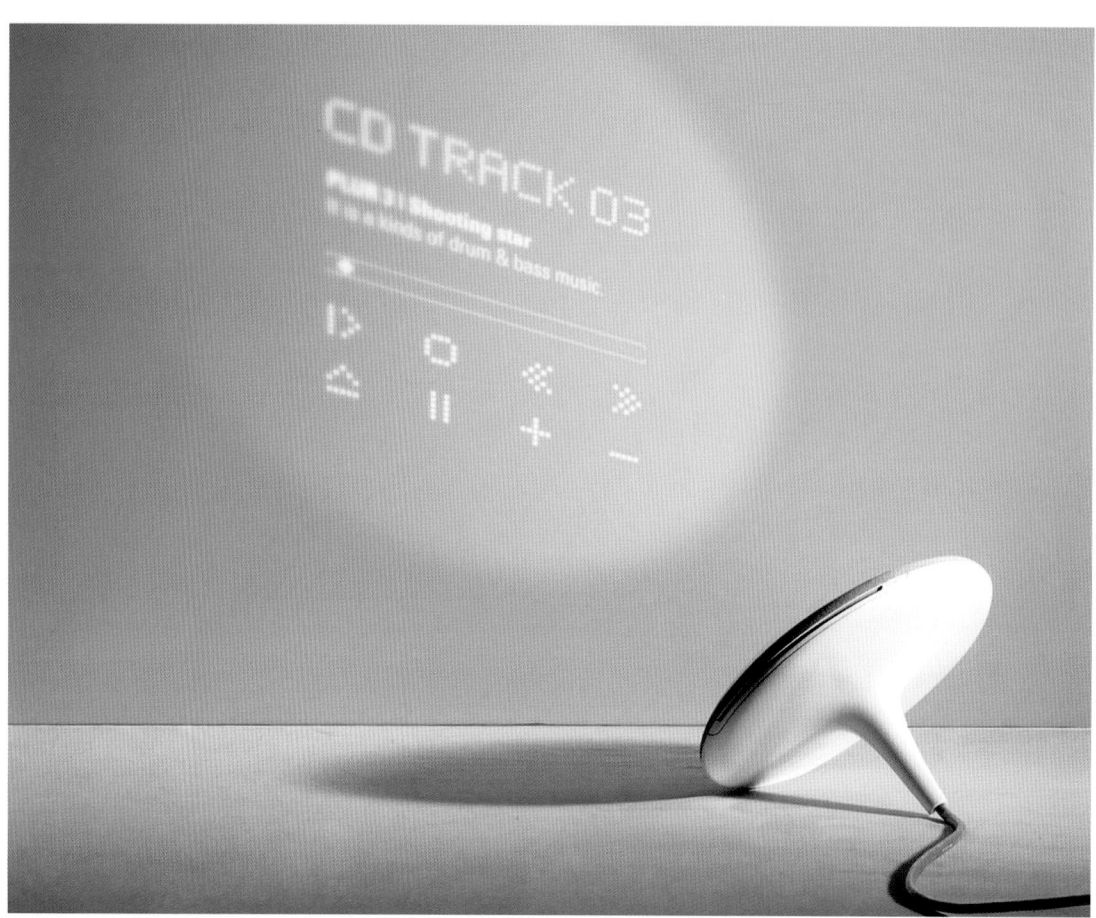

음악을 비추고 빛을 만지다
Spotlight the Music and Touch the Light

음악과 빛을 결합한 이석우의 졸업 작품으로,
CD 플레이어이자 조명등이라고 할 수 있다. 물리적
오브제와 시각적 메시지를 일상적인 사물에 녹여냈다.
CD를 넣으면 조명등이 켜지고, 면을 비추는 빛 속의
인터페이스를 터치해 음악을 재생한다. 당시 한국 대학생
최초로 미국 IDEA 어워드 금상을 수상했다.

Lee Sukwoo's graduation work that combines
music and light and said to be a CD player and
lighting lamp. He wanted to apply a physical
object and a visual message to everyday objects
simultaneously. When a CD is inserted, the light
turns on, and music is played by touching the
interface in the light that illuminates the surface.
At that time, he was the first Korean university
student to receive the US IDEA Award Gold.

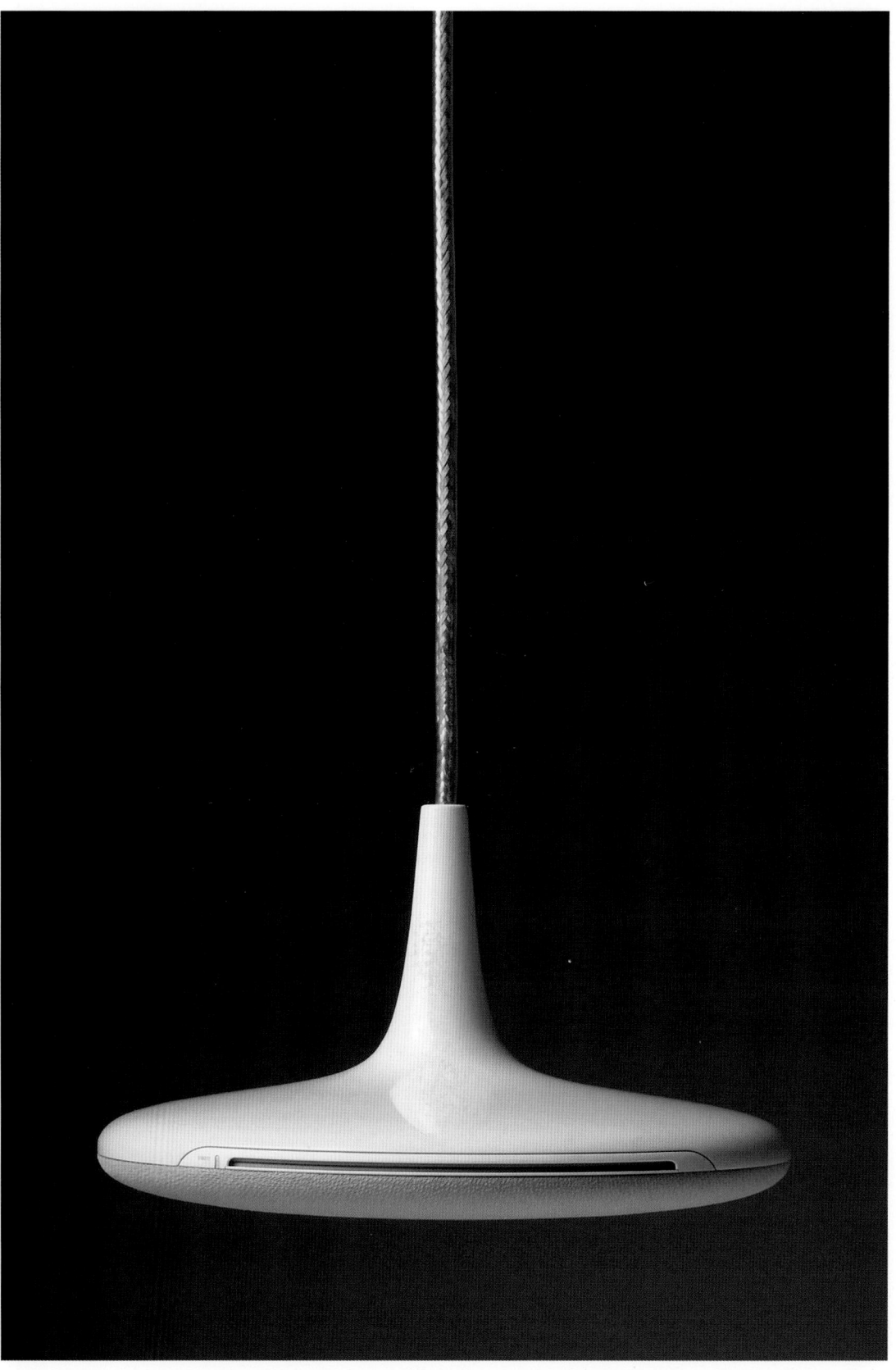

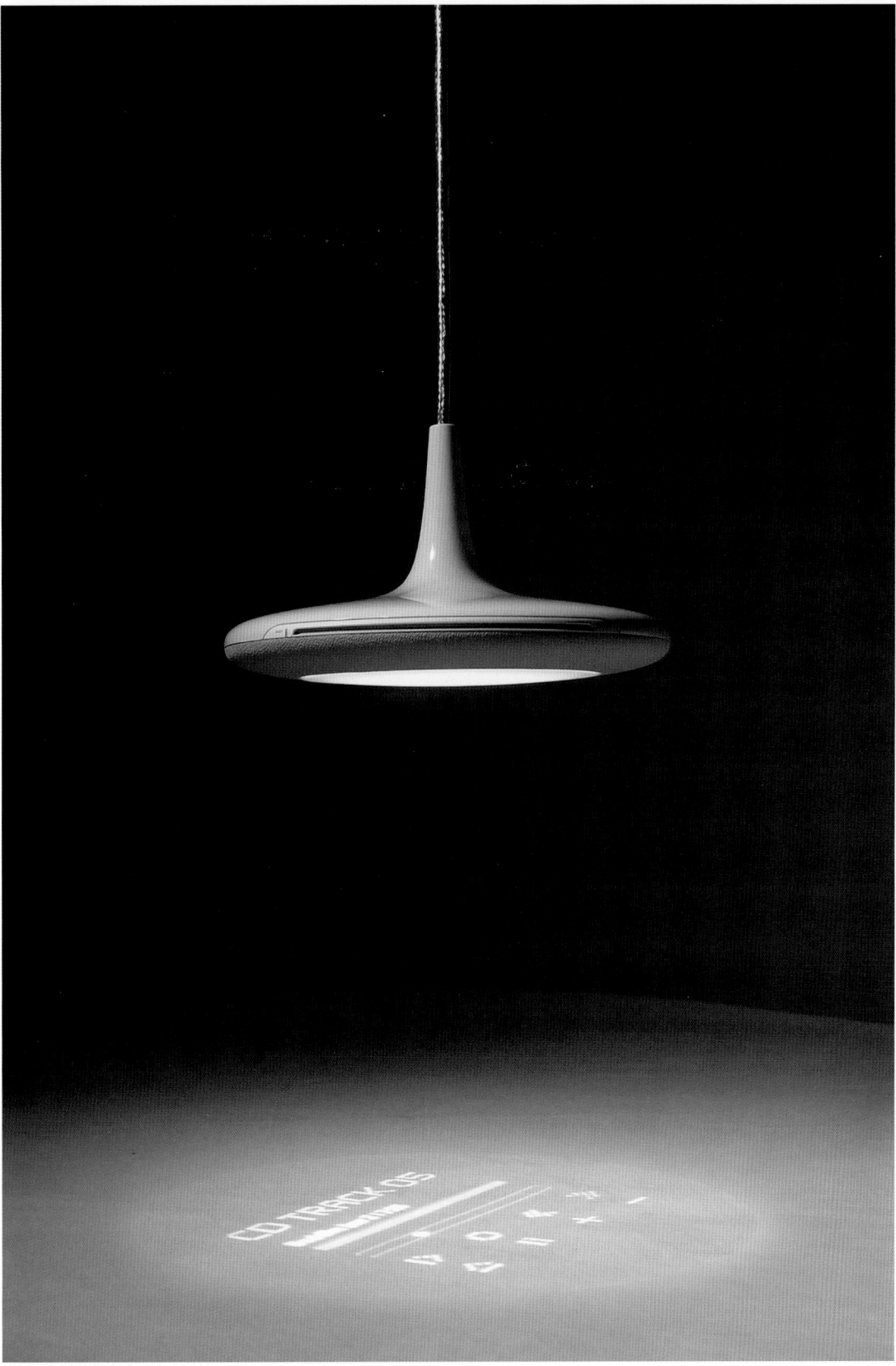

허들 조명
Hurdle Light

빛의 특징을 추상화해 통상적인 스탠드의 구조를
재해석했다. 반사되는 빛의 모습을 조형으로 정리해 광원과
몸체의 구분이 없다. 세우는 형태에 따라 두 가지 무드로
빛이 나온다. 라이터치 국제 조명상의 스페셜 멘션을
받았으며, 이탈리아 디자인 조명 회사인 플로스와
워킹 목업[1]을 만드는 조명 디자인 워크숍을 진행했다.

A design that abstracts the characteristics of light
and reinterprets the structure of a typical stand.
Through use of the reflected light as a structure,
there is no distinction between the light source
and the body. Light comes out in two moods
depending on the shape of the building. For this
work, Lee received a special mention from the
Lightouch International Lighting Award and held
a lighting design workshop to create a working
mockup[1] with Flos, an Italian design lighting
company.

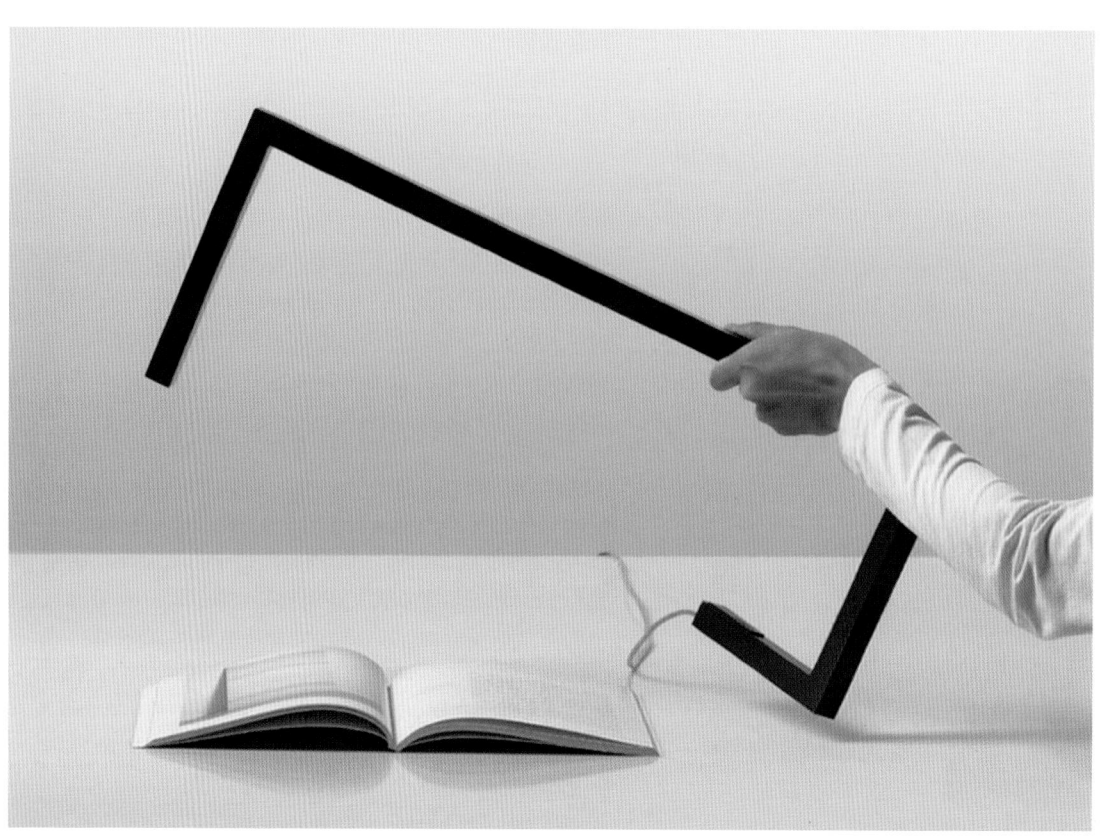

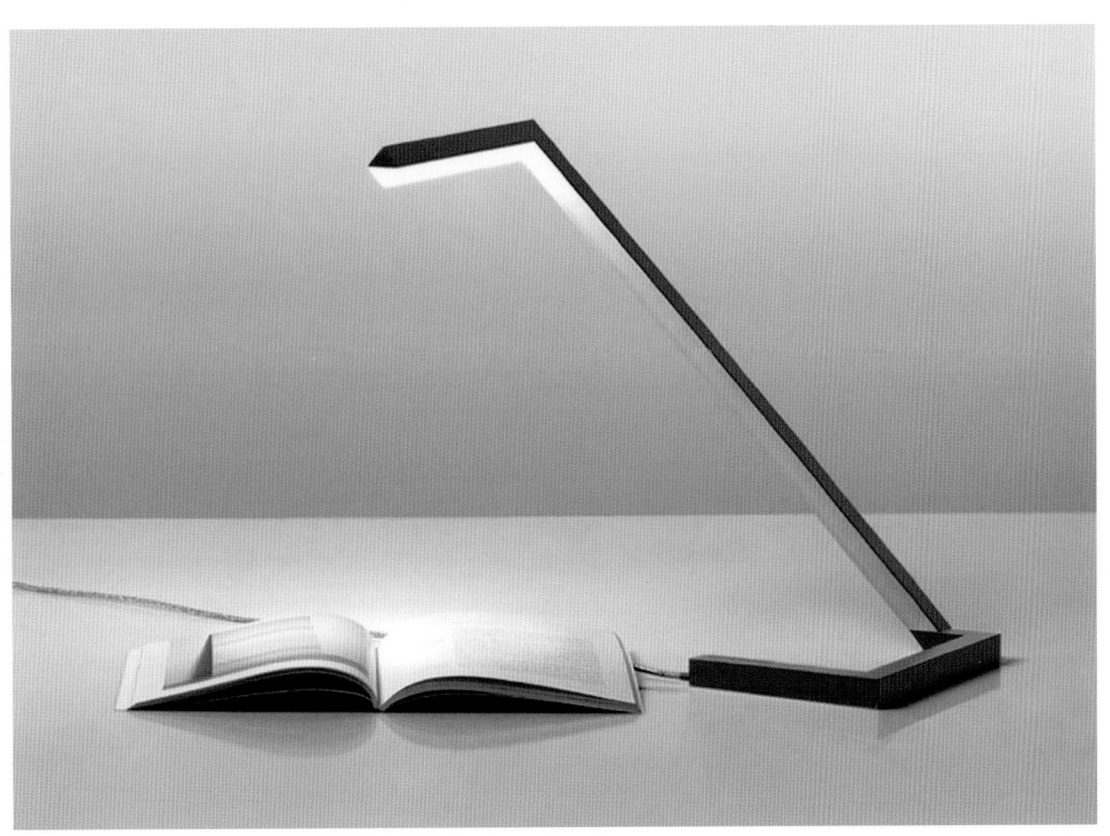

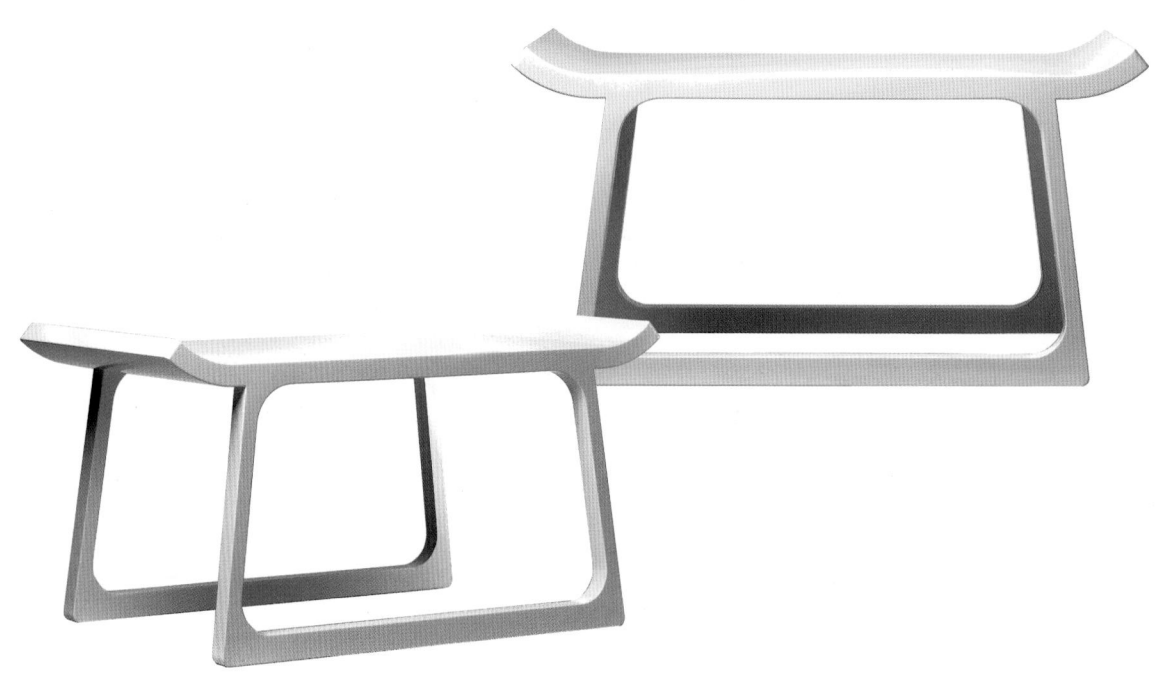

사물의 일상
Ordinariness of Object

2016년까지 홍익대학교 앞에 있었던 BMH 갤러리에서
연 첫 번째 단독 전시다. 평범한 일상의 사물에서 한국적인
정서를 발견하고 사용성과 조형성의 균형을 통해 특별함을
느낄 수 있도록 가구, 조명, 시계, 그릇 등을 디자인했다.
산업 디자인이나 제품 디자인 관련 전시가 거의 없던
시절이고, 개인적으로도 산업 디자이너로서의 정체성을
찾기 위한 시도였다. 그때의 감각이 지금까지 연결되어 있다.

This is Lee's first solo exhibition held at the BMH
Gallery in front of Hongik University until 2016.
Lee discovered the Korean sentiment in ordinary
everyday objects and designed furniture, lighting,
clocks, and bowls to make them have a special
feel through the balance between usability and
formativeness. It was a time when there were few
exhibitions related to industrial design or product
design, and personally, it was an attempt to find
his own identity as an industrial designer. Those
feelings then still exist to this day.

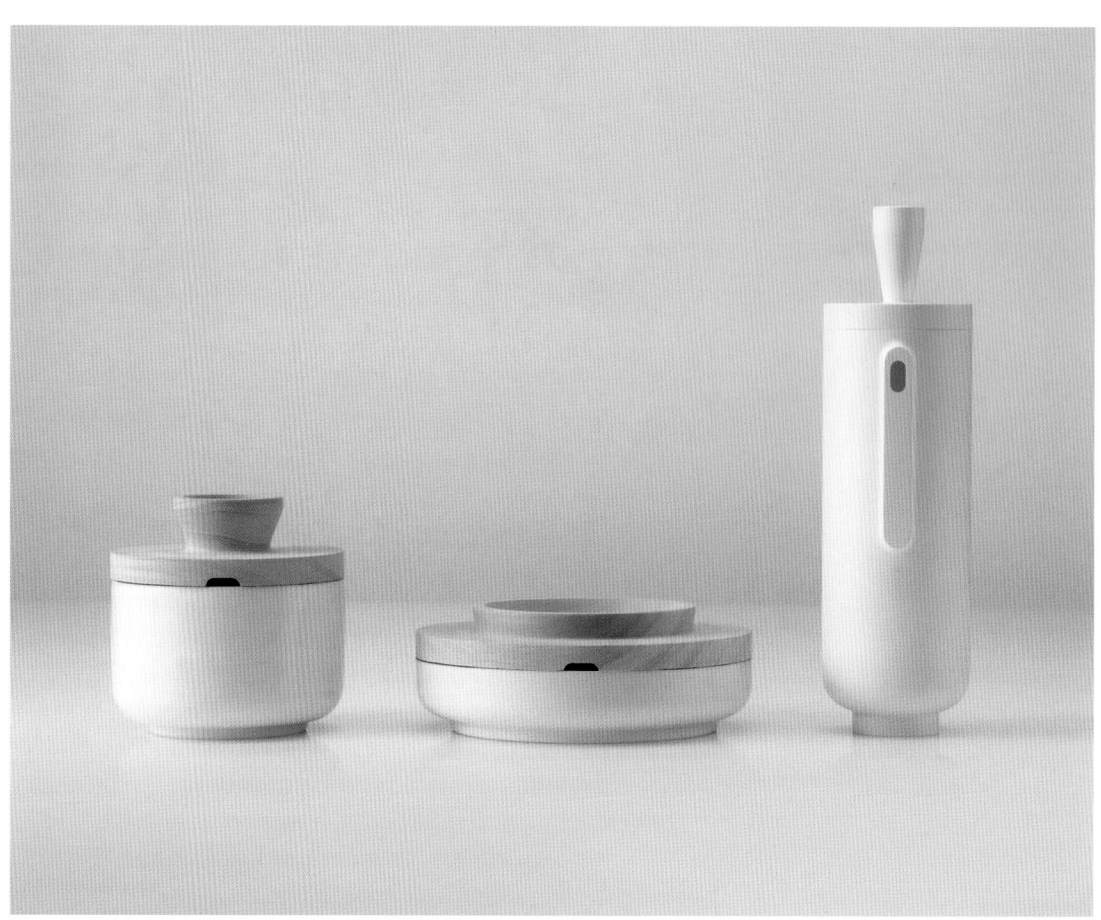

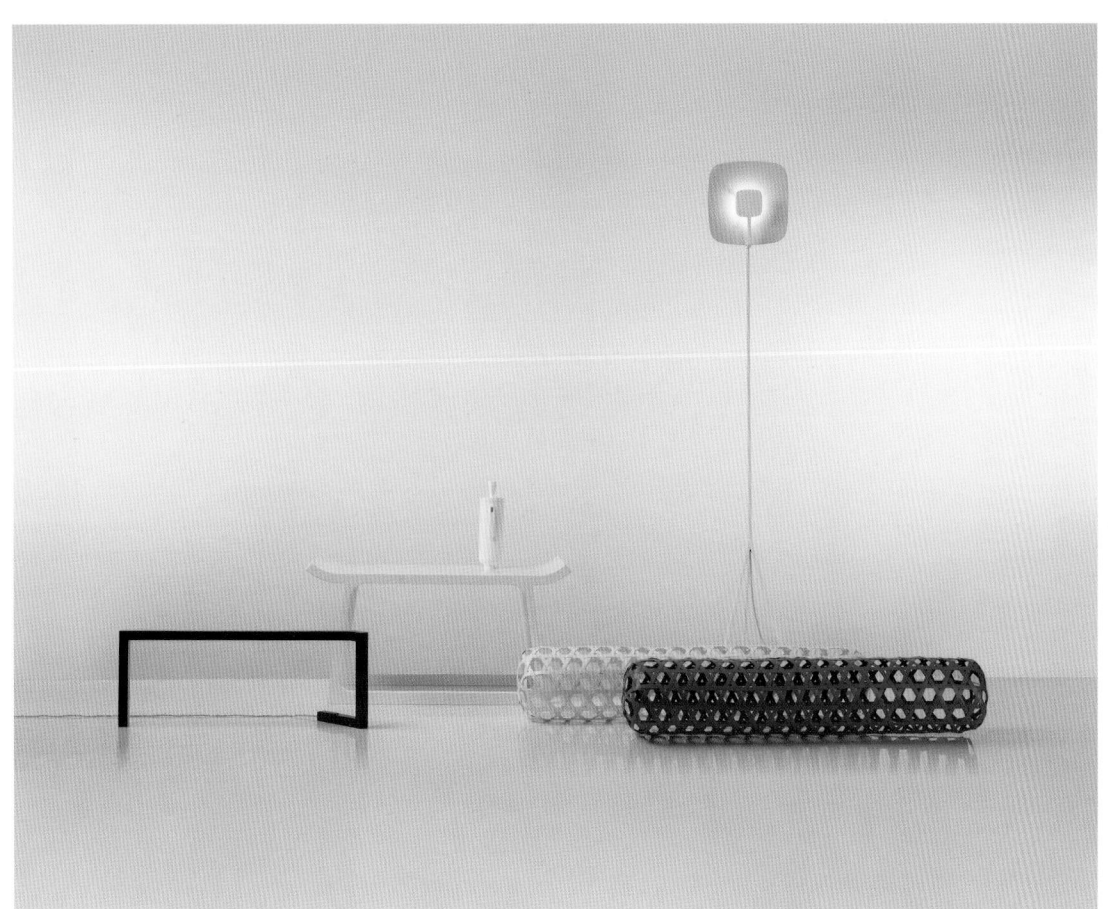

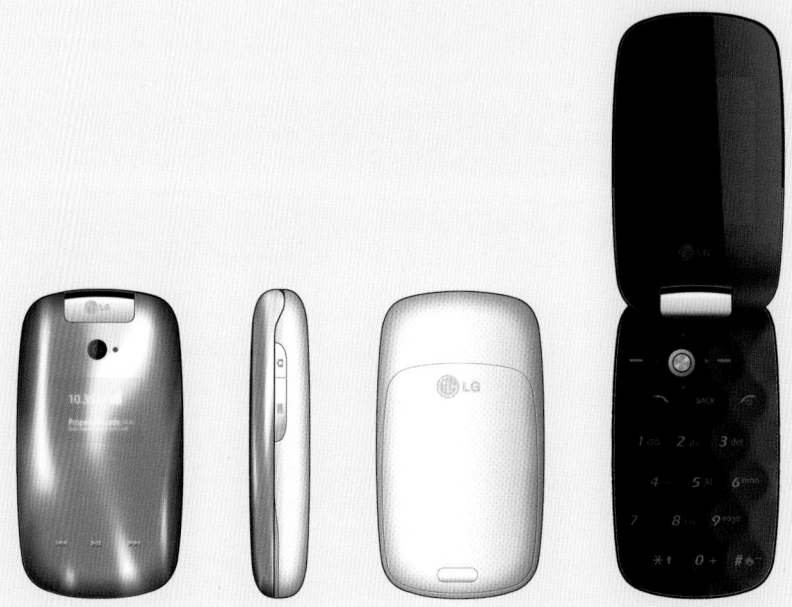

촉감 폴더블 핸드폰
Tactile Foldable Mobile Phone

사람이 핸드폰을 쥐었을 때 느끼는 촉감에 관한
고민으로부터 출발했다. 표면은 물결처럼 구불구불해
보이지만 만져보면 매끈한 촉감의 특수 도료를 사용했다.
안쪽은 골프공을 쥐었을 때의 느낌에 영감 받아 키패드에
골프공 콘셉트의 패턴을 적용했다.

This design started from consideration of the
tactility when a person holds a cell phone.
Although the surface looks wavy, a special paint
that feels smooth to the touch is used. The inside
was inspired by the feeling of holding a golf ball
and a golf ball concept pattern was applied to the
keypad.

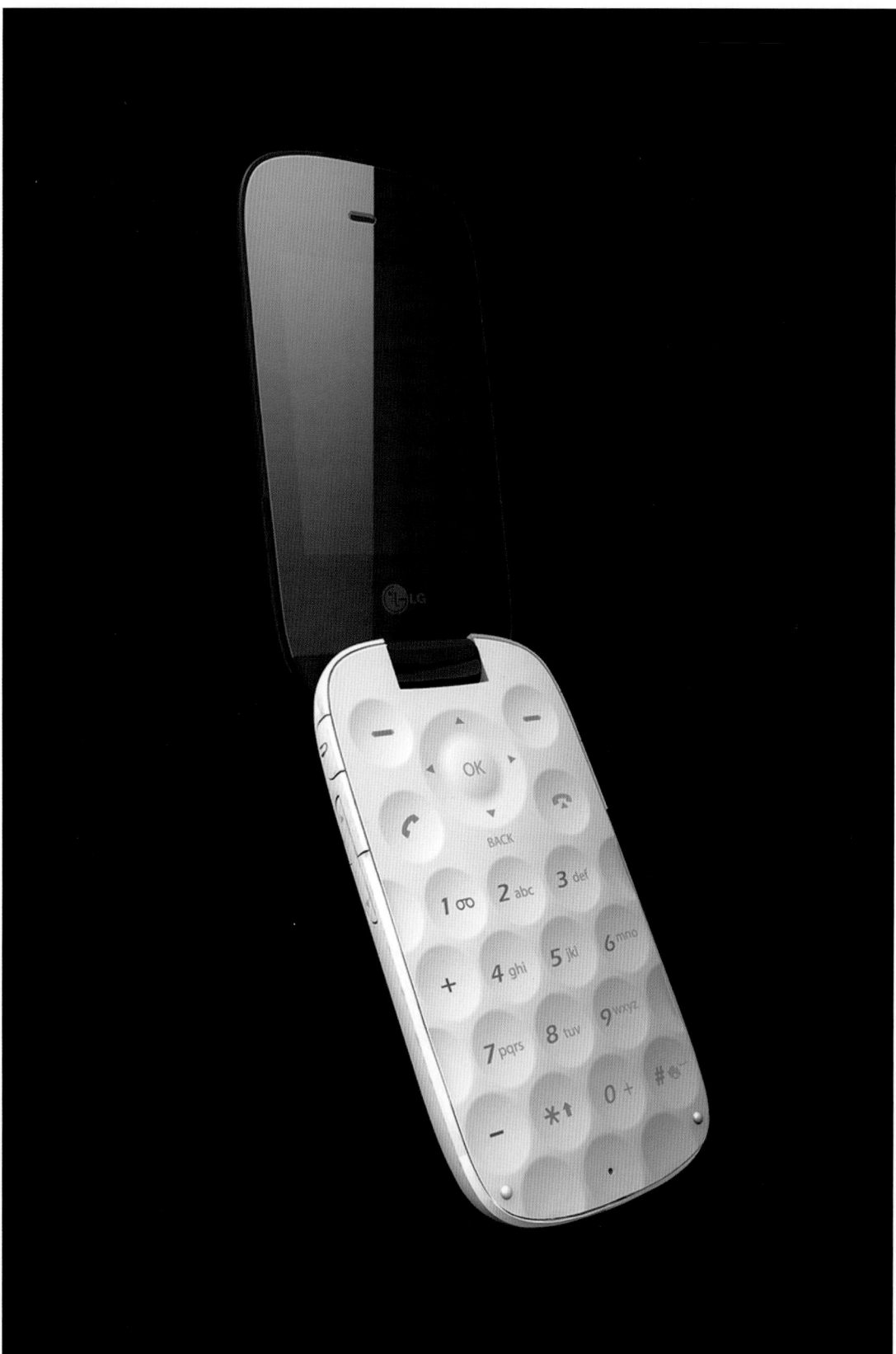

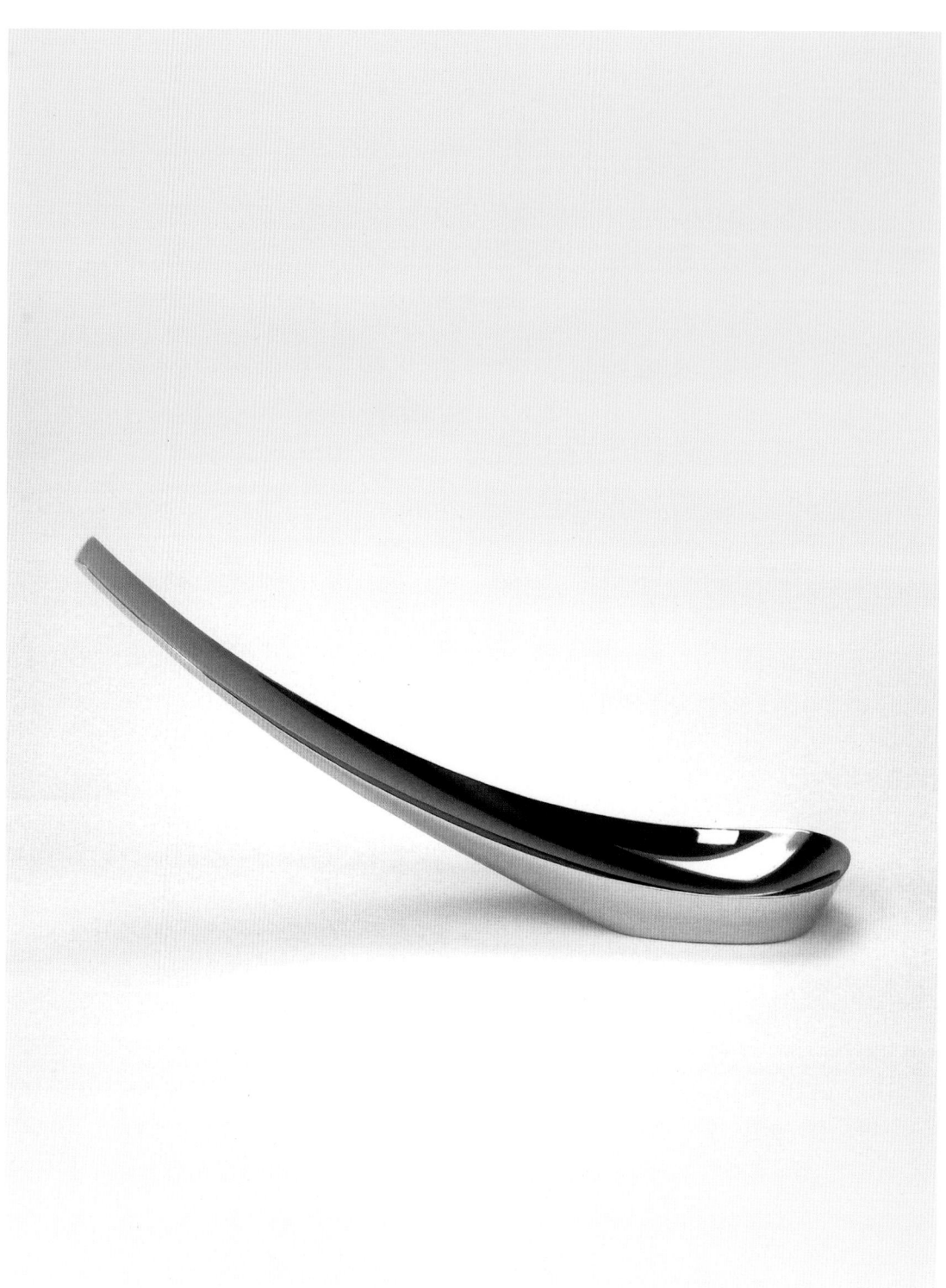

한 송이의 꽃을 위한 꽃병
Vase for Just One Flower

꽃병은 항상 기둥 형태라는 고정관념을 깨고 새로운 원형을
디자인하기로 했다. 많은 꽃도 좋지만, 한 송이의 꽃을 위한
꽃병이라면 한 줌의 물이면 될 것이다. 이런 생각에 스푼을
떠올렸고 조형으로 가다듬었다. 스푼 구조라서 물을 한 스푼
뜬 후 그곳에 꽃을 바로 놓을 수 있다.

Breaking the stereotype that the vase is always in
the form of column, Lee decided to design a new
type. A bunch of flowers are good, but a vase for a
single flower would require just a bit of water. With
this in mind, he thought of a spoon and refined
it into a shape. Since the structure is a spoon,
you can place the flower on top after adding a
spoonful of water.

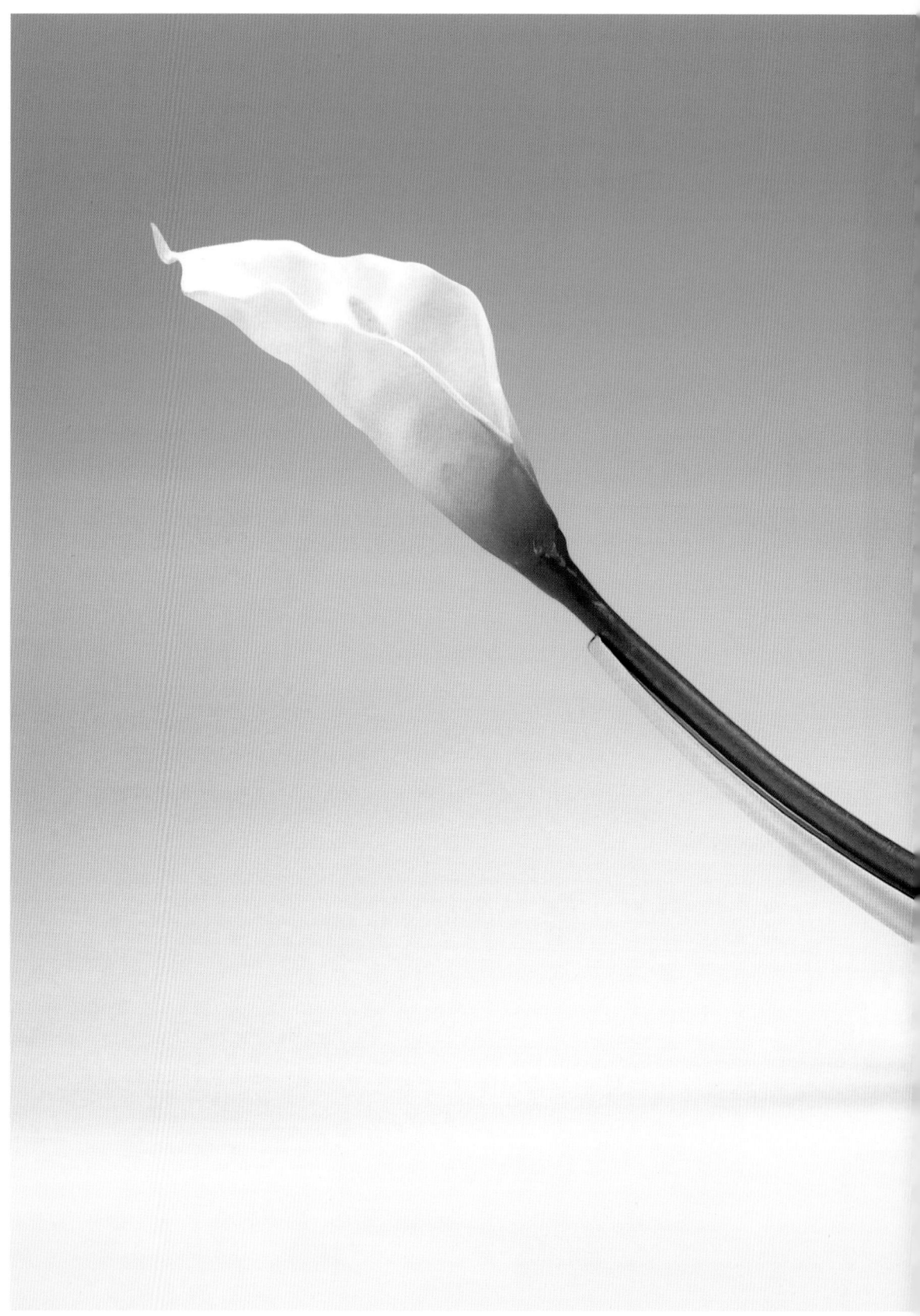

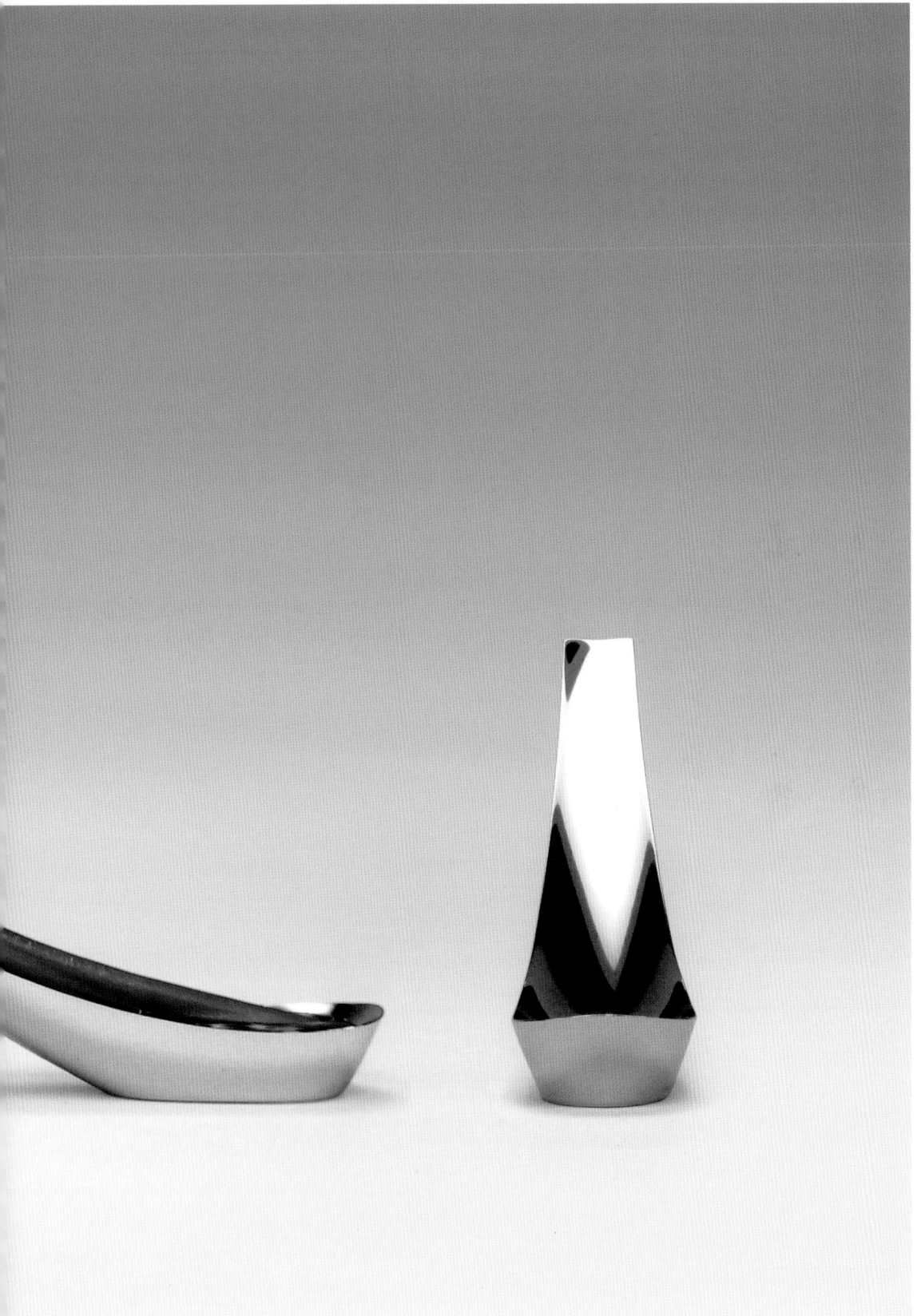

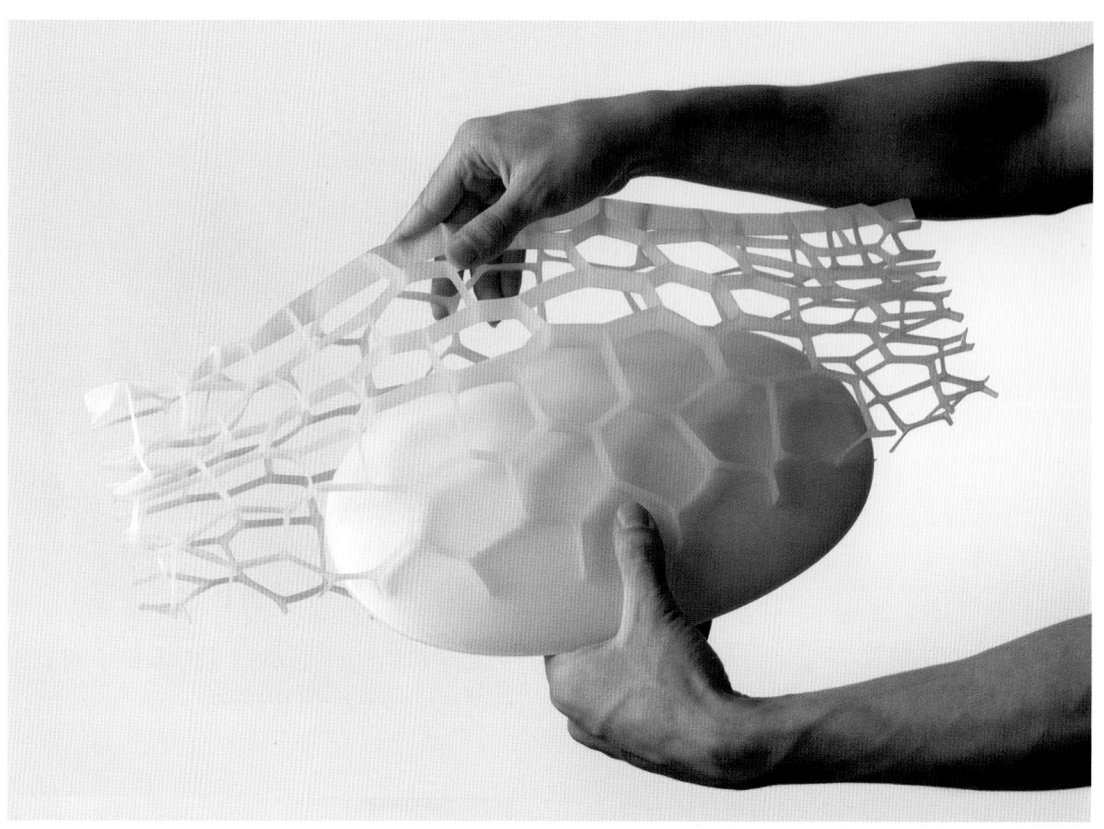

우뭇가사리 시리즈
Agar-agar Series

과학 도감에서 우연히 발견한 우뭇가사리 씨앗의 형태에
영감 받아 만든 조명등과 의자 시리즈다. 우뭇가사리 씨앗은
겉피가 내피를 보호하는 2겹 구조로 되어 있는데 그 모양
자체가 아름답다. 이 구조의 패턴을 정리해 비율을 키우고,
3D CAD 소프트웨어인 알리아스로 정리해 3D 프린트했다.

This is a series of lighting lamps and chairs
inspired by the shape of agar-agar seeds found
by chance in a science encyclopedia. Agar-agar
seeds have a two-layer structure in which the
outer skin protects the inner skin, and the shape
itself is beautiful. The pattern of this structure was
arranged to increase the proportions and printed
in 3D with Alias, a 3D CAD software.

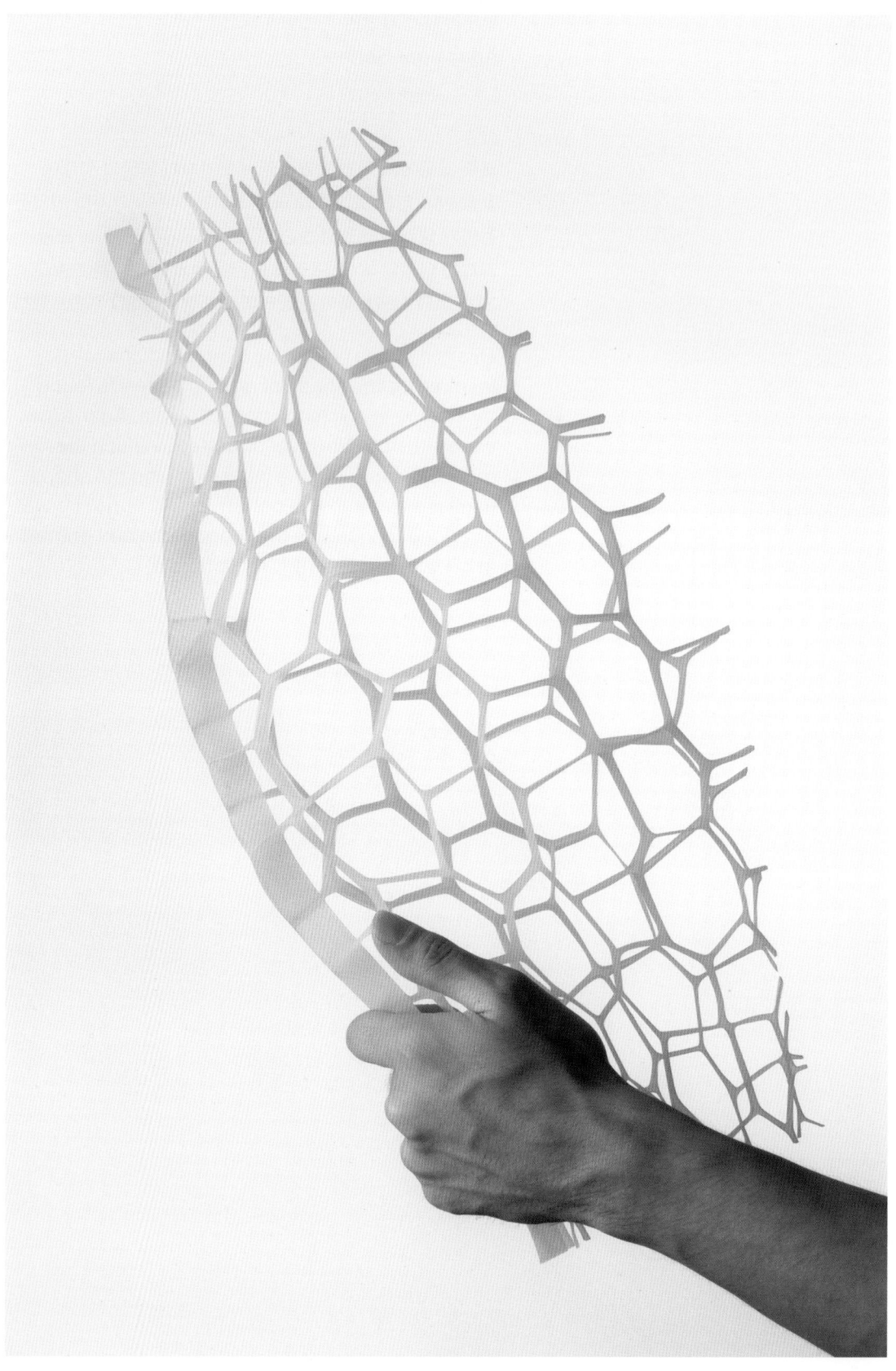

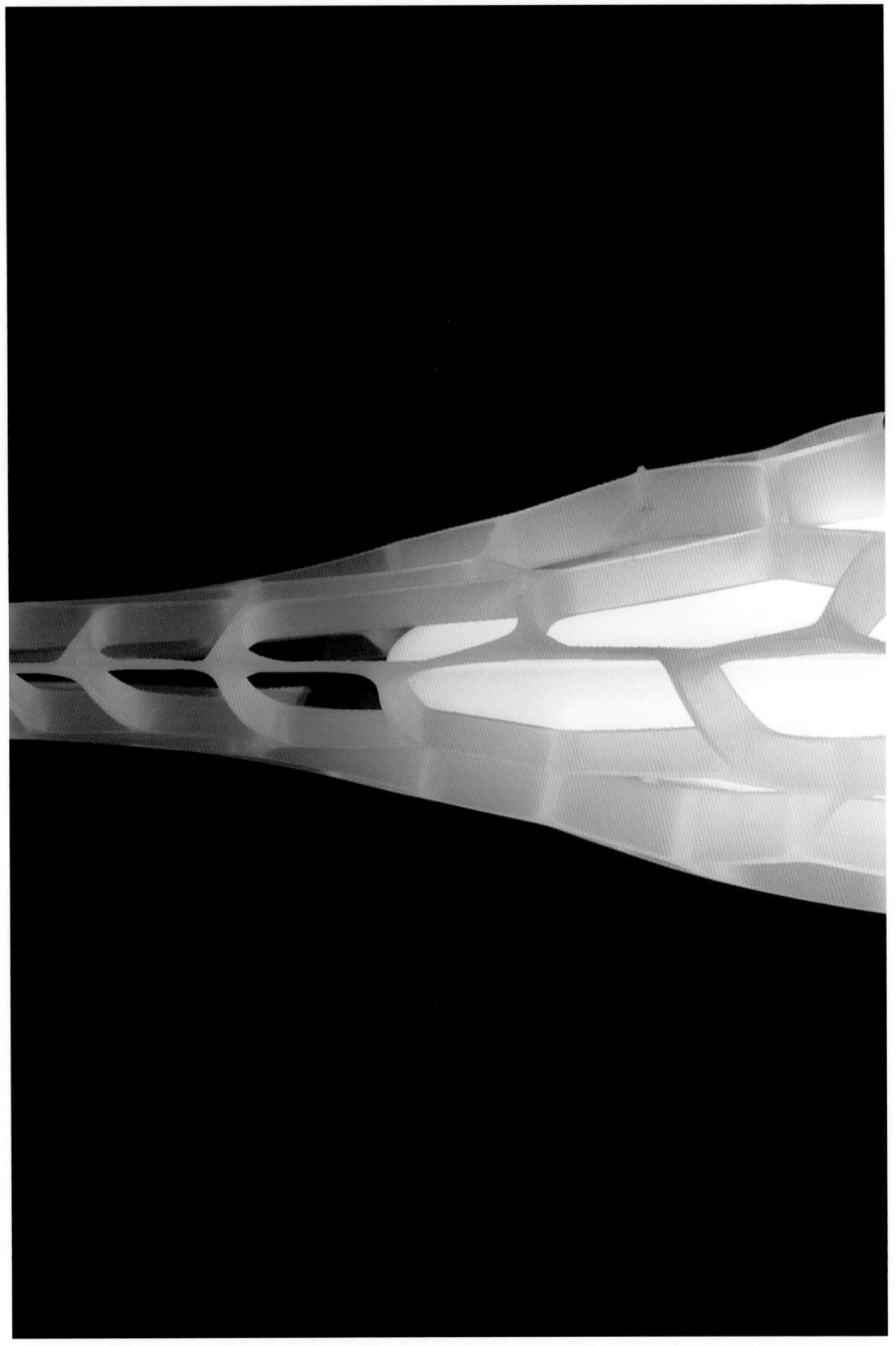

→
296

무중력 조명 시리즈
Zero-G Light Series

무중력은 무엇일까? 조명등이 중력의 영향을 받지 않는
것처럼 공중에 떠 있는 모습을 상상하면서 디자인한
시리즈다. 빛을 비추는 모양 자체가 스탠드의 다리가
된다. 2010년 이탈리아 밀라노의 슈퍼스튜디오 피유에서
전시했으며, 이를 본 이탈리아 리빙 브랜드 셀리티와
협업했다. 2011년 독일 출판사 게슈탈튼에서 출판한
현대 조명 디자인 책 『럭스: 램프 앤드 라이트』에
수록되기도 했다.

What is zero gravity? This is a series designed
by imagining the appearance of lighting lamps
floating in the air as if they are not affected by
gravity. The shape that shines the light itself
becomes the leg of the stand. The series was
exhibited at Superstudio Più in Milan, Italy in 2010,
and made in collaboration with Italian living brand,
SELETTI. It was also included in *Lux: Lamps and
Lights*, a modern lighting design book published
by German publisher, Gestalten, in 2011.

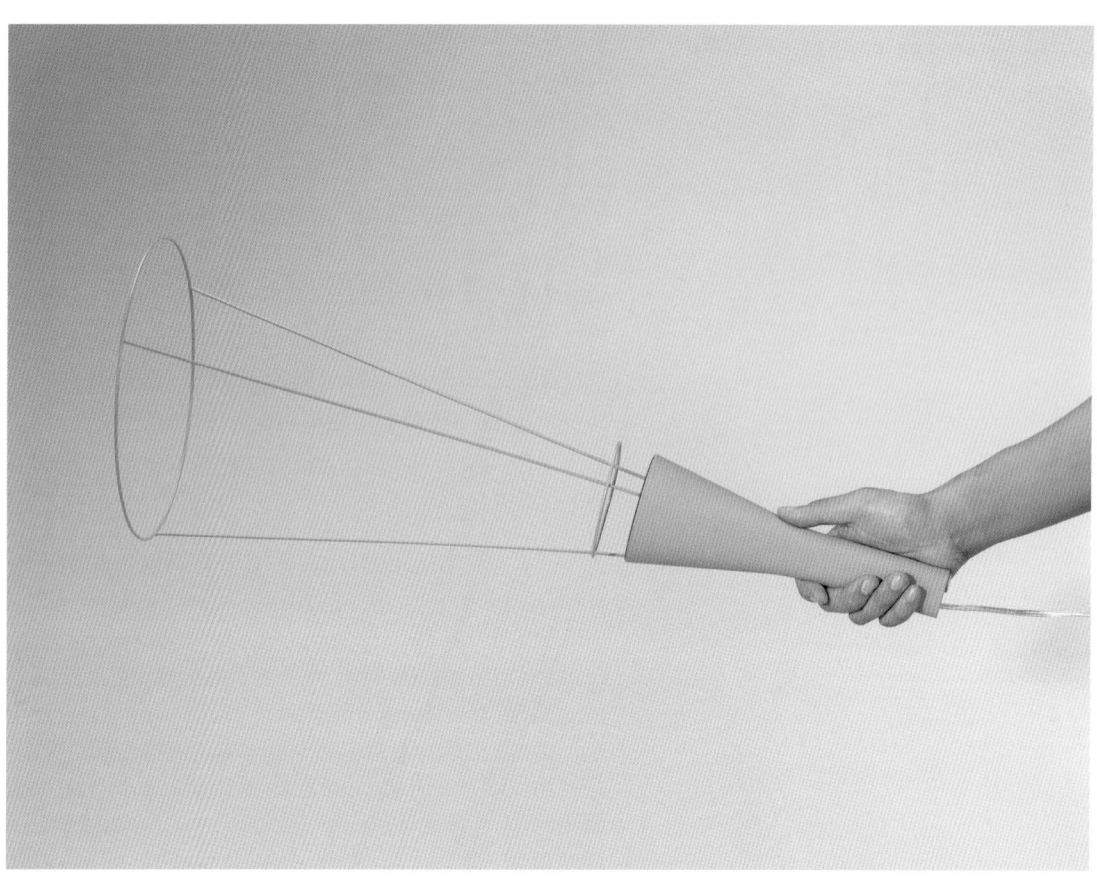

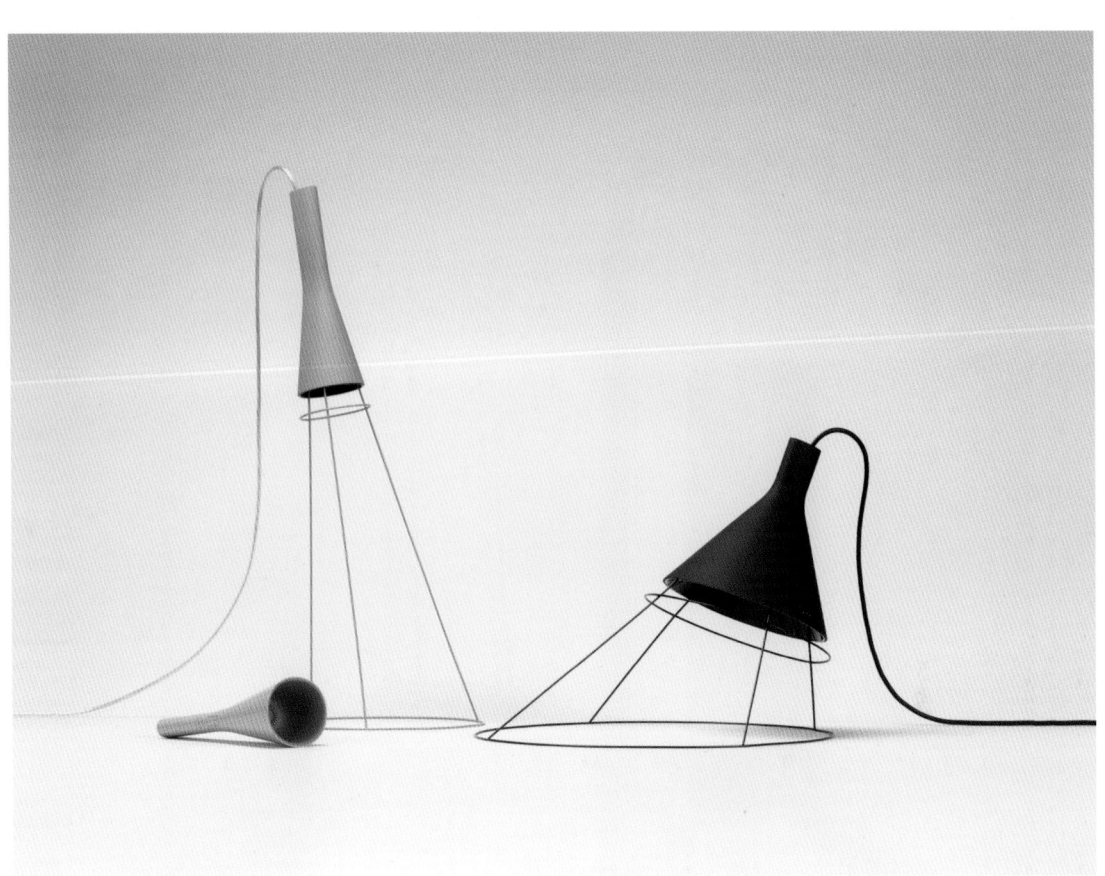

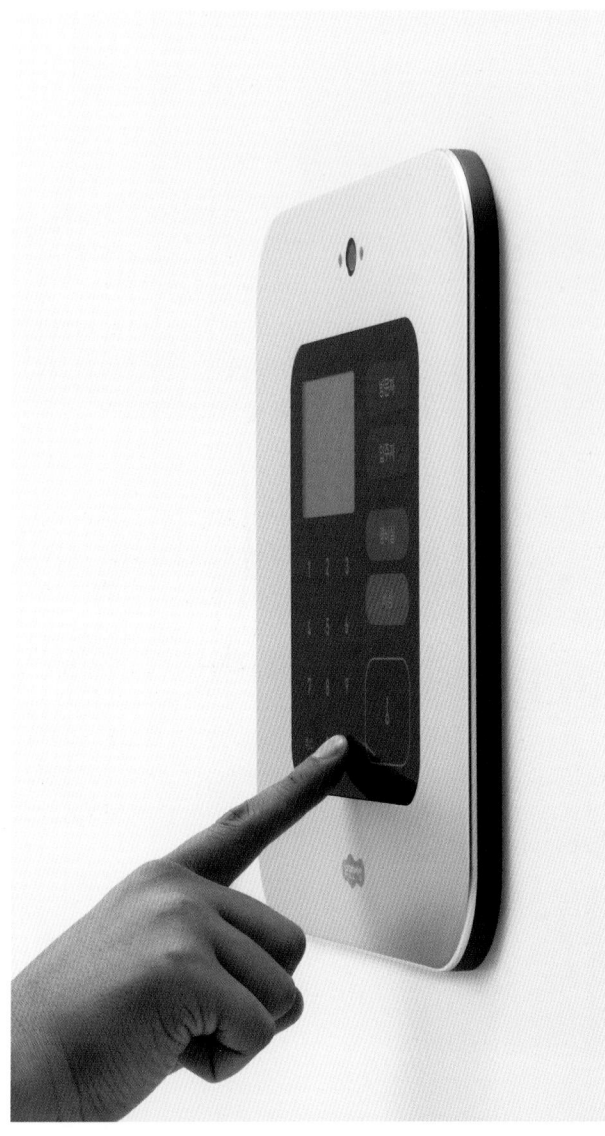
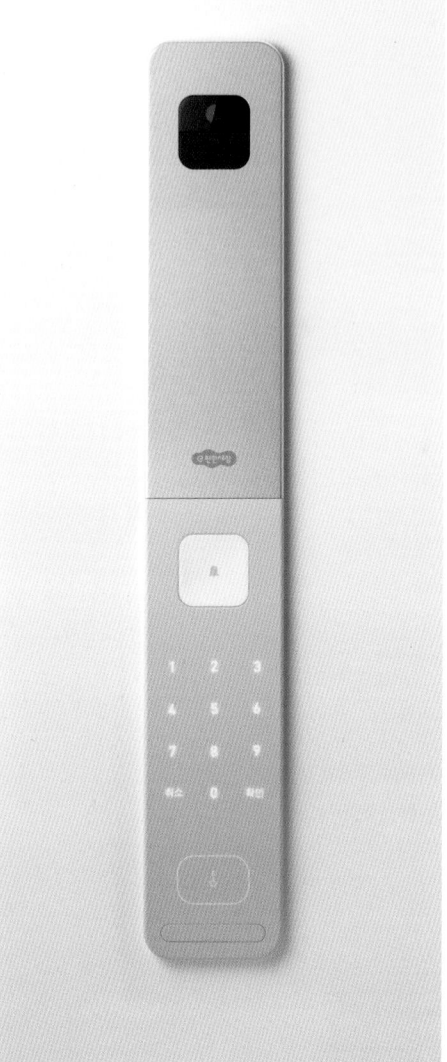

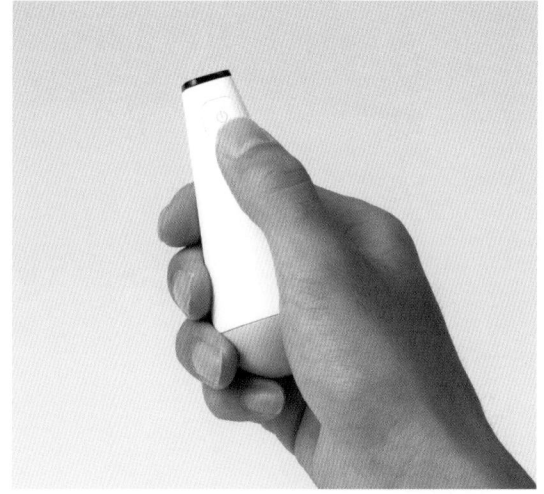

아파트 제품 아이덴티티
Apartment Product Identity

아파트 브랜드를 위한 제품 아이덴티티 디자인이다.
아파트 실내 공간의 스위치, 콘센트, 온도조절기, 월패드,
리모콘 같은 전기 장치에 흔히 보는 직사각형이 아닌
모서리를 둥글린 정사각형을 적용했다. 정사각형의 비례와
브랜드의 슬로건인 '진심이 짓는다'가 연결된다고 생각했다.
이 형태는 실외의 로비 폰, 도어락, 문손잡이 등 여러
제품으로 발전했다.

This is an identity design for an apartment brand.
A square with rounded corners was applied
to electrical devices such as switches, outlets,
thermostats, wall pads, and remote controls in
the apartment interior space, rather than the usual
rectangular ones. In this way, the proportion of the
square and the brand's slogan, "Sincerity Build,"
were connected. This form developed into several
products such as outdoor lobby phones, door
locks, and door handles.

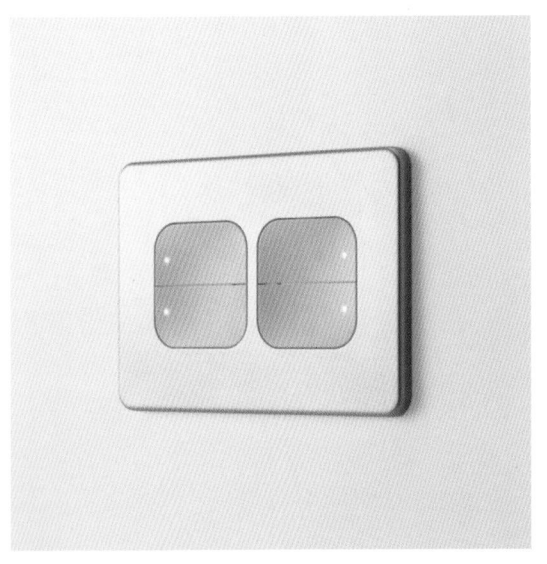

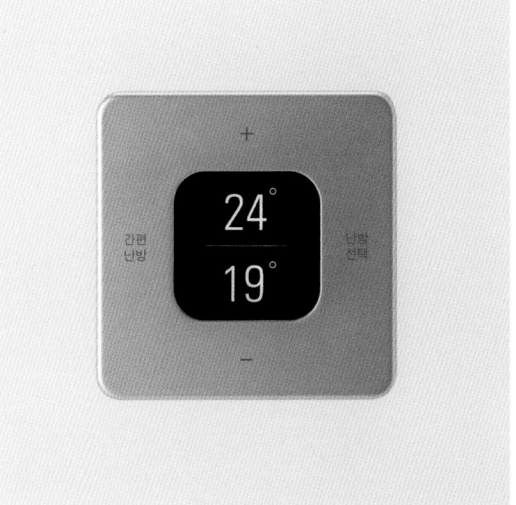

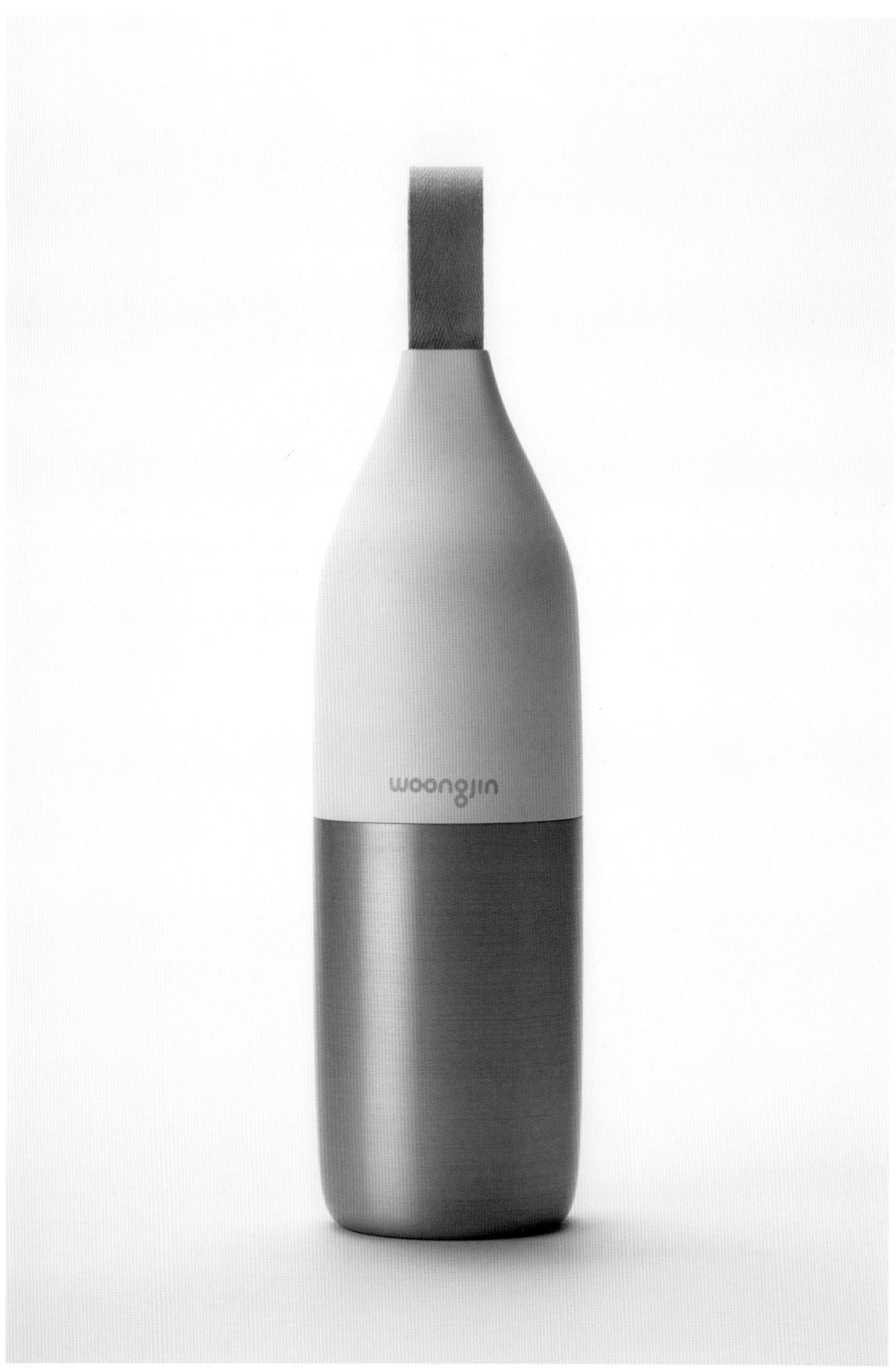

→
298

물병
Water Bottle

가전 렌탈 회사의 가전제품 하드웨어 디자인뿐 아니라
서비스 디자인까지 접근해, 서비스 접점에서의 다양한
매체를 통합적으로 디자인했다. 이 물병은 그들의
제품 가치를 담은 웰컴 키트다. 가정과 직장을 비롯해
어디에든 깨끗하게 정수한, 건강한 물을 공급하겠다는
메시지를 전달하기 위해 구성했다.

By approaching not only the hardware-design
of home-appliance rental companies but also
service-design, we designed various media at
service contact points in an integrated way.
This water bottle is a welcome kit containing the
companies' product values. It was created to
convey the message of providing clean, purified,
and healthy water anywhere including at home
and at work.

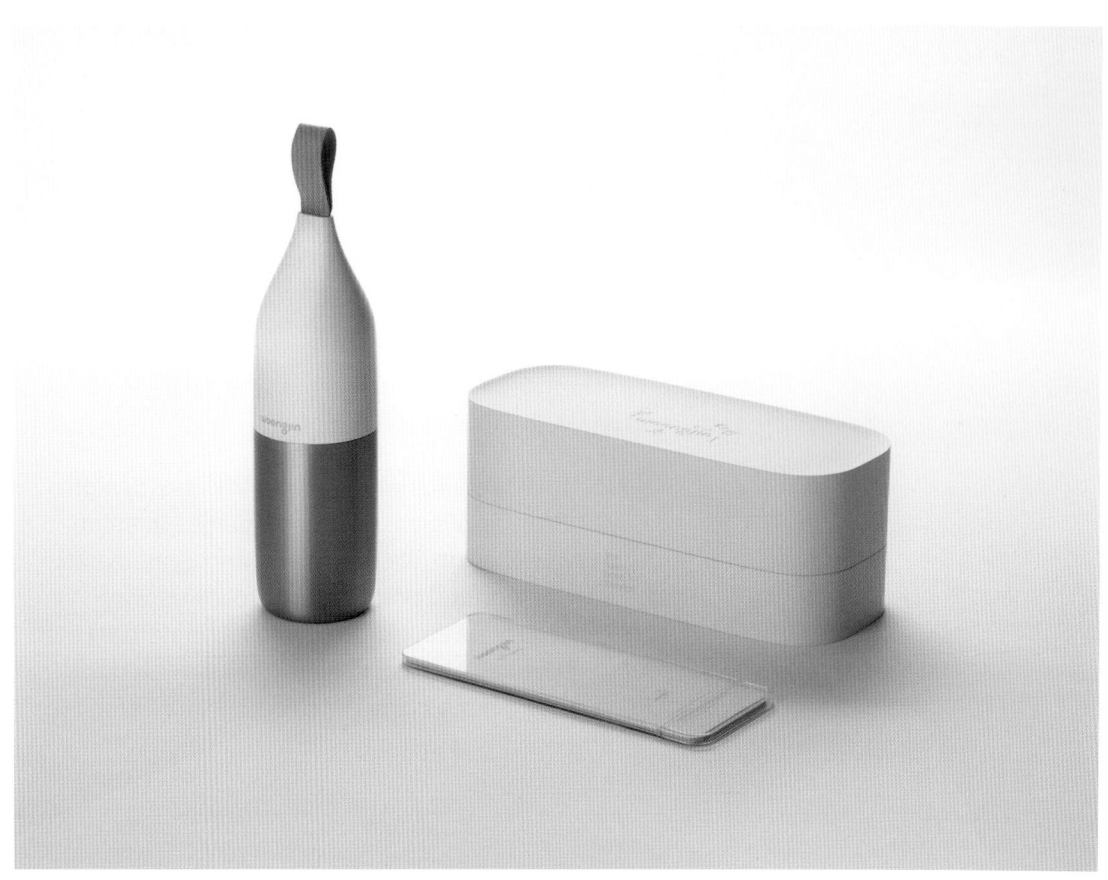

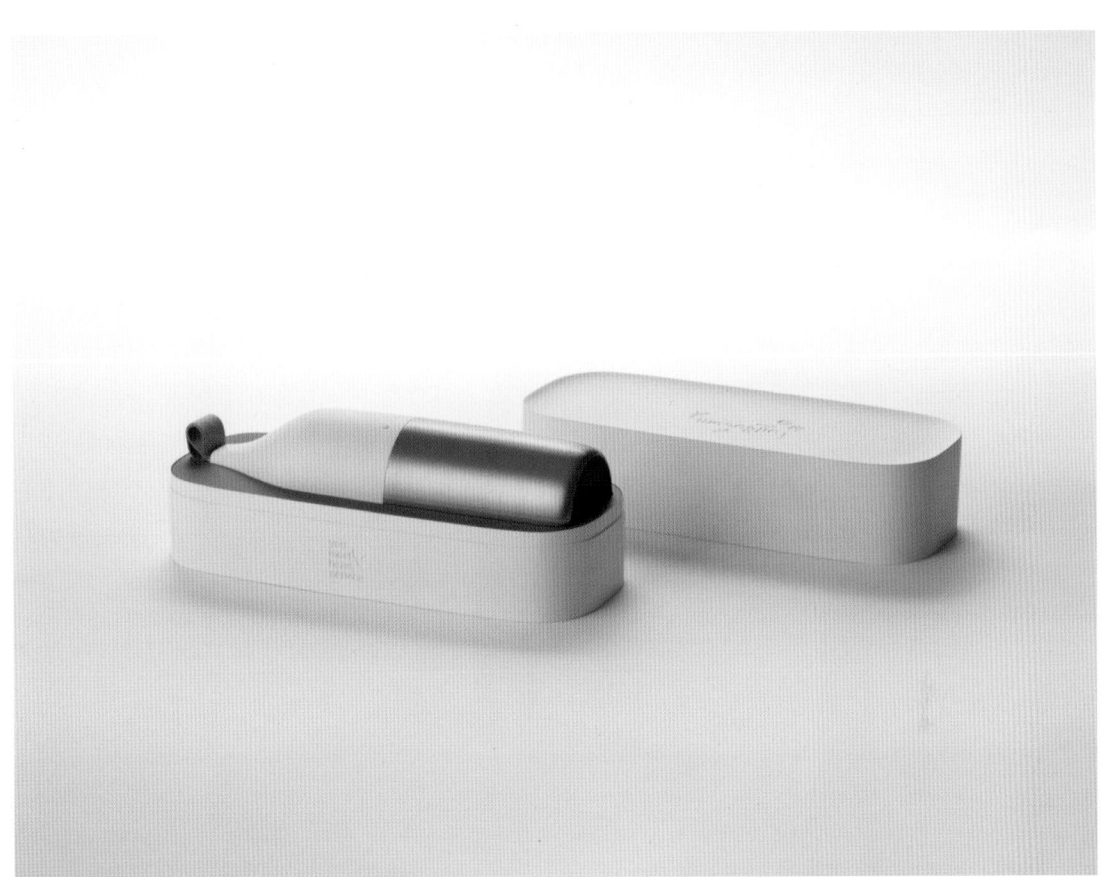

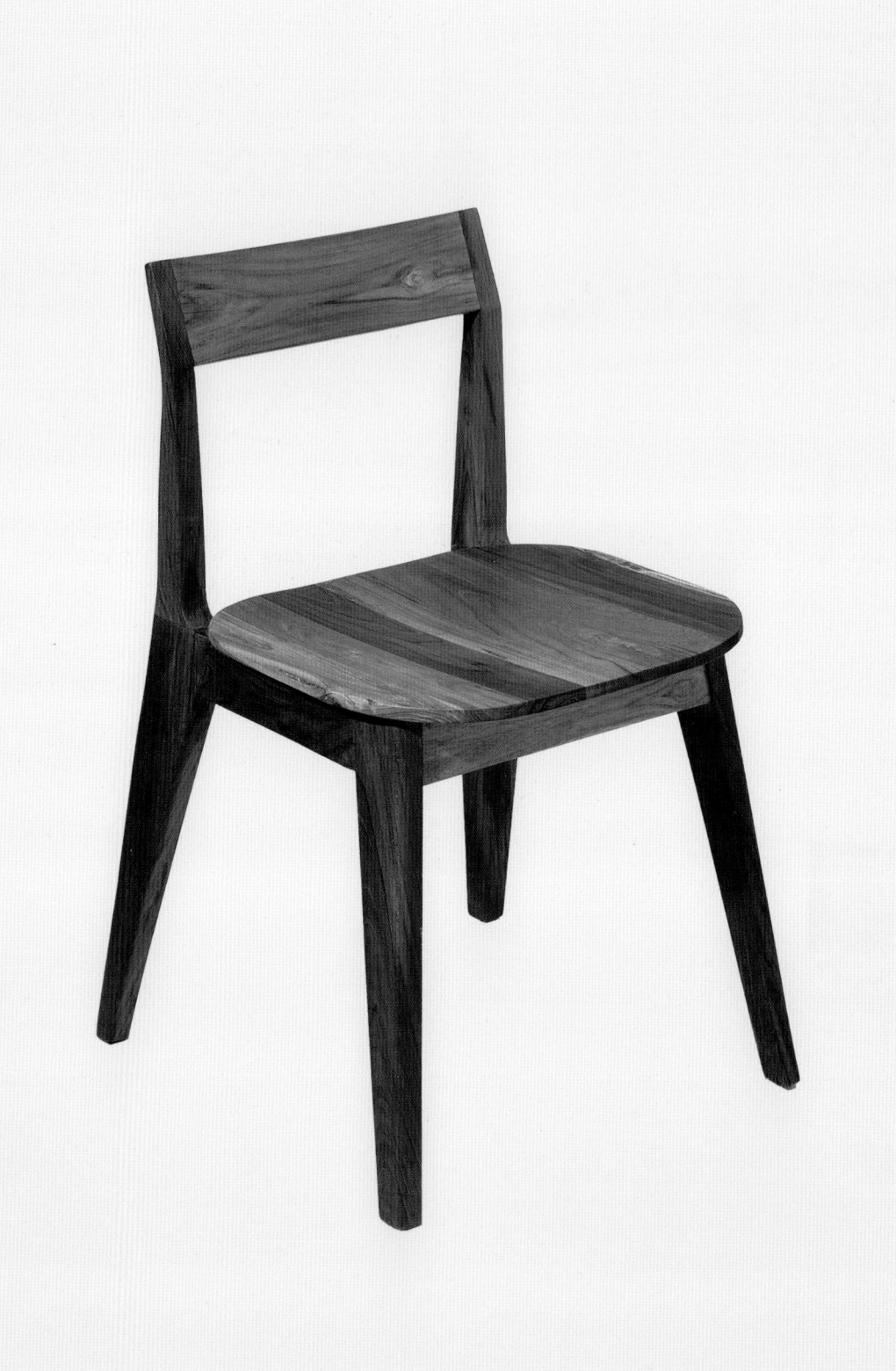

레그 퍼니처 시리즈
Leg Furniture Series

매터&매터는 2011년 론칭한 SWNA의 첫 번째 가구
브랜드로, 레그 체어는 매터&매터의 첫 의자이자 양산
제품이다. 의자 다리의 바깥쪽은 곡선을 넣어 부드러운
느낌, 안쪽은 각이 져 단단한 느낌이 들게 디자인해 안과
밖의 대비를 강조했다. 이런 조형성 덕분에 전체적으로
부드러우면서도 구조적인 느낌이 든다. 이 의자는 이후
스툴, 테이블, 암체어 등의 가구로 파생되었다.

Matter & Matter is SWNA's first furniture brand
launched in 2011, and the leg chair is its first
chair and mass-produced product. The outside
of the chair legs is designed to give a soft feel by
inserting a curve, and the inside was designed
with a hard feel with angles to emphasize the
contrast between the inside and the outside.
Thanks to this formativeness, the overall feel is
soft and structured. This chair later inspired other
furniture such as stools, tables, and armchairs.

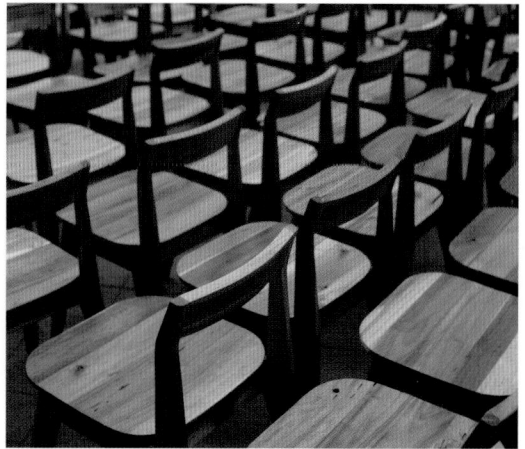

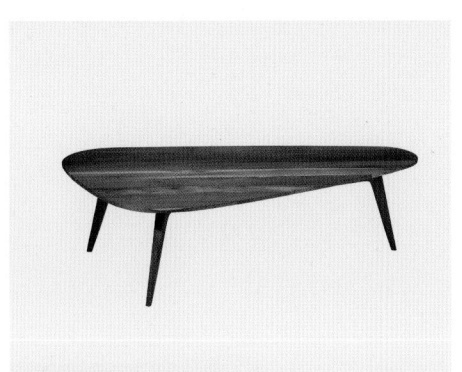

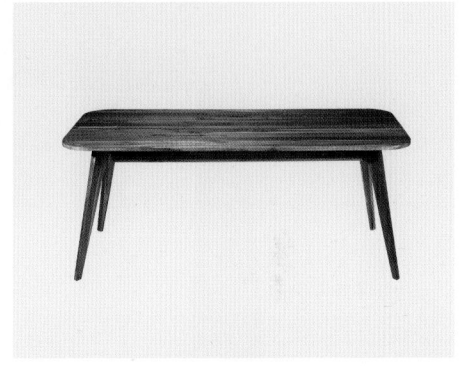

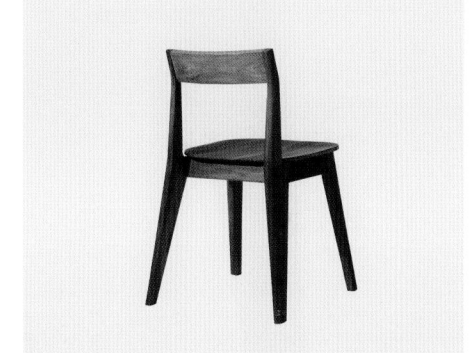

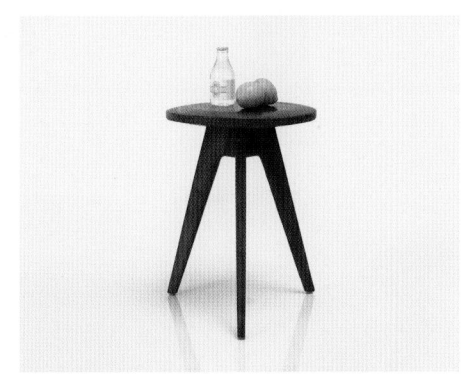

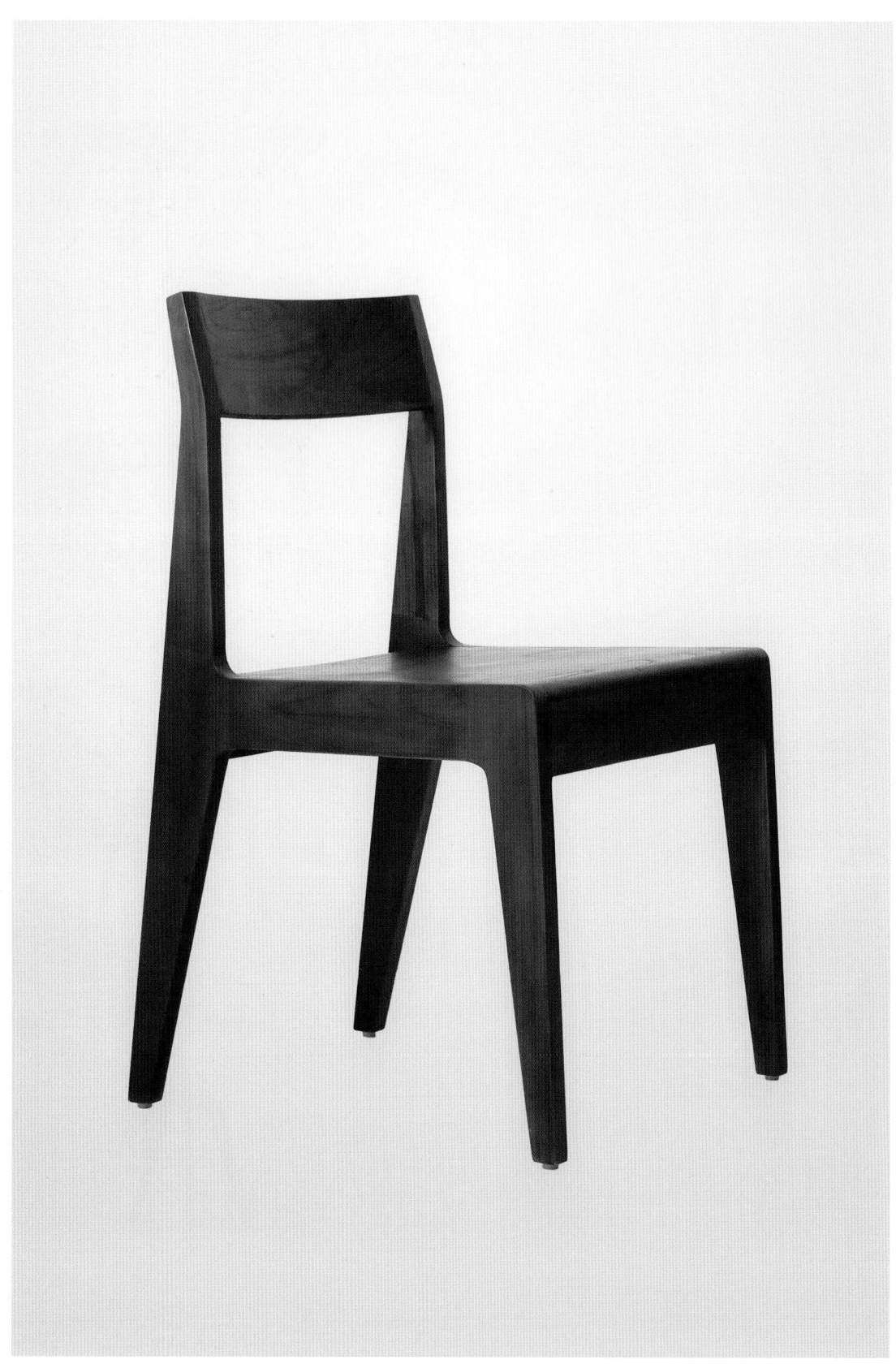

노말 체어
Normal Chair

매터&매터의 두 번째 의자다. 단순한 방식으로 제작하기
위해 특히 평면 가공에 최적화한 디자인이다. 전체적인
비율은 일반 의자와 흡사하지만, 가장 기본적인 형태와
요소를 오히려 극대화해 의자의 '원형'을 매터&매터
방식으로 재해석했다.

This is Matter & Matter's second chair. In order
to manufacture in a simple way, it is a design
optimized especially for plane machining.
Although the overall proportion is similar to that
of a general chair, by maximizing the most basic
shape and elements, the chair's original form has
been reinterpreted in the Matter & Matter method.

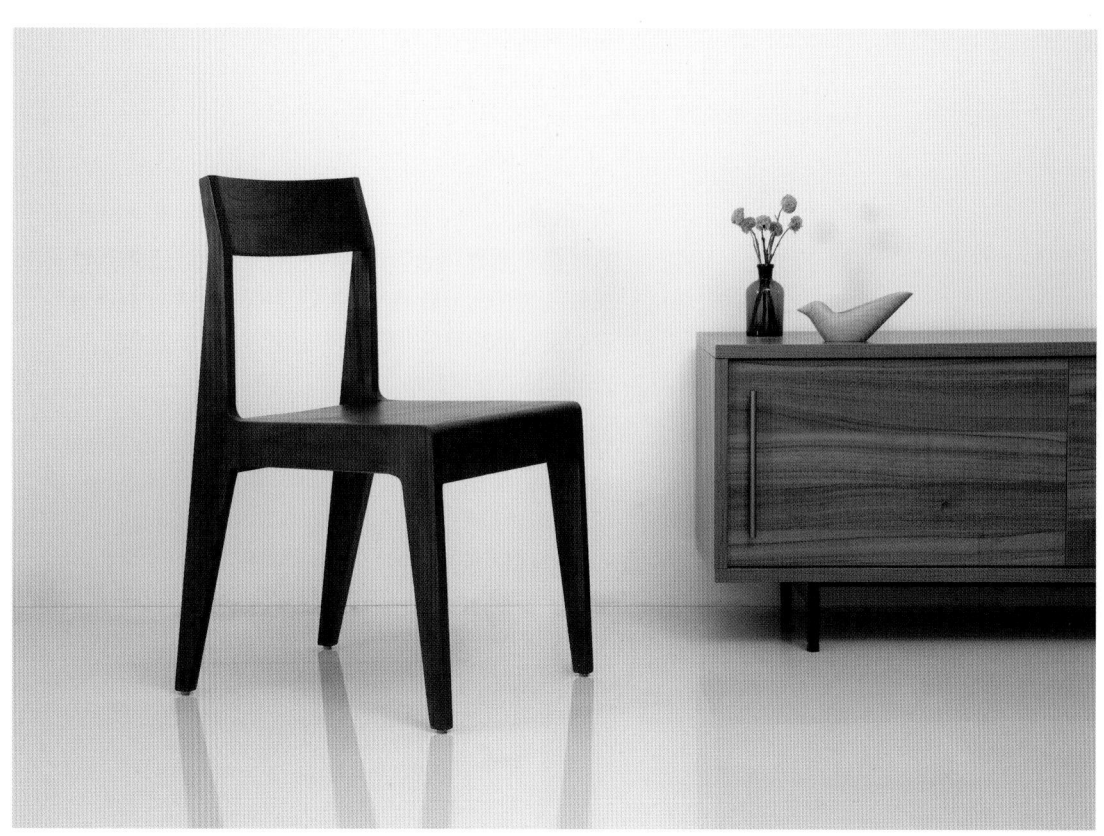

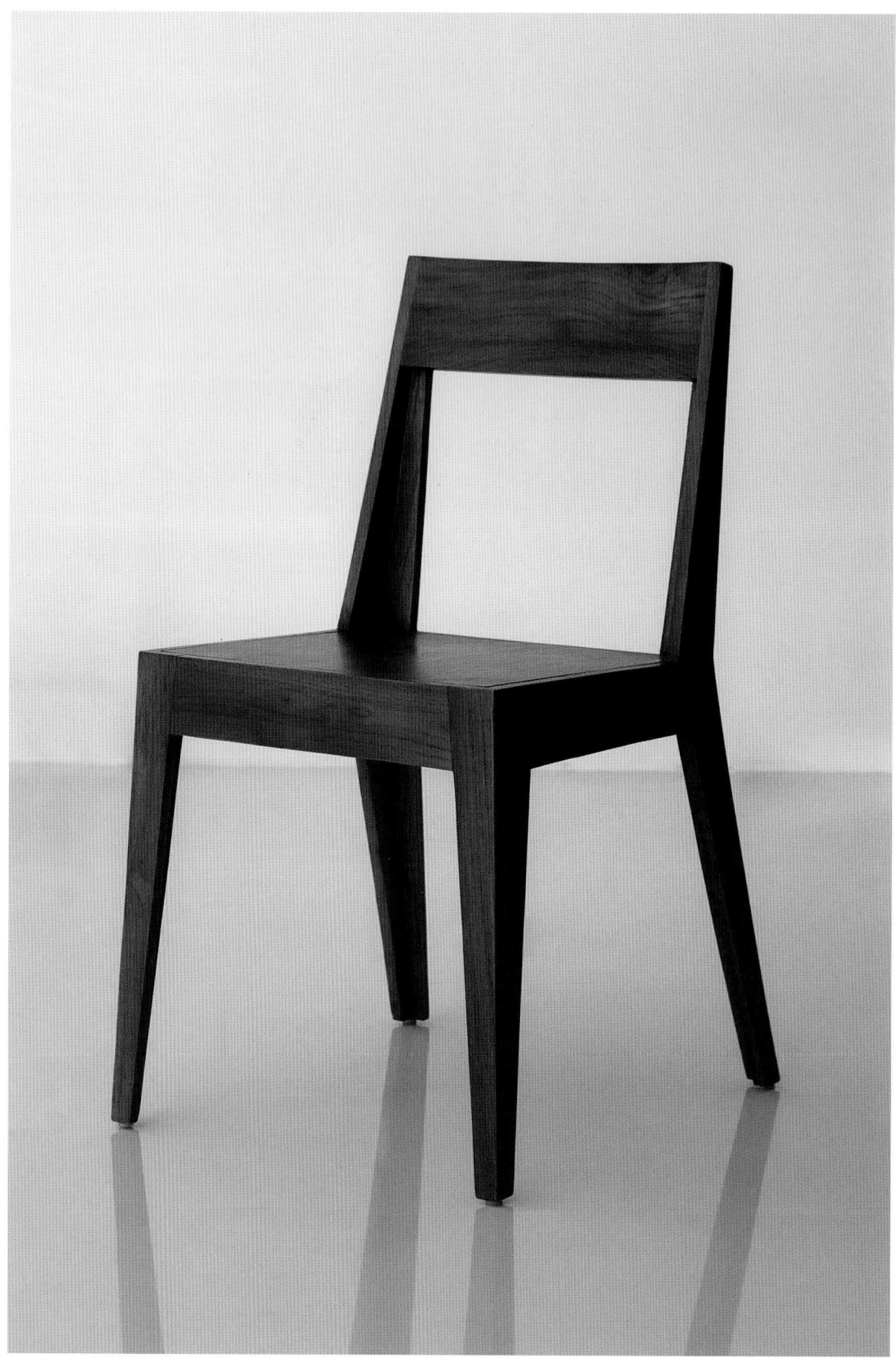

오리가미 체어
Origami Chair

종이접기 방식으로 조형을 만든 의자다. 다리와 등받이의
형태가 종이를 'ㄱ'자로 접은 모습과 같다. 각 요소에 접힌
종이의 조형적 특징을 표현하기 위해 각을 날카롭게
디자인했다. 그저 종이를 접은 듯한 느낌만 낸 게 아니라
구조까지 튼튼하게 설계했다.

This is a chair made in the origami method.
The structure of the legs and backrest is similar to
that of a paper folded in a 'ㄱ' shape. Each element
was designed with sharp angles to express the
structural characteristics of folded paper. Not only
did it look like folded paper, but the structure was
also designed to be strong.

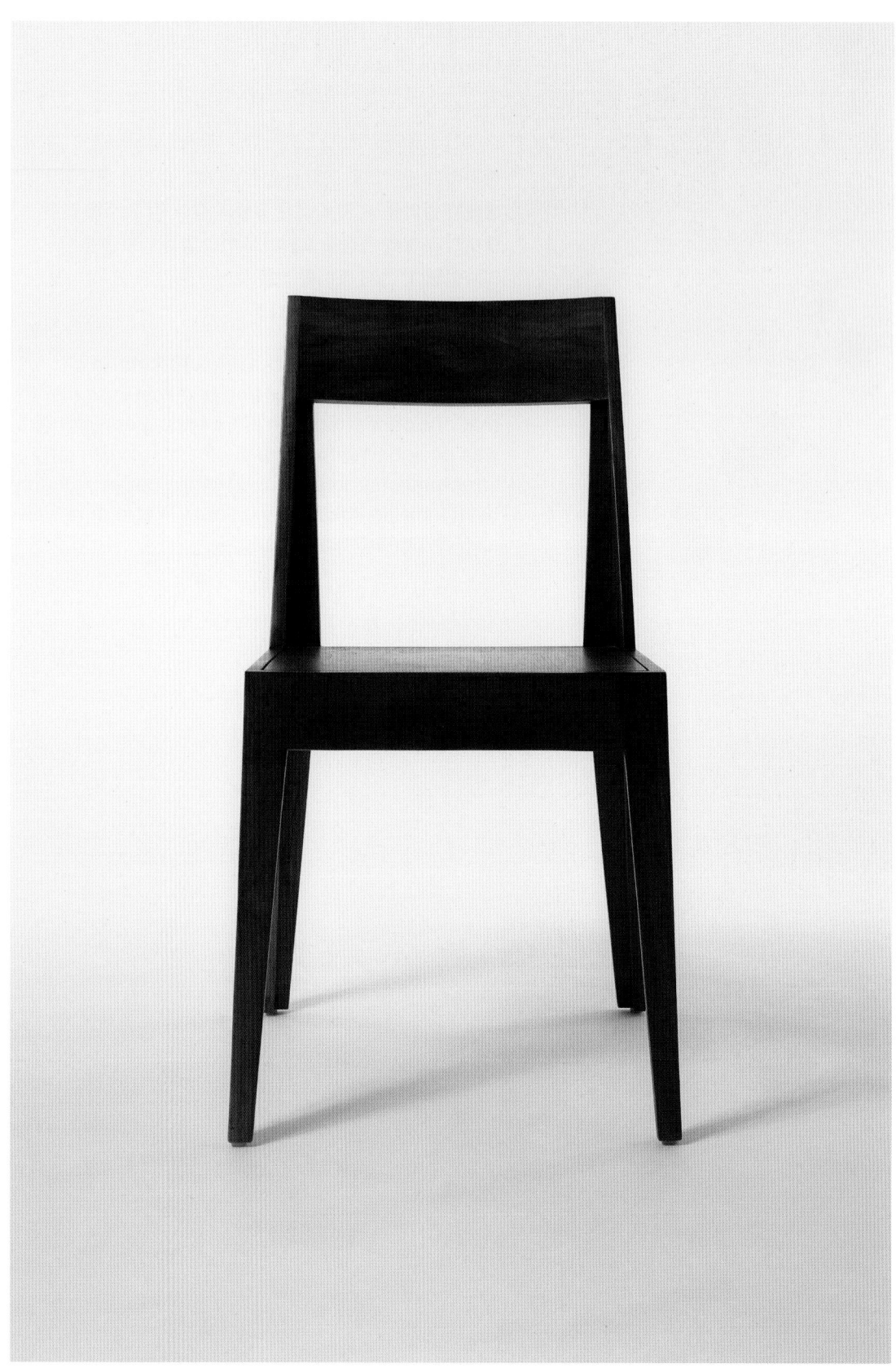

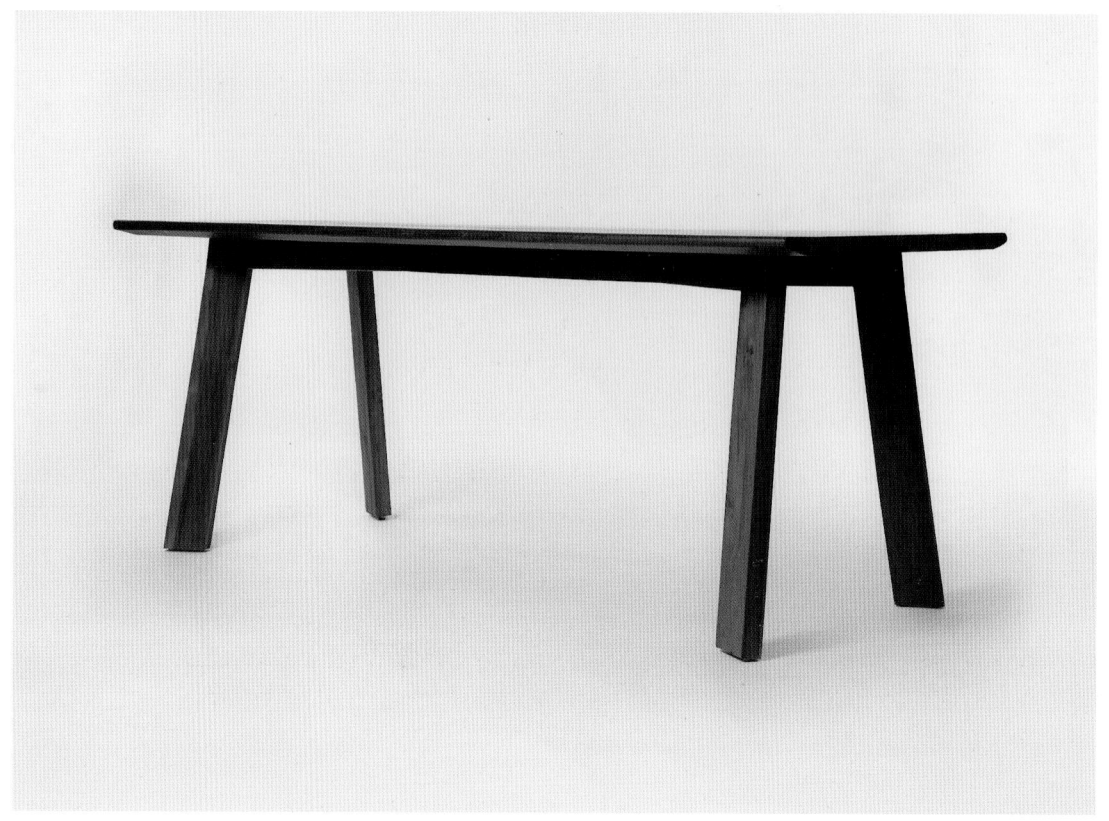

→ 302

윙 테이블
Wing Table

한정판으로 제작한 오피스 테이블이다. 업무시 사용 공간을
고려해 비대칭 조형으로 접근했다. 오각형 상판은 날개
형상을 모티브로 삼았다. 상판의 지지대와 다리가 연결되는
디테일이 특징이다. 상판 아래나 다리 안쪽처럼 사람들이
보통은 주의 깊게 보지 않는 구조도 아름답고 튼튼하게
만들고자 많이 고민했다.

This is a limited-edition office table. We
approached it with an asymmetrical design
considering the space used at work. The
pentagonal top plate has a wing shape as its
motif. Its uniqueness comes from the detail that
connects the support of the top plate and the legs.
A lot of thought was put into making strong and
beautiful the structure that people usually do not
pay close attention to such as the bottom of the
top plate or the inside of the legs.

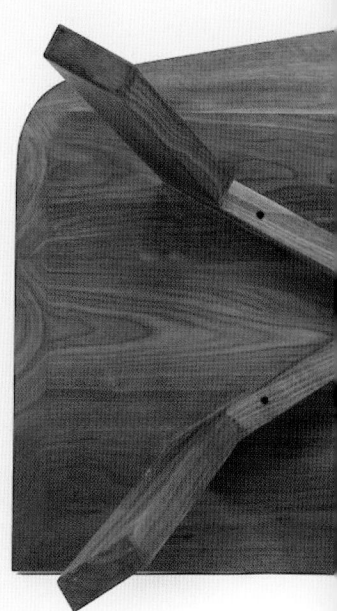

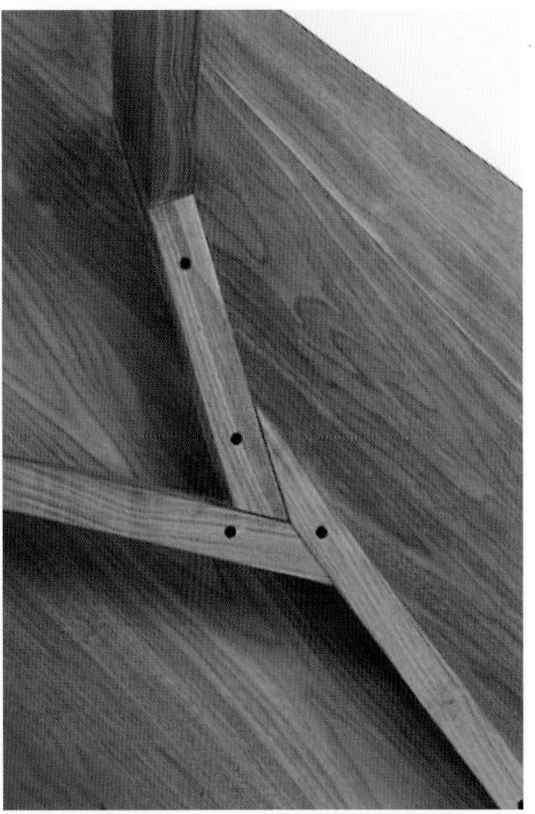

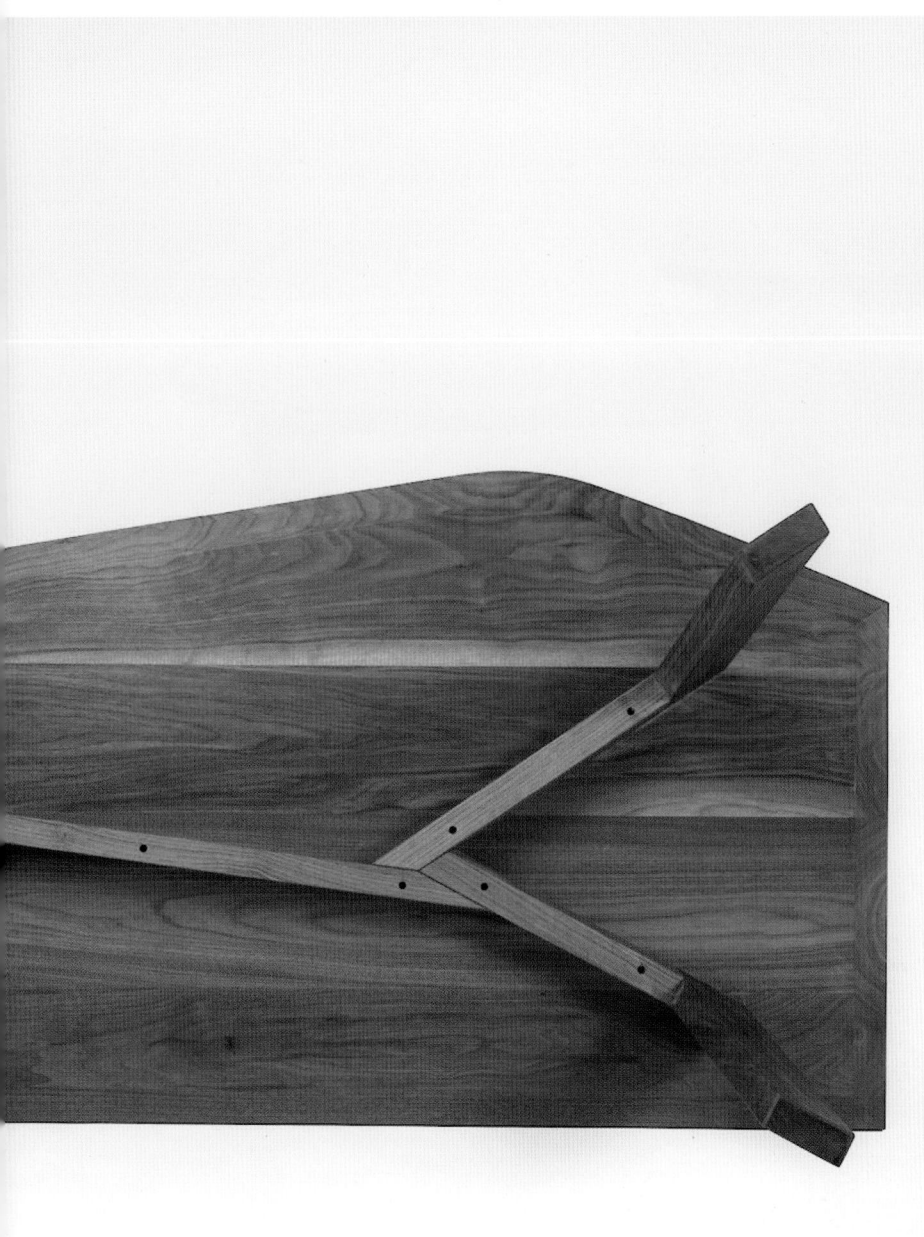

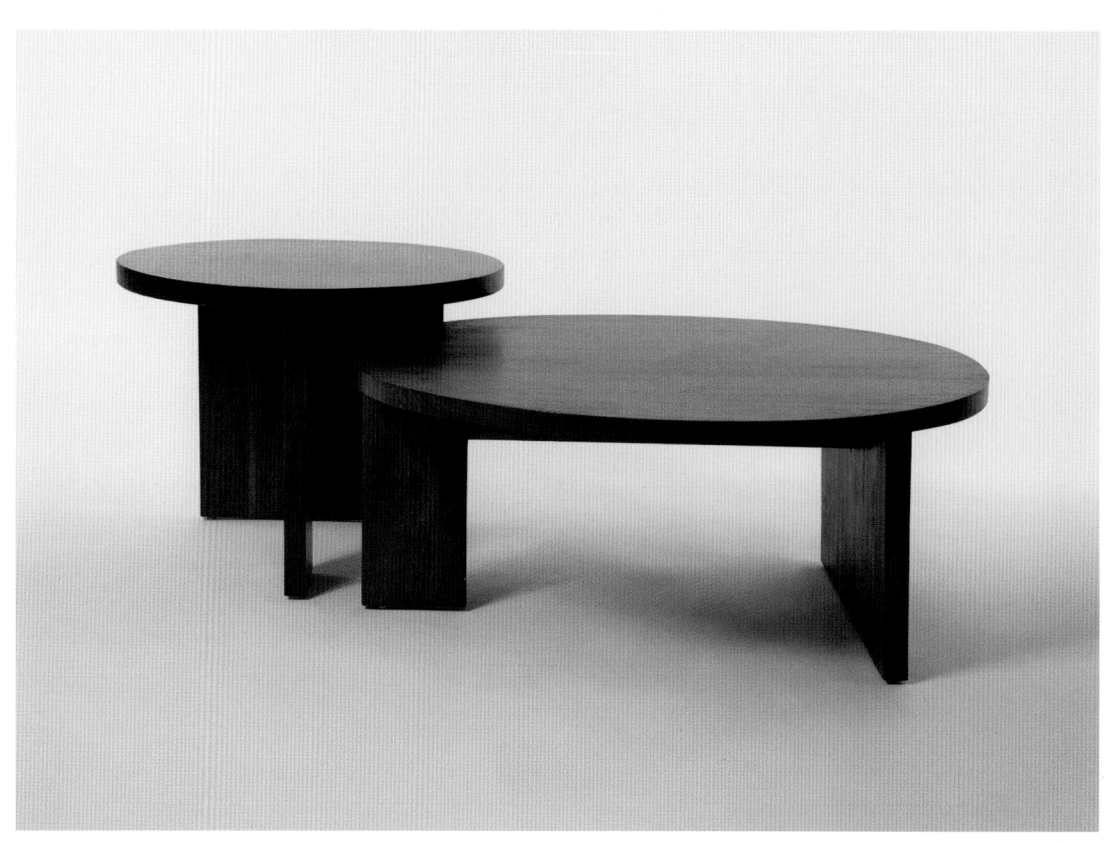

도트 테이블
Dot Table

원형과 직사각형을 조합해 단순하면서도 기하학적인 구조를
만들고 싶었다. 그 결과 점처럼 동그란 상판에 최소한의
구조로 설 수 있는 직사각형 두 개를 연결해 다리를 만들었다.
높낮이와 크기가 다른 테이블을 조합해 다양한 느낌으로
연출할 수 있다.

We wanted to create a simple yet geometric
structure by combining the circle and rectangle
shape. As a result, a bridge was made by
connecting two rectangles that can stand with a
minimal structure on a round top like a dot. Tables
of different heights and sizes can be combined to
create a variety of feelings.

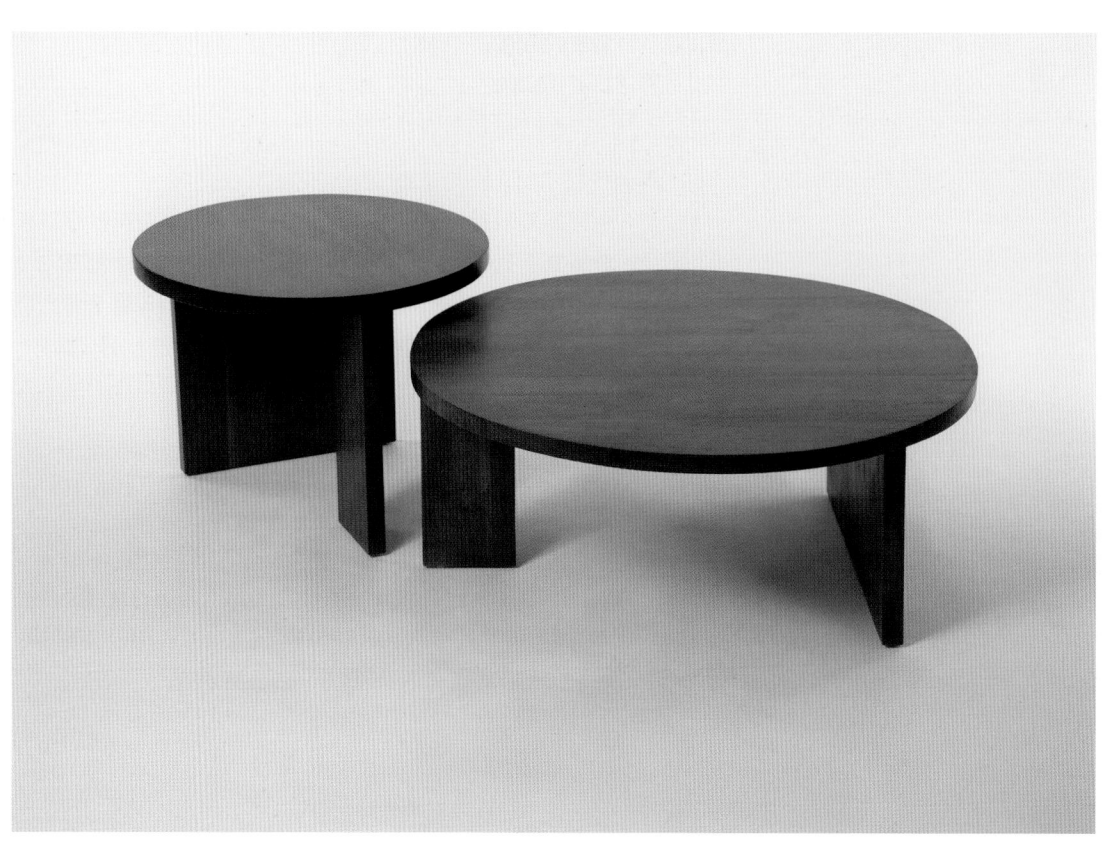

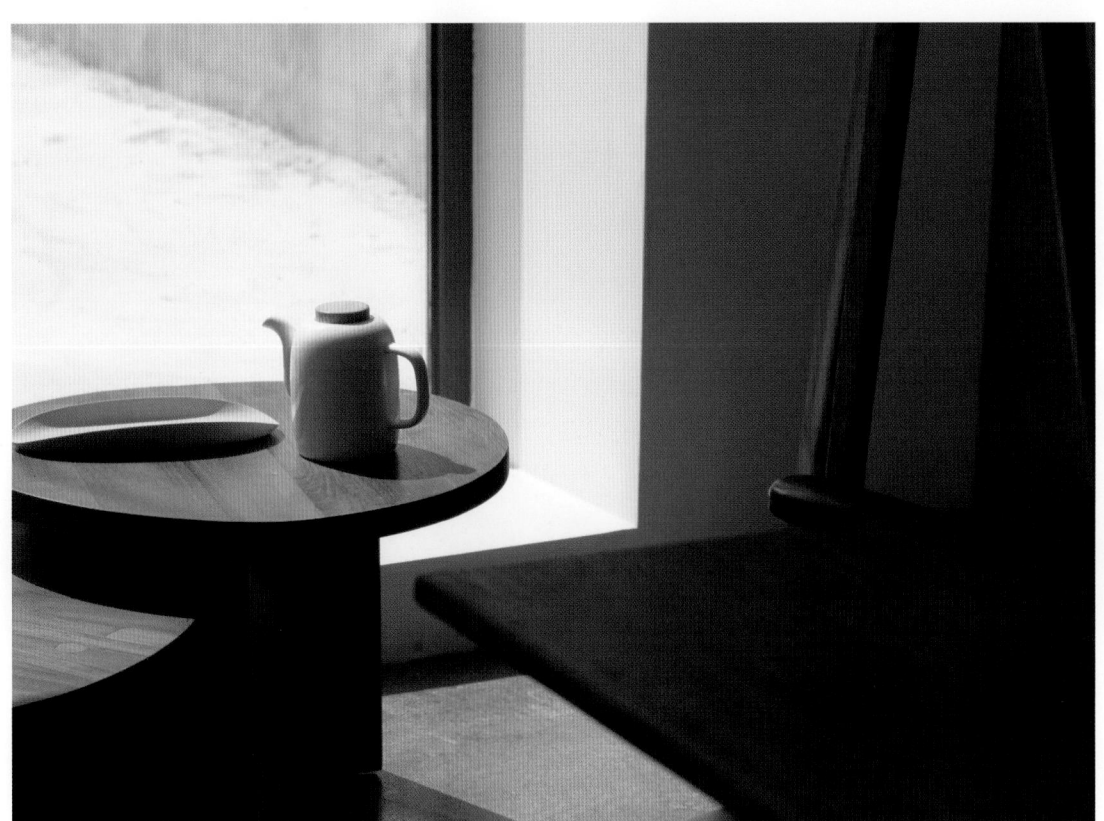

트로피칼 버드
Tropical Bird

새의 깃털이 색연필이라면 어떨까? '깃털 대신 색연필을 꽂아보자'에서 출발한 연필 트레이로 매터&매터의 첫 번째 소품 디자인이다. CNC² 기계를 도입하기 위해 새로운 제조 방식에 맞는 디자인 프로세스를 연구했다. 컴퓨터 데이터에 따라 기계로 정밀하게 가공하자, 나무 같지 않은 나무 제품인 특별한 느낌의 트로피칼 버드가 태어났다.

What if a bird's feathers were colored pencils? This is Matter & Matter's first accessory design with a pencil tray that started from "Let's use colored pencils instead of feathers." In order to use the CNC² machine, research on the design process suitable for a new manufacturing method was done. When the product was precisely made according to computer data, a special tropical bird made of wooden material that did not look like wood was created.

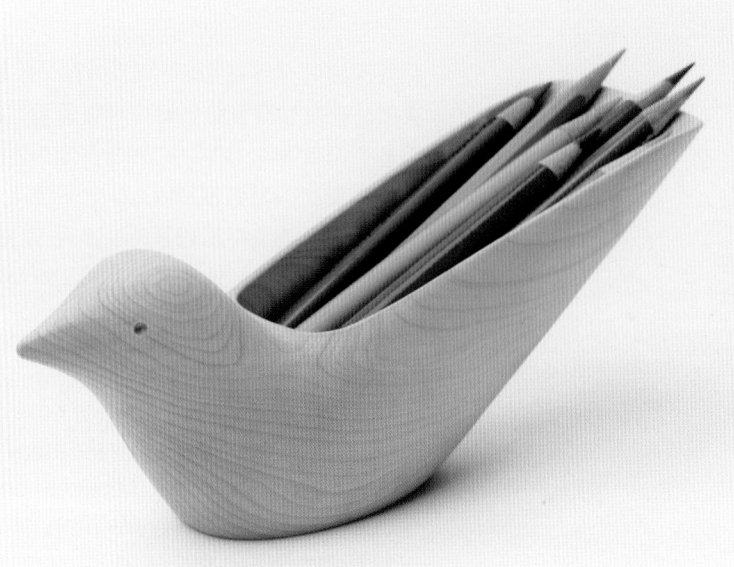

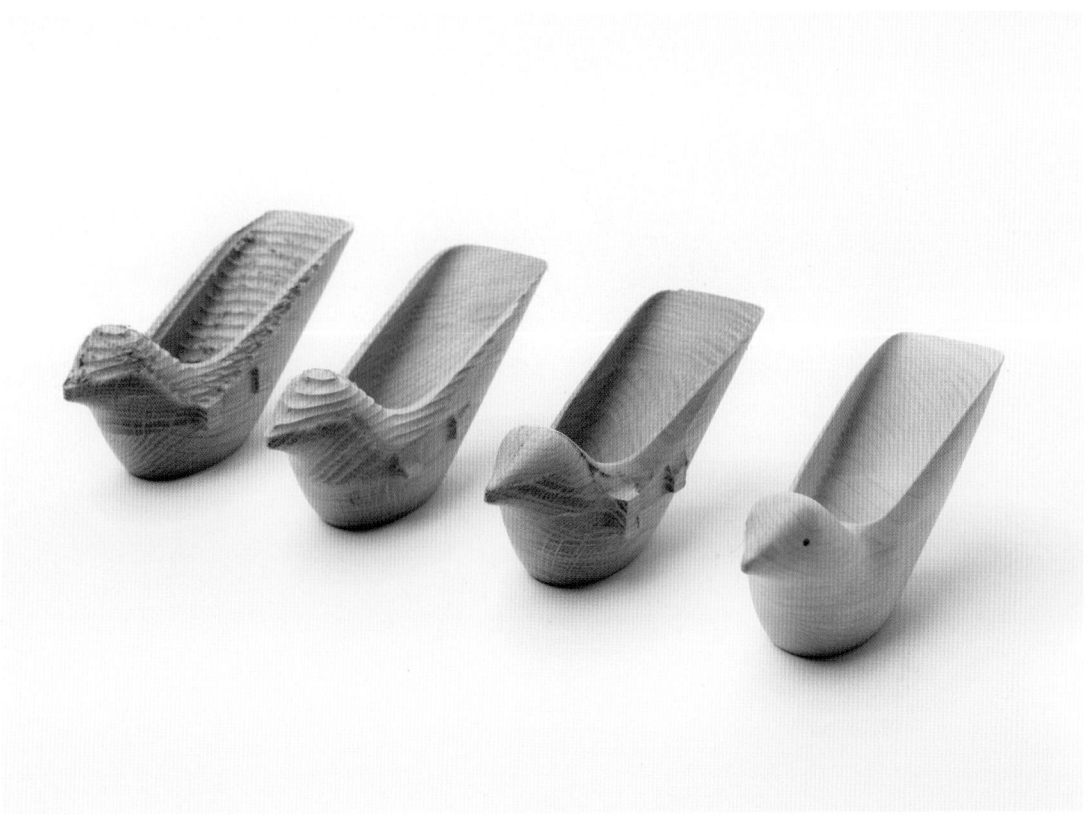

오래된 미래 테이블과 벤치
An Old Future Table & Bench

구 서울역사의 목재에는 세월과 문화의 흔적이 아름답게
남아 있다. 이 소재로 테이블과 벤치, 미니어처를 제작했다.
옛 서울역을 리모델링해 복합문화공간으로 새롭게 개관한
문화역서울284의 첫 전시회 〈오래된 미래〉 참여작이다.

In the wood of the old Seoul Station there are
beautiful traces of time and culture. Tables,
benches, and miniatures were made from this
material. This is participation works in the first
exhibition *An Old Future* of Culture Station Seoul
284, which was newly opened as a complex
cultural space by remodeling the old Seoul Station.

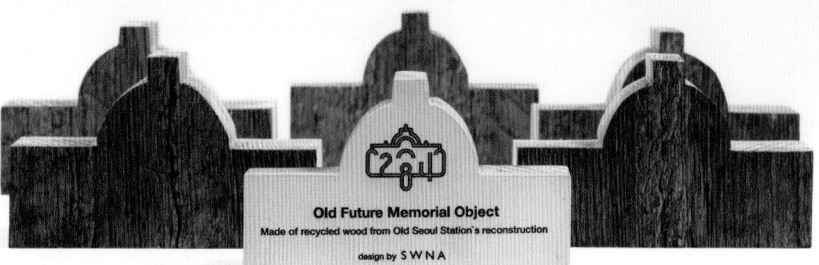

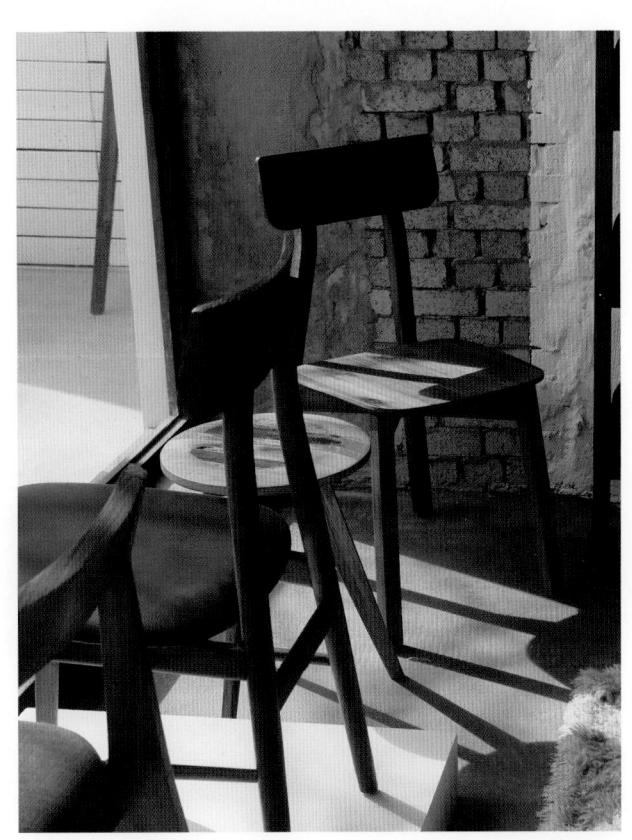

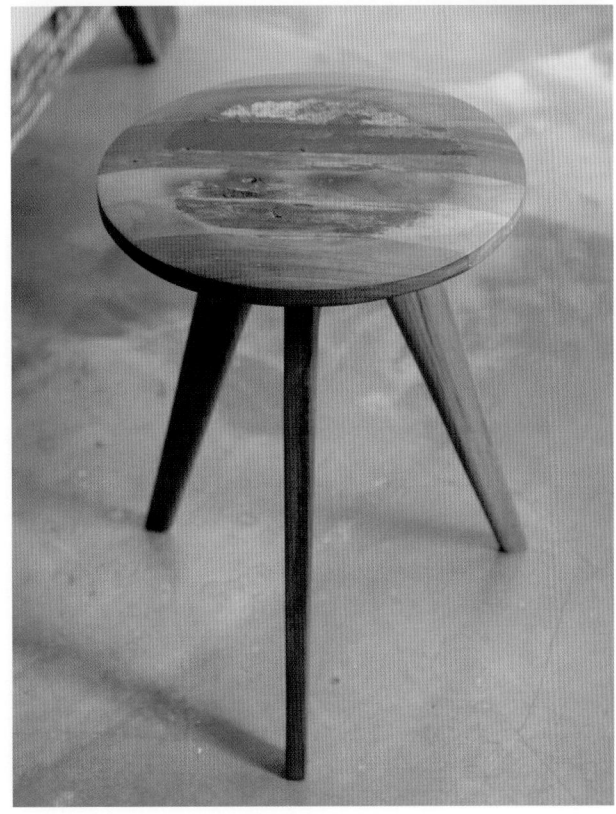

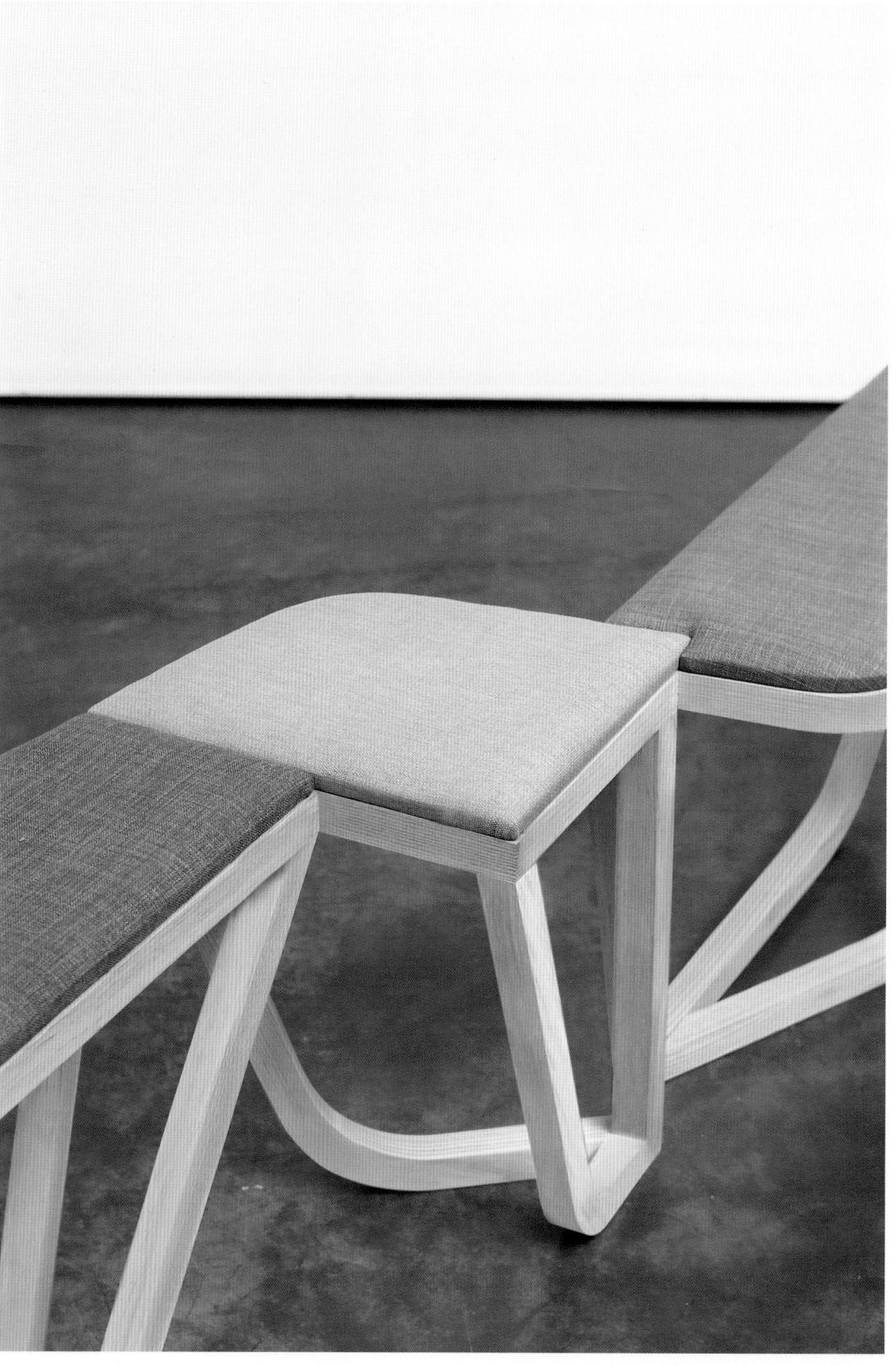

프로토 벤치
Proto Bench

평면과 입체를 넘나드는 소재로 머릿속의 생각을
구체화하다 보면 색다른 결과물이 나온다. 숨프로젝트의
아트클럽1563에서 기획한 전시 〈프로토_라이트〉를
위한 벤치 디자인을 시작할 때, 철사나 나무살을 구부리고
붙이면서 입체 스케치를 적용해 조형을 만들었다. 철사는
평면이지만 구부리면 입체가 되는, 평면의 선인 동시에
입체의 선이다. 선을 평면에 그릴 때와 입체로 그릴 때는
상상의 범주가 달라진다.

If you materialize the thoughts in your head
with a material that crosses the plane and the
three-dimensional, a novel result will appear.
When we started designing the bench for the
exhibition *PROTO_LIGHT*, which was planned
by artclub1563 of the SUUM project, we created
a model by applying a three-dimensional sketch
while bending and pasting wires or wooden
beams. The wire is flat, but when it is bent, it
becomes more dimensional, so it is at the same
time flat and three-dimensional. The range of
imagination is different when drawing a line on a
flat surface and drawing on a three-dimensional
shape.

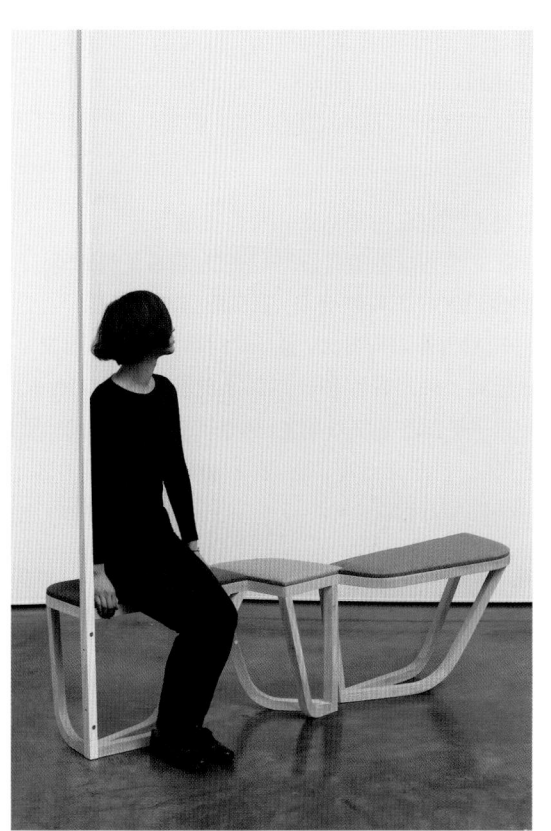

숨쉬는 타일
The Respirer

옹기토의 특징은 공기만 통과하고 물은 통과하지 못한다는 것이다. 이런 성질이 건축 현장에서 아주 특별한 소재가 될 수 있지 않을까? 이런 생각으로 시작해 새로운 재료의 가능성을 보여주었다. 옹기토를 틀에 넣고 구운 조각을 겹겹이 이어 붙여, 새로운 개념의 건축 외장재 및 내장재를 제안했다. 전시 〈2012 설화문화전: 흙, 숨쉬다. 옹기〉에 선보인 설치 작업이다.

The characteristic of Onggi is that it is airy but waterproof. We started out with the idea that showed the possibility of new materials that could be very special in construction. We proposed a new concept of exterior and interior materials for construction by attaching layered pieces of earthenware that were baked in a pot made of soil (Onggi). This is an installation work shown in the *Sulhwa Cultural Exhibition: Soil, Breathe, Onggi* in 2012.

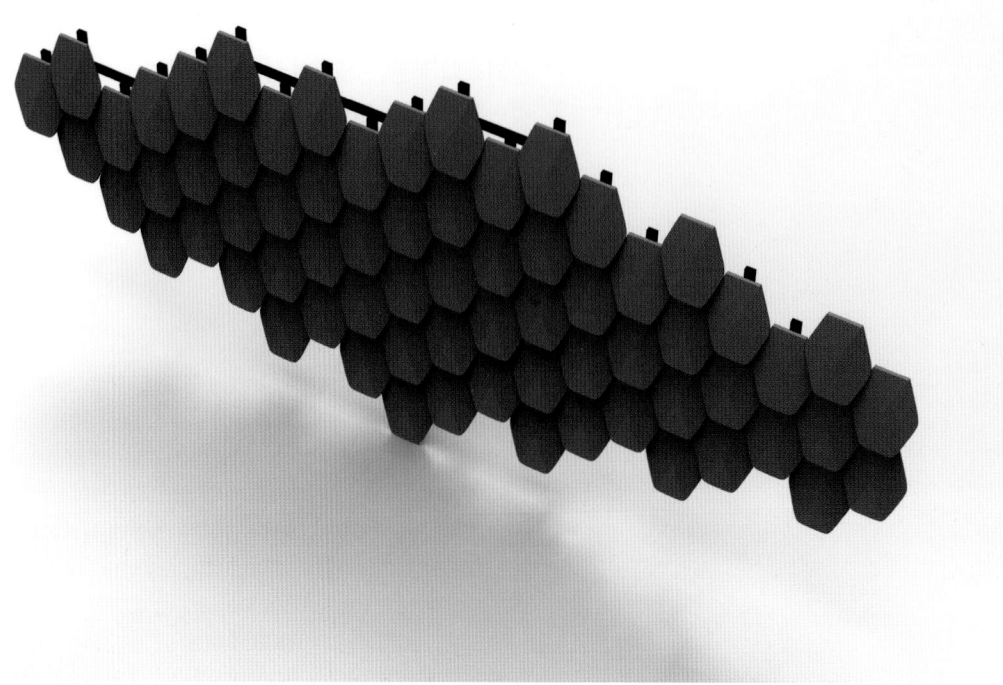

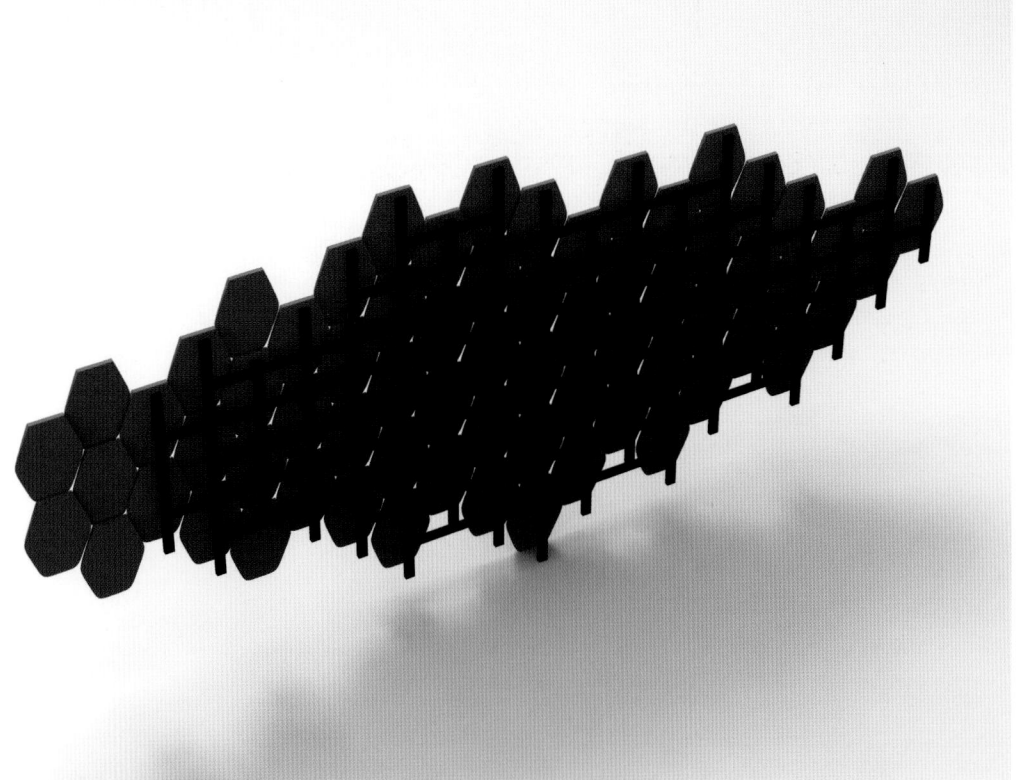

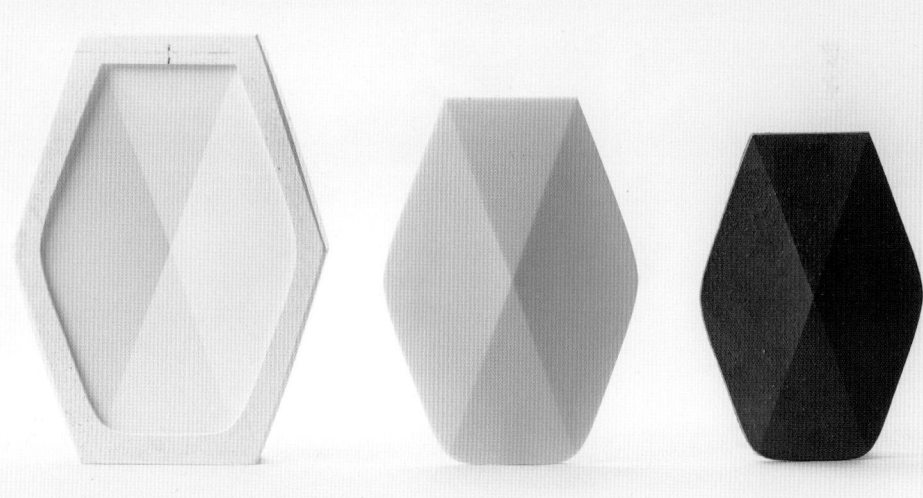

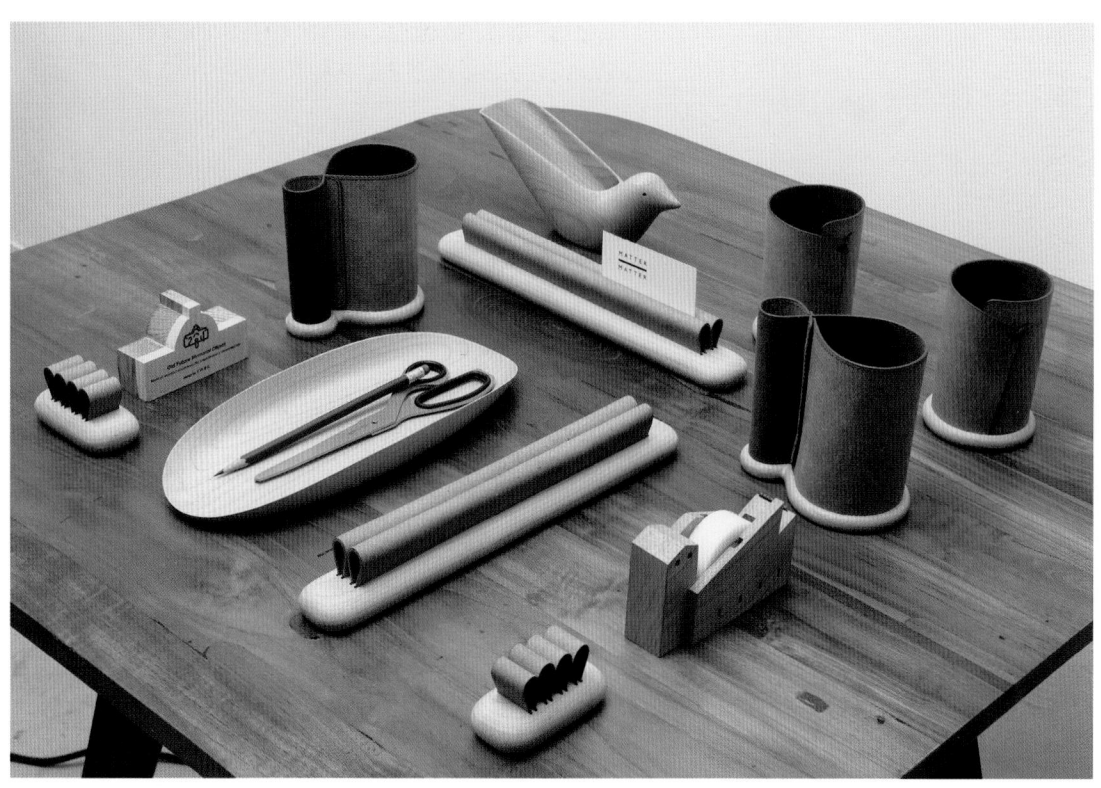

데스크 액세서리 시리즈
Desk Accessories Series

가방이나 신발을 만들고 남은 자투리 가죽을 모아서
만든 업사이클링 시리즈다. 부드럽고 유연한 가죽의
재료적 특성을 이용해 구부린 패턴을 만들고, CNC
가공으로 조각한 나무에 조립해 각 소재의 속성을
극대화했다. 한정판으로 제작해 2013년 프랑스 파리의
메종&오브제에서 판매했다.

This is an upcycling series made by collecting
scraps of leather left over from making bags and
shoes. Using the material properties of soft and
supple leather, we created a curved pattern, and
the properties of each material were maximized by
assembling it on wood carved by CNC machining.
The series was produced in a limited edition and
sold at Maison & Objét in Paris, France in 2013.

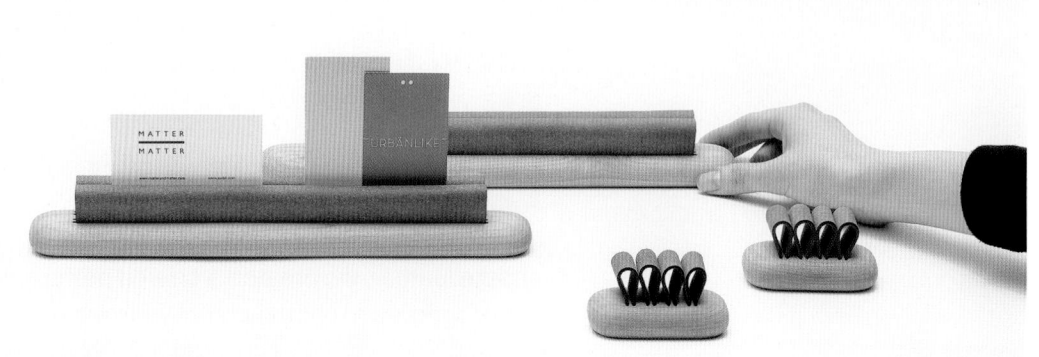

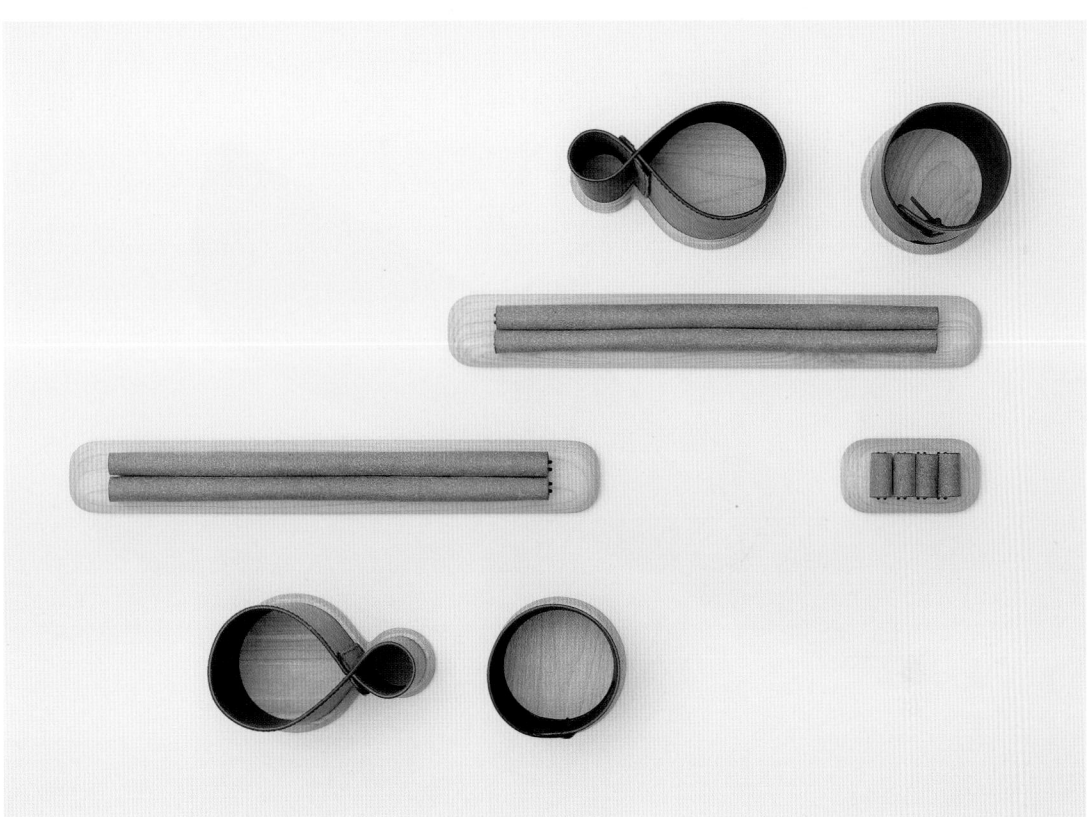

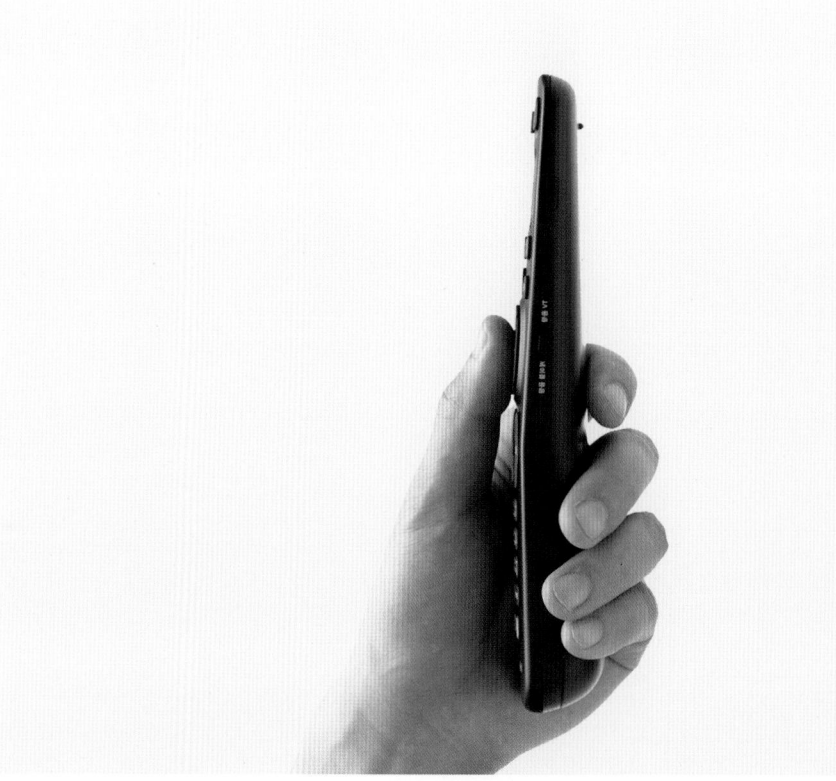

→
309

TV 리모컨
TV Remote Control

용도에 따라 사용자가 직관적으로 구분할 수 있도록 유도한
디자인이다. 디지털 방송 콘텐츠를 시청할 때 쓰는 미디어
버튼은 위에, 일반적인 TV 리모컨에 쓰는 버튼은 아래에
두었다. 위치뿐 아니라 질감과 색상도 대비를 주었다. 뒤쪽은
손가락 마디의 형태를 조형적으로 해석해서 적용했다.

This is a design that induces users to intuitively
distinguish how to use the remote depending on
use. The media button used for watching digital
broadcast content is placed on the top, and the
button used for a general TV remote control is
placed on the bottom. Not only the location, but
also the texture and color give contrast. The back
part was formed by interpreting the shape of the
knuckle.

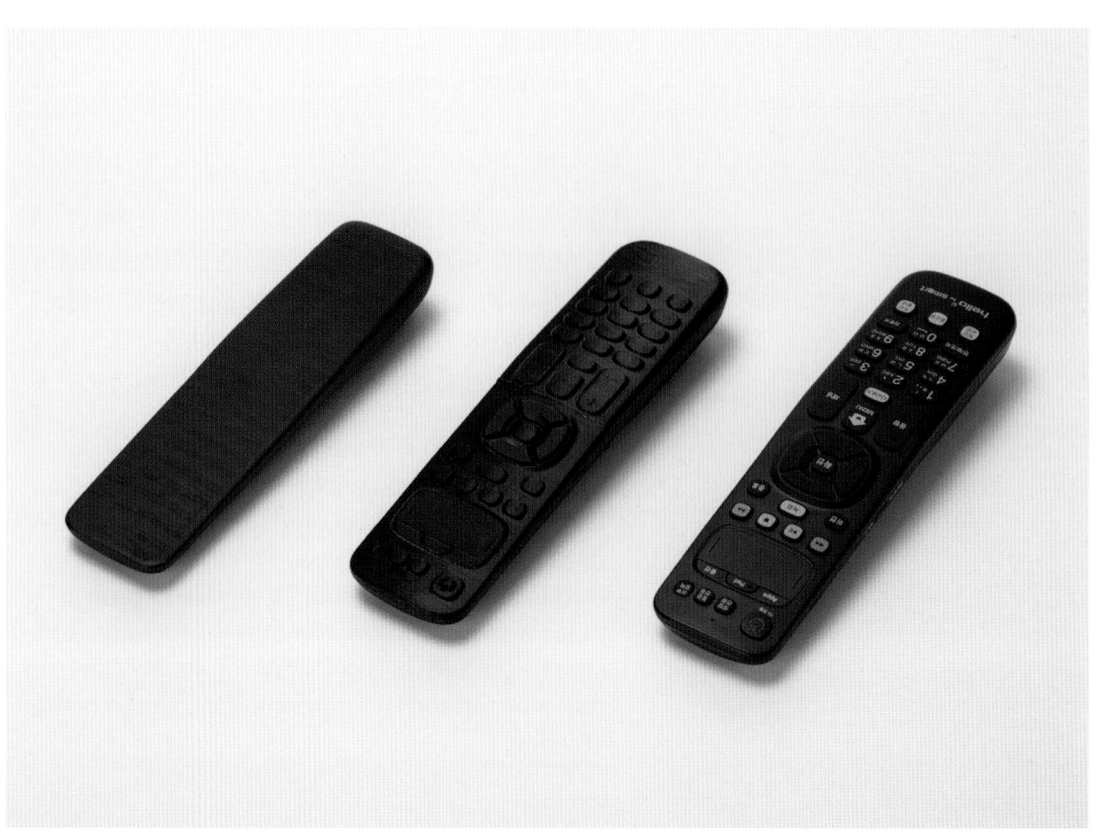

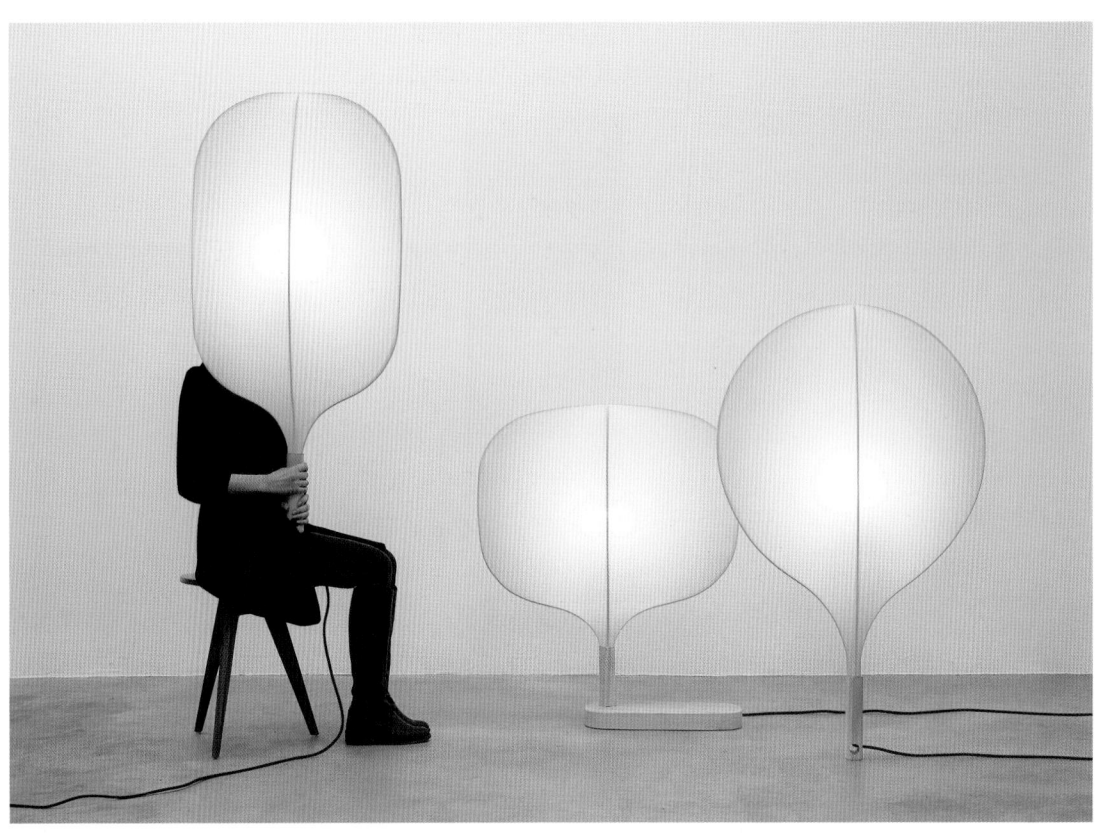

굴뚝 조명등 시리즈
Chimney Light Series

굴뚝에서 연기가 나오는 모양을 닮아서 이름에도 굴뚝을 붙였다. 신축성 있는 스판덱스[3]의 일종인 라이크라 섬유와 CNC로 정밀 가공한 목재를 이용했다. 라이크라를 통과한 빛은 은은하면서도 따뜻하게 보이며, 뒷면에 가죽끈이 있어 전구를 쉽게 교체할 수 있다. 한정판으로 제작해 2013년 메종&오브제에서 판매했다.

The series was given its name because it resembles the shape of smoke rising from a chimney. It uses Lycra® fiber, a type of stretchable spandex[3], and wood that is precisely cut by CNC. The light passing through the Lycra looks soft and warm, and there is a leather strap on the back for easy replacement of the bulb. It was produced in a limited edition and sold by Maison & Objét in 2013.

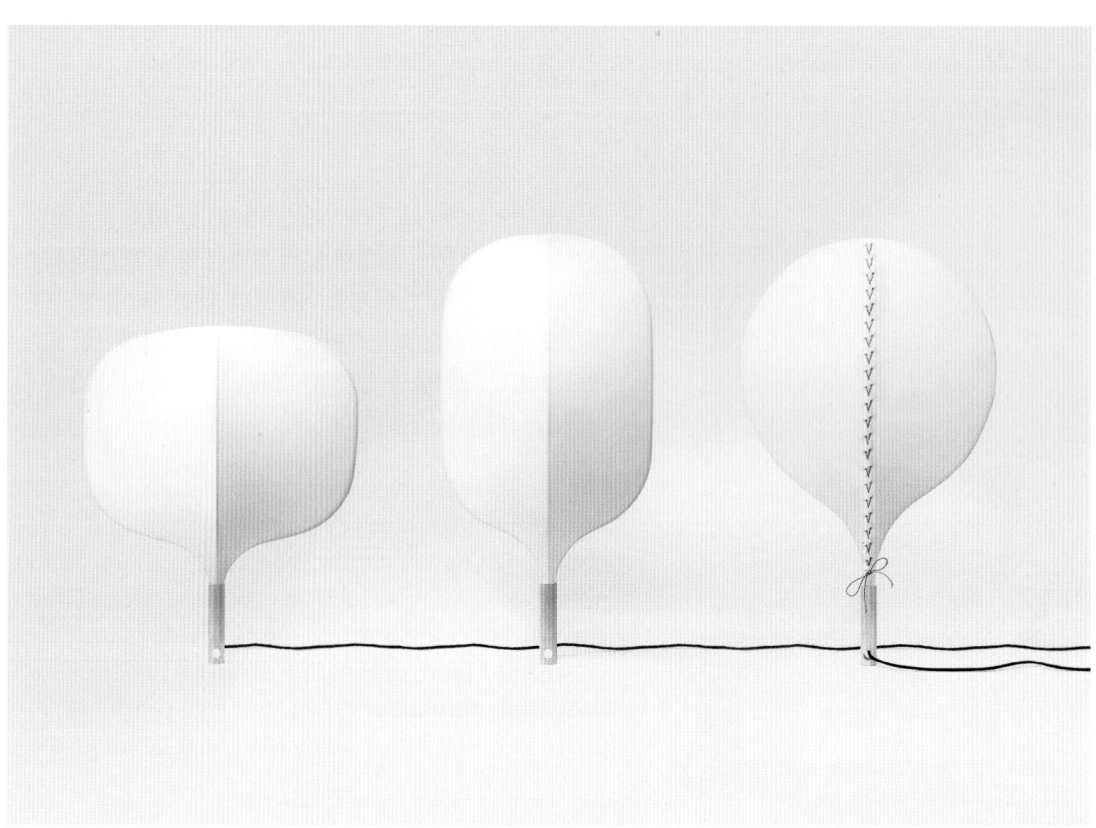

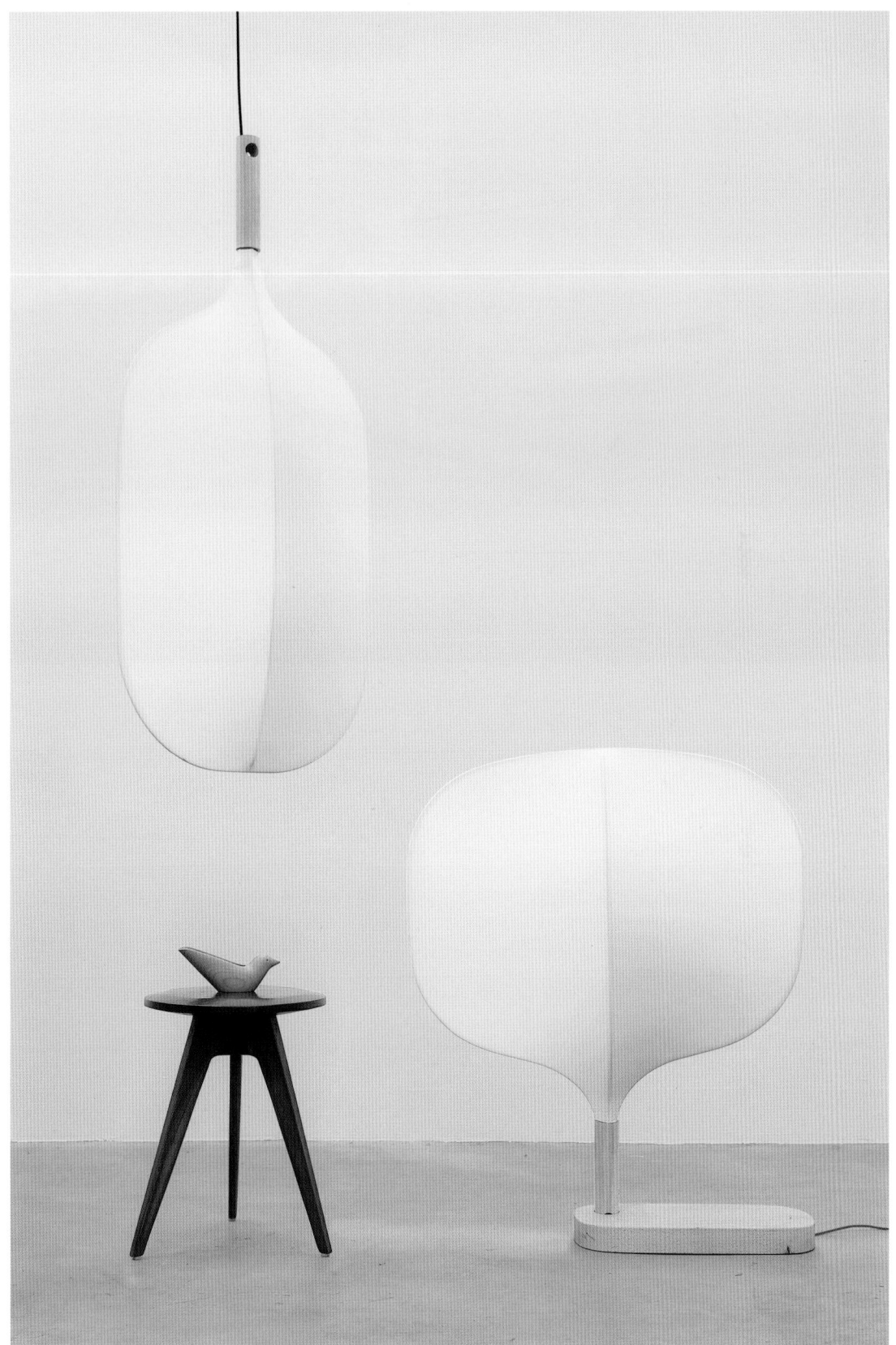

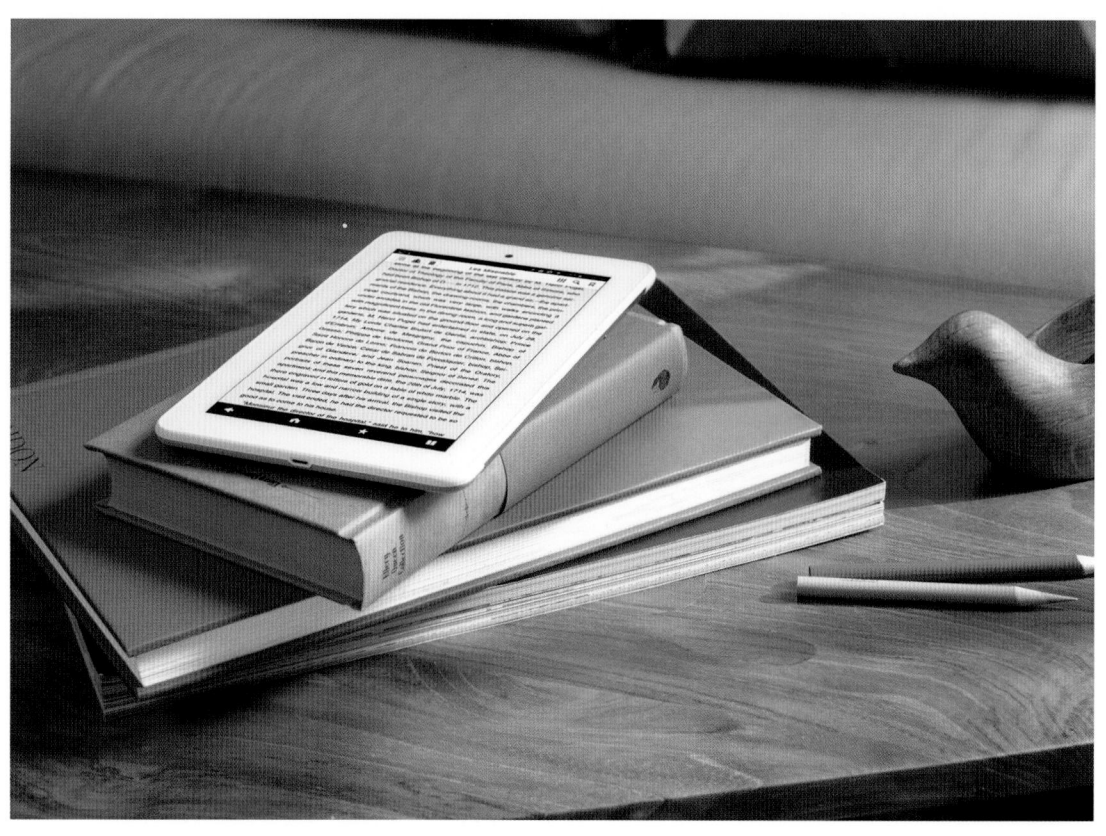

전자책 단말기
eBook Reader

스마트폰이나 태블릿과는 다른, 전자책 단말기만의
'책을 읽는 경험'에 디자인 포인트를 두기로 했다. 버스나
지하철에 서 있을 때 한 손은 손잡이를 잡아야 하기에,
한 손으로만 책장을 넘길 수 있어야 한다. 이를 위해 측면에
클리커블 터치센서를 넣어 쉽게 책장을 넘기도록 만들었다.
손으로 붙잡아야 하는 아래쪽 부분에는 천연 가죽을 덧대
감촉을 개선했다.

The design point for this was a 'book reading
experience' unique to e-book devices, which is
different from smartphones and tablets. On the
bus of subway, one hand holds the handle so only
a single hand can turn the book page. To this end,
a clickable touch sensor was placed on the side
to make it easy to turn the bookshelf. The lower
part, which has to be held by hand, is padded with
natural leather to improve the feel.

 → 312

잎사귀 트레이
Leaf Tray

양 끝이 아름답게 말려 올라가는 가을 잎사귀에
영감받아 만든 트레이다. 3D로 형태를 만들고, 목재를
직접 CNC 가공해 제작했다. 디저트를 위한 작은 트레이,
과일을 위한 중간 크기의 트레이, 간단한 아침 식사를 위한
큰 트레이까지 총 세 가지 종류가 있다.

This tray was inspired by autumn leaves that are
beautifully curled at both ends. The shape was
made with 3D data, and the wood was directly
CNC machined. There are three different types:
a small tray for dessert, a medium tray for fruit,
and a large tray for a light breakfast.

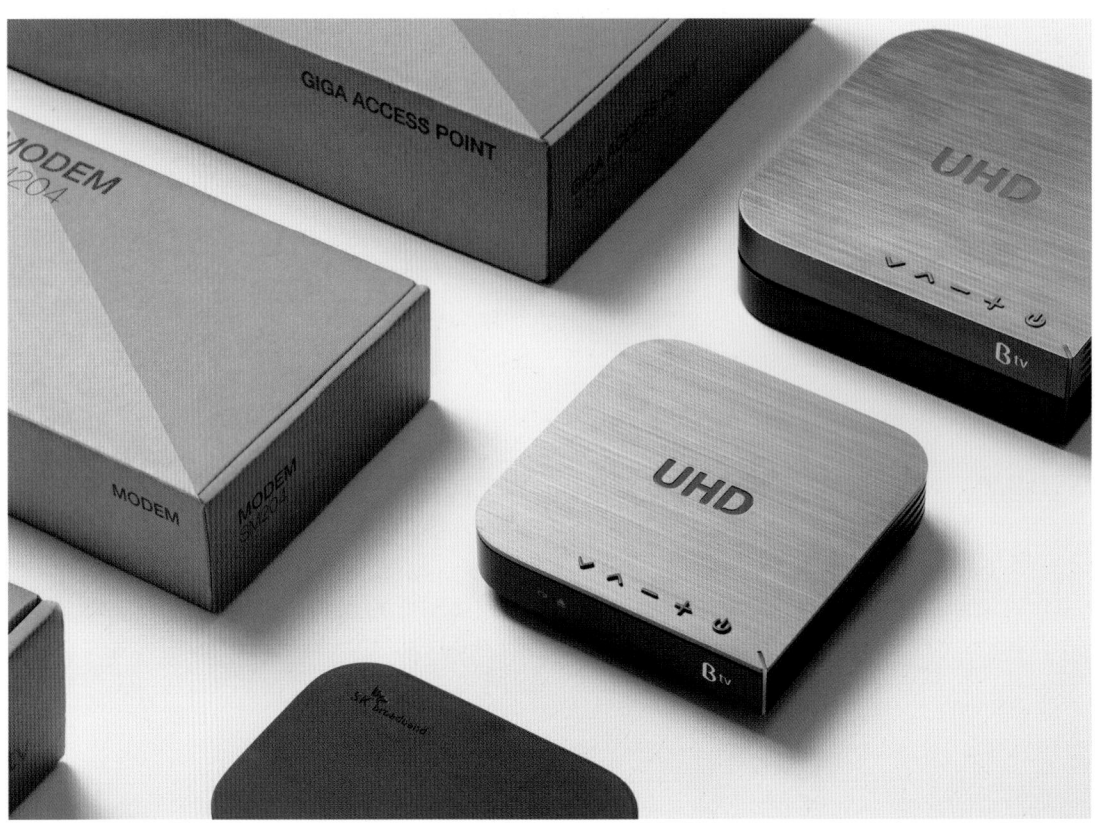

 → 313

TV 셋톱 박스
TV Set-top Box

기능을 위해 아름다움을 포기할 수는 없지만, 아무리
아름다워도 기능이 결여되면 그것만큼 조악한 것도 없다.
형태와 기능이 구조적으로 일치하는 디자인이 필요했다.
기존 셋톱 박스처럼 바닥에 눕혀둬도 잘 어울리고, 기존과
다르게 세로로 세워도 어색하지 않도록 완성했다.

Although beauty cannot be sacrificed for function,
no matter how beautiful the product is there is
nothing worse than separation from function. A
design in which the form and function align was
needed. We completed a set up box that looked
good whether it was placed horizontally on the
floor like before or set vertically, a new way.

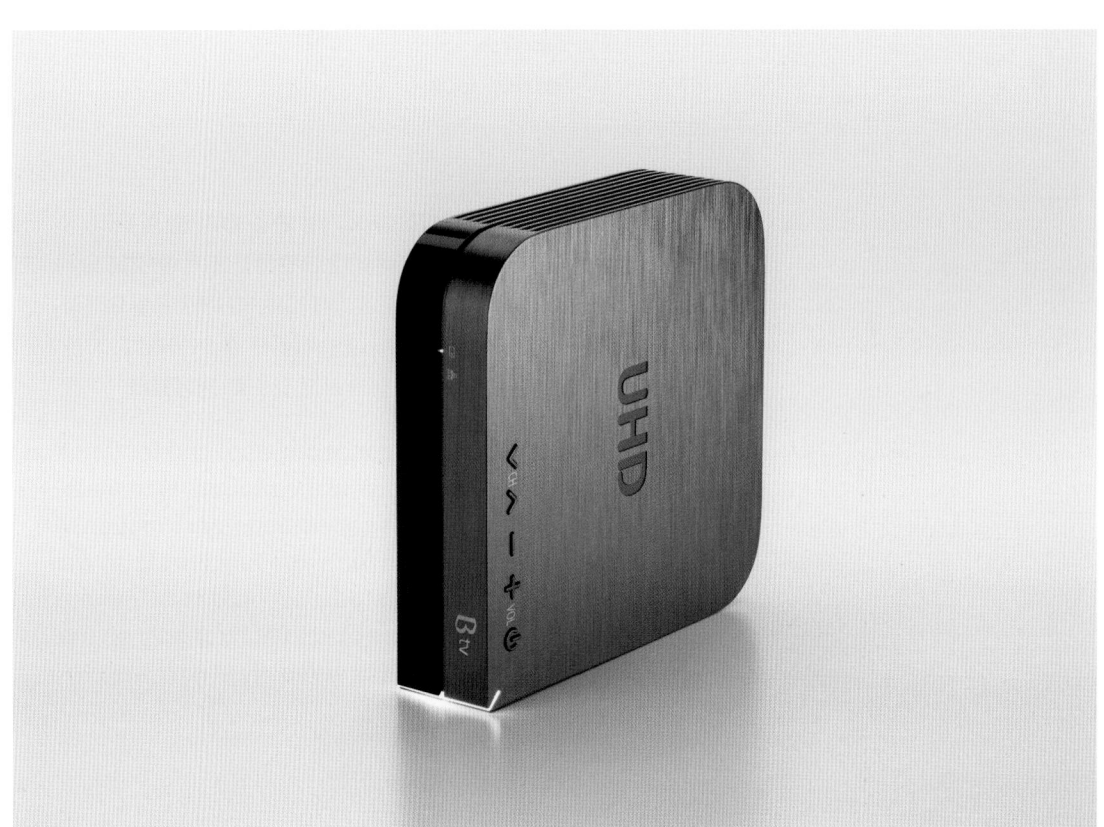

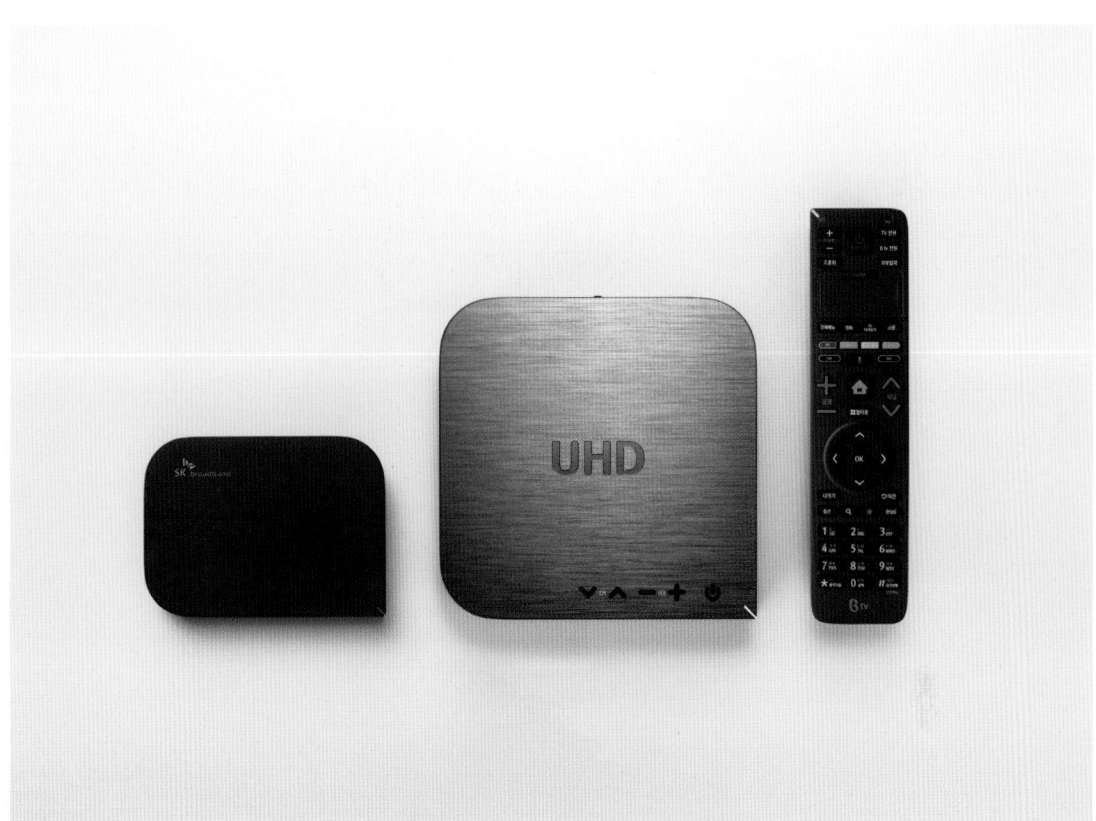

스마트 밴드
Smart Wristband

손목에 차는 헬스케어 웨어러블 디바이스다. 일반적인
제품은 디스플레이가 전면에 노출되어 있으나, 이 제품은
모서리 사선 면에 디스플레이가 오도록 디자인했다. 덕분에
손목을 모두 들지 않고 팔은 쭉 뻗은 자세에서도 쉽게 정보를
읽을 수 있다.

This is a healthcare wearable device for the wrist.
In most devices, the display is exposed on the
entire surface, but for this device it was designed
to show only diagonally on the corner. Thanks
to this, there is no need to lift the wrist since the
wearer can easily read information with straight
arms.

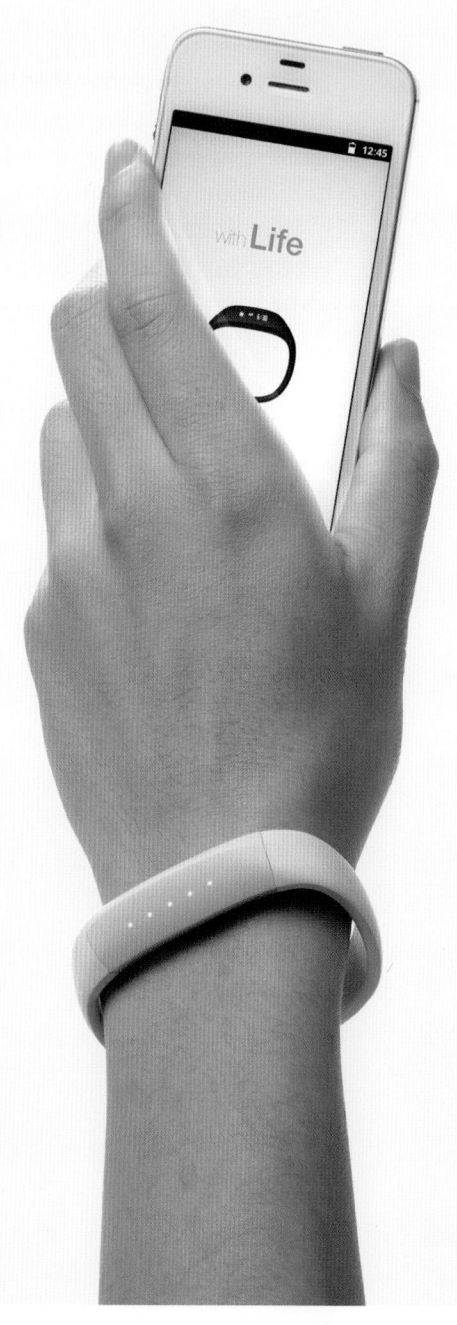

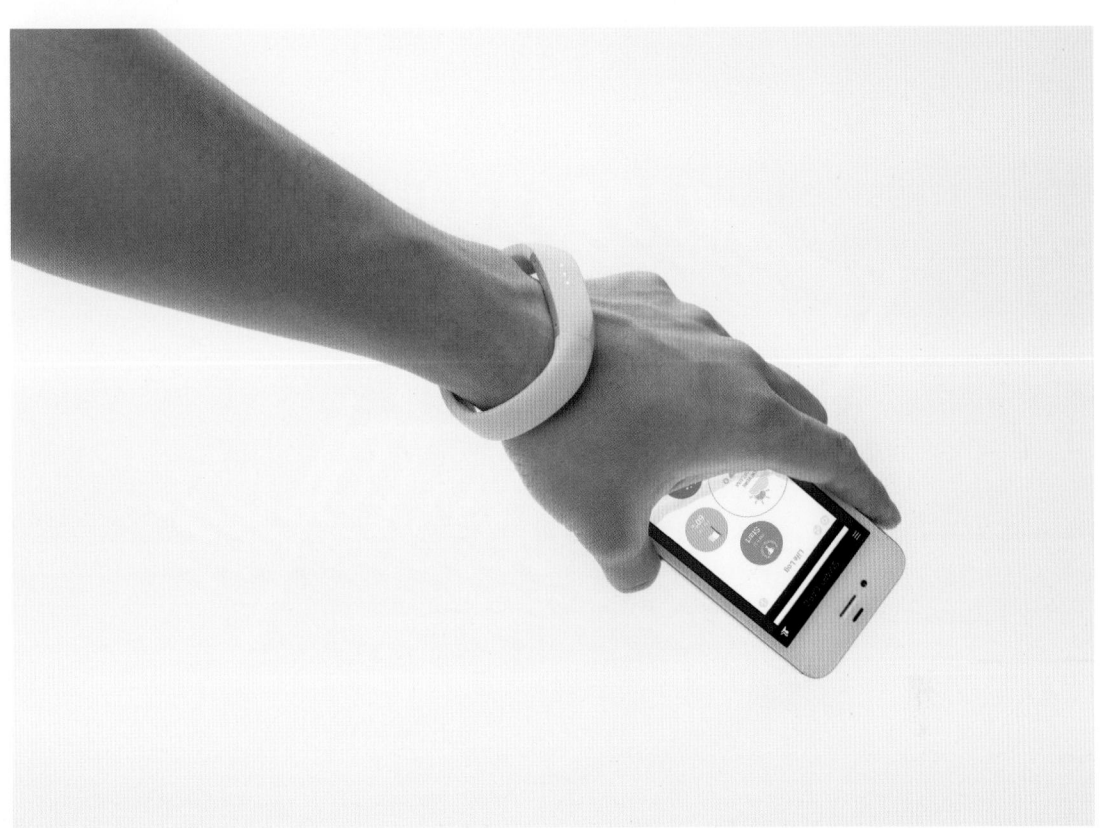

오피스 가구 시리즈
Office Furniture Series

포털 사이트 운영사의 오피스 가구 전반을 디자인하는
프로젝트였다. 먼저 이들의 환경을 관찰해 어떻게 일하고
협업하고 활동하는지를 바탕으로 한 시나리오 스케치를
진행하고, 이를 기반으로 디자인을 발전시켰다. 업무 특성상
컴퓨터, 태블릿, 스마트폰 등의 디바이스를 많이 사용하는
만큼 케이블이 많았기에 데스크에 슬라이딩 형식의 케이블
매니지먼트 솔루션을 적용했다. 또한 팀 작업과 개인 작업을
유연하게 보조하는 이동식 캐리어 및 화이트보드 캐리어
등을 제작했다.

This was a project to design the office furniture
for a portal site operator. First, by observing their
environment, we sketched a scenario based on
how people worked, collaborated, and acted,
and the design was developed based on these
factors. Due to the nature of work, there were a
lot of cables due to devices such as computers,
tablets, and smartphones, so a sliding-type cable
management solution was applied to the desk.
In addition, we produced mobile carriers and
whiteboard carriers that flexibly support team and
individual work.

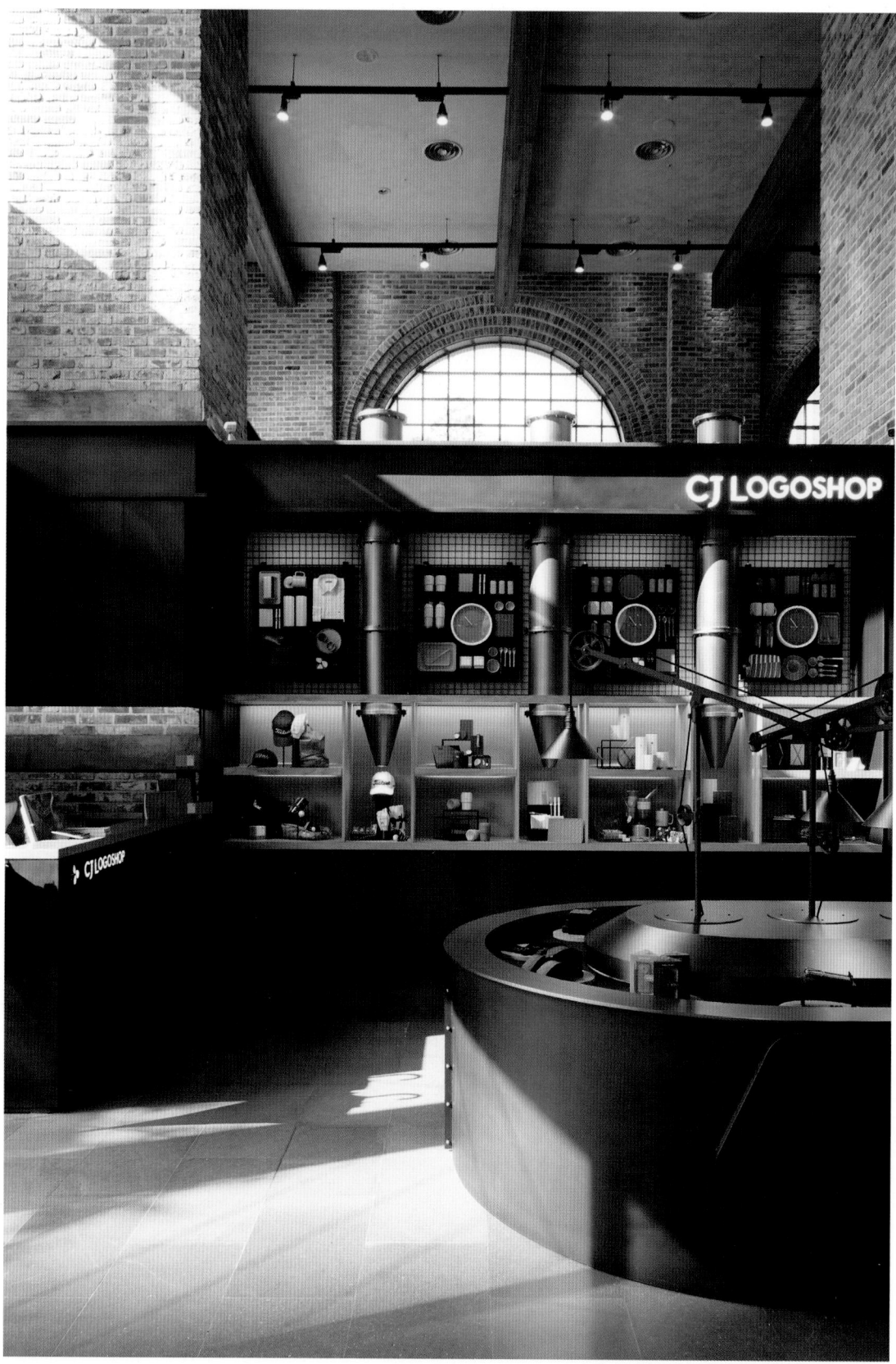

브랜드 스토어
Brand Store

브랜드 설립의 기반이 된 공장, 특히 제분소에서 영감을
받아 초기 제분소의 모습을 현대화했다. 매장 중앙에는
실제 컨베이어 벨트를 설치해 브랜드 제품이 천천히
회전했다. 벽면과 조명의 구성 또한 공장의 여러 이미지를
보고 얻은 아이디어를 재해석해서 설계했다. 통합적
관점에서 디자인해 방문자가 공간과 제품을 동시에 경험할
수 있도록 유도했다.

Taking inspiration from factories on which the
brand was founded, especially the mills, we
modernized the look of the early mills. At the
center of the store, a real conveyor belt was
installed to rotate the brand's products slowly.
The design of the wall and lighting was also done
by reinterpreting the ideas obtained by looking at
various images of the factory. We designed with
an integrated point of view so that visitors could
experience the space and the product at the same
time.

아파트 인테리어 조명 시리즈
Apartment Interior Light Series

브랜드의 핵심 가치인 '진심이 짓는다'와 그들의 진정성을
반영하고 싶었다. 원형에서 출발해 오랫동안 유행에
휩쓸리지 않고 사용할 수 있도록 조형을 정리해나갔다.
침실등과 주방등은 기존 인테리어에 스며들도록 2010년에
디자인한 스위치 시리즈의 모티브를 적용해서 모서리를
둥글린 정사각형으로 디자인했다. 또한 직사각형과
정사각형을 모듈화해 모든 천장형 조명등이 같은 그리드에
적용되도록 형태와 크기를 표준화했다.

We wanted to reflect the brand's core value of
"Sincerity Build" and their sincerity. Starting from
the original shape, the format was organized so
that it could be used without going out of fashion
for a long time. The bedroom lights and kitchen
lights are designed in a square shape with rounded
corners by applying the motif of the switch series
designed in 2010 to permeate the interior. In
addition, by modularizing rectangles and squares,
the shape and size were standardized so that all
ceiling lights are applied to the same grid.

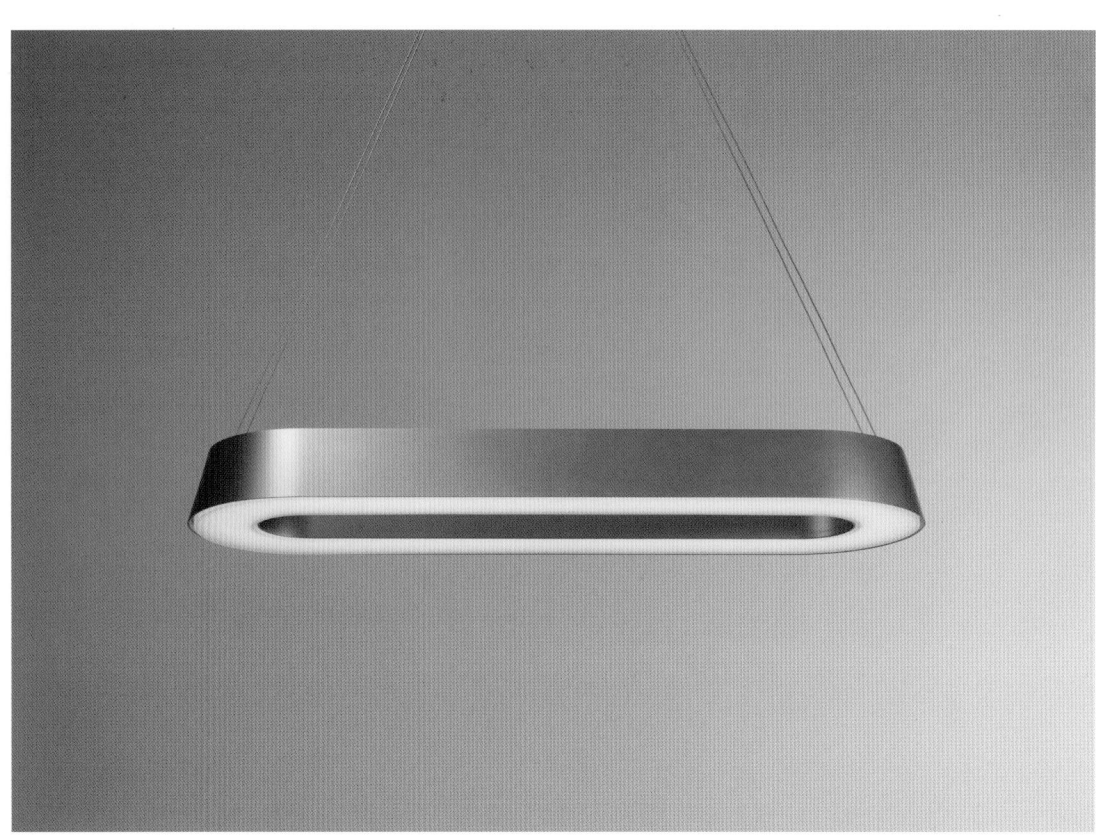

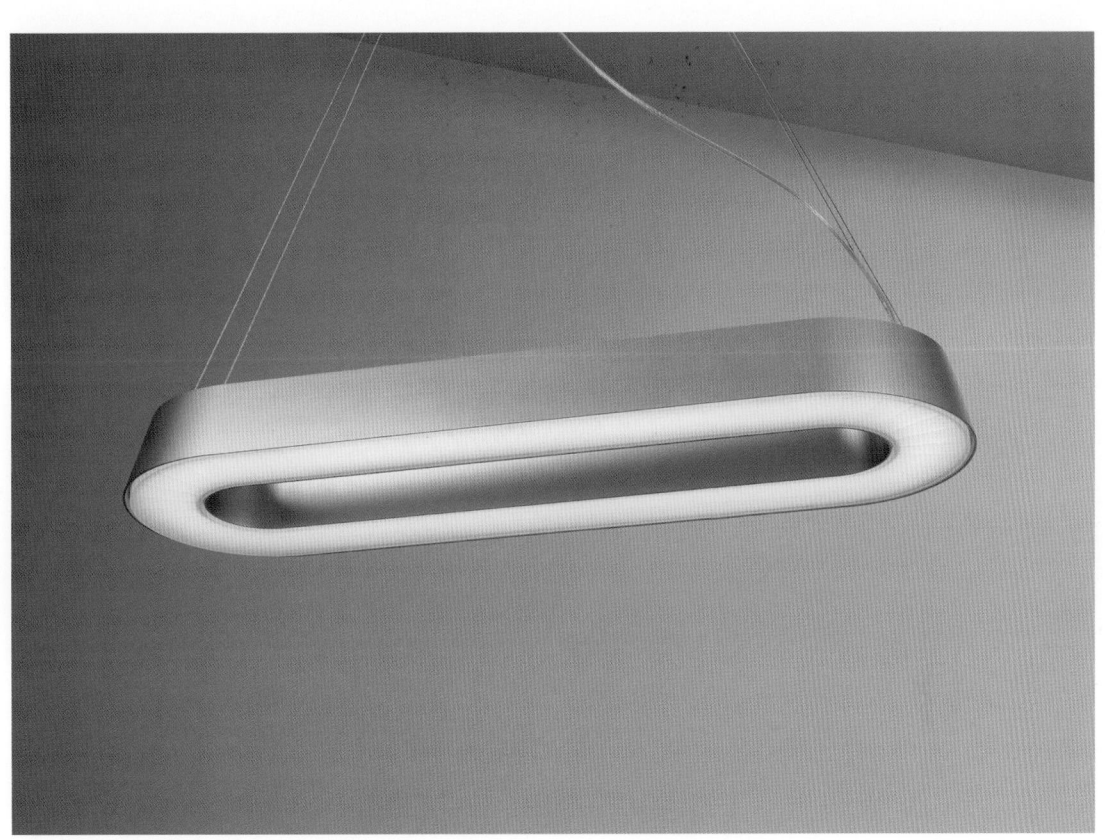

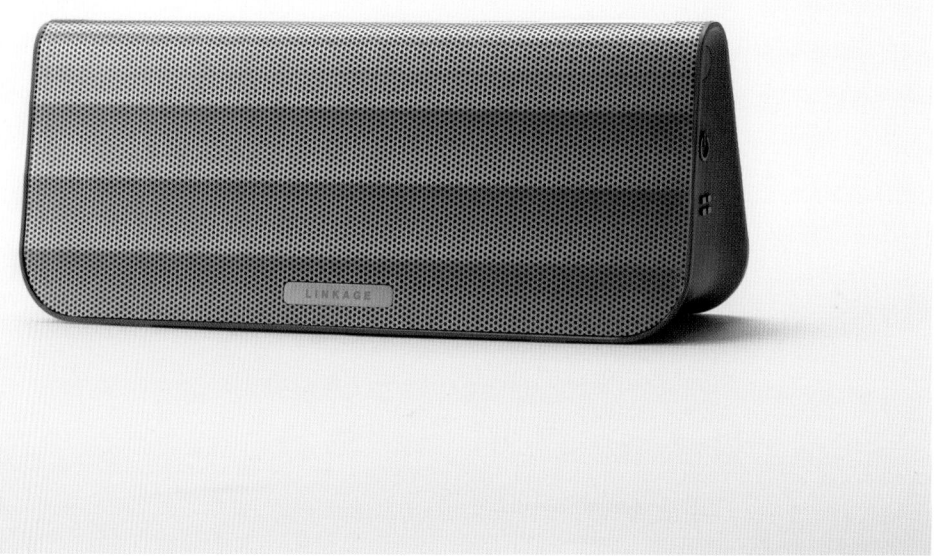

스마트 스피커
Smart Speaker

스피커는 음악이 나오는 면에 다소의 각이 있을 때 음향이
잘 뻗어 나간다. 자연스럽게 음악이 가장 잘 나올 각도를
찾는 데서 출발했다. 또한 손에 쥐었을 때 느낌이 좋고
다양한 배경에 잘 어울려야 했다. 목적성과 상시성이 균형을
이루는 데 집중했다.

When music comes out of a speaker, the
acoustics are better if there is an angle on that
side. We naturally began this project with finding
the best angle. Also, it had to feel good when held
and blend well with various backgrounds. We
focused on function and permanence.

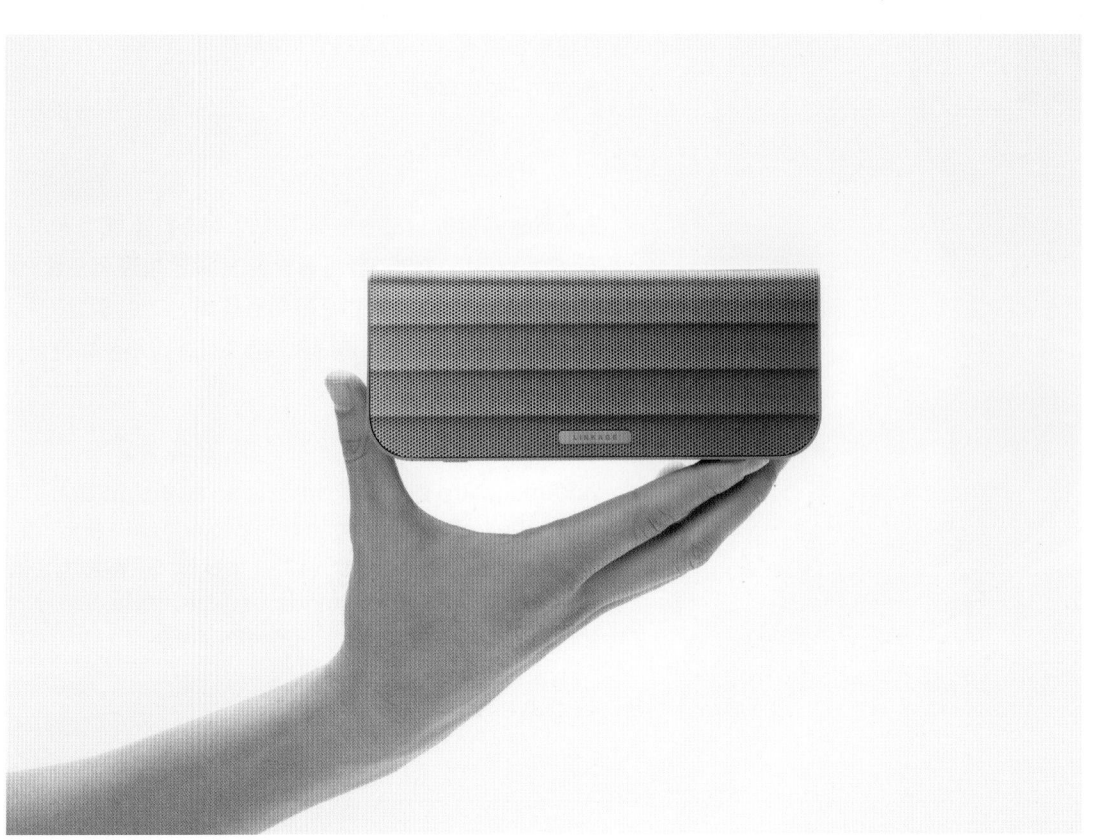

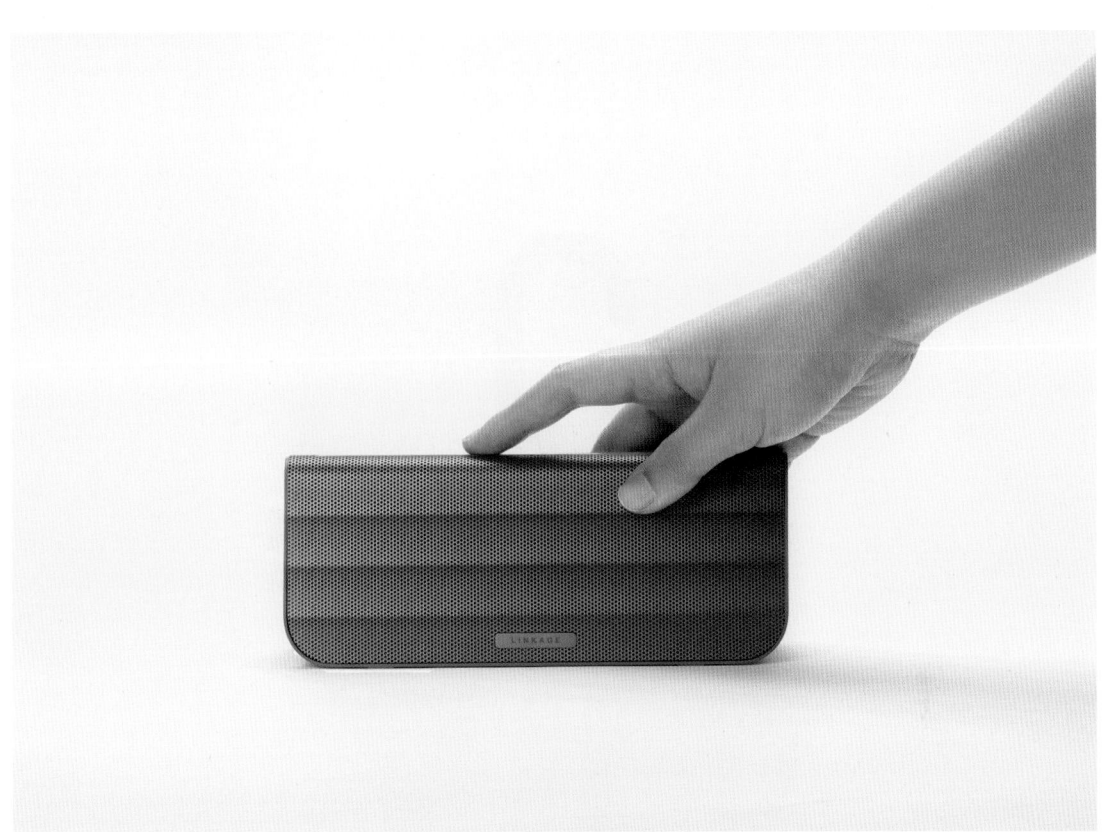

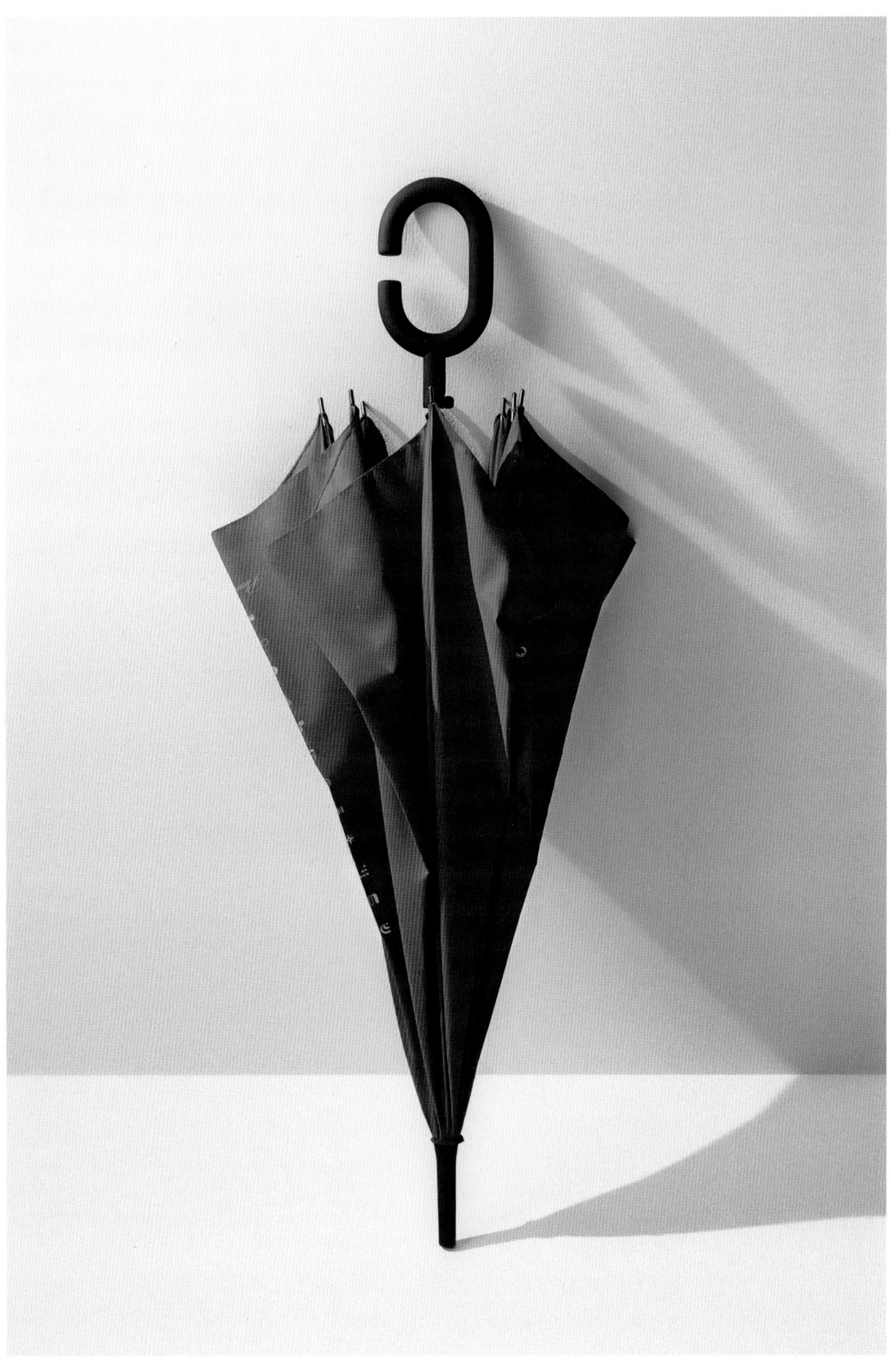

우산
Umbrella

비 오는 날, 보통 어깨와 턱 사이에 우산대를 끼우고
스마트폰을 본다. 비도 안 맞고 스마트폰도 좀 더 편리하게
사용할 방법이 없을까? 이런 질문에서 출발해 작은 혁신을
만들어낸 우산이다. 다른 부분은 여타 우산과 크게 다르지
않지만, 이 우산은 쓴 상태로 손잡이에 손목을 걸 수 있다.
비 오는 날에도 한결 안정적으로 스마트폰을 사용할 수 있는
것이다.

On rainy days, we usually look at our smartphones
with an umbrella stand between our shoulder and
chin. The Umbrella, which became an innovation,
arose from the question, "Isn't there a way to use
the smartphone more conveniently when it's not
raining?" Other parts are not so different from
other umbrellas', but for this umbrella, you can
hang the handle on your wrist with your umbrella
open. You can use your smartphone with ease
even on rainy days.

320

4D 영화관 의자
4D Theater Chair

일반 영화관 의자와 달리 4D 체험이 가능한 의자다.
바람, 소리, 물, 진동 등 다양한 자극을 전달해준다.
의자가 주는 경험과 맞게 팔걸이 부분의 역동성을 강조했고,
열과 줄이 좀 더 잘 보이도록 디자인했다.

Unlike common movie theater chairs, you can
have a 4D experience with this chair. It delivers
various stimuli such as wind, sound, water, and
vibration. In line with the experience of the chair,
the dynamics of the armrests were emphasized,
and the rows and lines of chairs were designed for
better visibility.

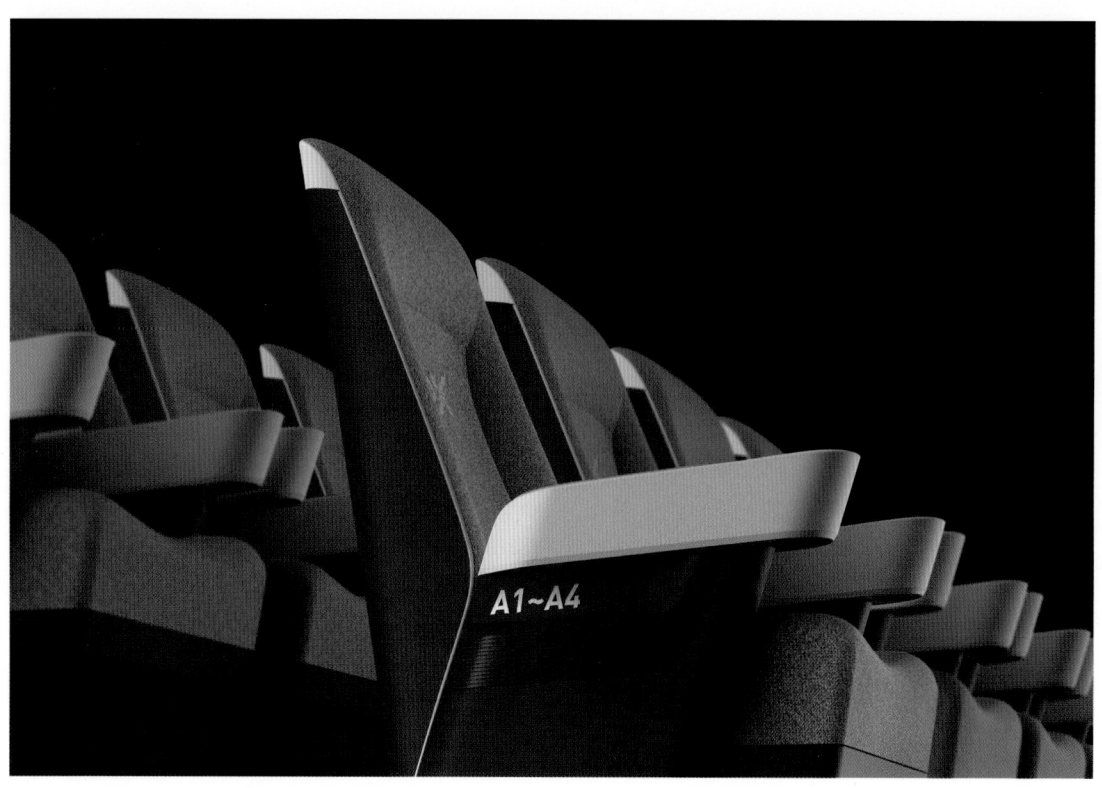

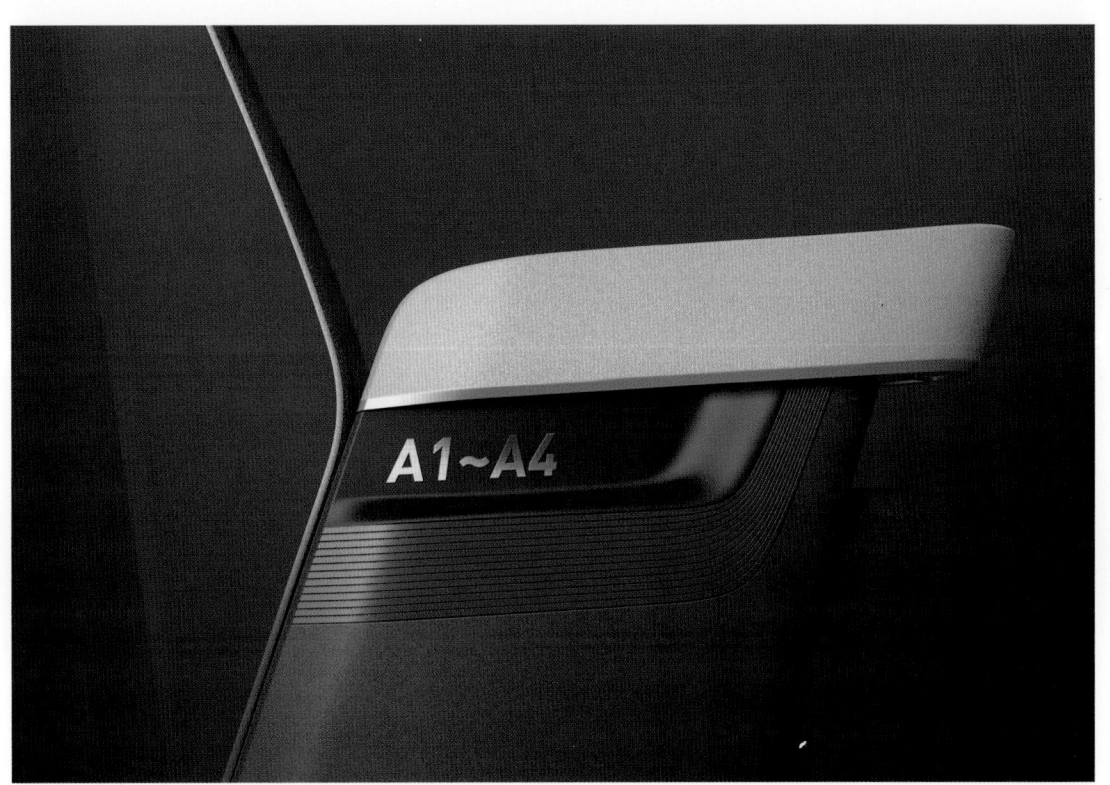

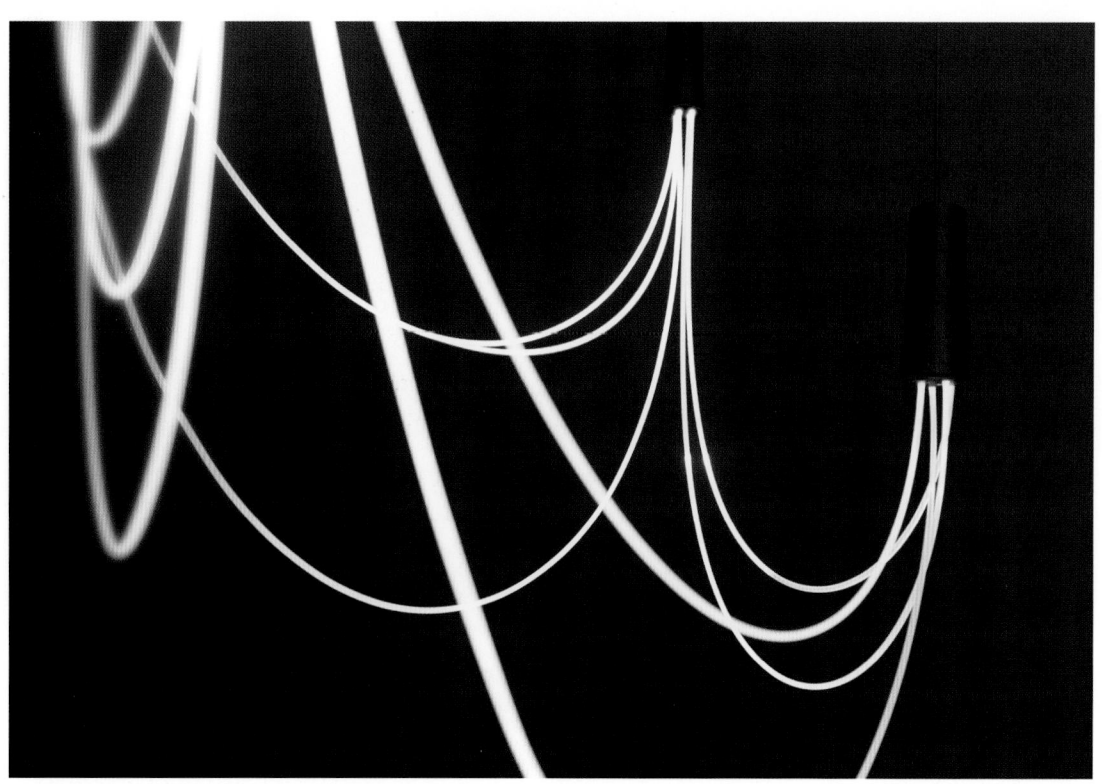

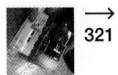
플록 벌브
Flock Bulb

자기만의 조명등을 만들 수 있는 플록 벌브다. 자동차나
건축물 등의 조명으로도 사용하는 특수 소재인 광섬유[4]의
특성을 이용했다. 전구가 들어가는 기존 조명등과 호환이
가능하며, 여러 개의 플록 벌브에 광섬유를 원하는 대로
재단해 다양하게 연출 가능하다. 조명등의 형태와 크기를
정하고 설치하는 과정까지 일반 소비자도 쉽게 다룰 수 있다.

The Flock Bulb can generate its own lighting
by using the characteristics of optical fiber[4], a
special material that is also used for lighting in
automobiles and buildings. It is compatible with
existing lighting that contain light bulbs, and can
be displayed in various ways by adjusting optical
fibers in as many Flock Bulbs as desired. Even the
general consumer can easily handle the process
of determining the shape and size of the lighting
and installing the bulb.

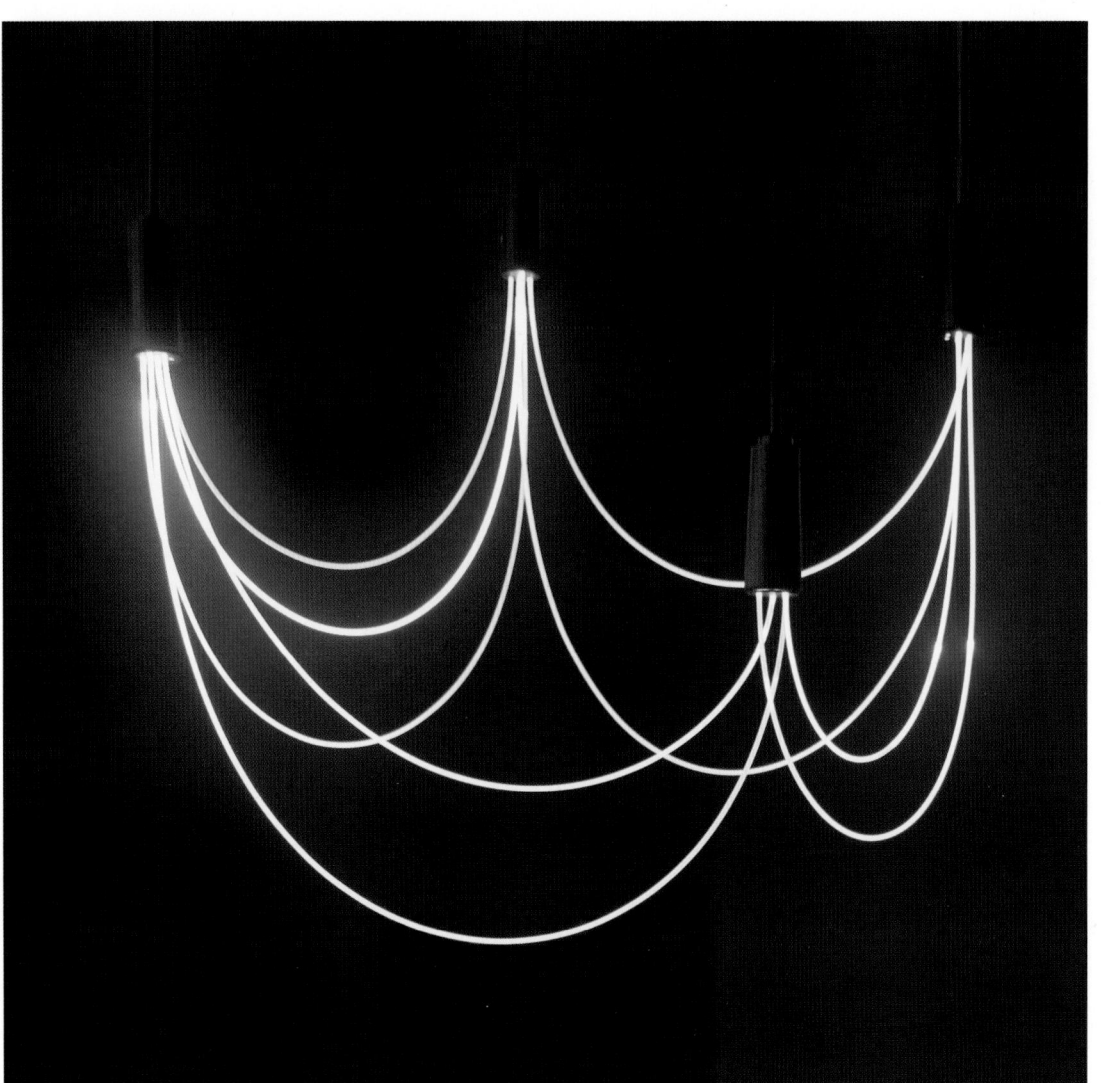

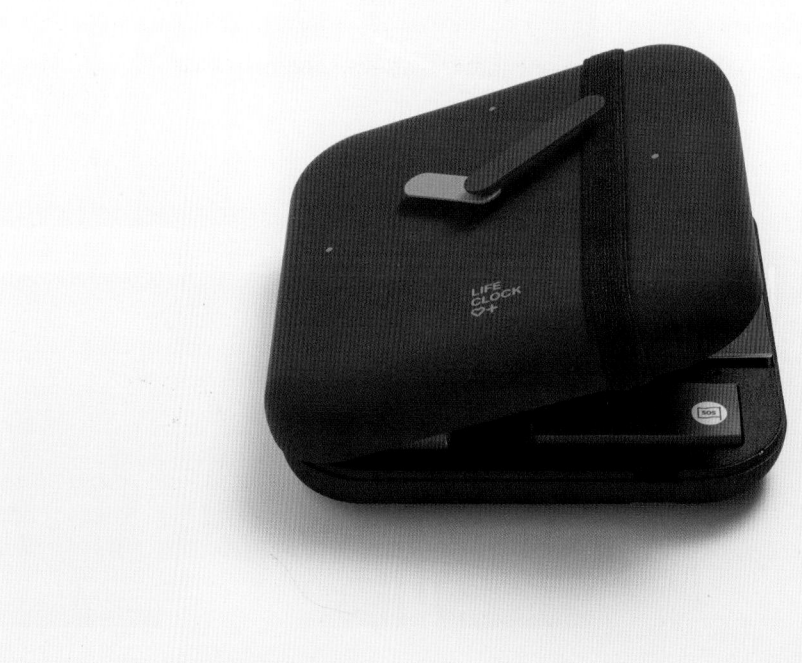

라이프 클락 재난 키트
Life Clock Disaster Kit

재난은 얼마든지 언제든지 우리 주변에 일어날 수 있다는
인식이 확산되는 게 중요하다고 생각했다. 디자인을 통해
이 미션을 이루려면, 특별한 무언가가 아니라 우리 삶에
친숙하게 공존하는 재난 용품이 필요했다. 라이프 클락
재난 키트는 평상시 시계로 일상에 자연스레 스며들고,
비상시 시계를 열어 안을 보면 재난 용품이 들어 있다.
골든타임인 72시간 동안 긴급 상황에 즉각적인 대처가
가능하도록 생명을 유지하는 데 도움 되는 실내용 재난
대비 용품으로 구성했다.

Spreading awareness that disasters can happen
around us at any time is important. To achieve
this mission through design, we needed familiar
disaster supplies that coexist in our lives, rather
than something special. The Life Clock Disaster
Kit naturally permeates our daily life as a normal
watch, and in case of an emergency, if you
open the clock and look inside, you will find
disaster supplies. It comprises indoor disaster
preparedness supplies that help maintain life so
that you can immediately respond to emergency
situations during the golden 72 hours.

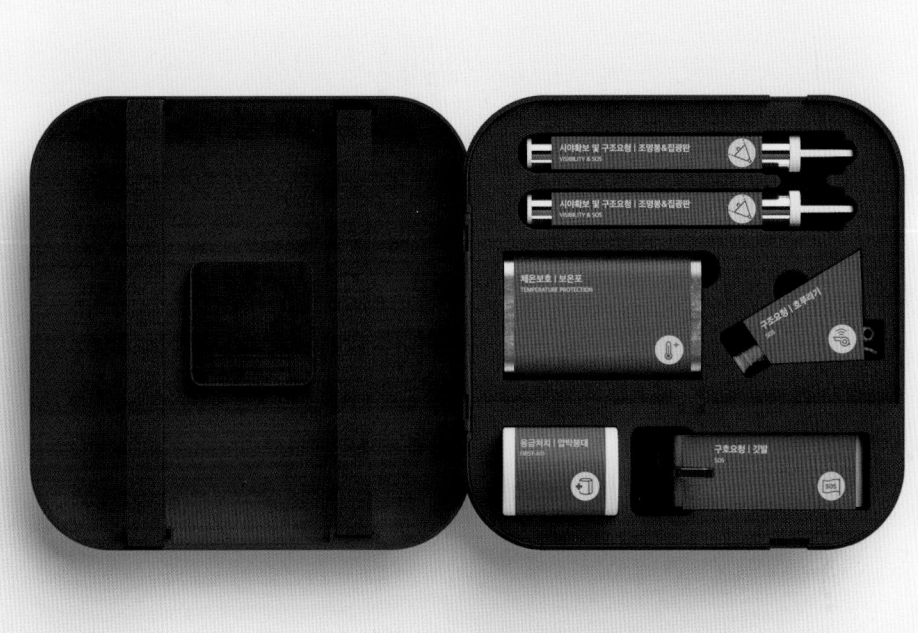

스마트 충전기
Smart Charger

스마트폰을 무선 충전하는 동시에 화면을 볼 수 있도록
구 형태의 디자인을 구상했다. 단순화한 반구 형태가
자유자재로 돌아가게 할 방법을 찾았고, 힌지⁵ 대신 자석을
사용하니 제조비를 절감할 수 있었다. 기본적으로 사용하기
쉽고 단순한 모양새가 되도록 설계했다.

A spherical design was conceived so that a
smartphone could be wirelessly charged and the
screen could be viewed at the same time. We
found a way to allow the simplified hemispherical
shape to rotate freely, and by using magnets
instead of hinges[5], able to manufacturing costs
could be reduced. Fundamentally, the charger
was designed to be easy to use and simple in
appearance.

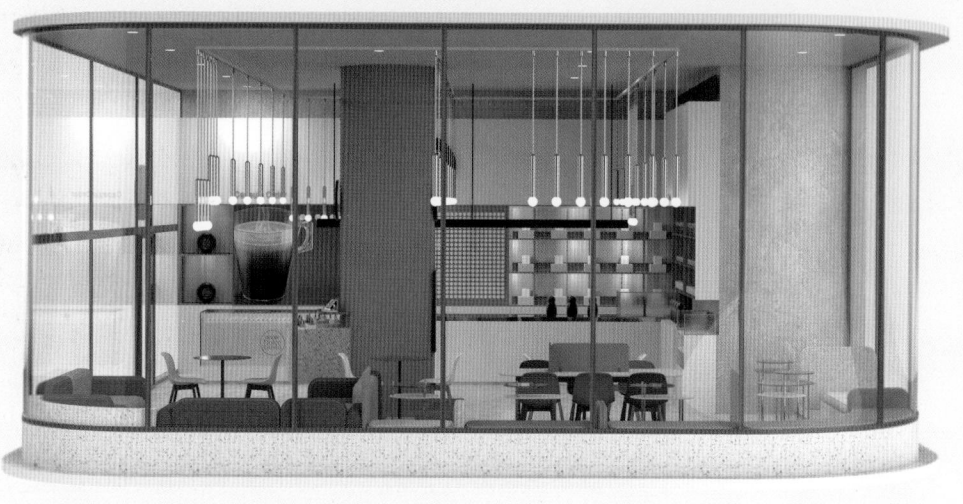

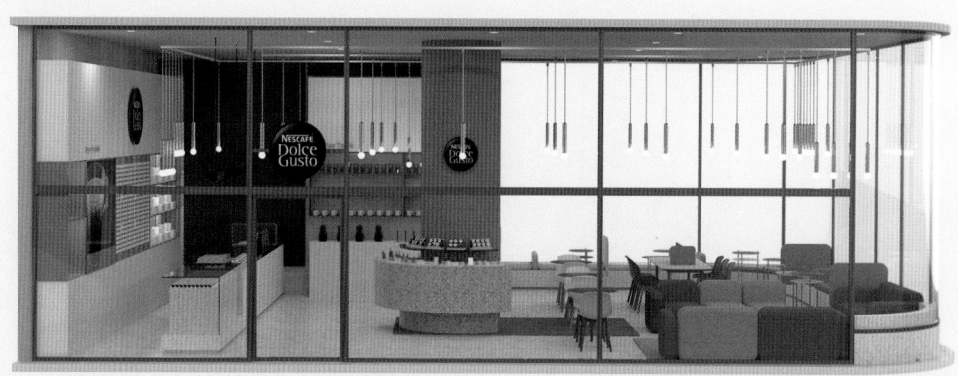

플래그십 스토어 카페
Flagship Store Cafe

커피 브랜드의 플래그십 스토어 카페 디자인으로 커피머신
콘셉트에서 출발했다. 골라 먹는 커피 핀을 중심으로,
여러 가지 향과 맛을 직접 체험해보고 구매할 수 있도록
유도했다. 조명등과 가구 등 스토어 전반의 디자인에
참여했다.

This started with a coffee machine concept as the
coffee brand's flagship store cafe design. With a
focus on coffee phins to choose from, we tried to
encourage purchase after experiencing various
aromas and flavors. We participated in the overall
design of the store including lighting and furniture.

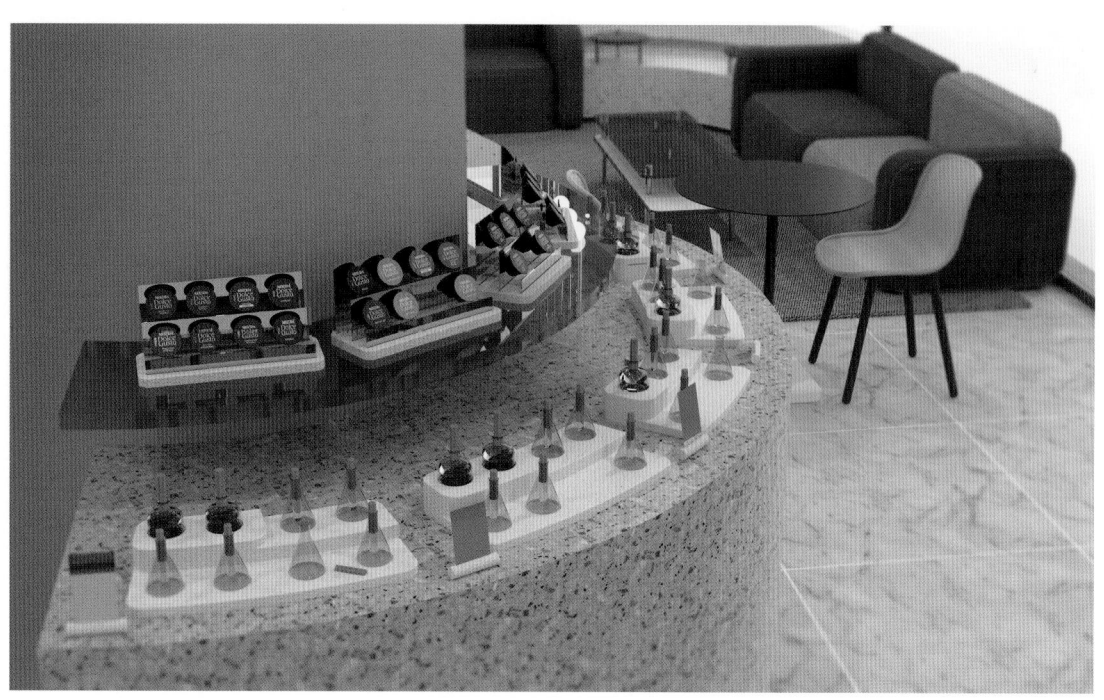

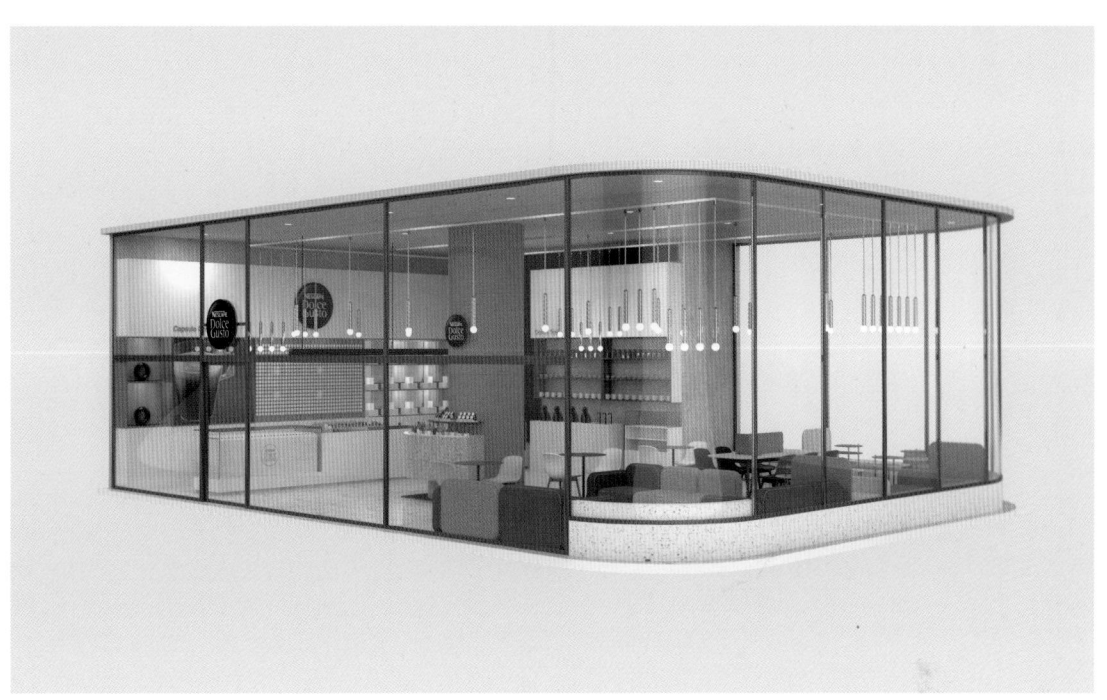

163

그래피컬 조명
Graphical Light

을지로 조명 상가와 국내 디자이너가 만나 새로운 조명등
디자인을 제안하는 'By 을지로' 프로젝트를 위한 작업이다.
평면 그래픽의 선적인 형태를 입체로 치환해 형상화했고,
빛과 빛이 겹칠 때 그 사이에 연출되는 부분을 패턴화한 것이
특징이다. 세 가지 다른 형태와 다른 색상을 조합할 수 있다.
'By 을지로' 프로젝트에 참여한 조명은 2018년 전시
⟨By 을지로: 디자인 컬래버레이션⟩에 다시금 선보였다.

This was a project for 'By Euljiro' Project which was
a collaboration between Euljiro Lighting Shopping
Mall and domestic designers in order to propose a
new lighting design. Graphical light's uniqueness
was formation through replacing the linear form
of flat graphics with a three-dimensional shape,
and patterning of the part that is produced when
lights overlap. Three different shapes and different
colors can be combined. The graphical lighting
that was created in the 'By Euljiro' Project was
displayed in the 2018 exhibition *By Euljiro: Design
Collaboration*.

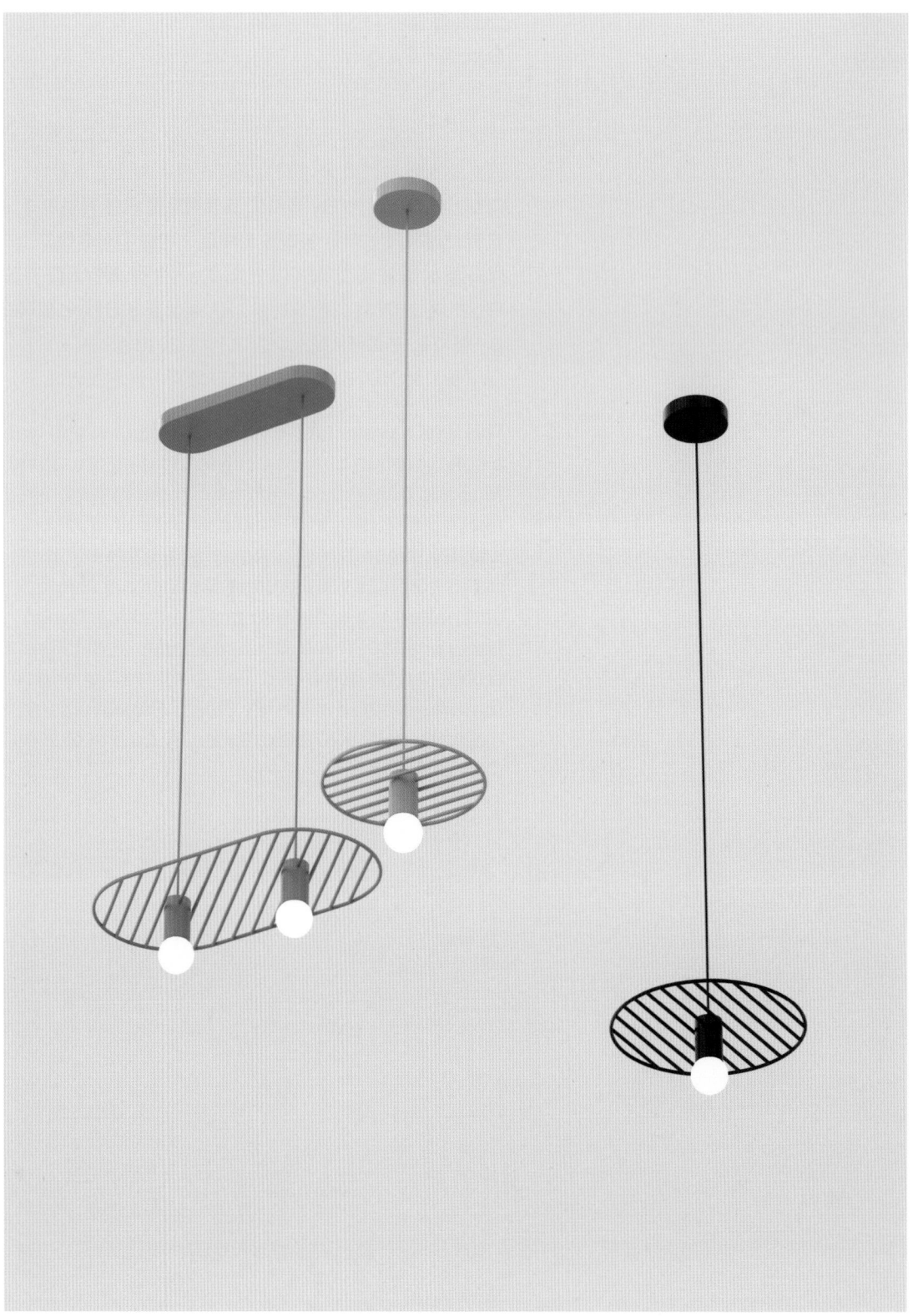

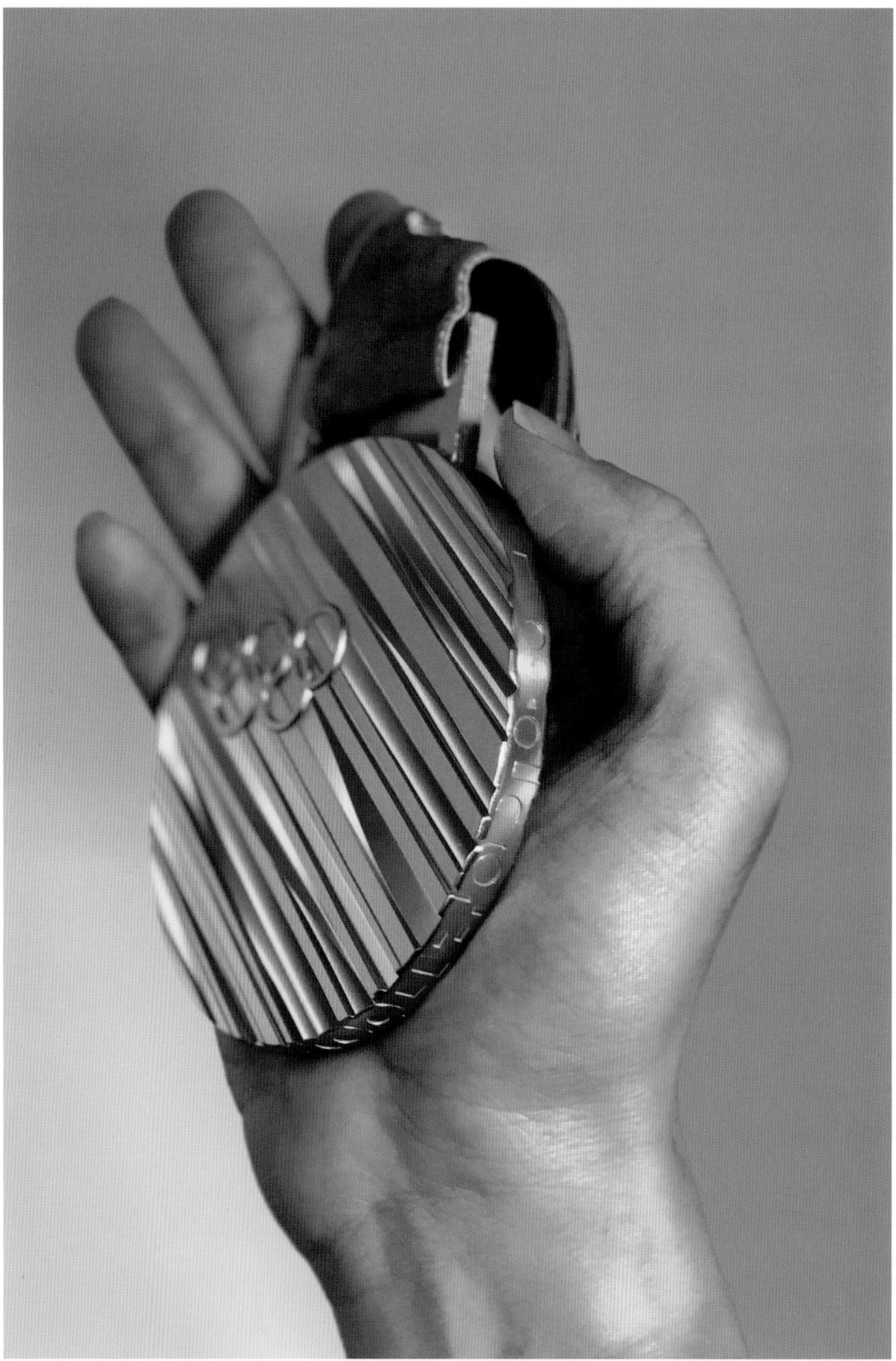

2018 평창 동계 올림픽 메달
2018 PyeongChang Winter Olympic Medal

문자는 문화의 씨앗이다. 한글이라는 씨앗을 정성스럽게
키우면 꽃과 열매 같은 문화가 맺히며, 줄기는 문화를
맺어가는 과정이라고 할 수 있다. 이 줄기가 올림픽 정신과
흡사하다고 생각했다. 여기에 문화의 씨앗인 한글을
입체적으로 해석한 메달 디자인을 구현했다. 2차원의
한글 자음이 자라서 3차원이 된 형상을 원형으로 잘라내,
옆면에는 한글을, 전면에는 줄기를 표현했다. 목에 거는
리본은 한복을 짓는 갑사 기법을 사용해 만들었으며,
케이스는 한국 전통 오브제를 해석해 특유의 단아하면서도
아름다운 곡선을 나무로 제작했다.

Letters are the seeds of culture. If this seed,
Hangeul, is carefully nurtured, culture will bloom
like flowers and fruits, and the stem is the process
of forming a culture. I thought this stem was
similar to the spirit of the Olympics. Here, a medal
design that three-dimensionally interpreted
Hangul, the seed of culture, was implemented.
After the two-dimensional Hangeul consonants
grew and became three-dimensional, the shape
was cut out in a circle, and Hangeul, the seed, was
expressed on the side, and the stem, the process,
on the front. The ribbon around the neck was
made using the Gapsa technique that is used to
make hanbok, and the medal case was made of
wood with a unique elegant yet beautiful curve by
reinterpreting traditional Korean objects.

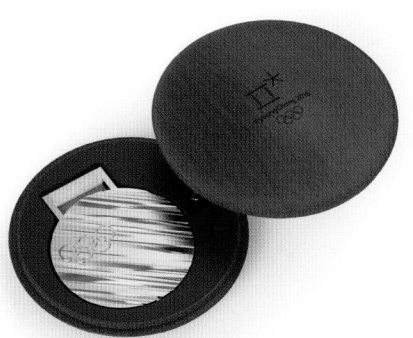

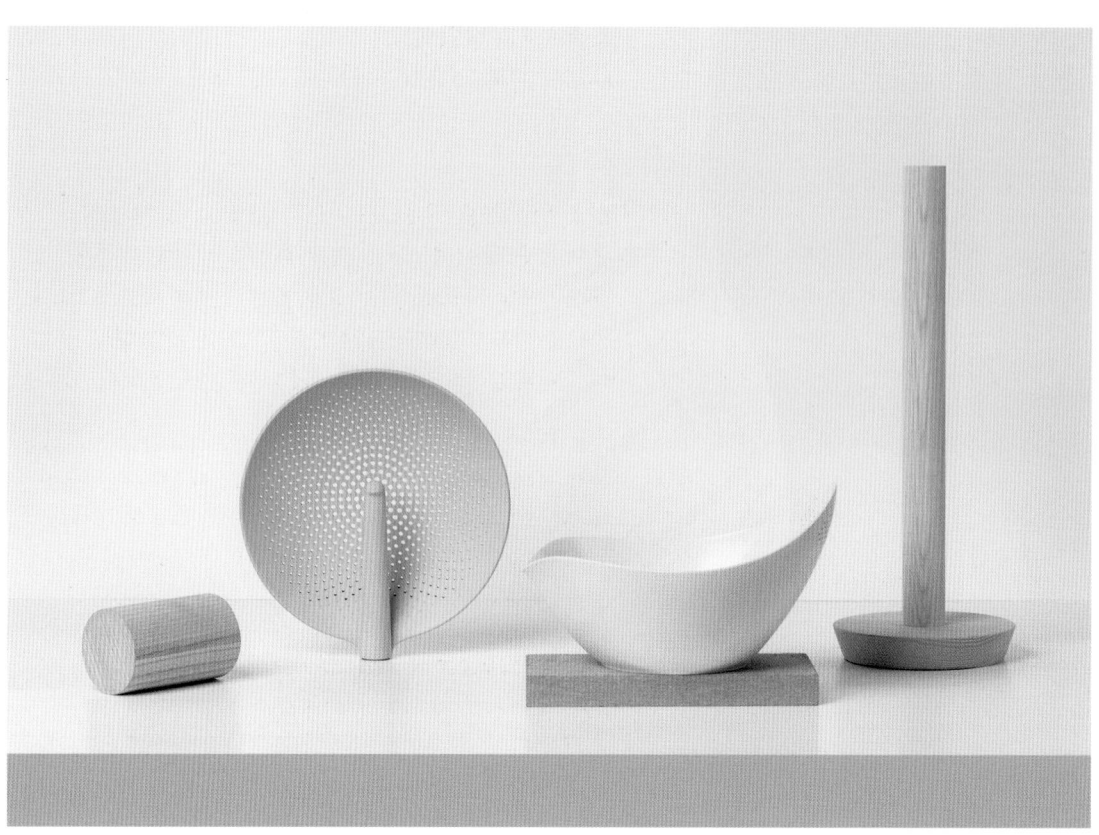

서클 피콕과 테일 버드
Circle Peacock & Tail Bird

인스턴트 냉면을 위한 조리 도구 시리즈로, 끓인 면을 차가운
물로 헹굴 때 사용하는 두 가지 종류의 채다. 채의 경우
목적 지향적인 조리 도구이기에 주방에 꺼내 놓고 쓰더라도
주변 환경에 어울려야 한다. 클라이언트 회사의 심볼
마크에서 영감을 받아 새 형상의 디자인을 전개했다.

A series of cooking tools for instant naengmyeon,
they are two types of sieves used to rinse boiled
noodles with cold water. The sieve is a purpose-
oriented cooking tool, so even if you take it out
of the kitchen and use it, it should blend with the
surrounding environment. We were inspired by
the symbol signature of the client company when
developing the new design.

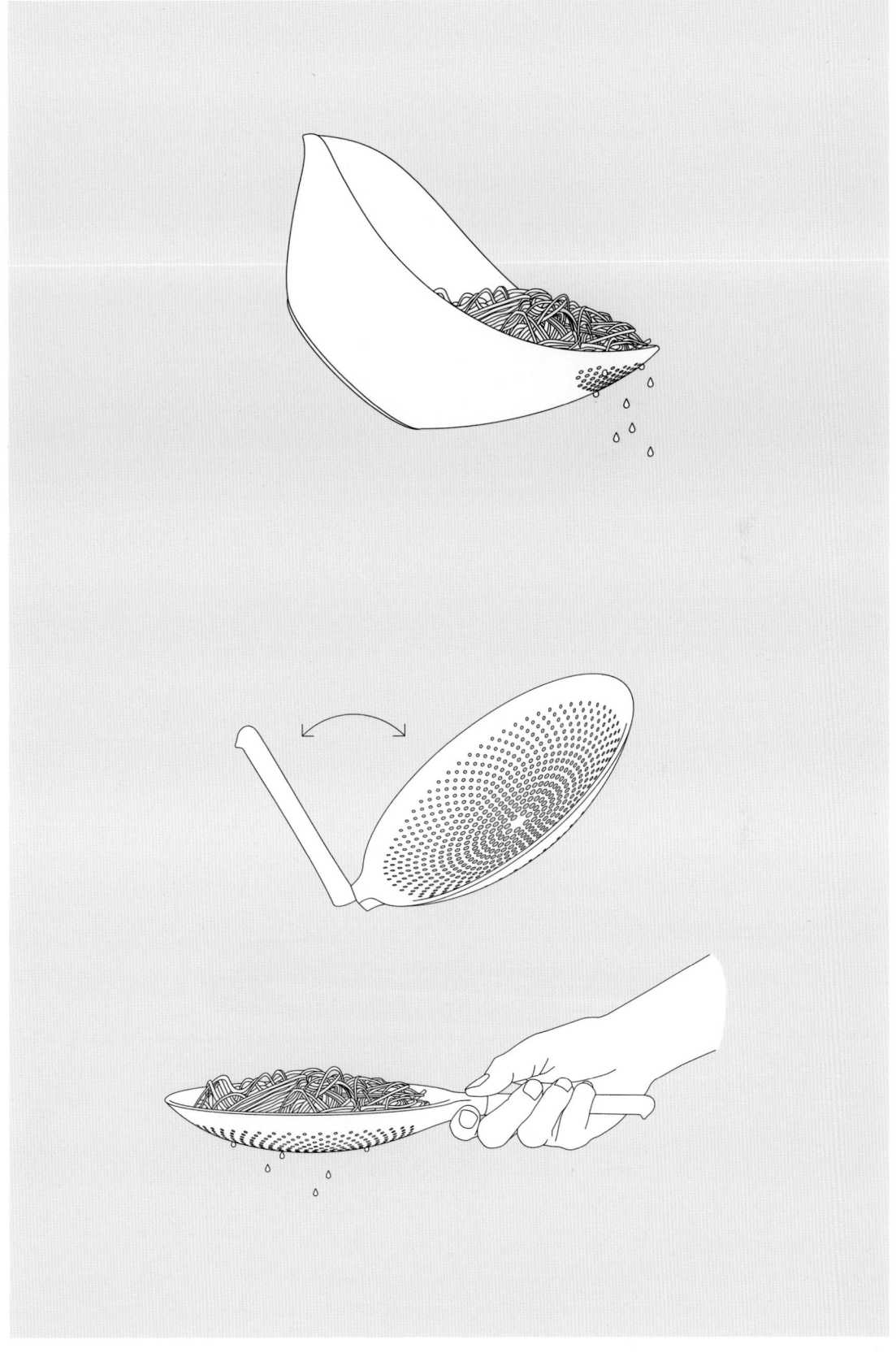

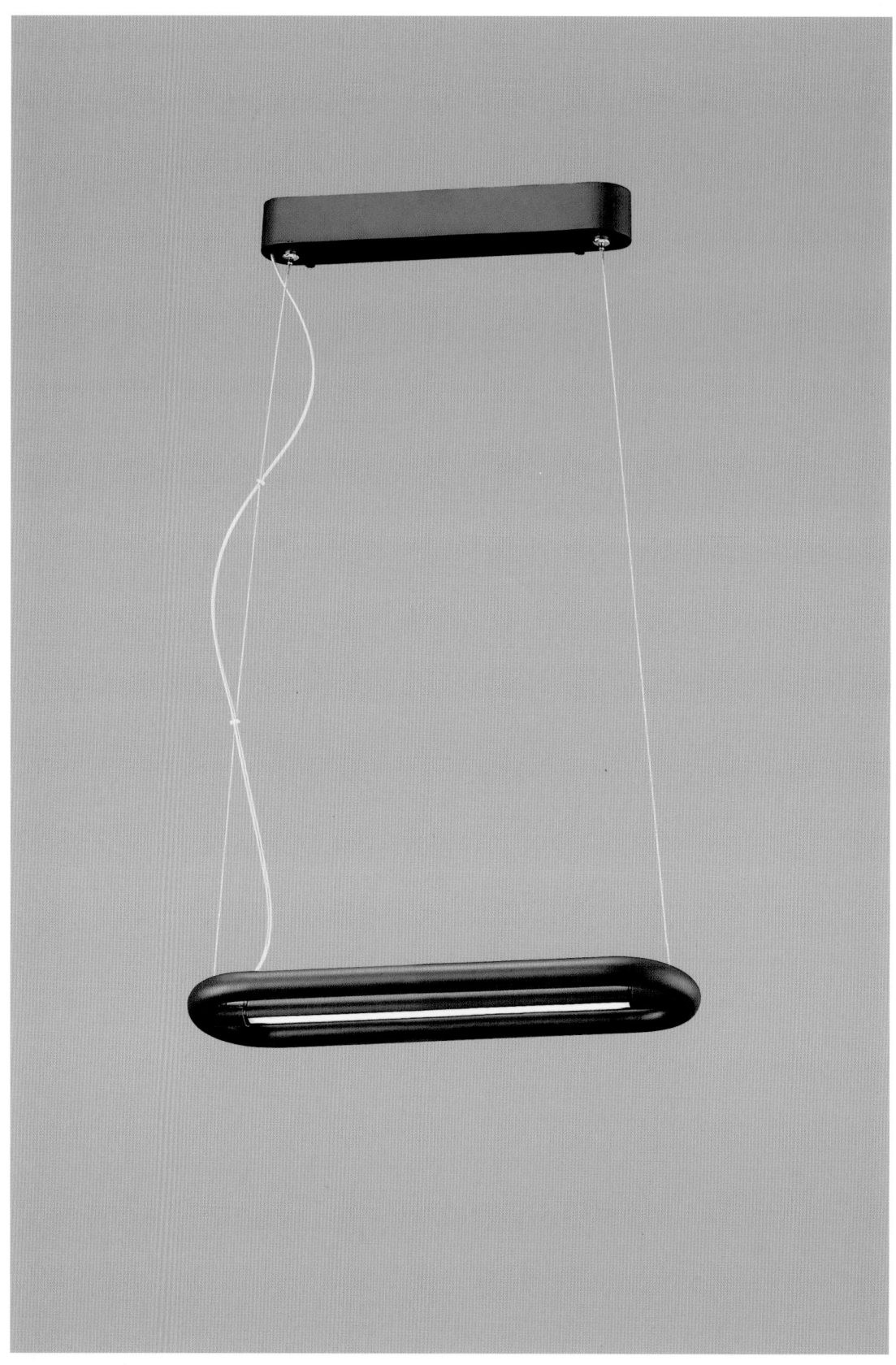

버클 조명 시리즈
Buckle Light Series

버클의 단순한 형태와 기능에서 영감 받아 디자인한
'By 을지로' 프로젝트 작업이다. 패브릭 소재나 반투명 소재
등을 버클 형태의 헤드에 걸어 자유롭게 조명등을 연출할 수
있다. 버클에 거는 소재에 따라 빛의 형태와 색상이 변화한다.
빛을 비추는 조명에서 빛을 보여주는 조명으로 의도했으며,
빛으로 공간이나 환경을 나누는 파티션 역할도 한다.

This is the 'By Euljiro' project that was inspired
by the simple form and function of the buckle.
You can freely create light by hanging fabric or
translucent materials on the buckle-type head.
Depending on the material hung from the buckle,
the shape and color of the light change. From a
light that shines light to a light that shows light, it
also serves as a partition that divides a space or
environment with light.

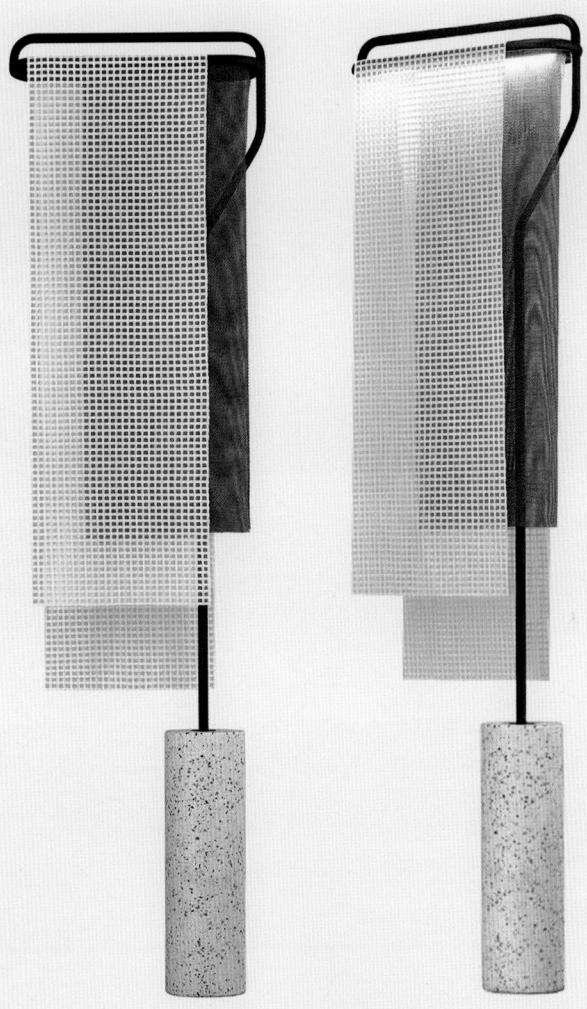

문화역서울284 굿즈 시리즈
Culture Station Seoul 284 Souvenir Series

문화역서울284 전시와 함께 기획한 굿즈 시리즈다.
구 서울역사는 100여 년의 역사를 가졌을 뿐 아니라
건축적으로도 의미 있는 건물이다. 건축물에서 찾아볼
수 있는 여러 요소를 세밀하게 관찰하고 재해석해 새로운
형태의 오브제를 제작했다.

This is a Souvenir Series planned in collaboration
with the Culture Station Seoul 284 exhibition. The
former Seoul Station, an architecturally significant
building, has a history of more than 100 years.
A new type of object was created by closely
observing and reinterpreting various elements
found in architecture.

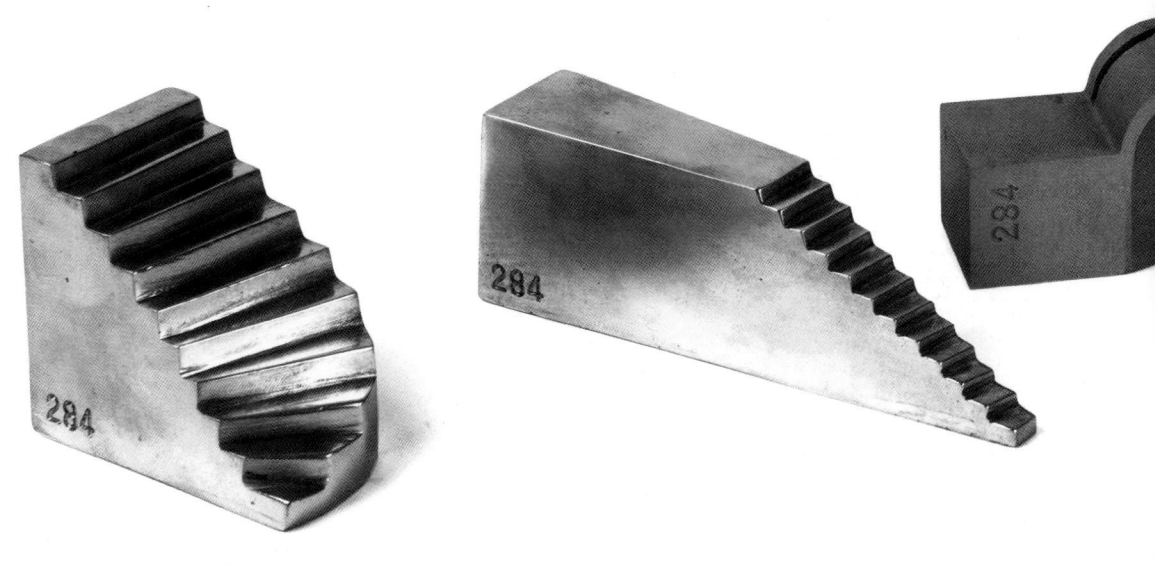

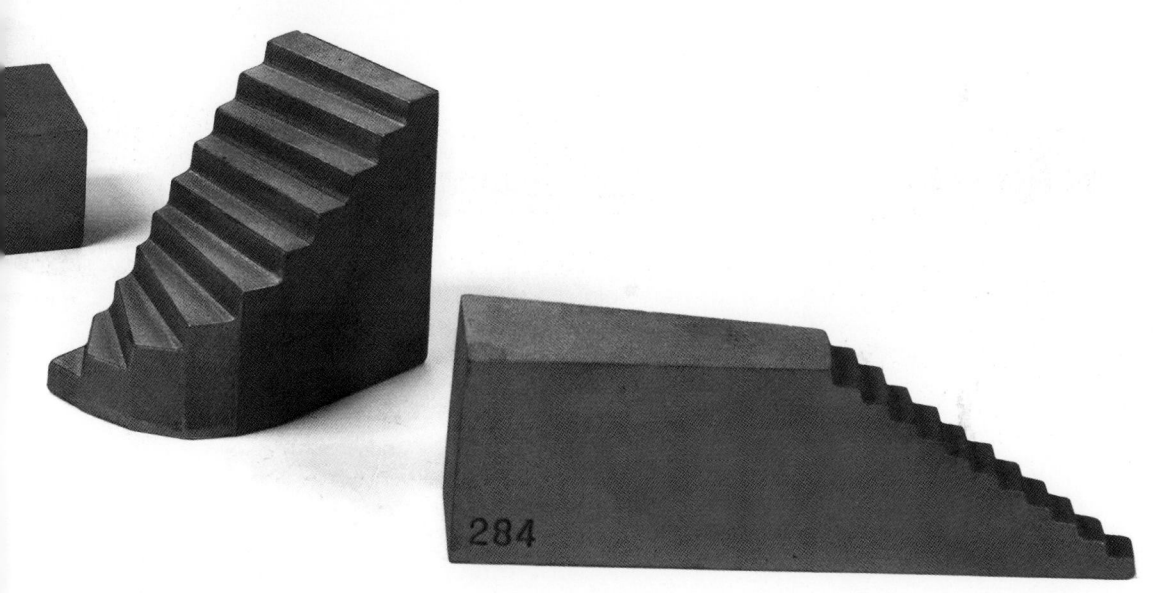

284

아파트 브랜딩 및 마스터플래닝
Apartment Branding & Masterplanning

아파트 단지 전체의 외관부터 실내, 시설, 환경, 조경,
상가, 커뮤니티 시설, 사인, 공공 퍼니처와 전기 설비 등
주거를 위한 모든 요소와 브랜드 총괄 디자인 및 마스터
플래닝을 진행했다. 친환경을 강조하는 메시지로 브랜드를
이루어왔던 클라이언트가 더 깊은 차원의 아파트로
느껴지도록 이야기를 풀어 나갔다. 과거의 푸르지오가
자연이었다면 미래의 푸르지오를 자연스러움으로 정의하고,
'본연이 지니는 고귀함'이라는 키워드를 통해 한 단계 더
발전한 푸르지오의 이미지를 만들었다.

From the exterior of the entire apartment complex
to the interior, facilities, environment, landscaping,
shopping arcades, community facilities, signs,
public furniture and electrical installations, all
elements for housing and brand overall design and
master planning were carried out. We developed
the story so that the client who had built the
brand emphasizing eco-friendliness could feel the
apartment was at an enhanced level. If Prugio of
the past pursued nature, Prugio of the future was
redefined as "natural", and through the key phrase,
"The Natural Nobility," the image of Prugio was
further developed.

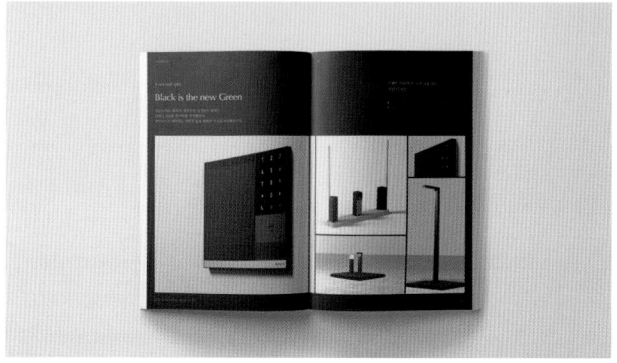

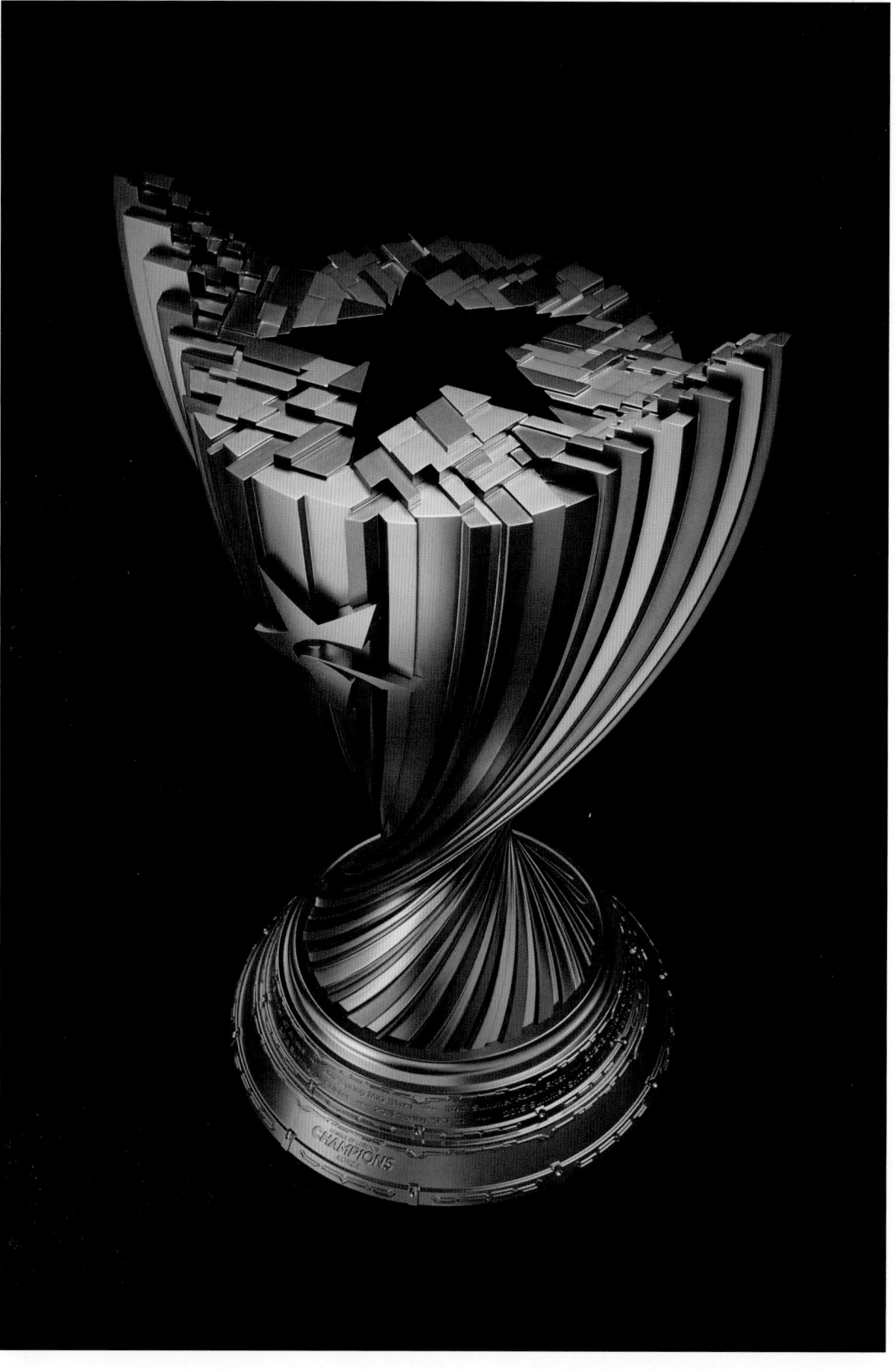

리그 오브 레전드 트로피
Trophy LOL

게임 '리그 오브 레전드'의 우승 트로피 디자인이다.
선수를 의미하는 게임 속 140여 종의 챔피언을 라인으로
형상화했고, 그 라인이 상승하며 트로피를 이루도록
만들었다. 결과로서의 승리가 아닌 과정으로서의 승리를
표현하며 선수 개개인의 노력과 성장을 강조하고 싶었다.
제작은 기존 방식의 한계를 넘기 위해 알루미늄을
3D 프린트하는 방식을 사용했다.

This was the champion trophy design for the game
'League of Legends'. 140 champions of the game,
the players, are shaped into lines, and the lines
rise to form the trophy. We wanted to emphasize
the effort and growth of each player by expressing
victory as a process rather than the result. For
production, 3D printing of aluminum was used to
overcome the limitations of existing methods.

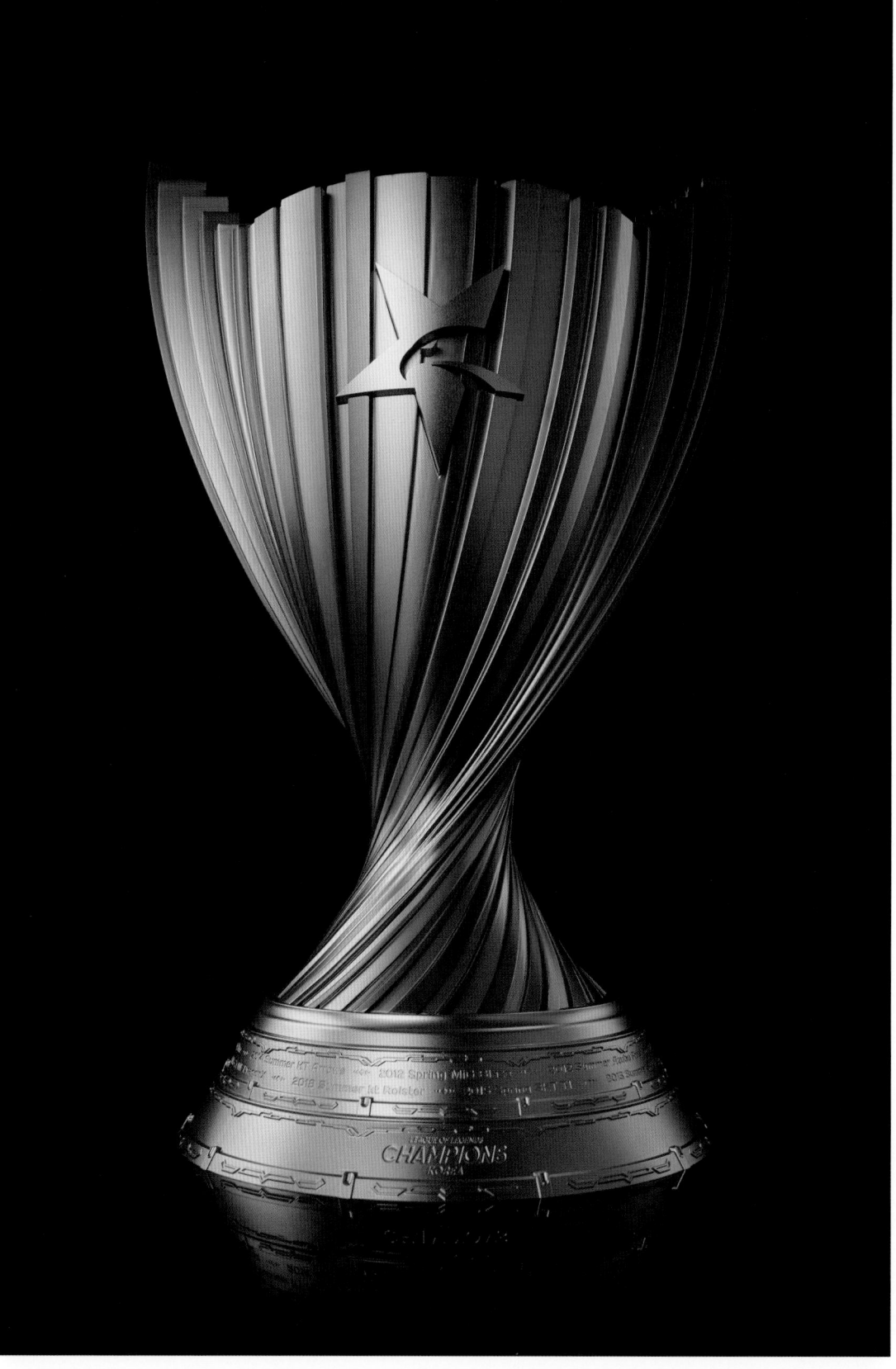

스테이션 지오메트리
Station Geometry

서울역사에서 찾아볼 수 있는 다양한 건축 요소를 재해석한
오브제를 전시했다. 구 서울역사의 일부가 그대로 보존된
공간에 디자인 언어를 거쳐 원래의 조형과 특성을
유지하면서도 새롭게 해석한 오브제들이 어우러졌다.
과거와 현재가 공존하는 전시를 관람하며 숨어 있는
디테일을 통해 건축적·역사적·문화적 가치까지도 마주할 수
있다.

We exhibited objects that were reinterpretations of
various architectural elements found in the history
of Seoul. In a space where a part of the old Seoul
Station had been preserved, newly interpreted
objects were harmonized while going through
the language of design and maintaining their
original shape and characteristics. By viewing the
exhibition where the past and the present coexist,
one can also encounter architectural, historical,
and cultural values through hidden details.

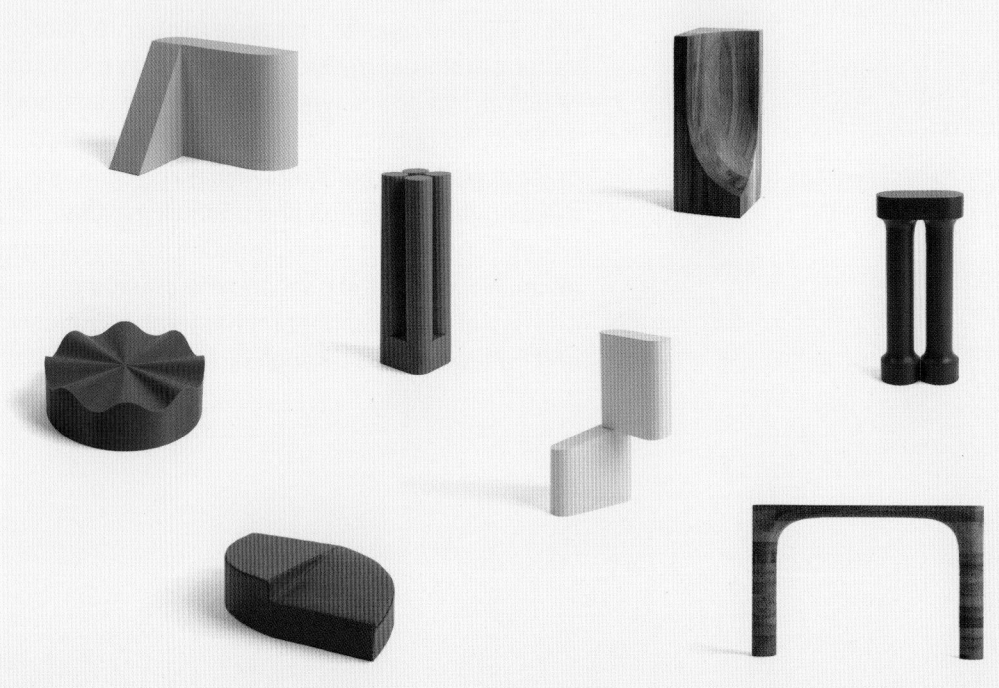

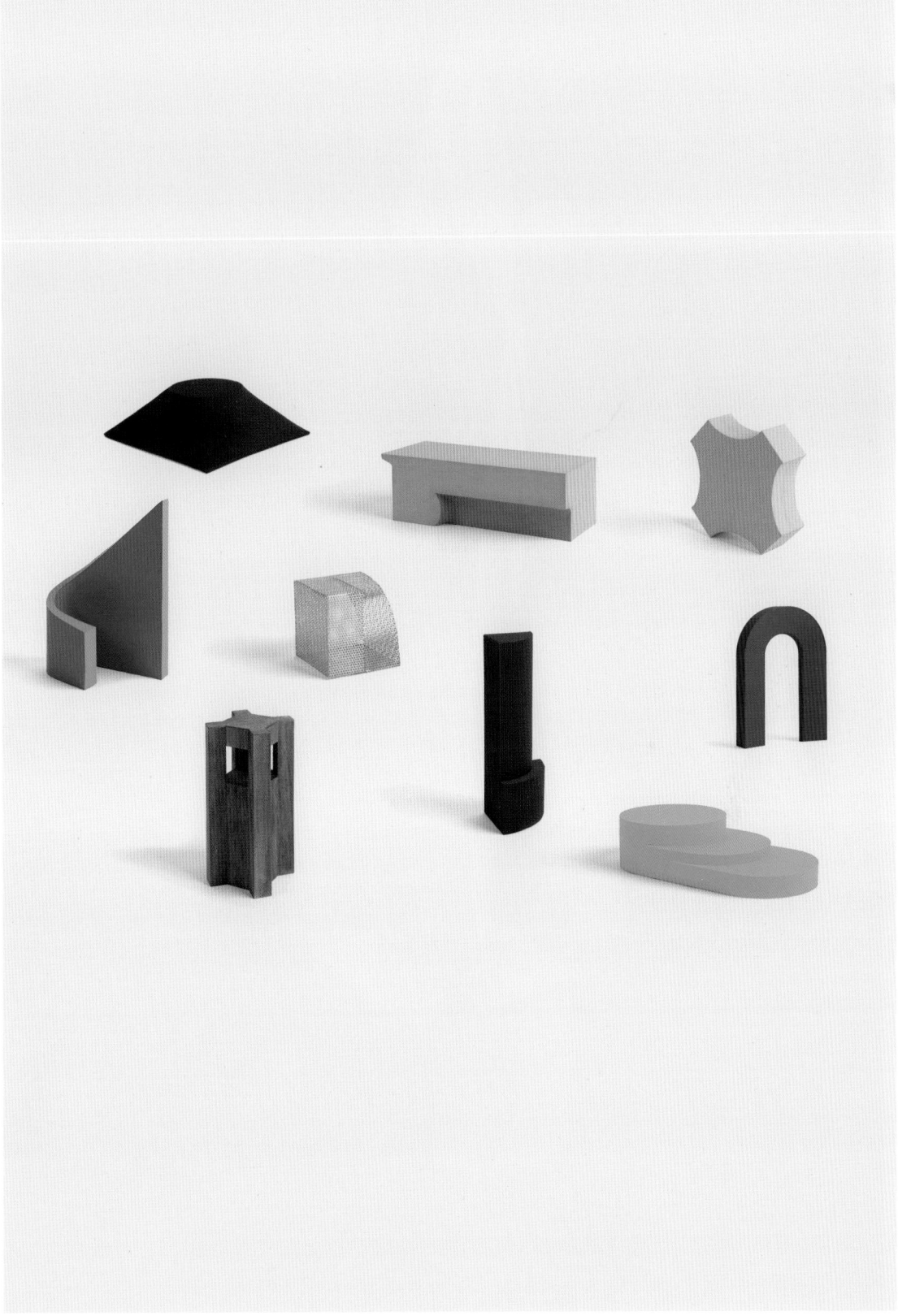

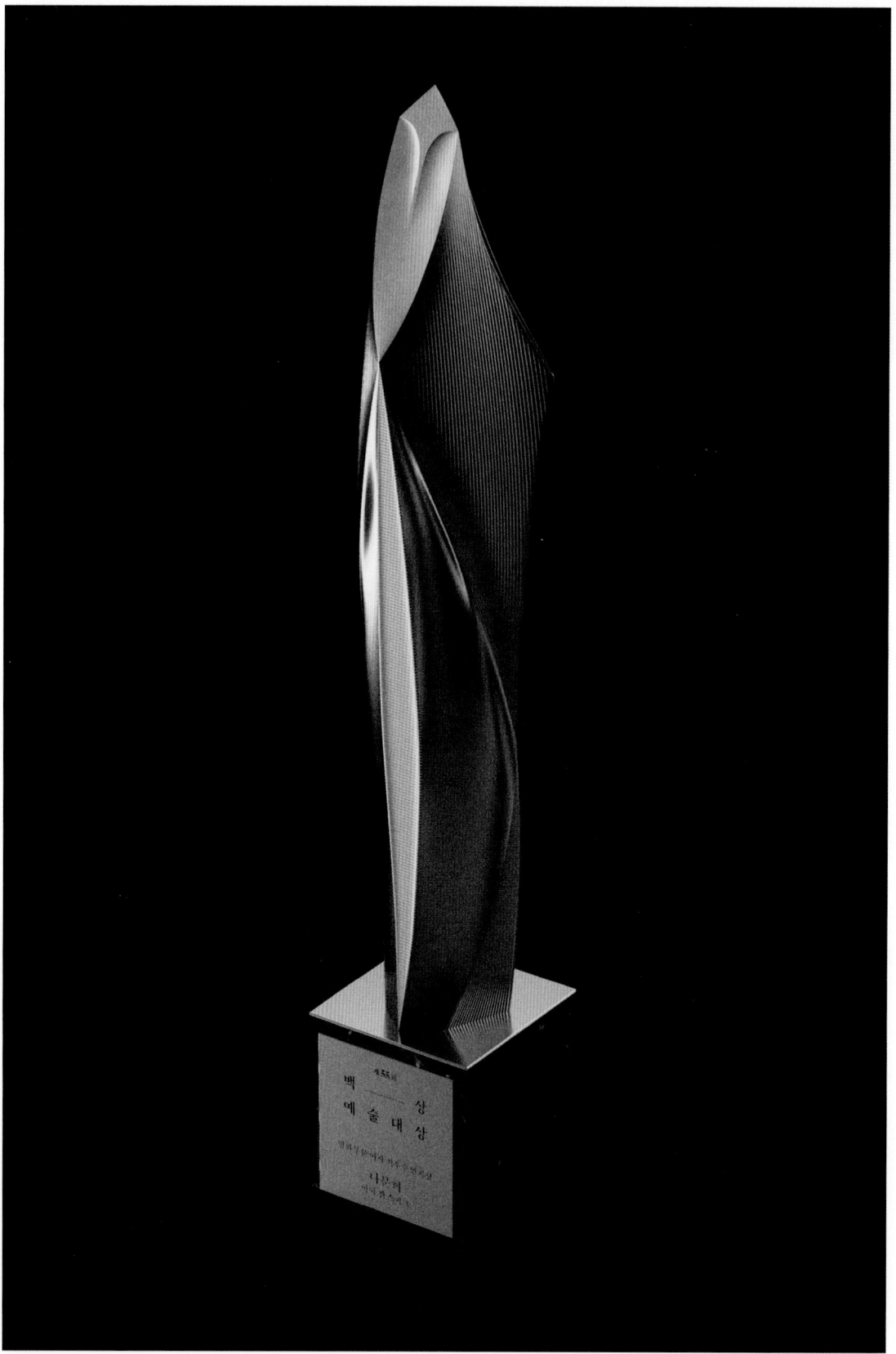

백상예술대상 트로피
Trophy Baeksang

백상예술대상을 위해 디자인한 트로피다. 곡선과 곡선이
입체로 만날 때 나타나는 의외성과 금속 소재의 대비에
예술인을 형상화한 조형을 부여했다. 최종 디자인은
열 가지가 넘는 시안 중 선택되었다. 조각적인 접근과
이를 해석하는 과정이 특별했던 프로젝트다.

This trophy was designed for the Baeksang Arts
Awards. The trophy was given a shape of an artist
through the contrast between the unexpected and
metallic material when a curve and curve meet
three-dimensionally. The final design was chosen
from over ten models. The project was special
for its sculptural approach and the process of its
interpretation.

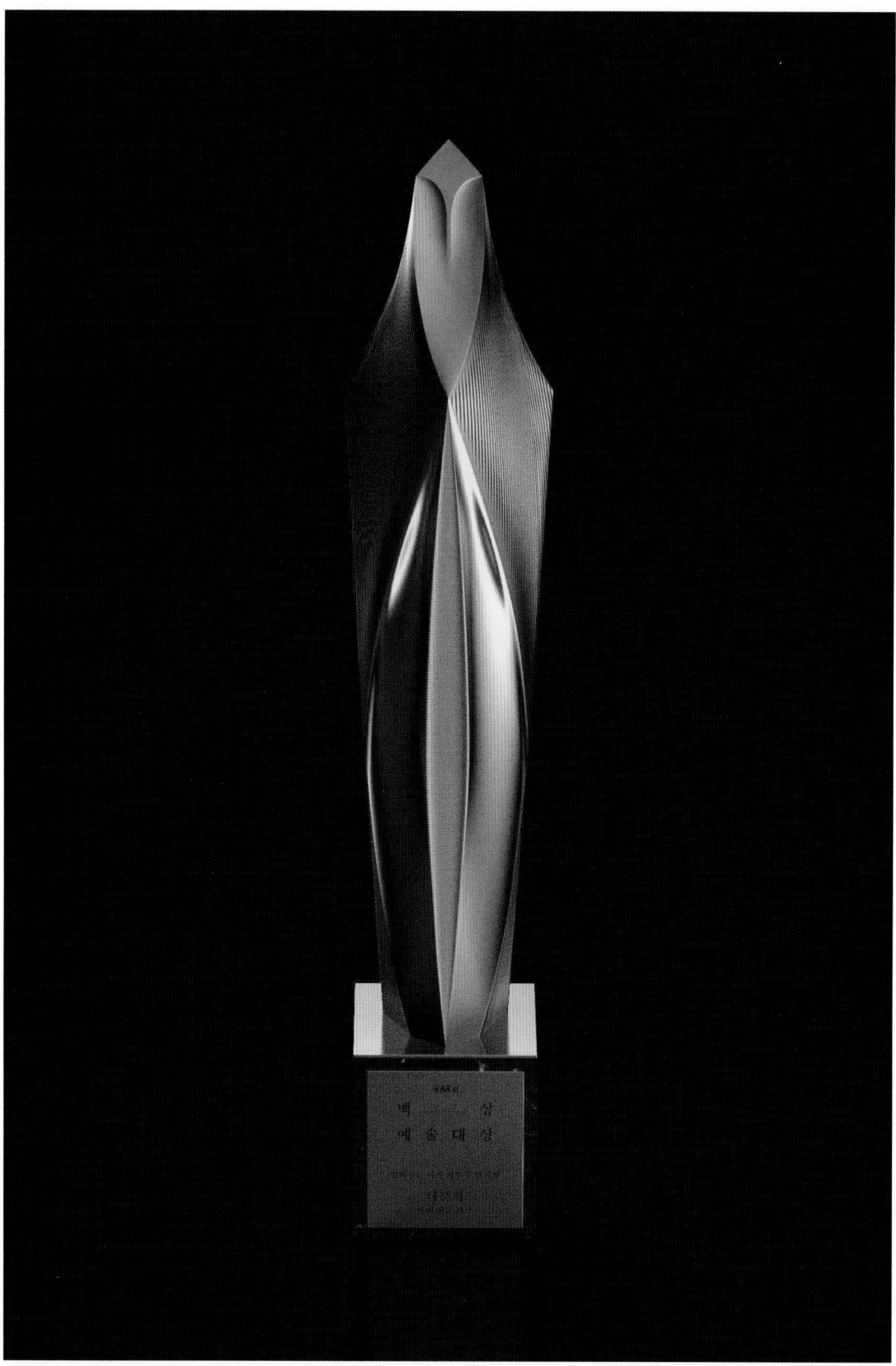

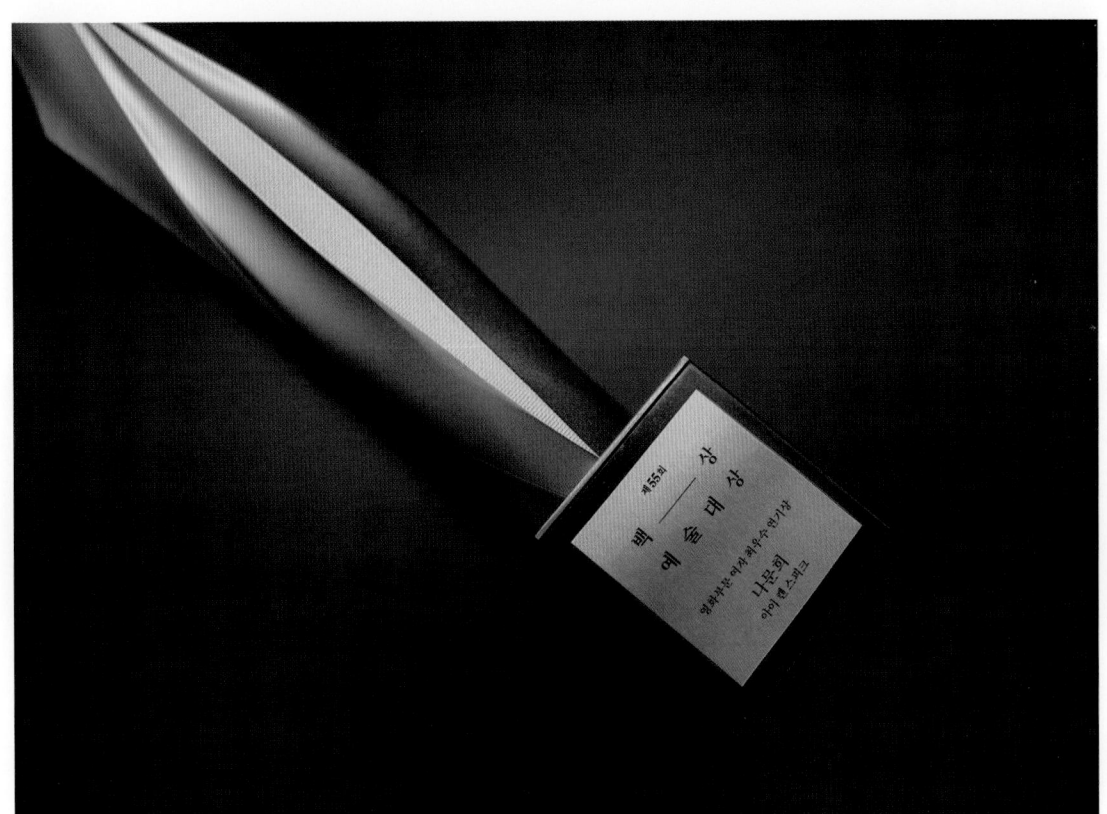

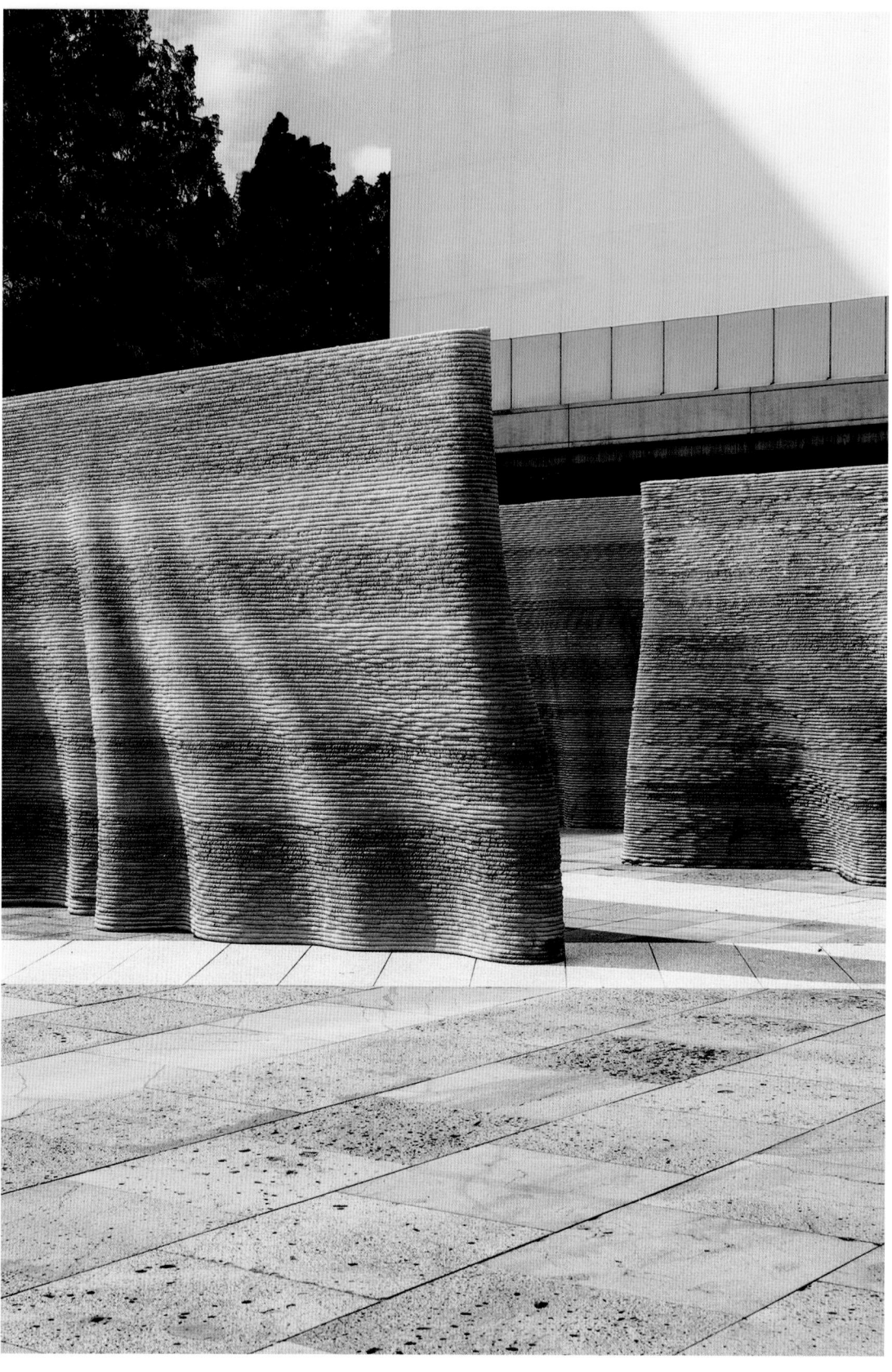

콘크리트 커튼
The Curtained Wall

바람 부는 날의 커튼에서 영감을 받아 한국 광주디자인센터를
위해 만든 설치 미술품이다. 콘크리트를 3D 프린터로 뽑아
제작했으며 콘크리트가 안정적으로 설 수 있도록 하단에
주름을 주었다. 마치 바람에 흔들리는 커튼이 서 있는 것처럼
의도해, 소재의 의외성과 콘크리트 프린팅의 가능성을
실험했다.

The Curtained Wall was inspired by the curtains on
a windy day and is an installation art created for
the Gwangju Design Center in Korea. It was made
by using concrete with a 3D printer, and wrinkling
was made at the bottom to give it stability. It was
intended to seem like a curtain swaying in the
wind, and experimentation was done with a unique
material and the possibility of concrete printing.

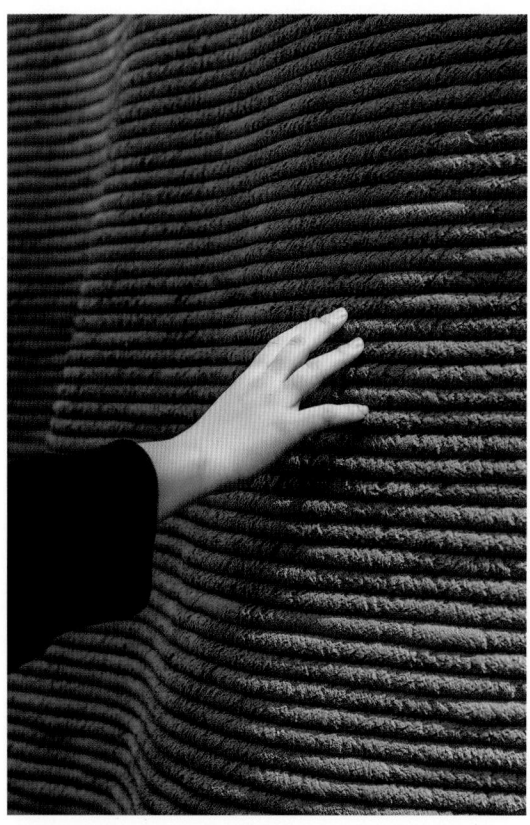

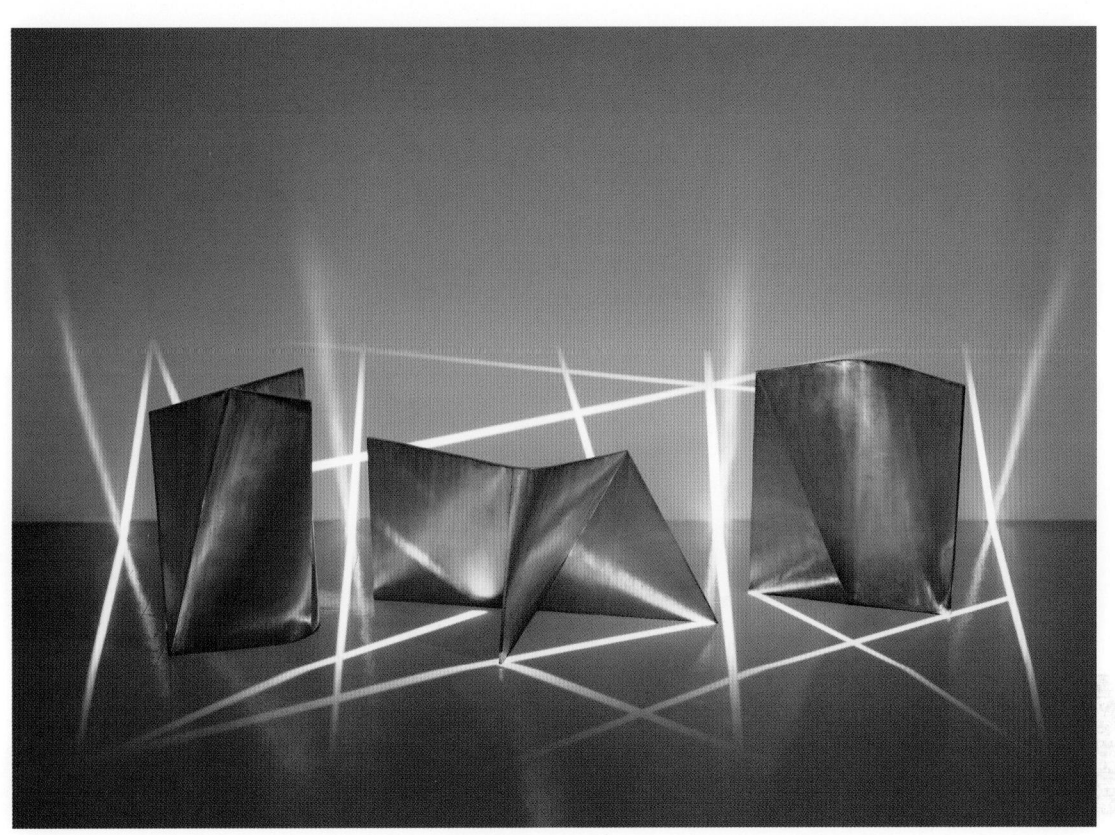

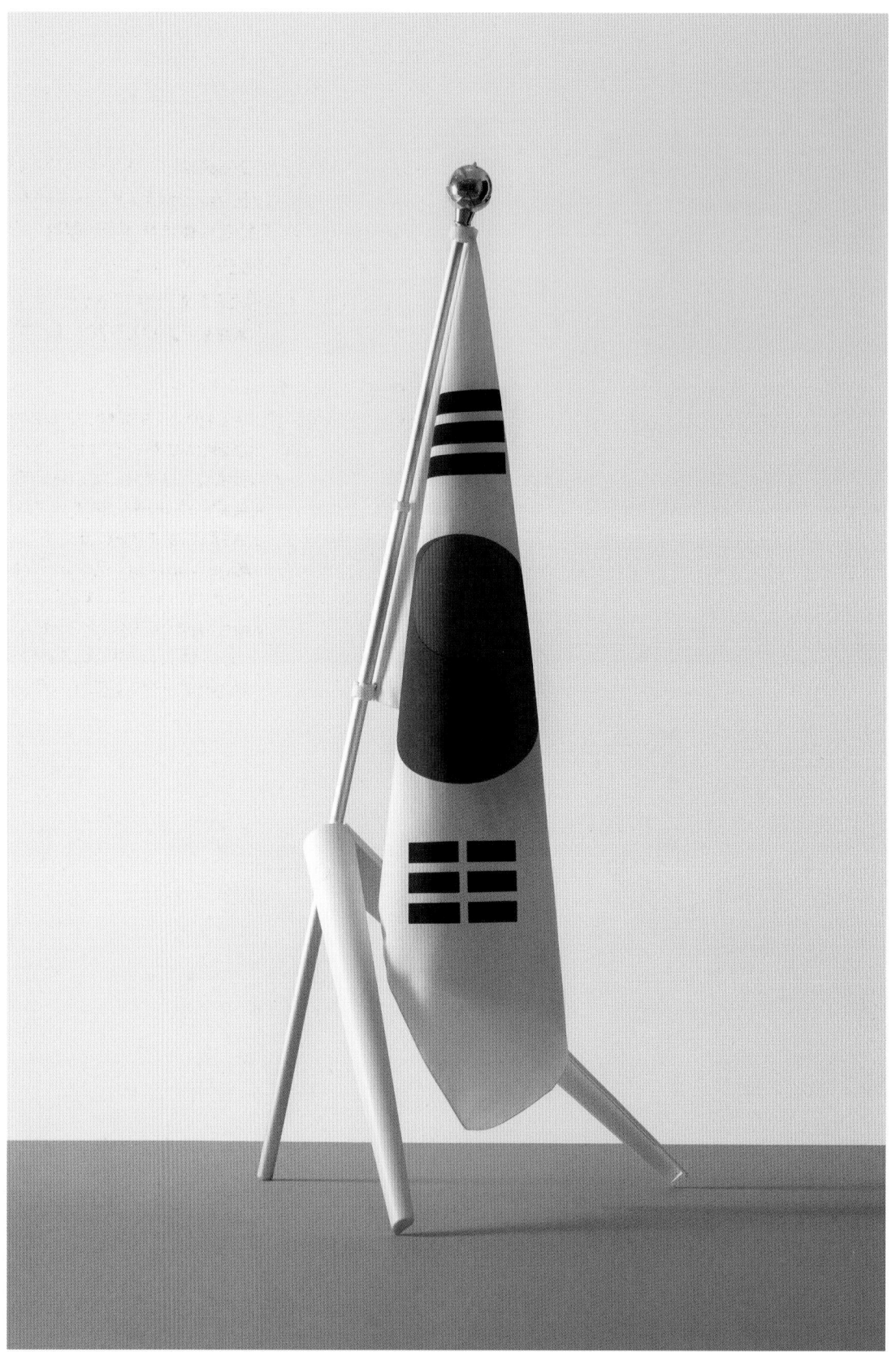

태극기함
Korean Flag Case

국기를 게양하는 이의 비율은 해마다 현저히 낮아진다.
이 문제를 해결하기 위해 MBC와 함께 태극기함
프로젝트를 진행했다. 게양대 역할을 겸하는 국기함으로,
함을 열고 깃대를 끼우면 국기를 안정적으로 세워놓을 수
있는 삼각대 구조가 형성된다. 상시성이 있어 사용하지 않을
때도 적절한 위치에 인테리어 소품으로 보관할 수 있다.

The number of those who hang the national flag
decreases significantly from year to year. To solve
this problem, the Taegeukgi Box project was
carried out with MBC. A flag box that has a tripod
structure can become a pole that can stably hold
a flag. Since it has permanence, it can be stored
as an interior accessory in an appropriate location
even when not in use.

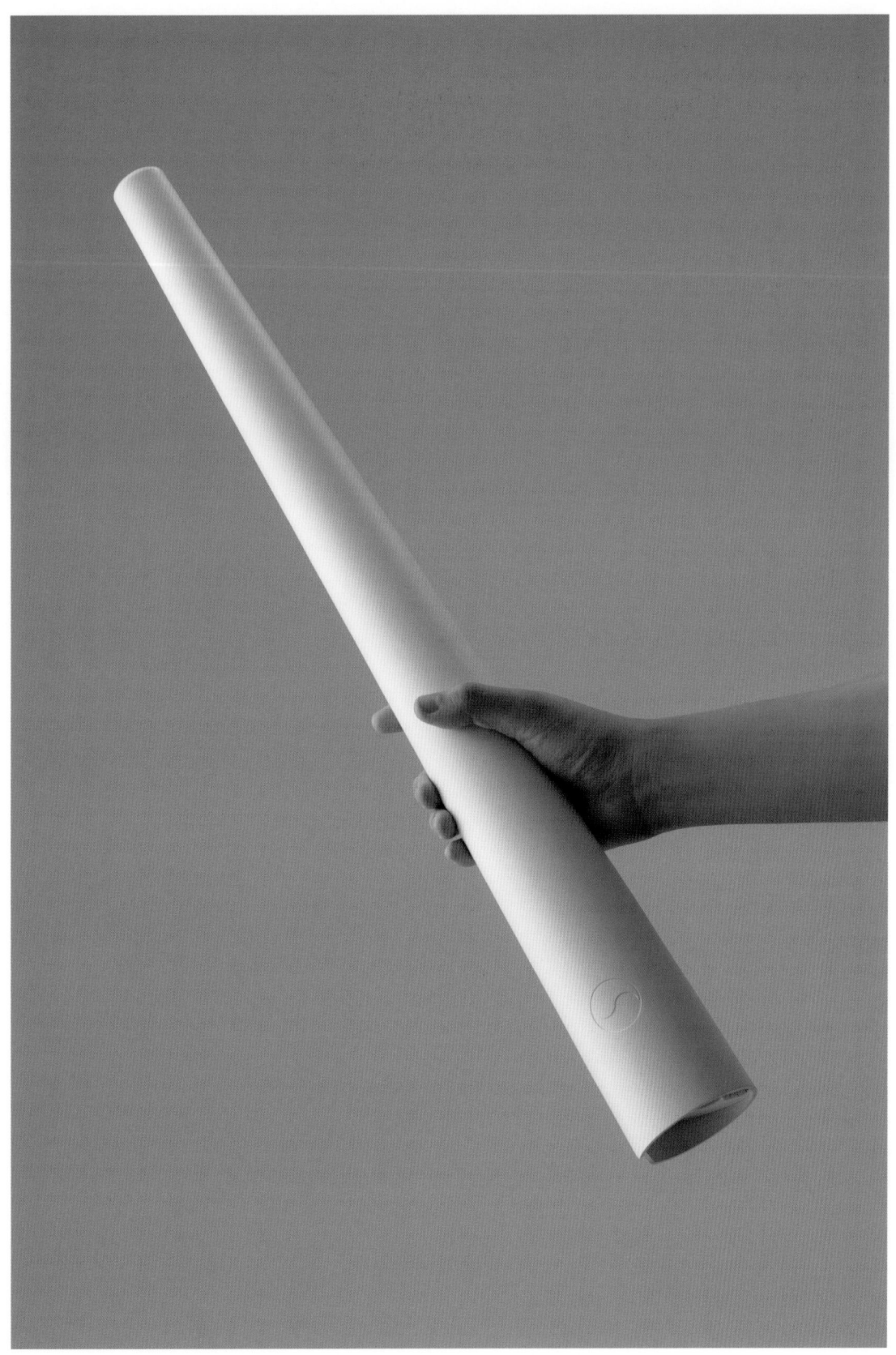

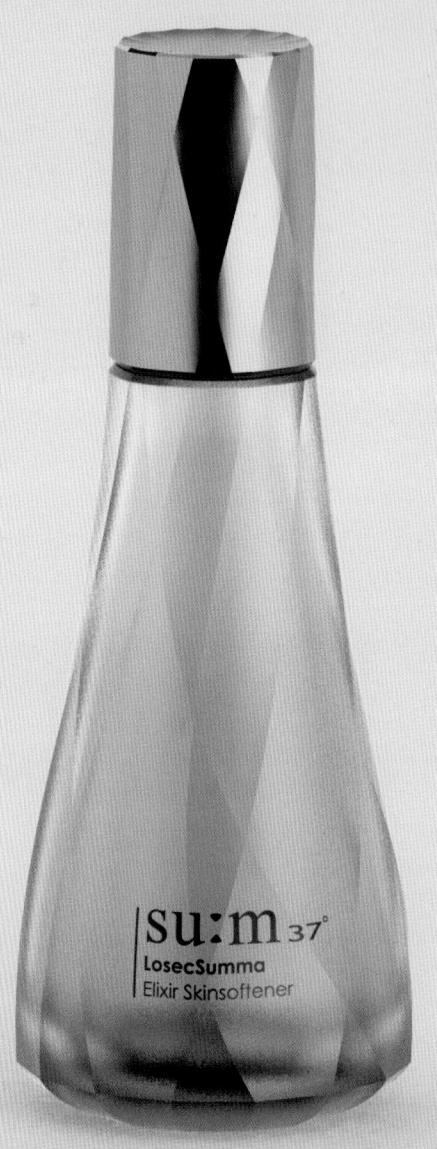

화장품 용기
Cosmetic Bottle

프리미엄 코스메틱 브랜드의 화장품 용기 디자인이다.
여러 곡선이 교차하며 만나는 동안 면이 생겨난다.
각 면의 디테일 변화를 은은하게 표현했다. 화장품 용기는
스타일링이 중요하기에, 기존 조형의 아이덴티티를
유지하면서도 발전시켰다.

This is a cosmetic container design for a premium cosmetic brand. On top of this, the details of the changes in the surface as several curved lines intersect and meet were subtly expressed. Styling is important for cosmetic containers, so we developed while maintaining the original model's identity.

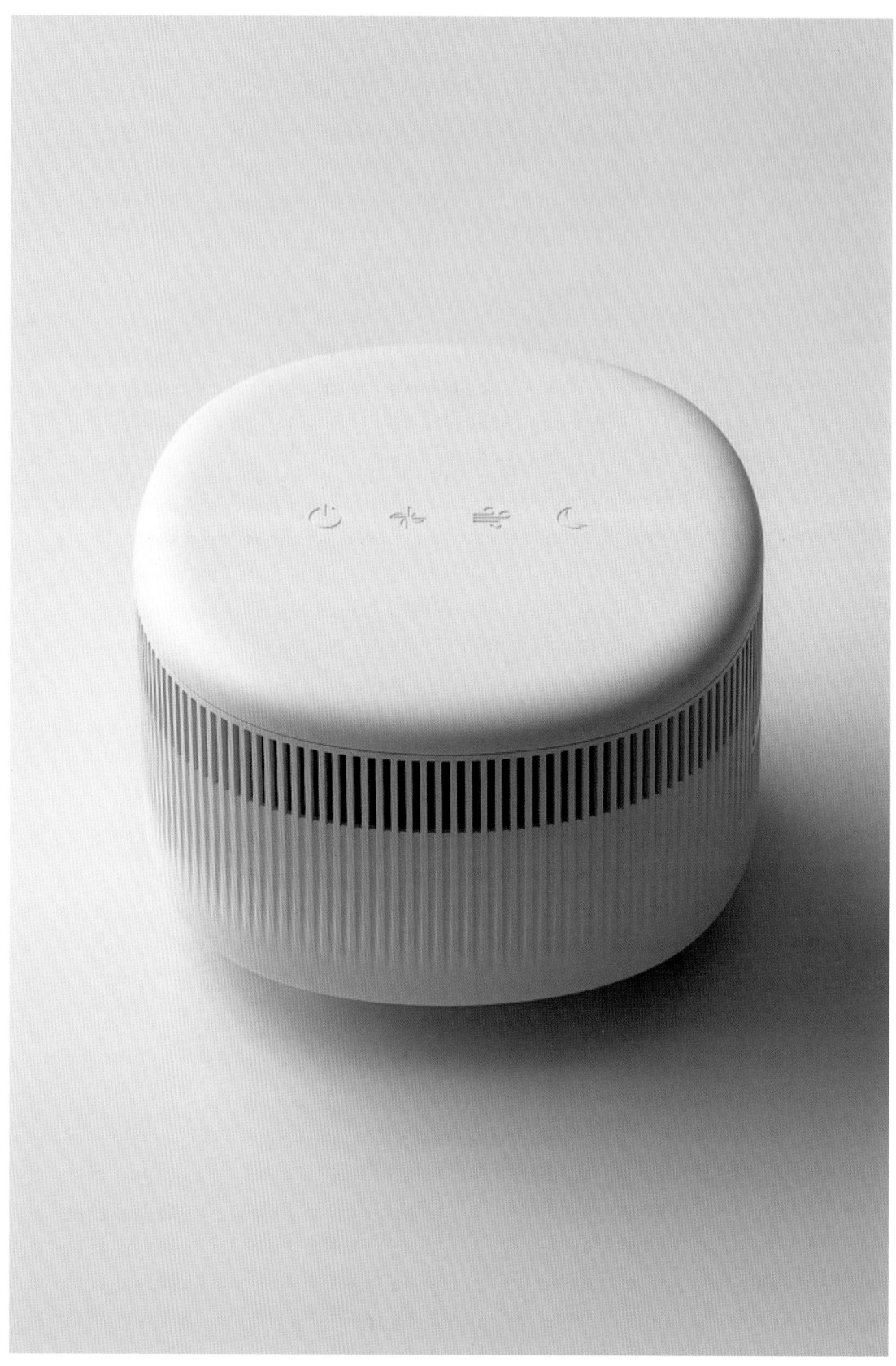

공기청정기
Air Purifier

심플하고 가벼운 외관으로 어느 실내환경에든 조화롭게
어울리는 공기청정기다. 거실이나 작은 방 같은 공간에
최적화한 크기로 디자인했다. 클라이언트와 협업해 한국형
라이프 스타일을 반영한 첫 번째 제품으로, 이후 암 체어,
트롤리, 트레이까지 함께 만들었다.

This is an air purifier with a simple and light
exterior that fits well into any indoor environment.
It is designed in a size that is optimized for
spaces such as living rooms and small rooms. In
collaboration with the client, it is the first product
that reflects the Korean lifestyle and soon after, an
arm chair, a trolley, and a tray were made together.

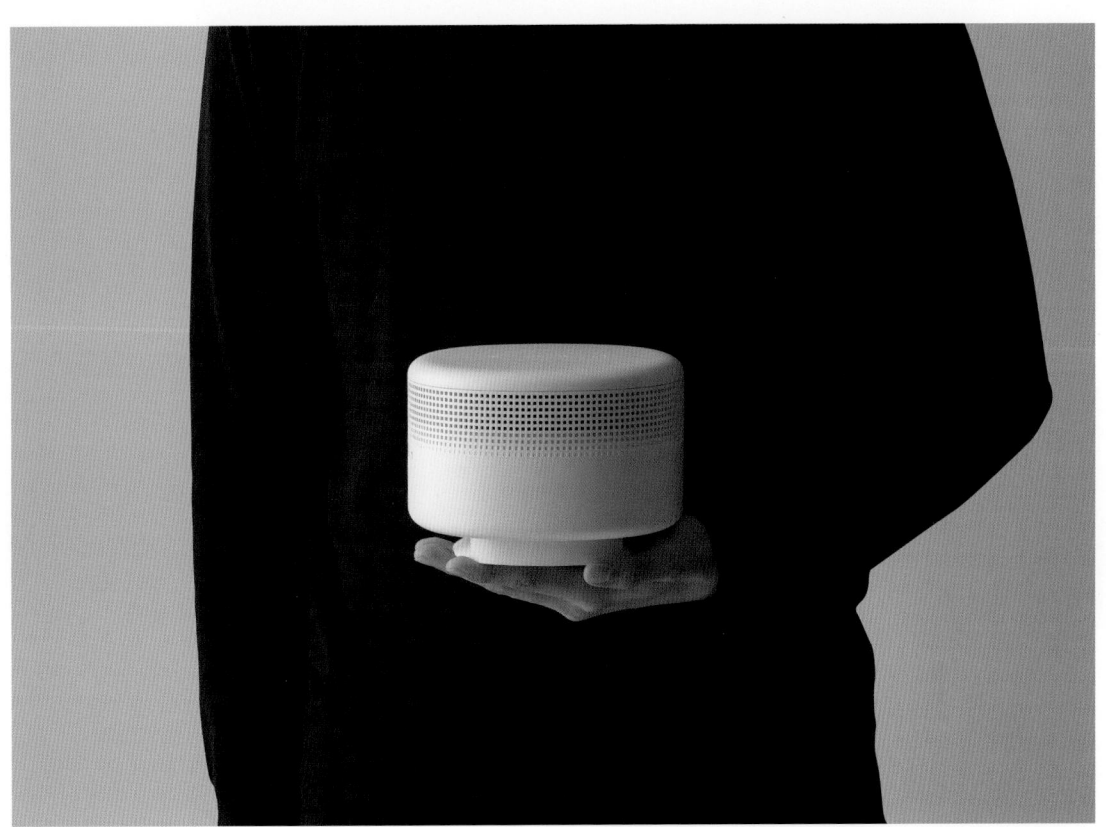

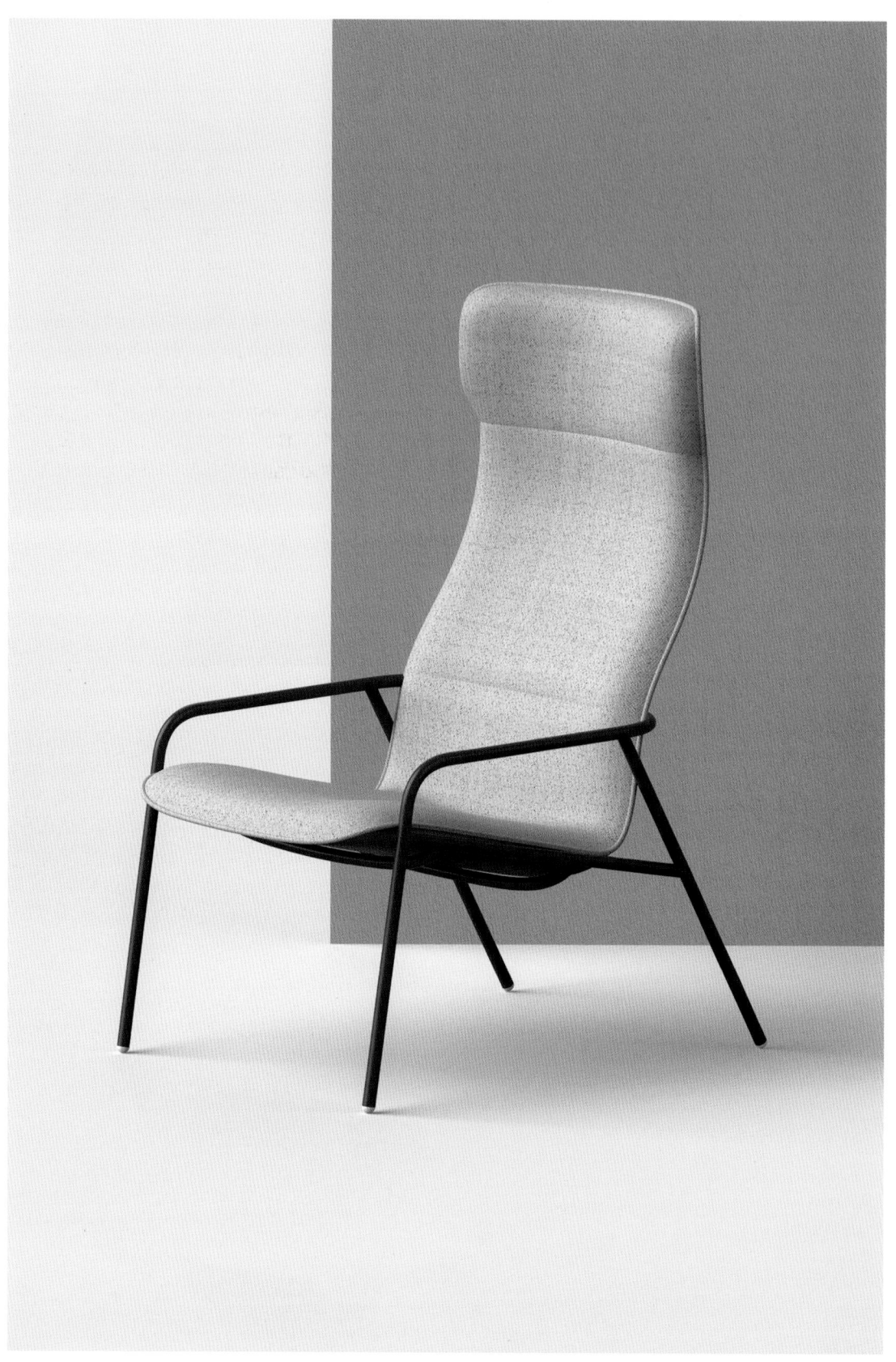

→
339

암 체어
Arm Chair

해외 기준에 맞춰진 암체어의 크기와 높이는 한국의 주거
특성상 공간에 잘 맞지 않았다. 국내 가정에서 사용하는
암체어를 유심히 관찰하고, 적은 공간을 차지하면서도
편안한 일상을 즐길 수 있도록 소재와 구조를 단순화했다.

The oversea standards of size and height of the
armchair did not fit the space of Korean housing
and its characteristics. We carefully observed the
armchairs used in domestic homes, and simplified
the material and structure so that people could
enjoy a comfortable daily life while occupying a
small space.

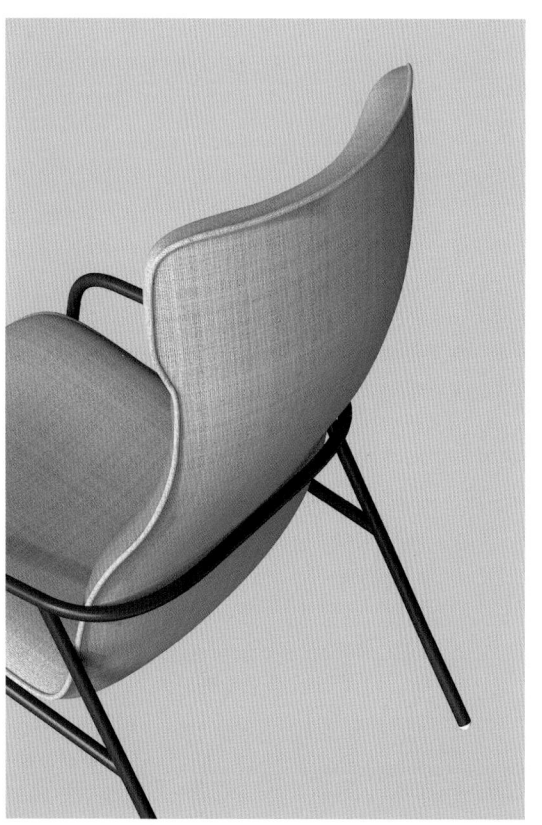
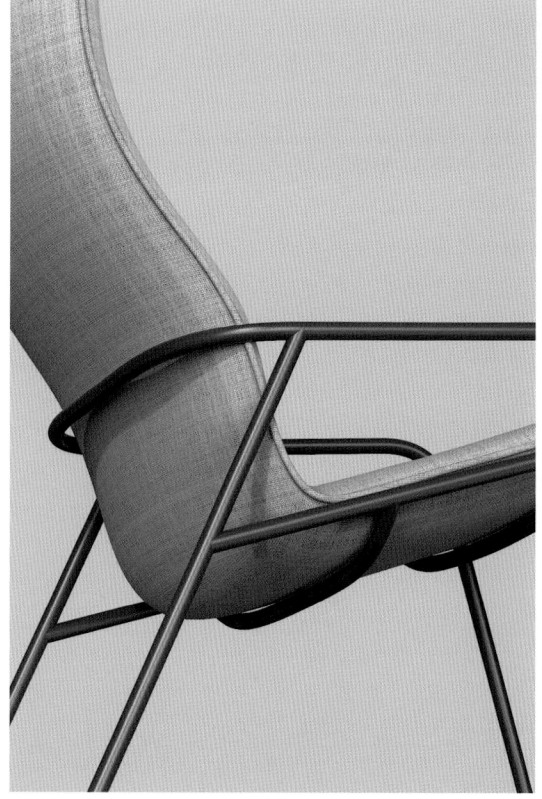

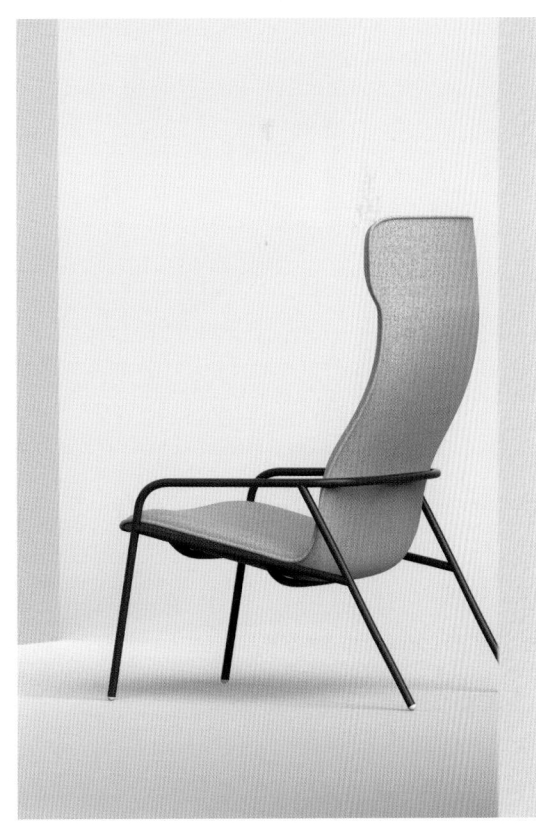

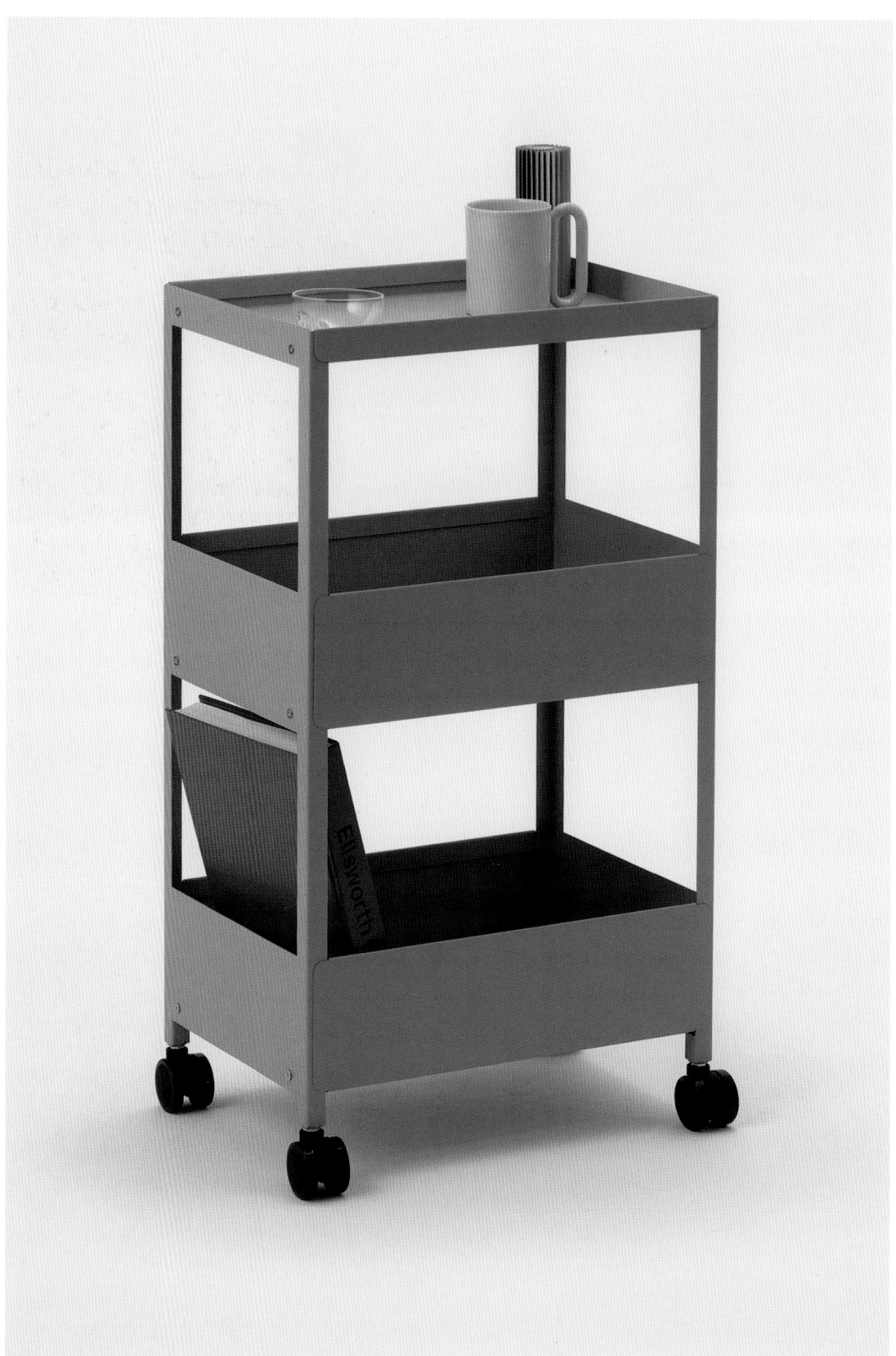

트롤리
Trolley

주방, 거실, 오피스 등 트롤리를 활용하는 일상 공간에서
사용자의 행동 양상을 분류했다. 그 결과 가장 위에
사용 빈도가 높고 작은 물건을, 가장 아래는 사용 빈도가
낮고 무겁거나 큰 물건을 수납하는 것으로 나타났다.
여기서 착안해 각 장소에서 주로 사용하는 물건의 평균값을
기반으로 전체 크기와 높이를 설계했다.

The behavior patterns of users were classified in
everyday spaces where trolleys are used, such as
kitchens, living rooms, and offices. As a result, it
was found that the top was used to store small
items with high frequency of use, and the bottom
was used to store heavy or large items with low
frequency of use. With this in mind, the overall size
and height were designed based on the average
value of the items mainly used in each space.

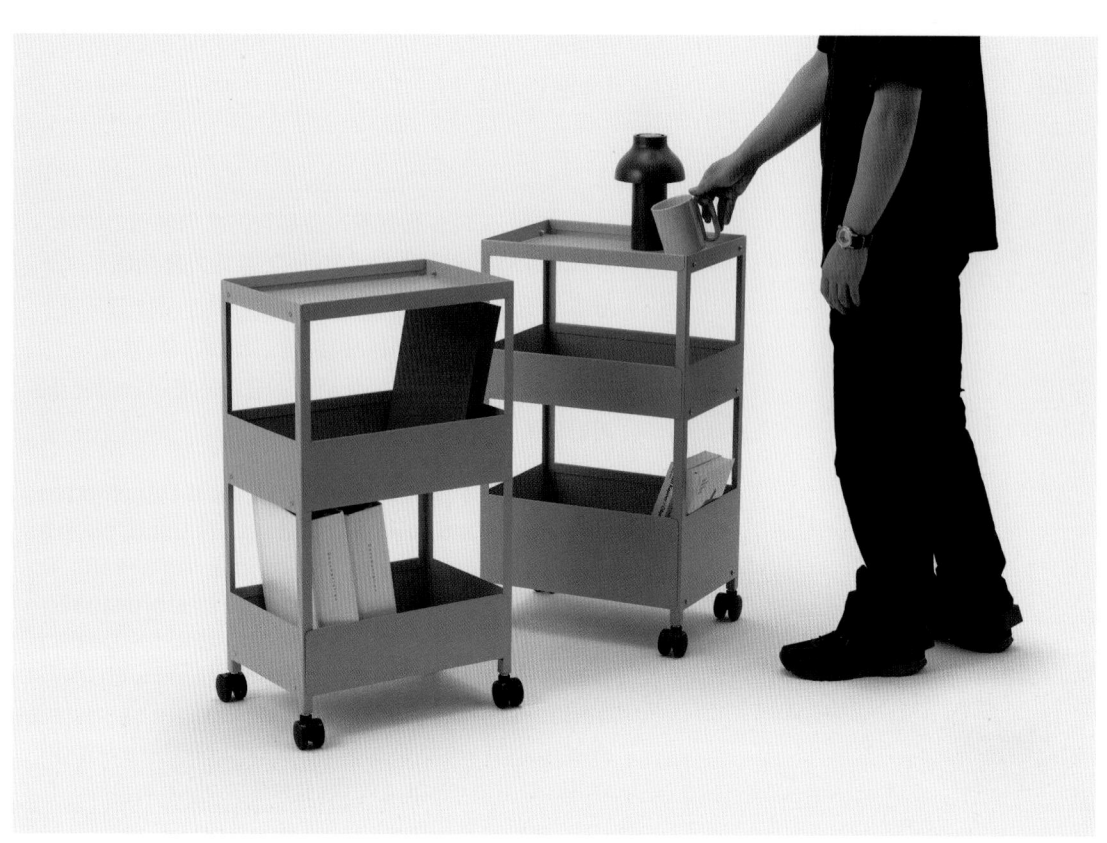

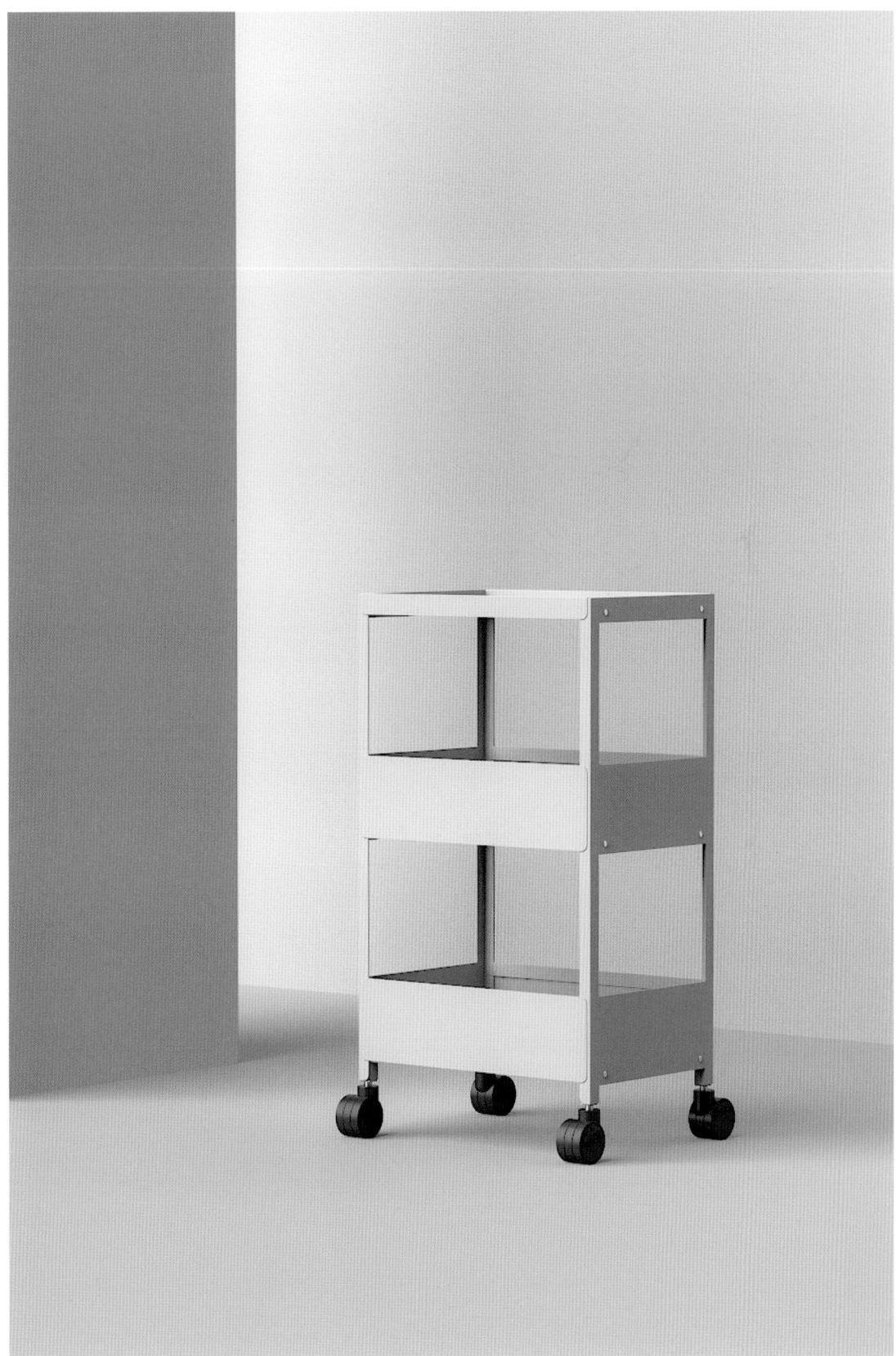

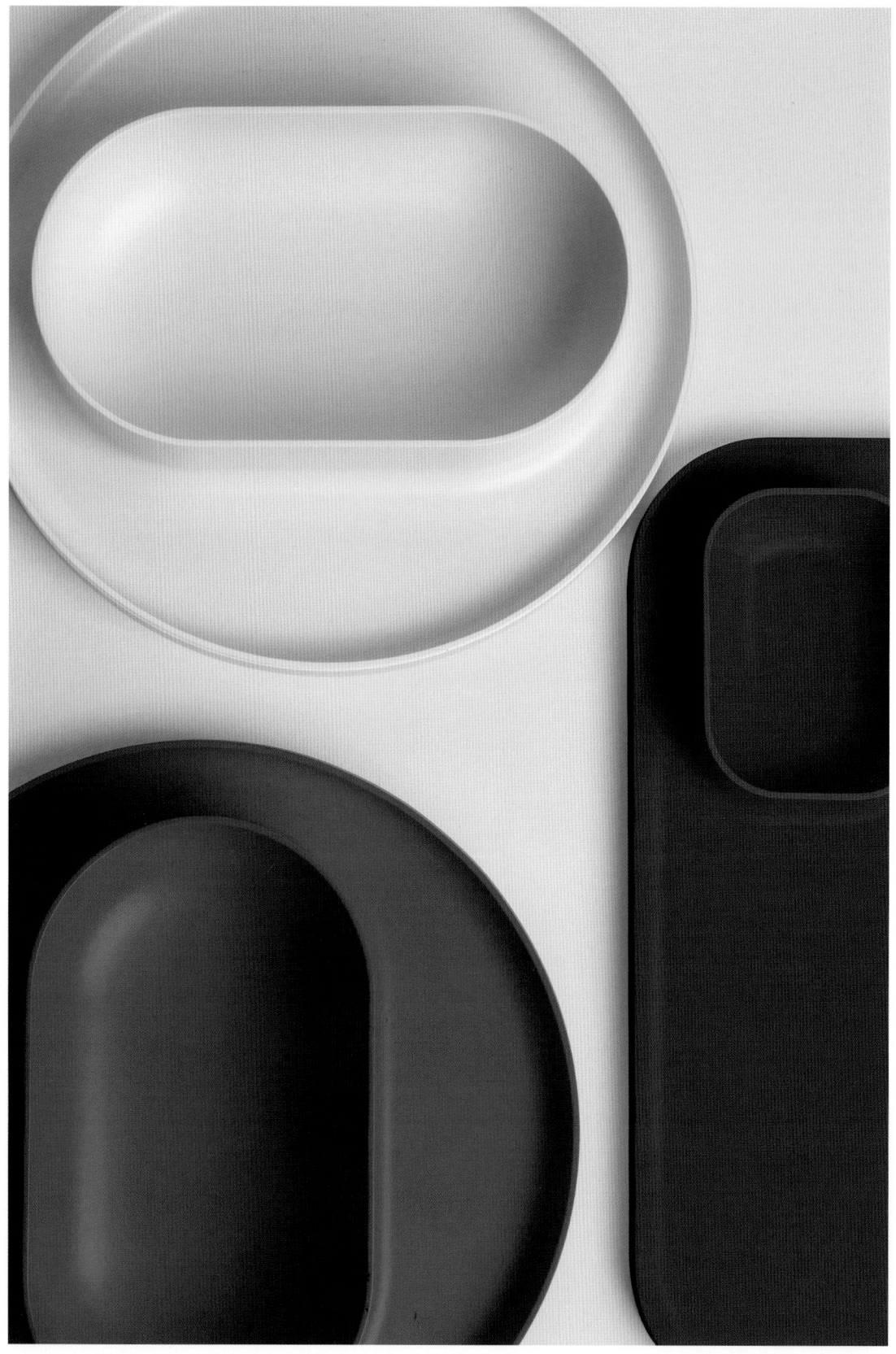

트레이
Tray

원형과 사각형을 조합해 수납 안의 수납이 가능한 트레이다. 형태마다 물건을 종류별로 분류해서 넣을 수 있다. 뒷면의 굽도 앞면 같은 수납 안의 수납 형태로 만들어서 앞뒤 모두 사용 가능하다.

This tray comprises round and square shapes and you can store items in two places. You can classify objects by type and put them in each shape. The heel on the back is also made in the same storage shape as in the front, so both can be used for storage.

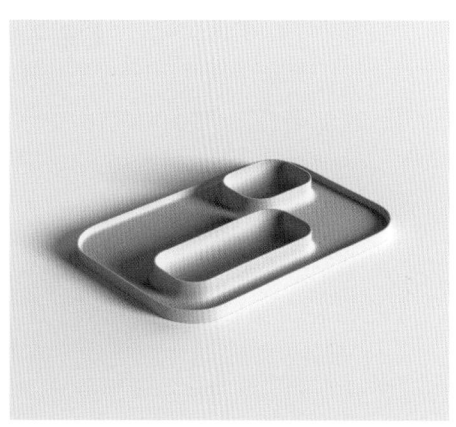

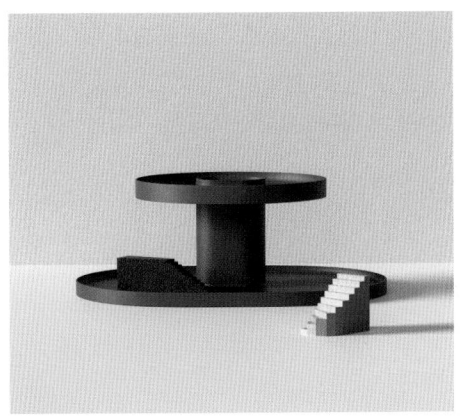

치약 패키지
Toothpaste Package

더하는 것이 아닌 빼는 것에 관한 메시지를 디자인하고
싶었다. 불필요한 성분을 제거한 순수 기능성 치약이라는
점을 강조하는 스토리로 접근했다. 제품에 치약의 통상적인
구성 성분을 모두 나열한 뒤 그중 일부를 마커로 삭제한 듯한
효과를 주고, 필요한 성분은 자신 있게 드러냈다.

We wanted to design a message about
subtraction rather than addition. We approached
the task with a story that emphasizes the
pure functional toothpaste that has removed
unnecessary ingredients. After listing all the
common components of toothpaste in the product,
we gave the effect of erasing certain ingredients
with a marker, and emphasized with confidence
the necessary ingredients.

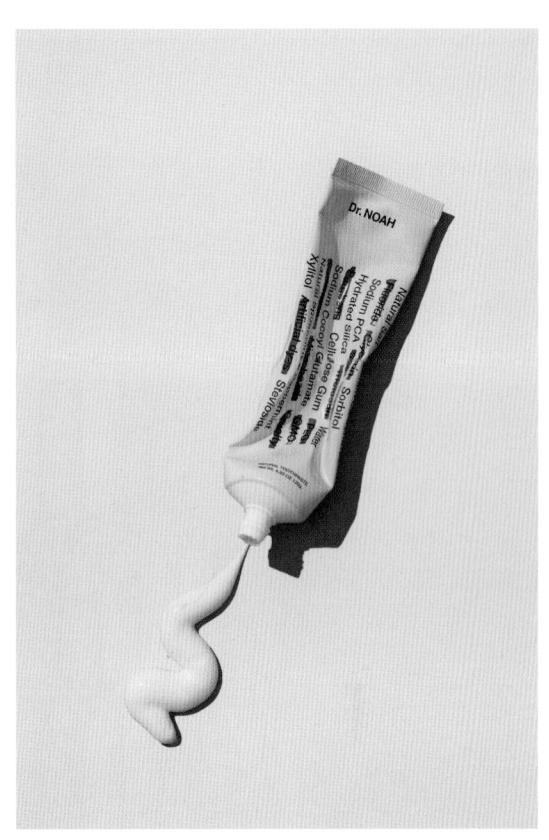

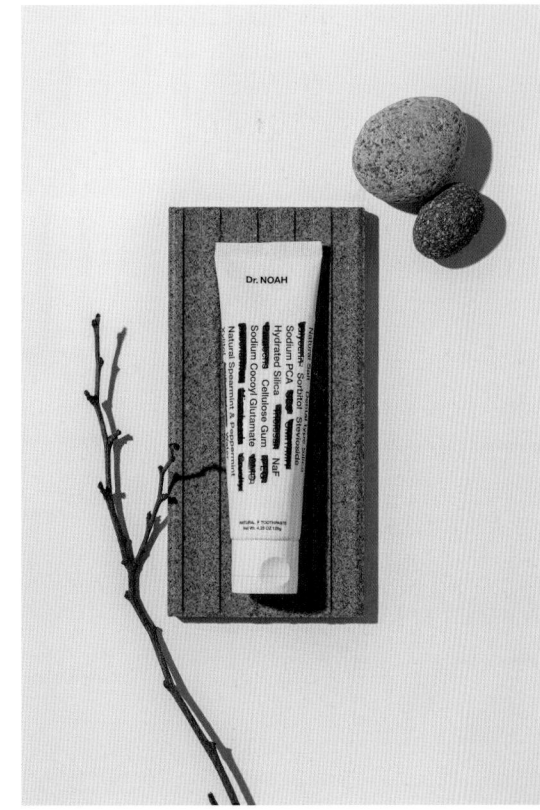

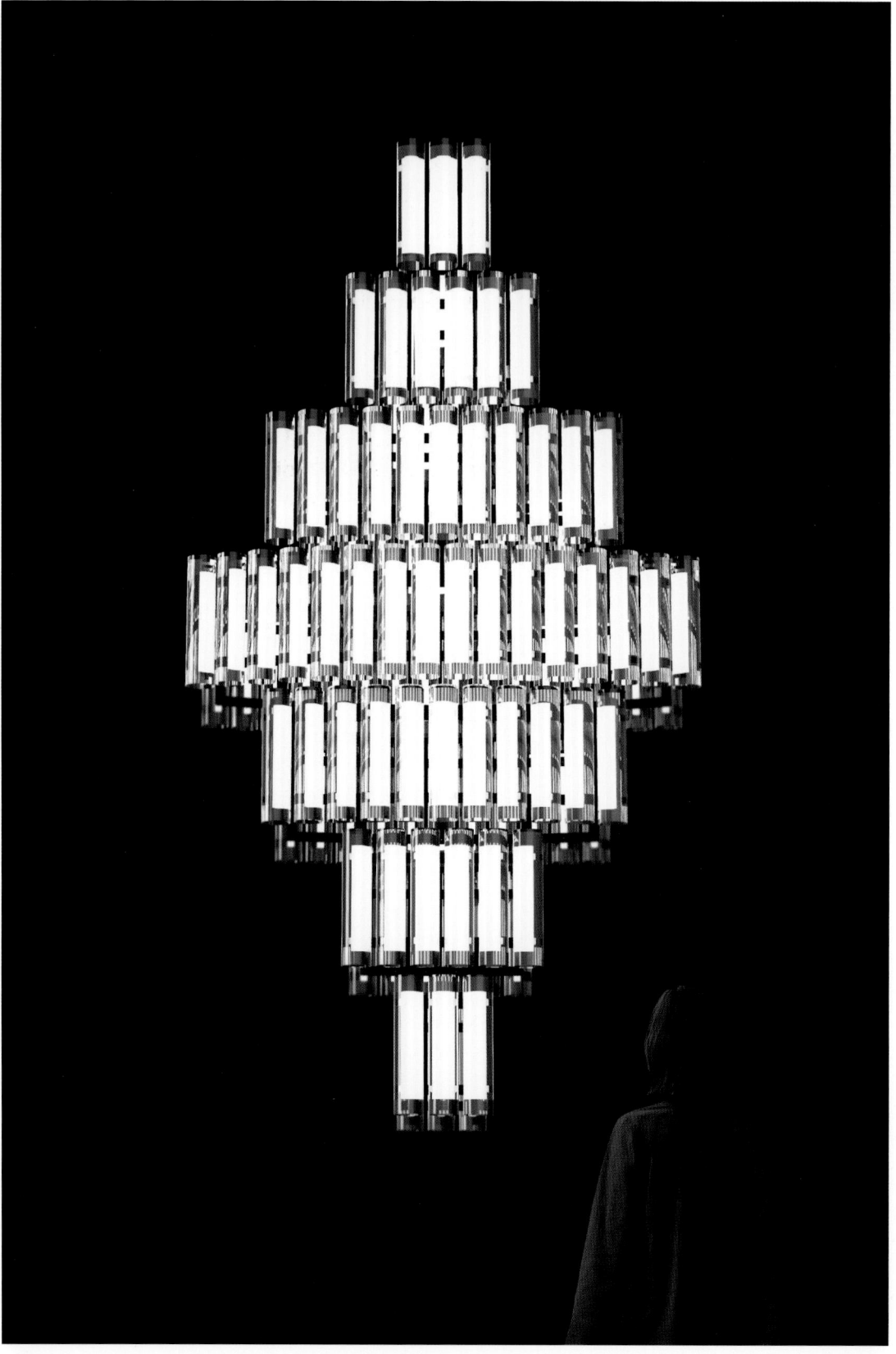

클러스터 오브 라이트
Cluster of Light

렌티큘러 필름[7]과 T5 램프[8]를 이용해 클래식한 샹들리에를 현대적으로 재해석한 조명등이다. T5 램프의 빛이 렌티큘러 필름을 통과하면 보는 각도에 따라 빛의 형태와 색상이 달라진다. 두 재료의 특징을 구조적으로 설계해, 단순한 조합으로 화려하고 극적인 조명 효과를 연출했다.

This is a modern reinterpretation of a classic chandelier using lenticular film[7] and a T5 lamp[8]. When the light from the T5 lamp passes through the lenticular film, the shape and color of the light changes depending on the angle of view. By structurally designing the characteristics of the two materials, we created a spectacular and dramatic lighting effect with this simple combination.

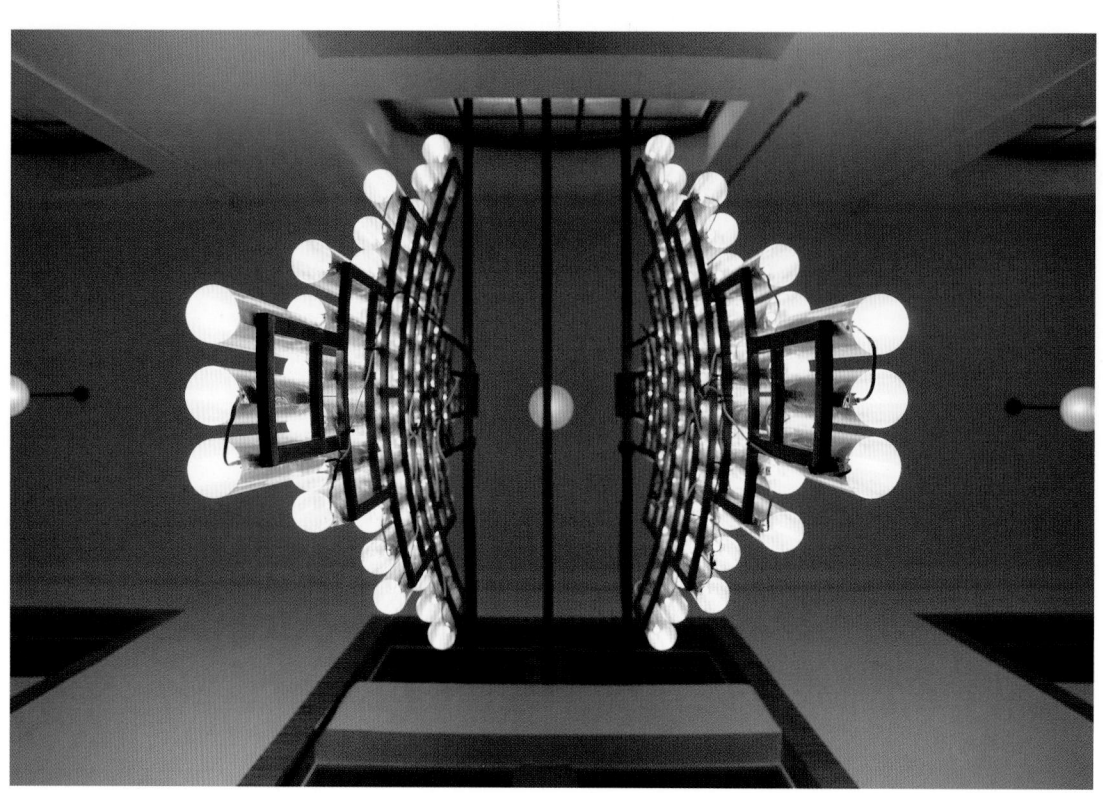

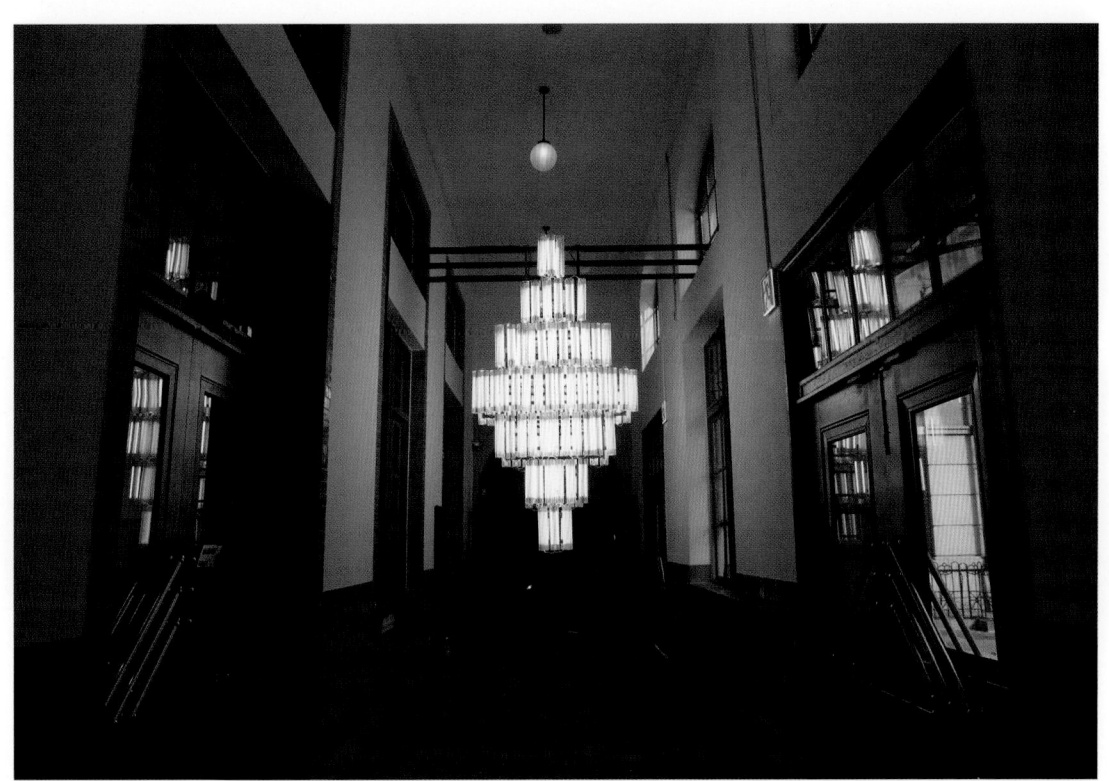

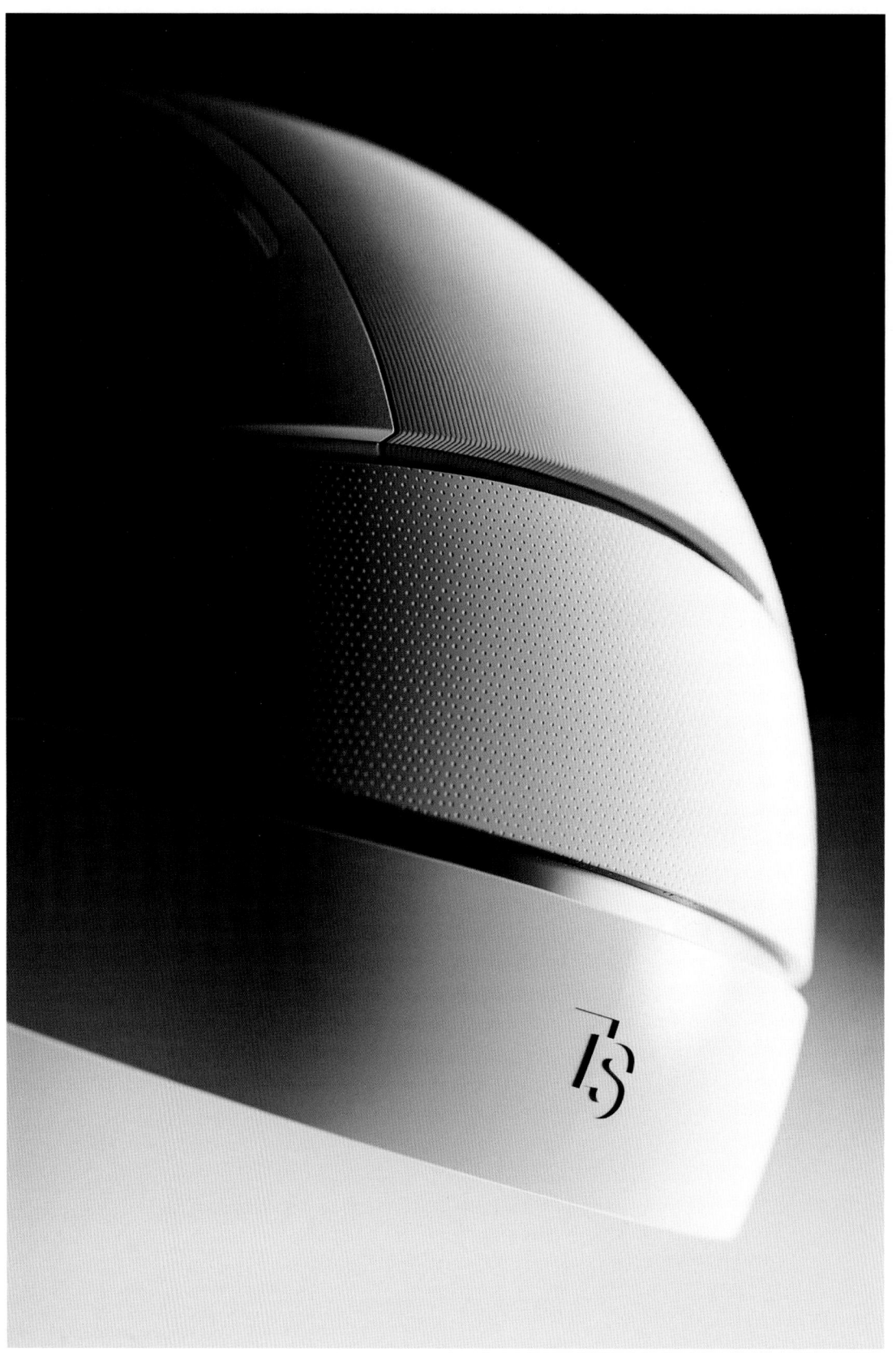

 344

LED 헤어 디바이스
LED Hair Device

LED를 이용한 두피 건강 헬스케어 제품이다. 머리에 쓰는
형태인 만큼 헬멧과 디바이스를 아우르는 중간 지점의
조형을 유도했다. 나중에 기능성 액세서리를 부착하는 등
제품이 확장될 것을 고려해, 처음부터 넷으로 나누어진
파트가 탈착 가능하도록 디자인했다.

This is a scalp health care product that uses LED.
As it is a shape for the head, the midpoint that
encompasses the helmet and the device had to be
considered. Considering that the product would
be expanded by attaching functional accessories
later, we designed with four parts that were
removable from the beginning.

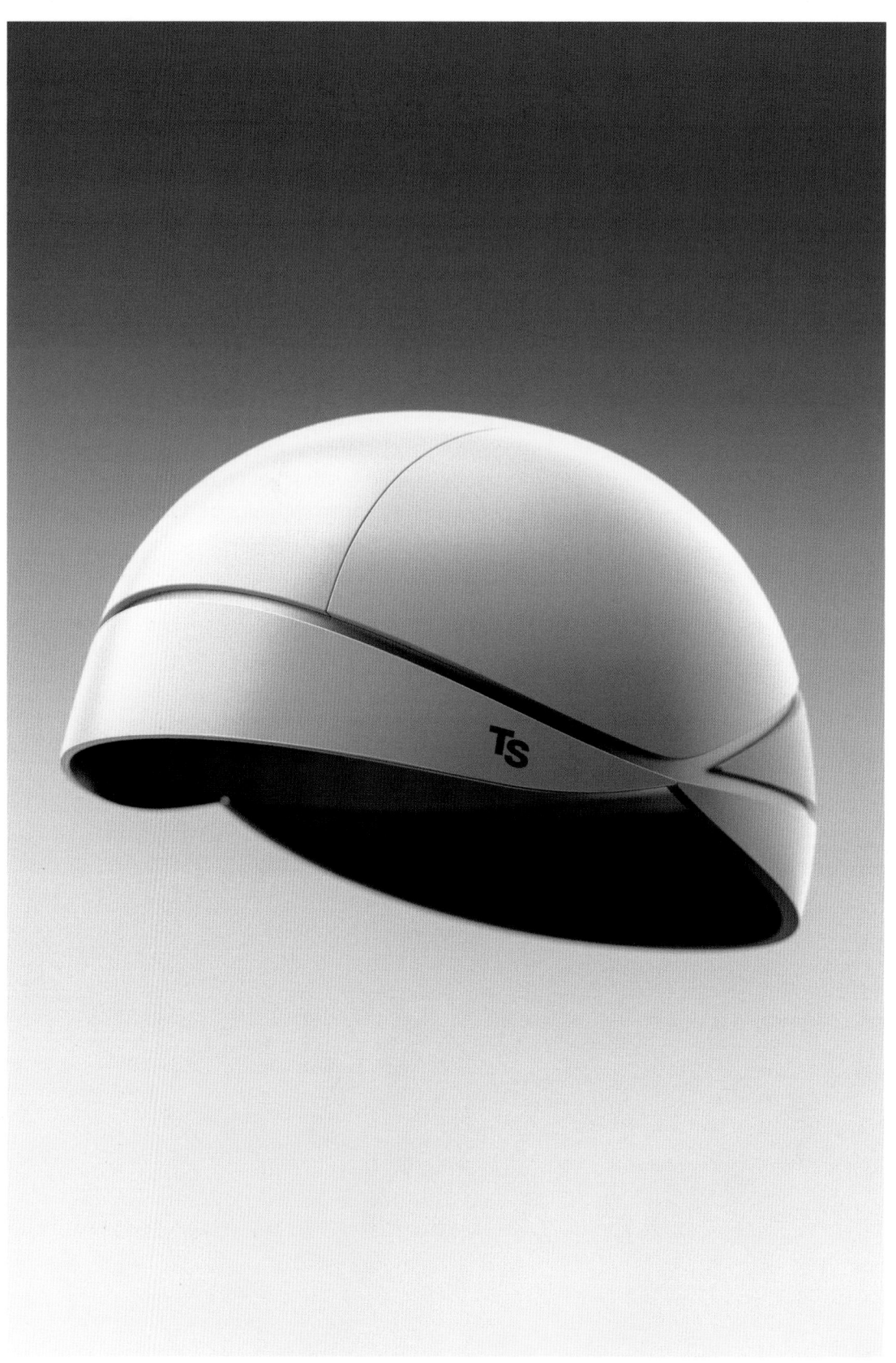

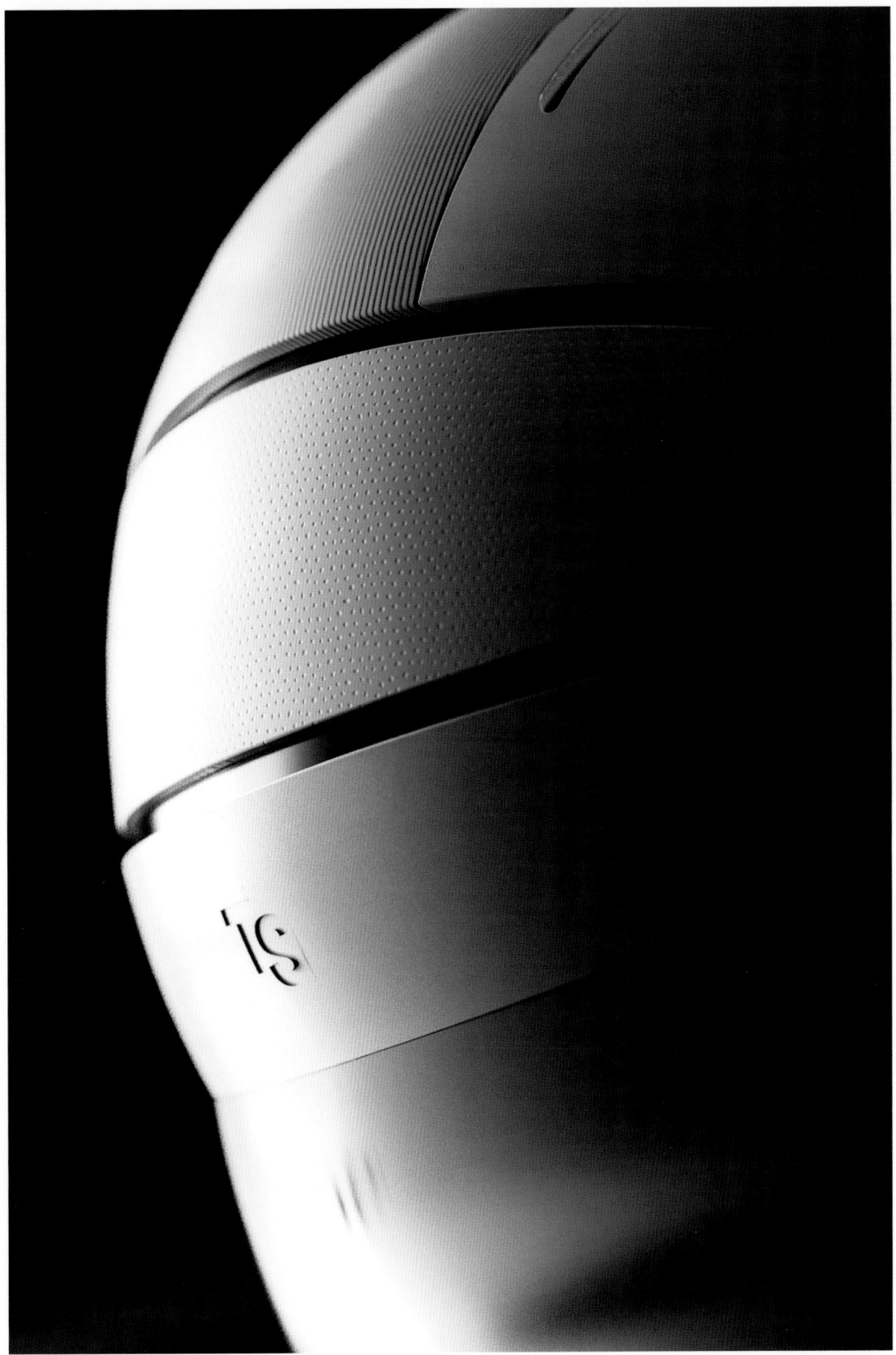

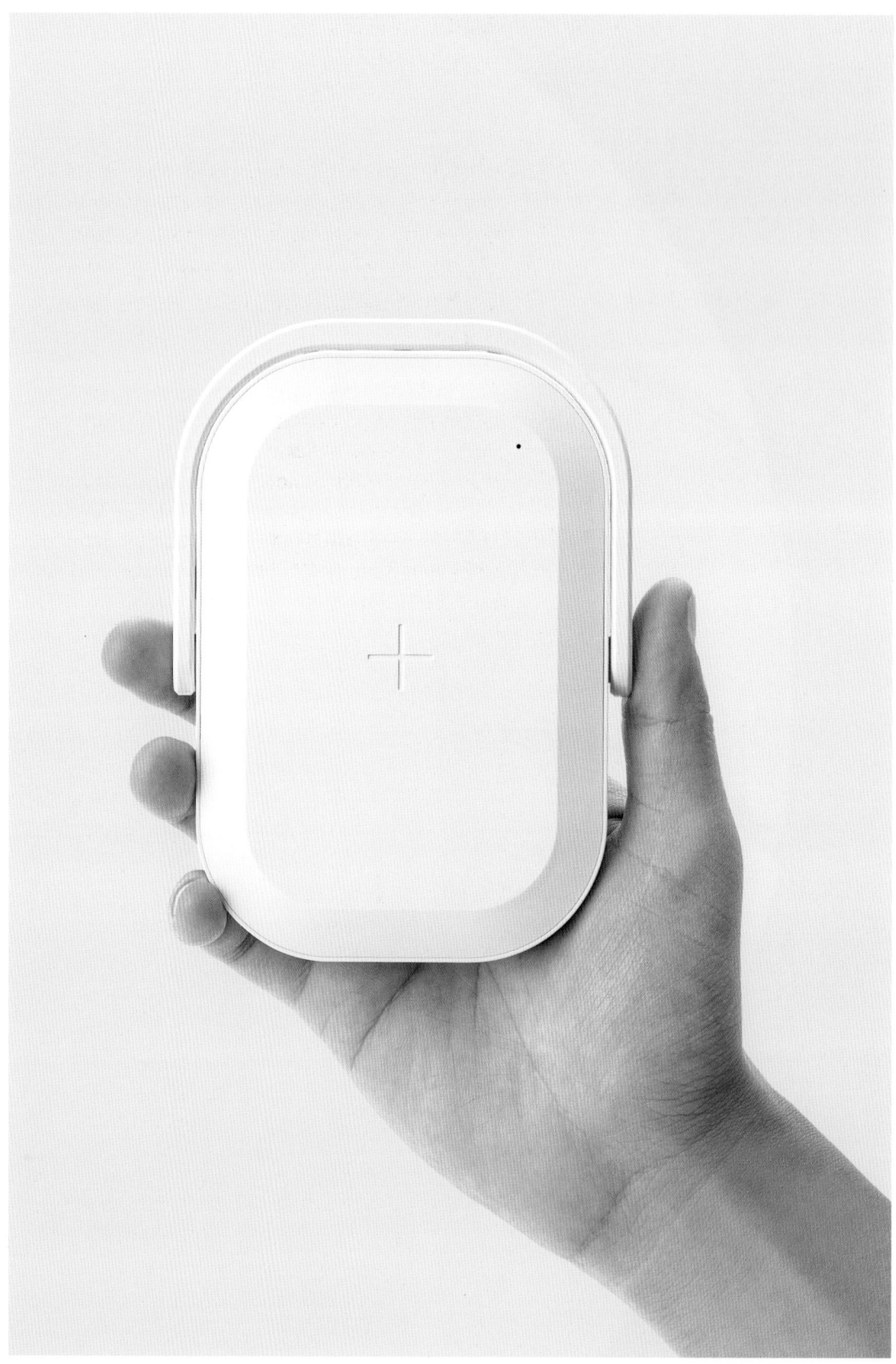

 345

스마트폰 UV 충전기
Smartphone UV Charger

스마트폰을 충전하는 동시에 UV LED 살균도 할 수 있는
기능성 무선 충전기다. 한눈에 보기만 해도 두 기능을 이해할
수 있는 형태, 사용하기 쉽고 단순한 형태를 고민했다.
UV LED 라이트가 나오는 부분을 접을 수 있어, 무선
충전기의 일차적 기능에 충실하면서도 살균이 가능하도록
완성했다.

This is a functional wireless charger that can
charge a smartphone and sterilize UV LEDs
simultaneously. We considered a form that
was easy for both functions to be understood
at a glance and simple to use. The UV LED
light part can be folded, so it is faithful to the
primary function of the wireless charger and also
sterilization enabled.

kt Shop
shop.kt.com

모델명	PUC-100M(민트) PUC-100W(화이트)
제품명칭	첨단24 UV Charger
정격입력	DC 3.7V, 10,000mAh
제품전원	USB C-type:5V, 2A
제조년월	2020.10
제조국	대한민국
제조원	(주)파이에코라따
	인천광역시 서구 가재울로 109 dh히즈타워 1차 306~313호
	EU101393-20682
	R-R-T30-MS-700

온수 매트 보일러
Hot Water Mat Boiler

온수 매트를 위한 실내용 보일러를 디자인했다.
기존 보일러는 온수 코드가 뒤쪽에 있어 앞뒤로 긴 형태인
반면, 이 제품은 좌우가 긴 제품으로 공간 활용에 유리하다.
편리하면서도 주변 환경에 잘 어울리도록 비대칭 구조를
강조했다.

This is a design for an indoor boiler for hot
water mats. Existing boilers have a long front
and back with the hot water cord at the back
but this product is long left and right, which
is advantageous for space utilization. The
asymmetrical structure is emphasized to be
convenient and to blend well with the surrounding
environment.

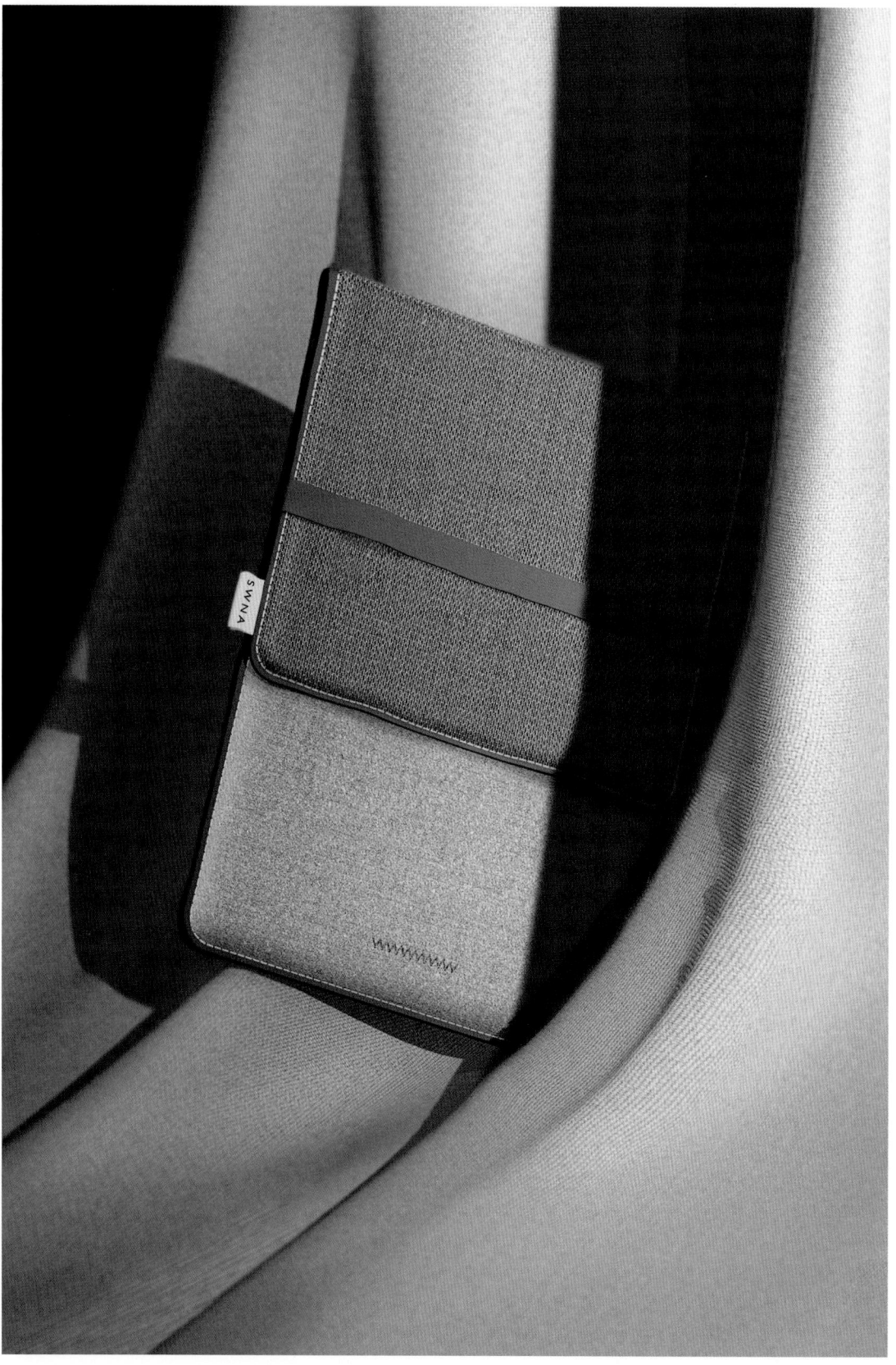

노트북 파우치
Notebook Pouch

노트북 파우치가 자연스럽게 작업 환경으로 변신하면
어떨까 하는 생각에서 출발한 파우치 겸 데스크 팩이다.
노트북을 꺼내고 파우치를 열면 커버 안쪽을 마우스 패드로
사용 가능하다. 커버 바깥쪽에는 어댑터나 마우스 등의
액세서리를 수납하는 보조 파우치를 부착할 수 있다.

This is a pouch-desk pack that started from the
idea of a notebook pouch that could become a
natural work environment. When you take out the
notebook and open the pouch, you can use the
inside of the cover as a mouse pad. On the outside
of the cover, you can attach an auxiliary pouch for
storing accessories such as adapters and mice.

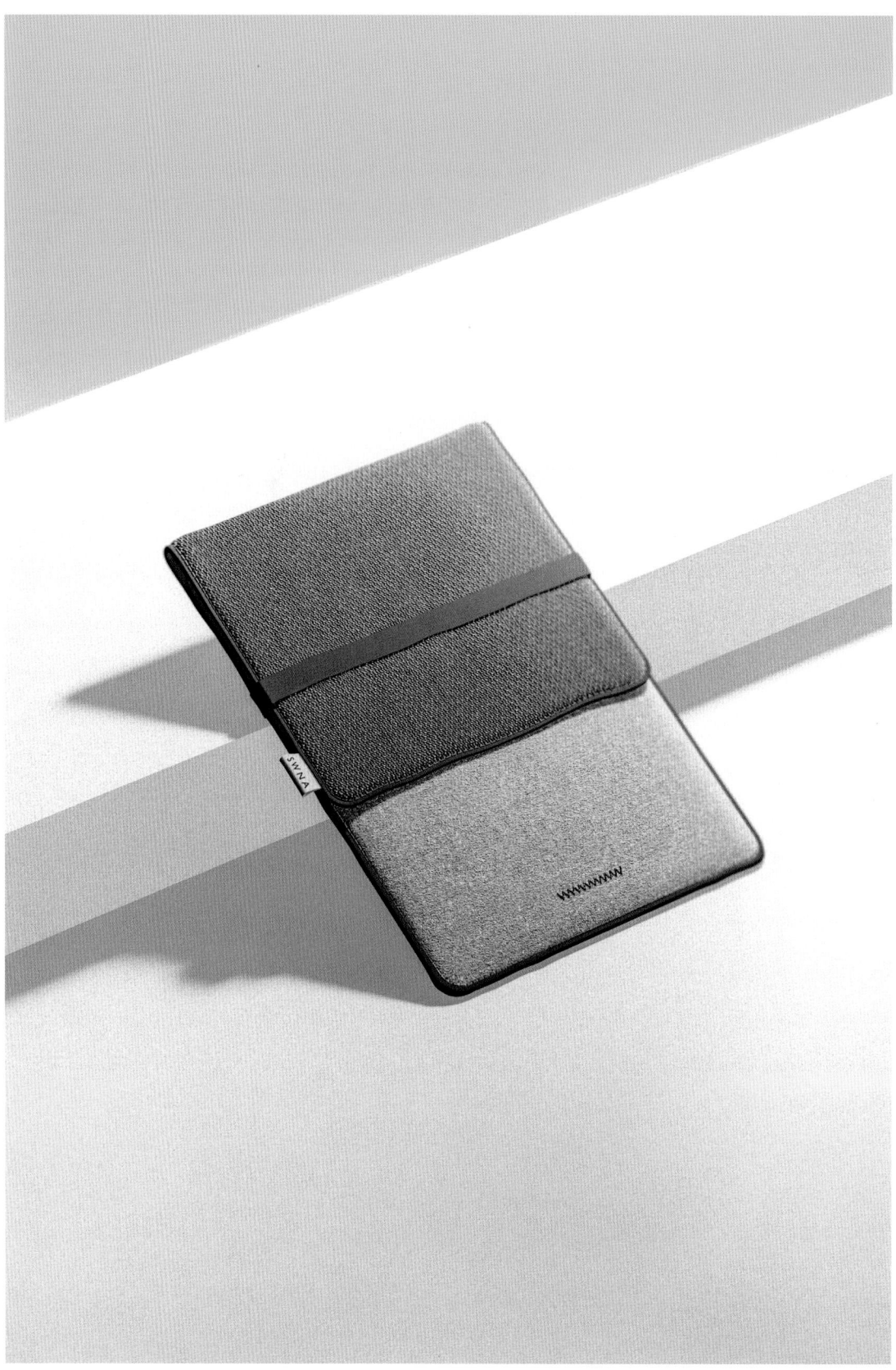

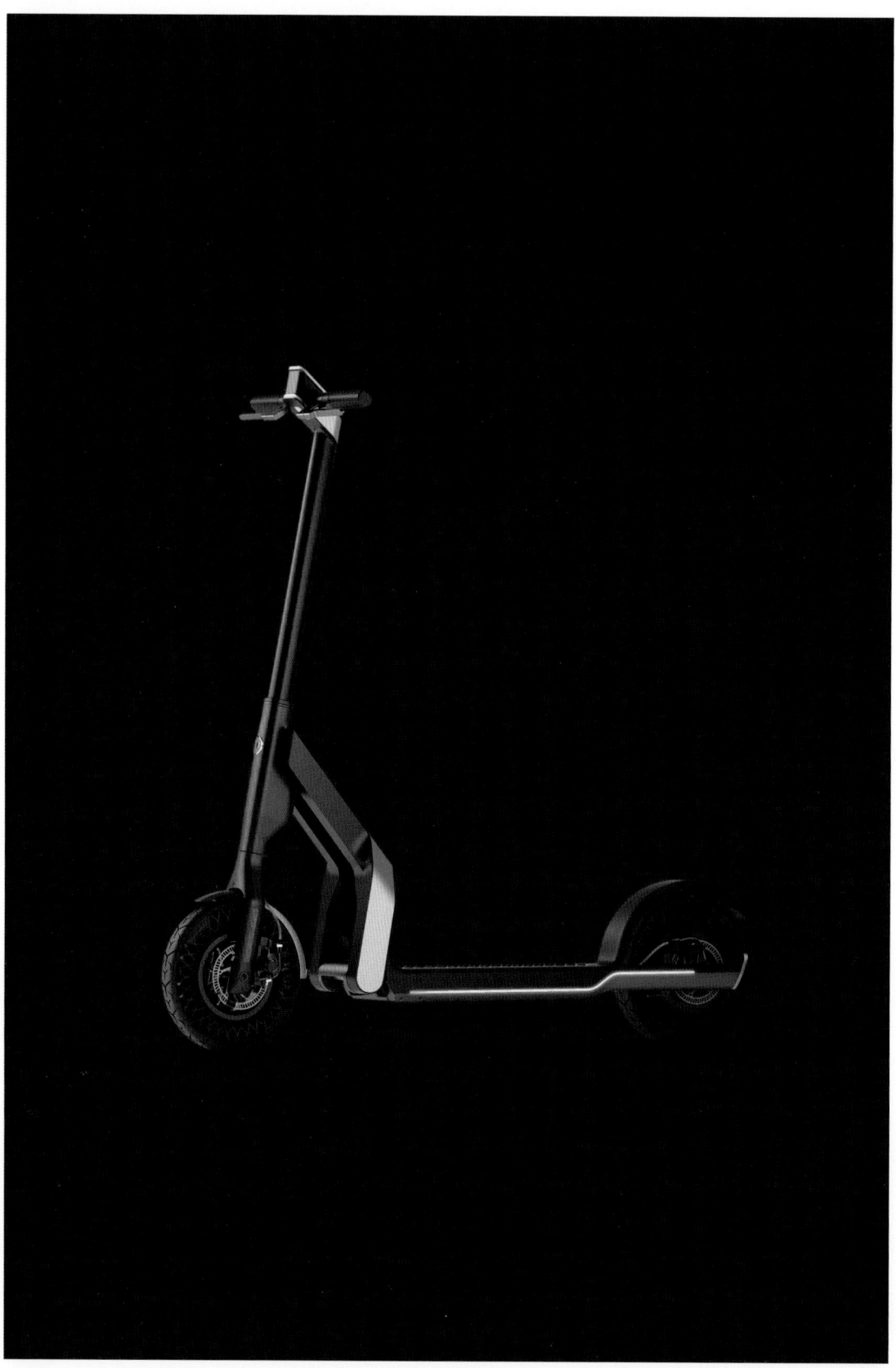

NPT 전동 킥보드
NPT Electric Scooter

NPT[9]가 적용된 전동 킥보드를 디자인했다.
이동 목적으로의 전동 킥보드는 그 형태가 계속 진화하는데,
보관 시의 불편한 점을 보완한 디자인은 거의 없었다.
처음 접근할 때부터 이런 점에 착안해 보관이 용이하도록
접을 수 있는 형태로 만들었다.

We designed an electric kickboard that applied
NPT[9]. The design of the electric kickboard for
the purpose of moving continues to evolve, but
there were few designs that compensated for its
inconvenient storage capability. With this in mind
from the first approach, a foldable form for easy
storage was made.

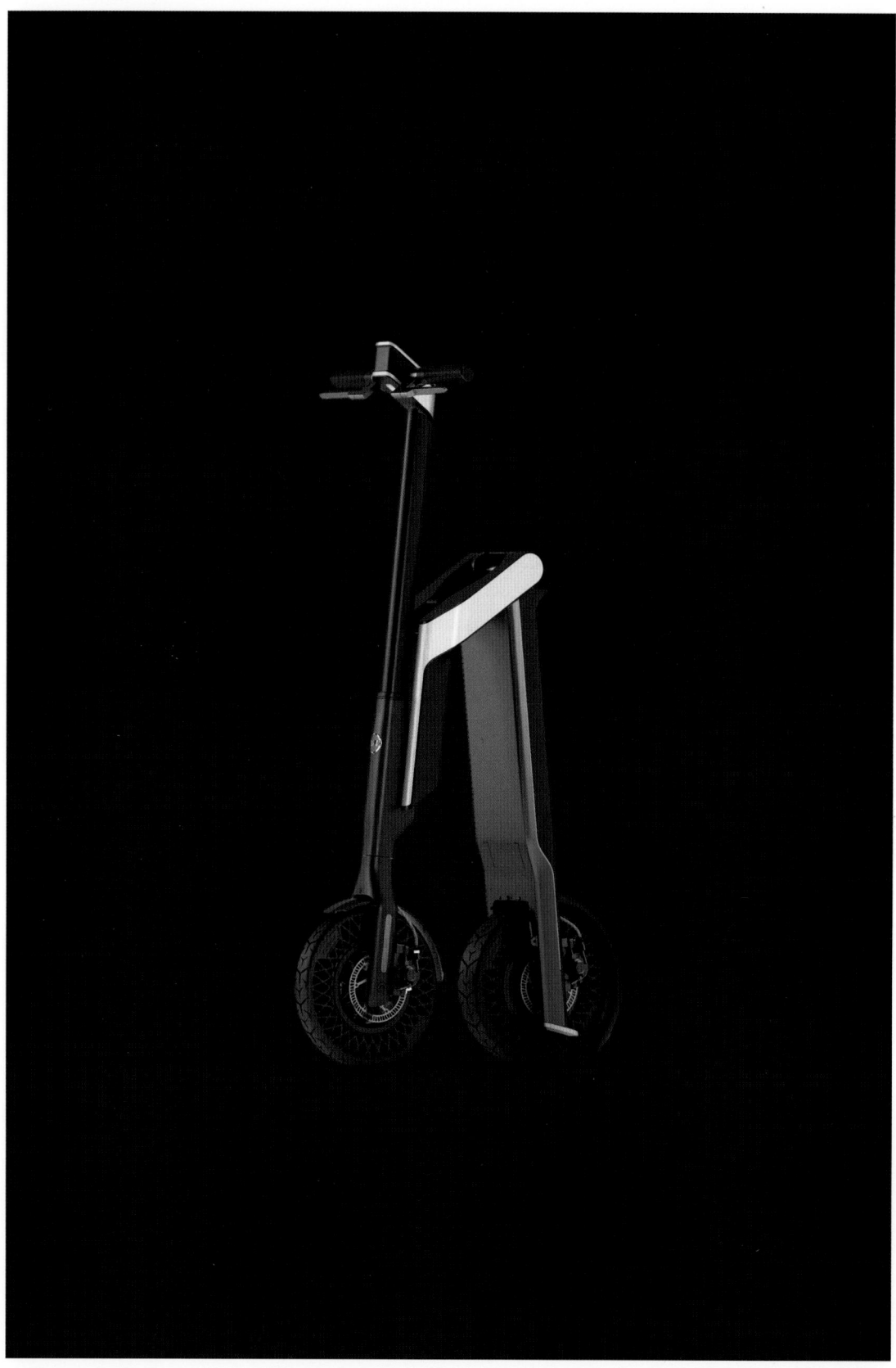

음악의 패턴
Pattern of Music

2020년 문화역서울284 기획 전시 〈레코드284—문화를
재생하다〉를 위해 디자인한 수납장 겸용 오브제다.
총 여섯 가지 오브제는 각 레코드판의 음악에서 영감을
받았다. 음악에서 느껴지는 운율을 시각화해 조형을 입체로
표현했다. 레코드판을 거치하거나 수납할 수 있도록
컬러 MDF[10]를 사용해 제작했다.

Pattern of Music is an object that also functions as
a storage cabinet designed for the 2020 Cultural
Station Seoul 284 special exhibition, *Record
284—Culture on a Turntable*. A total of six objects
were inspired by its own recorded music. The
rhythm felt in the music was visualized to express
the model in three-dimensions. It was made with
color MDF[10] to hold or store records.

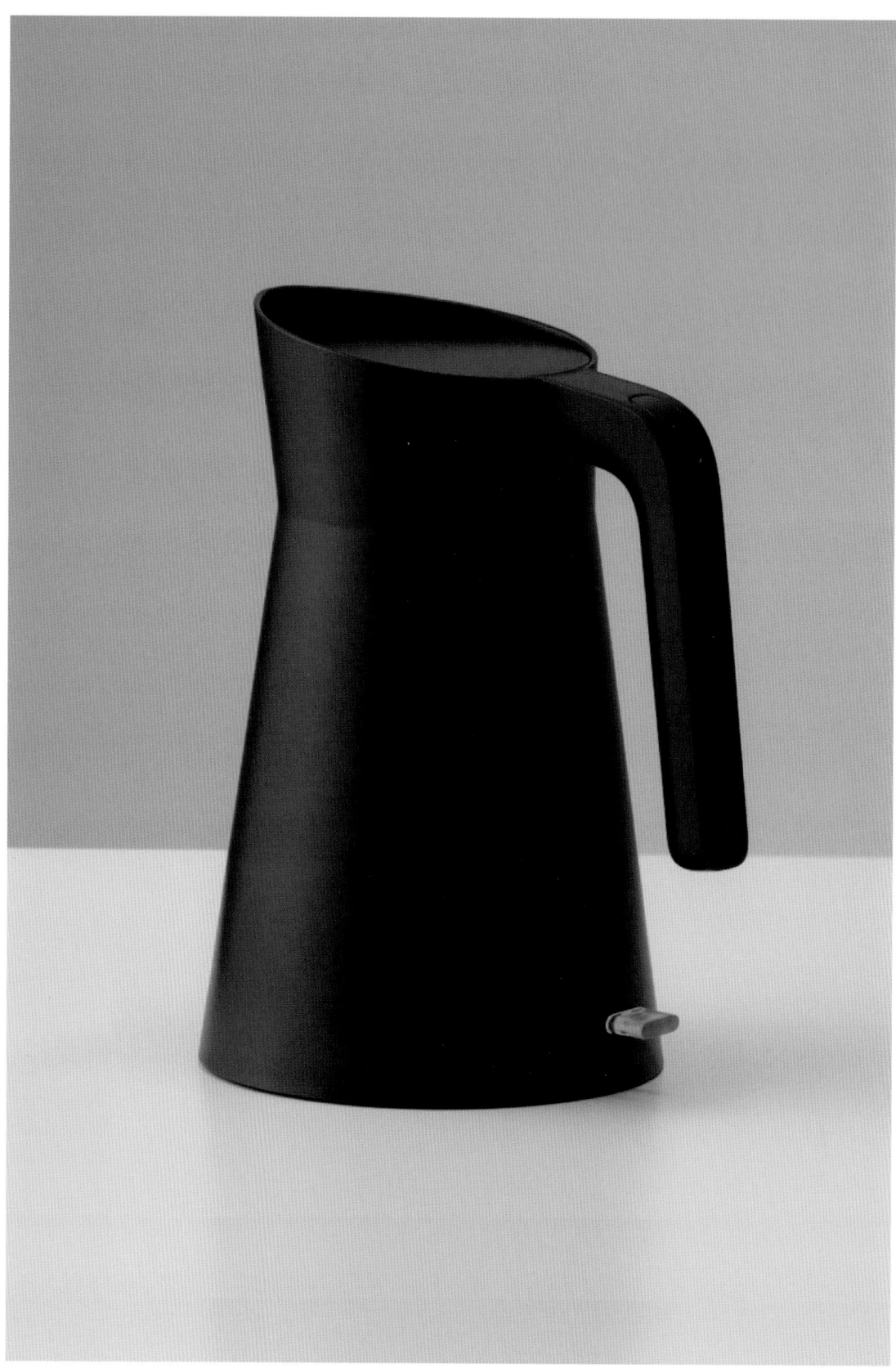

무선 전기 주전자
Wireless Electric Kettle

무선 전기 주전자는 주방뿐 아니라 다양한 공간에서
사용한다. 어느 환경에나 잘 어울리는 조형을 위해
물음을 던졌다. 무선 전기 주전자의 원형은 무엇일까?
말할 것도 없이 주전자다. 주전사의 본질에 접근해 사용하기
쉽고, 세척이 용이하고, 사용 환경에 따라 그 사용성이
적절히 유지되는 형태를 도출했다. 또한 편리성을 위해
표면의 스위치 및 가열버튼 등에는 디지털 요소를 최대한
드러내면서, 외관 자체는 아날로그 주전자의 본질적인
형상을 강조했다.

Cordless electric kettles are used not only in the
kitchen but also in various spaces. The question
was asked for a model that would fit well in
any environment. What is the prototype of the
cordless electric kettle? Needless to say, it is the
kettle. Approaching the essence of the kettle, we
came up with a model that was easy to use, easy
to clean, and maintains its usability appropriately
depending on the environment it is in use. Also,
digital elements such as switches and heating
buttons were exposed as much as possible on the
surface for convenience, while the exterior itself
emphasized the essential shape of an analog
kettle.

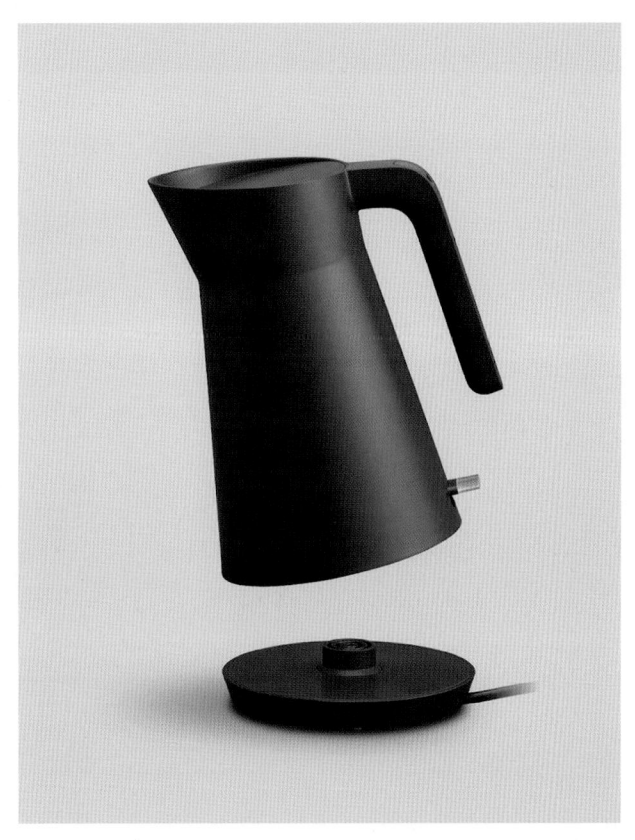

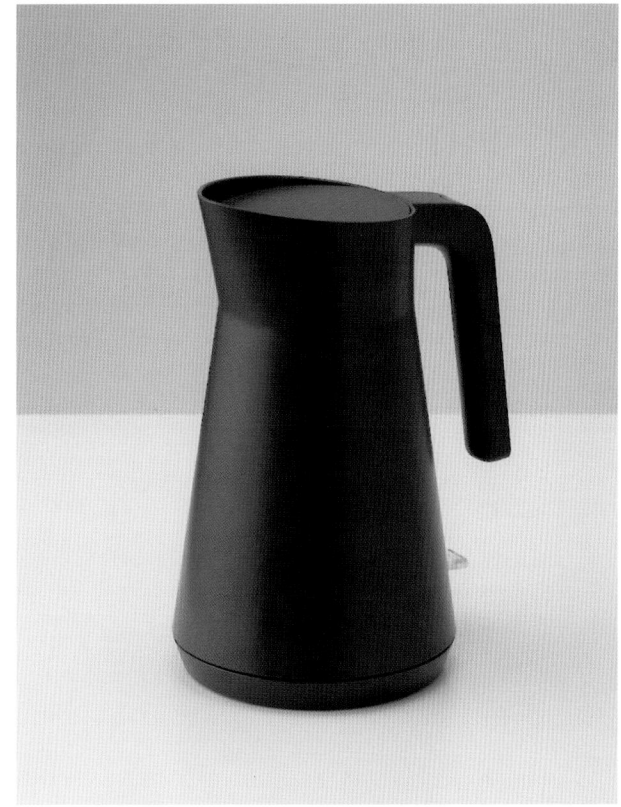

10 퍼스낼리티 10 체어
10 Personalities 10 Chairs

우리는 기본적으로 열정과 창의력으로 충만하다. 하지만 대부분의 시간 클라이언트의 이야기를 듣고, 대부분의 에너지는 그들의 디자인을 진행하는 데 쏟는다. 우리는 우리의 이야기를 할 필요가 있다고 생각했다. 나무, 그리고 등받이 의자라는 제한 안에서 SWNA의 디자이너가 저마다의 의자를 디자인했고, 의자라는 오브제를 통해 각자의 이야기를 전개했다. 이들은 2021년 4월 코사이어티 서울숲에서 열린 SWNA 단독 전시 〈맥락 속의 오브제〉에서 선보였다.

We are essentially full of passion and creativity. But most of the time we listen to our clients, and most of our energy goes into working on their designs. There are times when we need to tell our story. Within the limits of material wood and a chair with a backrest, SWNA designers each designed a chair, and through this object chair, each developed a story. They were presented at SWNA's exclusive exhibition *Objects in Context* held at Cociety Seoulsup in April 2021.

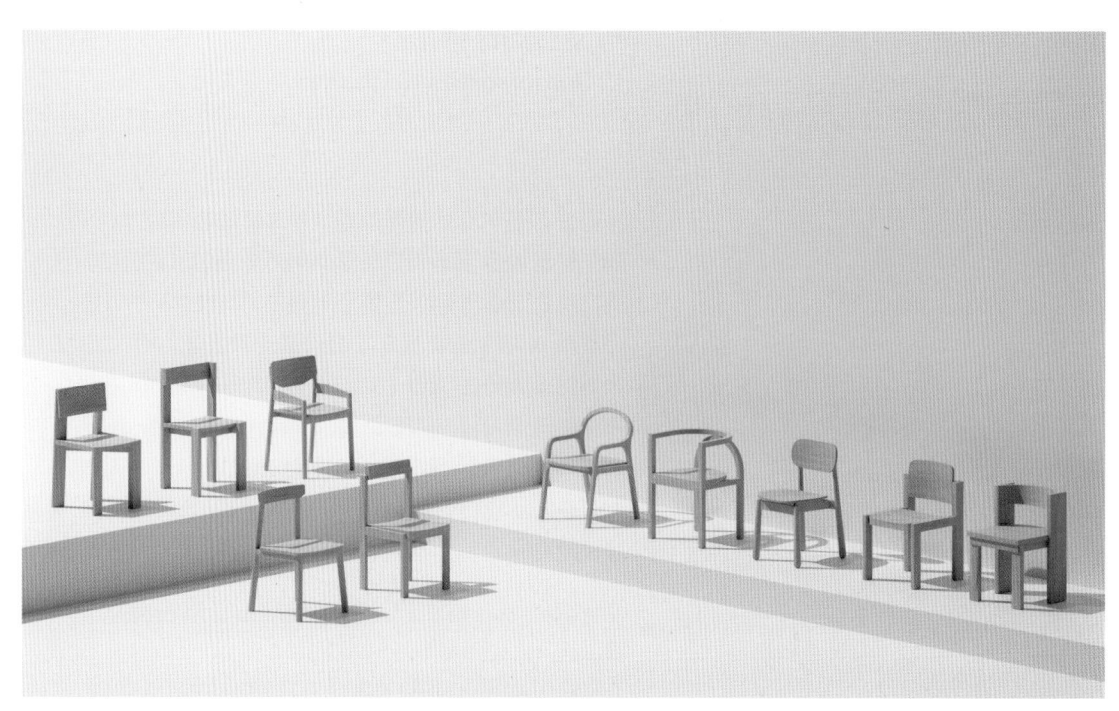

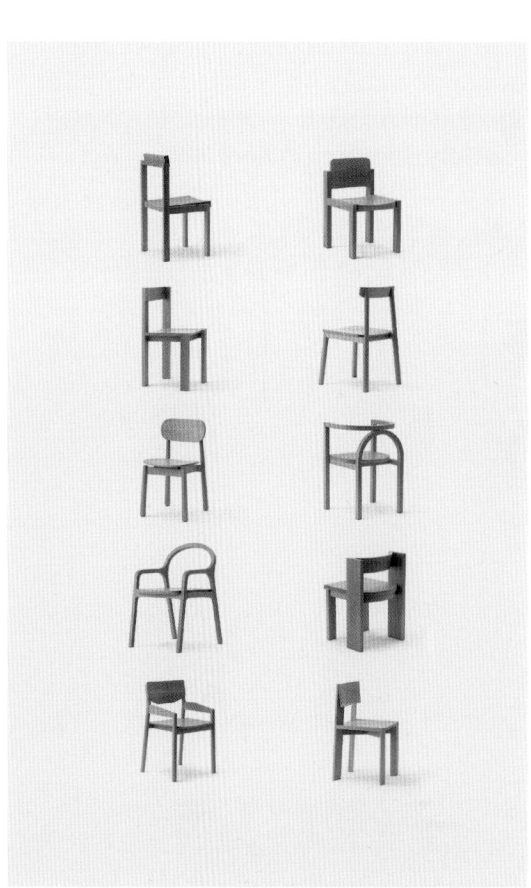

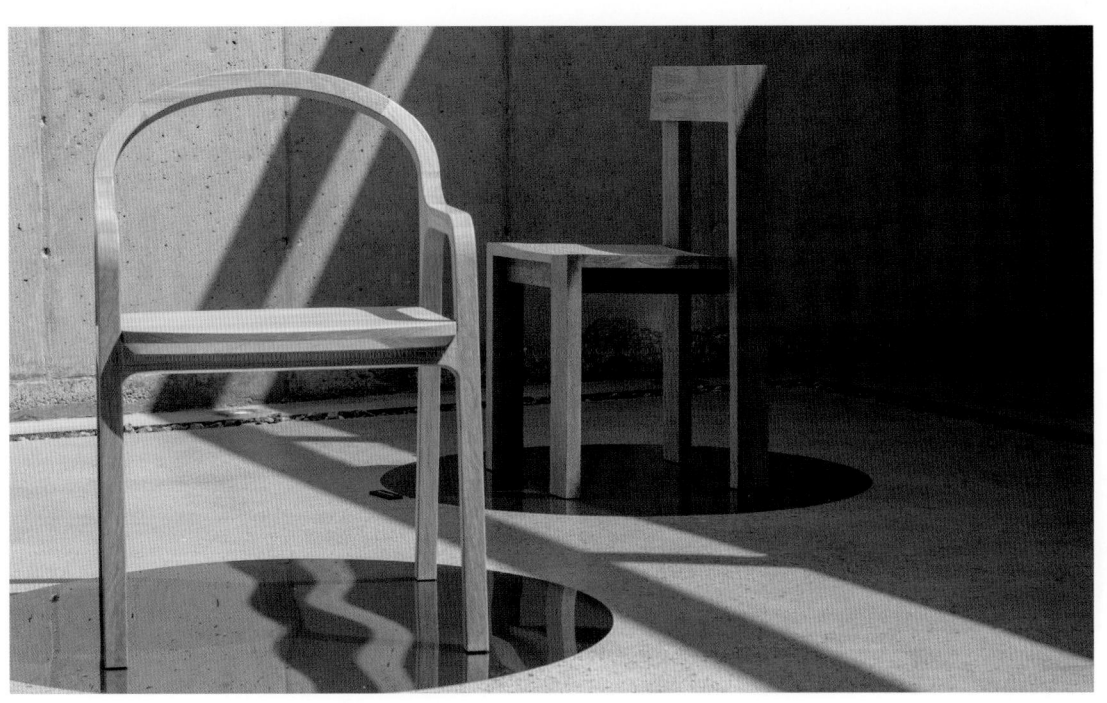

대화
Dialogue

디자이너의 사고 과정

인터뷰어: 김보섭
디자인 연구자, 고려대학교
디자인조형학부 교수
2016년 6월부터 2017년 5월까지,
5회에 걸쳐 나눈 대화를 정리했다.

김보섭
사물을 볼 때 그 사물에 매몰되는 현상을 고정관념이라고
합니다. 인지적 고착이라고도 하죠. 프로젝트를 시작할 때
항상 개입하는 이 고착 현상을 어떻게 극복하나요?

이석우
이전의 방식이 잘됐거나 성공적이었다면 그렇게
회귀하고자 하는 탄성이 생깁니다. 사람의 관성이 곧
양날의 검이 되는 것이죠. 저도 항상 경계하는 편입니다.
디자인 프로세스를 보완해, 다른 방식으로 할 수 없을지
의식적으로 노력합니다. 그러는 게 더 재미있죠.

김
어쩌면 인간은 무엇을 보는 것만으로도, 혹은 이해했다는
생각만으로도 고착이 생기는 걸지 모릅니다. 선입견이나
고정관념을 깨는 건 항상 어려워 보여요.

이
첫 시도라면 시행착오를 할 수밖에 없습니다. 사실
시행착오 자체가 더 많은 가능성을 열어놓는 일이기도
하죠. 예를 들어 제품 디자이너가 공간 디자인을
하면 스케일 감각이 달라서 색다른 작업이 나옵니다.
인간이라면 언제나 편한 것을 원하기에, 이미 가본 길을
더 적은 노력으로 가고 싶어 하는 고착은 자연스러운
현상입니다. 그러니 결과가 보장되지 않은 길을 가려면
의지가 있어야 해요.

김
경험이 쌓이면 결과가 예측될 텐데, 그럼에도 새로운 걸
시도하는 힘은 어디서 나오는 걸까요?

이
제게는 매번 다르게 해보려는 욕구나 일종의 본능이 있는

것 같습니다. '그런 걸 왜 시도하냐'고 묻는다면 말로는
잘 설명할 수 없어도, 몸은 본능적으로 반응하는 듯해요.
다른 방식이 없을까 고민하는 과정에서 재미를 느끼기도
합니다.

김
사물이 머릿속에서 꿈틀거리며 다른 이미지로 확장하는
느낌이네요. 생각의 확장이 이뤄지는 과정일까요?
그 과정이 궁금합니다.

이
제게 굉장히 중요한 사고방식 중 하나는 익숙한 것을
비틀어보는 '트윅'입니다. 기존의 것과 완전히 다른 걸
생각해 보는 것입니다. 사실 의도적으로 다르게 보려고
노력합니다. 새롭고 혁신적인 것을 만들기 위해서는
생각의 시작이 중요하다고 생각해요. 기존의 통념을 깨고,
조금이라도 가능성이 있다면 무엇이든 고려하죠. 사고가
자유롭고 유연하면 완전히 새로운 상황을 가정할 수
있어요. 사물의 가능성을 아예 비틀어 보는 겁니다.
책상 위에 컵이 있는 걸 보고 책상 밑에 있는 컵을
생각해볼 수도 있고, 컵이 아예 사라질 수도 있습니다.
그럼 완전히 다른 이야기가 되죠. 숟가락을 디자인한다면
'떠먹는 용도가 아니라, 씹는 용도의 숟가락은 없을까?',
간장병이라면 '간장이 천장에 달렸으면 색다른 경험을
주겠지?' 이렇게 다른 시각으로 보며 조건을 바꿔보는
겁니다. 또 리모컨을 디자인한다면 사용성을 조사하는
방법을 먼저 떠올리겠지만, 저는 사람들이 보통 어떤
콘텐츠를 보는지 먼저 생각할 겁니다. 콘텐츠를 보는
건 사물만 보는 것과 완전히 다르니 새로운 이야기가
나오겠죠. 트윅은 단순히 상황을 뒤트는 걸 넘어, 다른
생각을 해보는 방법입니다. 물론 평상시까지 다르게
보려고 노력하는 것은 아닙니다. 그렇게 산다면 진짜
피곤하겠죠.

김

이런 사고의 확장은 부분이 아니라 전체의 이미지를 보는 일이라 생각합니다. 디자이너에게는 부분보다는 전체, 사물을 넘어 상황을 이해하는 시야가 중요한 것 아닐까요?

이

우리 스튜디오에서는 '아키텍처 바꾸는 걸 먼저 하자'고 합니다. 이 단어가 적절한지는 모르지만 우리끼리 사용하는 말이에요. 우리가 '아키텍처를 흔들어 보자'고 하면 그 문제의 근본적 가치를 바꿔보자는 의미입니다. 대다수 디자인 프로젝트를 보면 근본적 가치까지는 건드리지 않잖아요. 우리는 먼저 아키텍처의 윤곽을 파악하고 다양하게 그려냅니다. 예를 들어 이어폰이라면 '좌우대칭부터 흔들어 보면 어떨까? 하나는 동그랗고 하나는 막대기 형태면 안 돼?' 하고 생각해 보는 겁니다. 그러다가 단순한 동그라미와 막대기 조형을 붙여봅니다. 이어폰의 아키텍처가 바뀐 겁니다. 그러니까 '다른 가치를 줄 수 있는가'에 대응해 큰 숲과 작은 숲을 유연하게 보는 게 가장 중요하죠.

김

큰 숲을 볼 줄 알면 다른 이야기를 할 수 있죠. 큰 숲과 작은 숲을 유연하게 잘 보는 사람은 더더욱 드물고요.

이

사실 이런 사고방식은 아주 오래 전부터 있었습니다. 일례로 일본 이쑤시개는 손잡이 부분에 홈이 파여 있죠. 왜 홈이 있을까요? 일본 사람들은 옻칠한 식탁을 주로 썼는데, 사용한 이쑤시개를 그냥 올려두면 침 때문에 옻이 부식되니까, 끝부분을 분질러서 사용한 쪽을 얹어놓을 수 있도록 만든 겁니다. 전체 상황을 다르게 이해하는 관점이 필요한 거죠.

김

반복되는 질문이기는 한데, 그 전체를 보는 시선이 고정되기가 쉬워 보여요. 누구나 그 고정관념을 벗어날 수 있는 것도 아닙니다. 이런 건 특별히 타고나는 걸까요, 아니면 노력일까요?

이

특별한 능력은 아닐 겁니다. 저도 보기보다 지구력으로 일합니다. 창의성이 어디서 나오느냐고 묻는다면 가능성을 집요하게 잡고, 뭔가 더 있지 않을까 질문하고,

끊임없이 재미있는 걸 탐색하는 과정에서 나온다고 대답할 수 있습니다. 막힌 길을 뚫고 나아가려 하는 미꾸라지 같은 노력이죠. 새로운 해결책을 찾기 위해 가장 중요한 건 집요함이에요. 자연스레 스튜디오의 프로세스가 길어져요. 리서치나 스케치의 양이 엄청나게 많은데, 다른 회사에서 100장을 그린다면 우리는 200장, 심지어 1,000장을 그립니다. 방법이 나오지 않을 수 없도록 하죠.

김

하지만 노력만으로는 충분히 설명되지 않아요. 저는 이미지가 뇌 속에 느슨하게 퍼져 있다가, 몸 상태가 좋아 생각도 잘될 때 떠오르는 것 같아요.

이

영감이라는 말을 종종 쓰는데, 영감을 받았다는 건 새로운 이미지가 번쩍 떠올랐다는 게 아니라 가능성이 열린 것이라고 생각합니다. 영감을 얻은 상태란, 더 많은 가능성을 생각할 수 있는 평온하고 자연스럽고 자유로운 상태입니다. 몸 상태가 안 좋으면 부정적인 생각만 들고 발상의 폭이 좁아지죠. 내가 편안해야 많은 게 긍정적으로 느껴지고 마음을 열 수 있어요. 2016년에 열린 토마스 헤더윅과 헤더윅 스튜디오의 전시 〈헤더윅 스튜디오: 세상을 변화시키는 발상〉을 봤을 때도, 단순히 조형이 멋있다는 데서 감상이 끝나는 게 아니라 사고하는 방식이 좋게 다가왔어요. 저는 생각만 하던 게 실제로 구현된 것 자체가 좋더라고요.

김

작업 과정은 판단의 연속입니다. 새로운 형태를 볼 때도 판단이 개입하고, 그걸 생소하다고 느끼는 것도 판단일 겁니다. 먼저 형태에 대한 판단은 어떻게 하는 것일까요?

이

형태를 비틀어 볼 때 새롭게 나오는 요소에서 실마리를 찾습니다. 이런 트윅의 원천은 머릿속 이미지들이고요. 실마리를 판단하는 데는 안목이 중요하고, 안목이 생기려면 많이 보아야 해요. 어떤 게 좋고 나쁜지 알 수 있을 만큼 봐야 하고, 또 볼 줄 알아야 합니다. 이렇게 하는 건 좋은 것이고 이렇게 하는 건 나쁜 것이라는 개념이 있어야 하죠. 기준을 알려달라고 하면 저도 쉽게 대답할 수 없지만요. 예전엔 사람들이 자주 쓰는 이미지를 트윅했기에 기존의 것과 유사한 형태가 나왔습니다.

지금은 내 속에서 좋아하는 것을 빼내려고 노력합니다. 남들이 이미 좋아하는 것에서 더 새로운 아이디어를 내는 건 한계가 있더라고요.

김

언어로 설명되지 않는 것이기 때문에 말로 표현하기는 어렵지만, 저는 디자이너가 이미 안다고 믿어요. 설명을 못 한다고 해서 모르는 건 아니죠. 디자이너 스스로 알지 못하면 밖으로 표현되어 나올 수가 없습니다. 그게 스케치든 디자인이든요. 어렵기는 해도, 디자이너의 창작 과정은 설명될 수 있다고 생각해요.

이

영감이 갑자기 떠오르는 것 같아도 언젠가 봤던 것에서 옵니다. 재난 키트 프로젝트를 하면서 시계로 디자인해야겠다고 생각한 것도, 예전에 괘종시계를 열었을 때 여유 공간을 본 순간의 느낌이 남아 있었기에 가능했습니다. 무심코 시계를 열었는데 '아무것도 없네' 한 기억이 있어요. 경험에 인상을 느낀 거죠. 당시 무언가를 넣을 수 있는 공간이라고 인식하고, 그 경험에 여러 기억이 혼합되어 나중에 작업으로 나온 겁니다. 디자이너는 이런 조각의 아카이빙을 잘해두고, 현재 직면한 문제에 대입해 적합한 방식을 찾아가는 사람이라고 할 수 있습니다. 이미지 기억력이 좋아 직관적으로 판단하고 조합하고 변형하기를 잘하는 거죠. 저도 암기는 못하는 편이었지만 상황, 순간, 이미지 같은 건 잘 기억해요. 공간을 지각하거나 이미지를 판단하거나 빠르게 인식하는 능력도 좋다고 생각해요. 물건의 형상, 색상, 어렴풋한 물체도 재빨리 보고 잘 기억하죠. 눈으로 보는 것에 유독 예민한 이런 능력을 '눈썰미'라고 표현할 수도 있을 것 같아요.

김

'생각이 난다'는 게 참 신기해요. 가만히 있는데 도대체 왜 생각이 나는 걸까요? 우리는 종종 생각이 잘 나는 상태를 경험합니다. 아침에 눈을 뜨자마자, 무심히 길을 걷다가, 혹은 가만히 멍 때리다가도. 무의식일 수도 있지만, 어쩌면 몸과 마음이 새로운 걸 지향하는 상태일지도 모릅니다. 인간의 신기한 능력 중 하나거든요.

이

연상은 창의적 과정의 일부일 뿐입니다. 비슷한 기억을 찾아내는 데서 그치면 그저 그뿐입니다. 연상을 어렵게

해냈더라도, 이를 다듬어 내는 과정이 필요합니다. 보통 가만히 있을 때는 아무 생각 안 나고, 집중해야 생각이 나죠. 의지를 가지고 생각해야 합니다. 상황은 상관없어요. 어떻게 해야 할지 대입하는 과정을 생각하는 거죠. 컨디션이 좋으면 기억나는 게 더 많을 겁니다. 기분이 나쁘면 나쁜 대로 생각해서 다른 걸 만들어낼 수도 있고요. 브레인스토밍 프로젝트에도 이런 과정이 있습니다. 생각하기 위해 노력하는 거죠. 즉흥적으로 생각나는 경우도 있지만 보통은 어떻게 풀지, 어떻게 할지 종일 노력해서 생각해요. 평창 동계 올림픽 메달도 처음부터 제조 방식을 바꿔보자, 방향성 자체를 다르게 가보자 했습니다. 새로운 것이 없을까? 메탈로 뽑아볼까? 기존 도형과 다를 수 있겠네. 메탈 속을 비우고 압출 성형[11] 기술을 쓰면 어떨까? 제겐 기술도 이미지예요. 메탈로 뽑은 결과물의 이미지를 연상하는 거죠.

김

평창 동계 올림픽 메달 디자인에 대한 이야기를 좀 더 듣고 싶습니다.

이

완전히 다른 형태를 뽑아내고 싶었던 작업입니다. 형태가 나오는 방식부터 달리하려고 했기에 사고의 시작이 먼저 달랐습니다. 기존 메달은 단조[12]를 쳐서 만드는데, 이 작업은 아예 3D 프린팅 기술을 사용했습니다. 제조 방법 자체를 바꿔서 근본적으로 다른 형태를 만들려던 겁니다. 기존의 메달을 만드는 방식, 예컨대 도안을 넣거나 자개를 넣어서 만드는 발상은 피하고 싶었습니다. 결국 압인[13]으로 정리되었죠. 발상의 과정을 얘기하면 기존의 통념을 꼬아서 보는 것입니다. 예전에는 이걸 틀어야 하나 말아야 하나, 좋은가 나쁜가 하며 망설였는데 요즘은 일단 시도해 봅니다. 틀면 보여요. 이런 방식을 자연스럽게 체화하는 중입니다.

김

뇌 과학에서 인간은 기본적인 인지 체계를 범주화하는 능력이 있다고 합니다. 인간이 의식을 갖는 기초적인 방법 중 하나로, 지도화라고도 하죠. 그리고 창의성은 세상을 범주화하는 능력과 관계가 있다고 해요.

이

범주화하는 동시에 범주화를 깨야 합니다. 물론 어렵죠. 범주화가 되어야 좀 더 효율적이고, 정량화가 되고,

인지 가능한 것이 되지만, 그만큼 유연성이 떨어지니까요. 범주를 넘나드는 능력은 이성이 아니라 감성의 영역에 있다고 생각합니다.

김

2004년 홍익대학교 졸업 전시 작품 〈음악을 비추고 빛을 만지다〉는 새로운 범주의 형상을 제시했다고 봅니다. 여전히 좋은 작업으로 회자되더라고요. 스피커인데도 인터페이스가 내부에 있지 않고 위에서 내려오는 방식입니다. 그 형태가 기본적으로 새로웠어요.

이

당시 빛이나 소리의 감성적인 부분을 좋아했습니다. 노키아 휴대폰이 나올 때였죠. IT가 개발되면서 전자제품이 쏟아져 나오는 시기였기에 저도 기술에 관심이 컸고, 기술과 감성을 결합한 무언가를 만들고 싶어서 빛과 소리가 관련된 걸 만들어 보기로 했습니다. 처음엔 데스크 스탠드 같은 형태였는데 별로더라고요. 그러다 상반된 두 개념을 뒤집으니, '음악을 비추고 빛을 만지다'라는 콘셉트가 나왔어요. 조명등 속에서 인터페이스가 나오는 방식이 새롭게 다가왔어요. 처음에는 그렇게나 막연했던 발상이 정리되었죠. 그때부터 트윅에 관해 생각했습니다.

김

원형의 이미지를 만드는 일이 디자이너의 가장 원천적인 역할이 아닐까 해요.

이

원형은 최대한 군더더기가 없는 상태를 의미합니다. 만약 외계인에게 지구의 물건을 설명해야 한다면 뭘 가져갈까요? 휴대폰이라면 아이폰을, 비누라면 도브를 가져갈 겁니다. 가장 정제되고 완성도 높은 물건을 가져가겠죠. 군더더기가 있다면 설명에 방해가 될 테니까요. 후카사와 나오토는 본인을 '나는 형태를 정리하는 사람'이라고 이야기합니다. 실제로 형태 정리를 엄청나게 잘하는데, 사물의 원형을 고민하기에 가능한 것이죠. 사고가 근본적으로 다르다고 봐요. 저도 학교 다닐 때부터 이런 사고를 하려고 노력했고, 영향을 크게 받았다고 할 수 있습니다.

김

예전에 비해 작업 과정이 달라진 게 있을까요?

이

생활이 규칙적으로 안정되었습니다. 아침 6시에 일어나서 산책 갔다가 회사에 걸어서 출근합니다. 8시부터 10시까지 혼자 스케치를 하기도 하는데 그때가 제일 좋습니다. 재미있어요. 이런 생활을 통해 스스로를 컨트롤하는 방법을 배웠습니다. 예전에는 아침에 전혀 못 일어났고, 스스로를 너무 다그치는 스타일이었습니다. 지나치게 절실했죠. 지금은 그런 부담감에서 좀 벗어나 간바이 좀 없어졌습니다. 너무 경직되거나 불안하면 오히려 작업이나 스케치가 별로 좋지 못합니다. 마음이 편해지면 훨씬 더 작업이 좋아져요.

김

실제로 과도한 스트레스나 과다한 욕망은 창의성에 도움이 되지 않는다는 연구가 많습니다. 그럼 어떤 상태일 때 작업이 제일 잘되나요?

이

재미가 있어야 합니다. 재미가 있으려면 스트레스가 없어야 하고, 스트레스가 있는 상태에서는 유희성이 제대로 나오질 않죠. 내 마음이 편하고 기분이 좋아야 작업도 잘됩니다. 한번 막혔다고 모든 걸 부정적으로 보면 안 되죠. 안되는 건 그냥 안되는 겁니다. 유희성을 중시한다는 건 생각보다 단순한 문제가 아니라고 생각해요. 인간이 왜 살아가나 여러모로 살펴보면, 아마 종족 번식과 놀이가 가장 중요할 겁니다. 누군가 놀러 나가자고 하면 강박적으로 생산적인 활동을 하려 들 게 아니라 말 그대로 즐겨야 해요. 그게 놀이입니다. 그렇게 놀듯이 작업하는 건 분명 상상력에 영향을 줍니다.

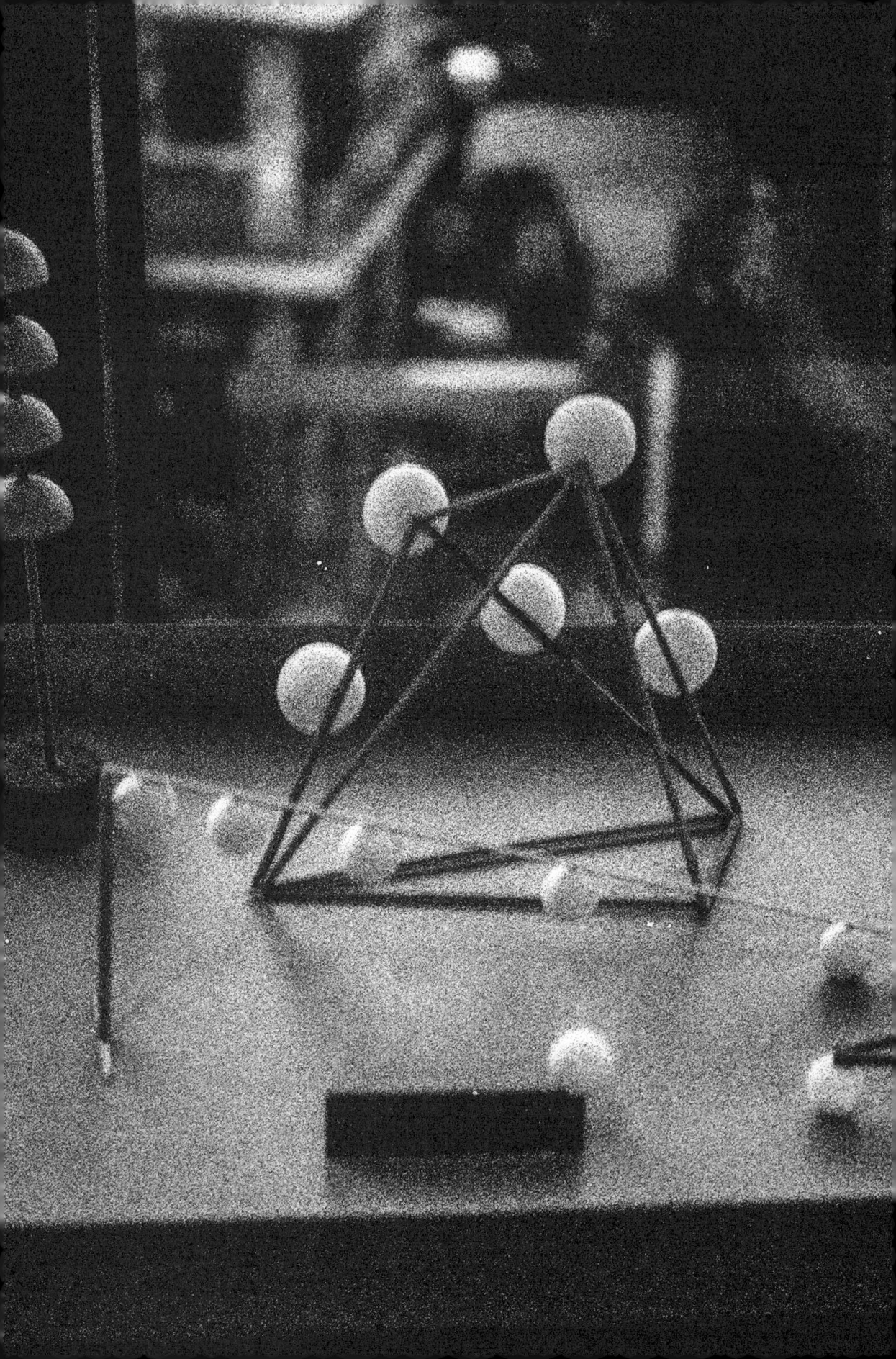

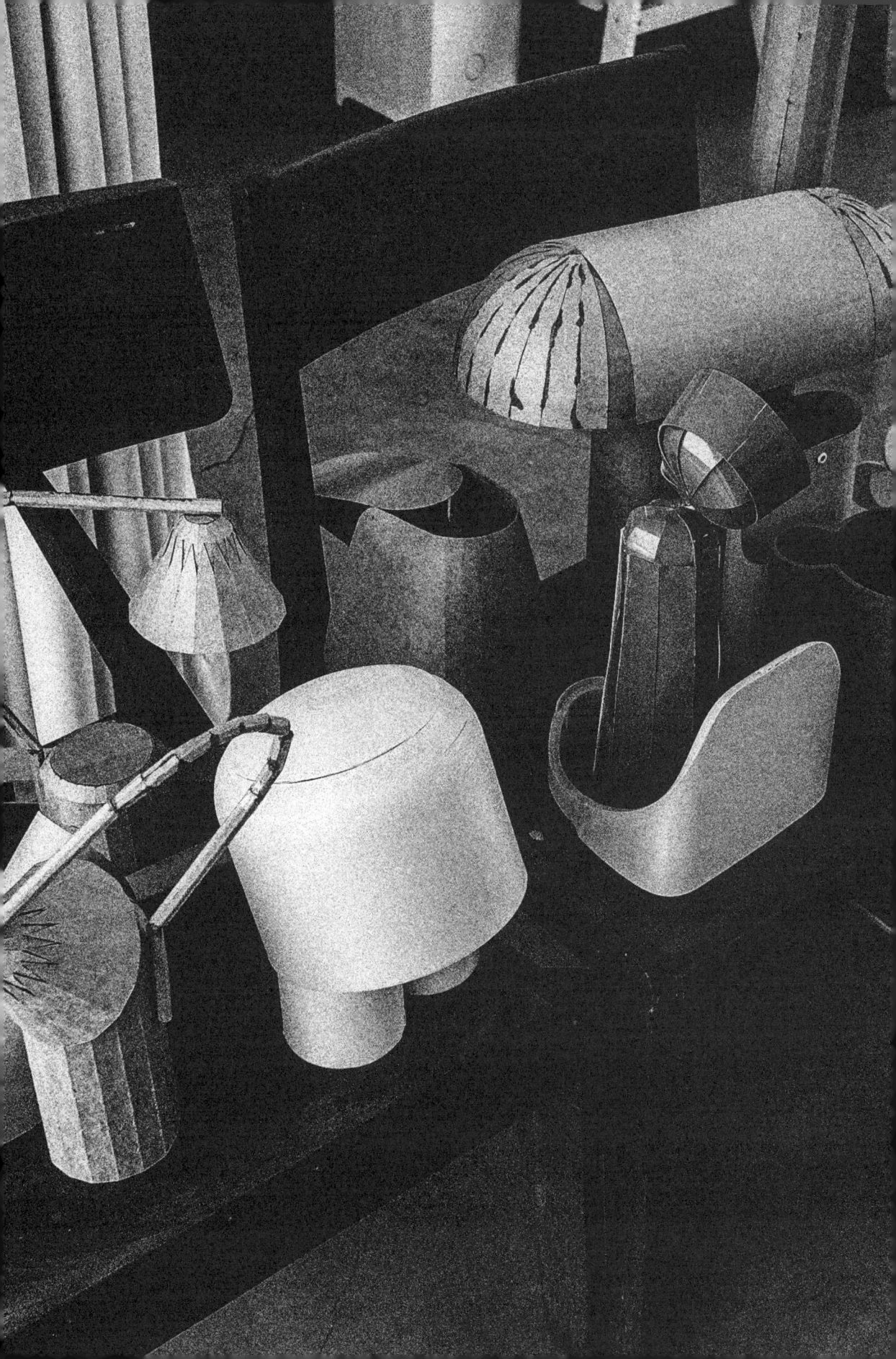

The Thinking Process of a Designer

Interviewer: Kim Bosub
Researcher, Professor of
the School of Design and
Architecture, Korea University
This is a summary of five
conversations from June 2016
to May 2017.

Kim Bosub

The phenomenon of being immersed in an object when looking at it is called a stereotype or fixed way of thinking. It is also called "cognitive fixation." How do you overcome this fixation, which is always involved at the beginning of a project?

Lee Sukwoo

If you've been good or successful in doing something in a certain way, there's a pull to go back. Human inertia becomes a double-edged sword. I'm always on the borderline. By supplementing the design process, I consciously try to see if I can do things another way. It's more fun that way.

K

Maybe humans become fixated just by seeing something or thinking that they understand it. It always seems difficult to break preconceived notions or stereotypes.

L

If it's your first attempt, there will be trial and error.
In fact, trial and error itself opens up more possibilities. For example, when a product designer designs a space, the sense of scale is different, resulting in a different work. As humans, we always want to be comfortable, so it is natural to want to go down the road we have already taken with less effort. Thus, if you want to go down a path with no guaranteed results, you need to have strong will.

K

As experience accumulates, results can be predicted, but despite this, where does the strength to try new things come from?

L

I seem to have a desire or some sort of instinct to try something different each time. If you ask, "Why are you doing such a thing?", I think my body reacts instinctively, even if I can't explain it well in words. It is also fun to think about whether there is another way.

K

It feels like things are percolating in your head and expanding into other images. Could it a process of expanding ideas? I'm curious about this process.

L

One of the most important ways of thinking for me is to 'tweak' which is twisting the familiar. It's about thinking about something completely different from what it used to be. In fact, I deliberately try to see things differently. In order to create new and innovative things, I think beginning to think is important. I break the conventional wisdom and consider anything that has the slightest possibility. When your thinking is free and flexible, you can imagine completely new situations. It's about completely tweaking the possibilities of objects. You may see a cup on the desk and think of the cup under the desk, or the cup may disappear altogether. That's a completely different story. If you design a spoon, you can think "Isn't there a spoon for chewing instead of scooping?", and for a soy sauce bottle, "Wouldn't the experience be different if the soy sauce were hanging from the top?" Also, when designing a remote control, people first think about how to research its usability, but I would first think about the kind of content people usually watch. Since viewing content is completely different from looking at only objects, a new story would emerge. A tweak is more than

just twisting things around; it's a way of thinking differently. Of course most times I don't try to see things differently. Living like that would be really tiring.

K

I think the expansion of this thinking is to see the image as a whole, not the parts. For a designer, isn't it important to know the whole rather than the parts,
the perspective that understands the situation beyond the object?

L

At our studio, we say, "Let's change the architecture first." I don't know if this phrase is appropriate, but it's something we use anyway. When we say, "Let's shake up architecture," we mean to change the fundamental value of the problem. If you look at most design projects, you don't touch the fundamental values. We first outline the architecture and draw it in various ways. For example, in the case of earphones we can think, "Why don't we begin with shaking up the left and right? Can't one be round and the other in the shape of a stick?" Then we attach a simple circle and stick shape. The architecture of earphones has changed! So, it is most important to flexibly look at large forests and small forests in response to "Is it possible to create other values?"

K

If you can see the big forest, you can tell different stories. There are even rarer people who can see large forests and small forests with great flexibility.

L

In fact, this way of thinking has been around for a very long time. For example, Japanese toothpicks have a groove in the handle. Why is there a groove? Japanese people mostly use lacquered tables, but if you just put a used toothpick on top of it, the saliva will corrode the lacquer. So the tooth prick was made so the end part could be broken and placed on the groove. So a different perspective is needed to understand the whole situation.

K

This may seem repetitious, but it is easy for our gaze that looks on the whole to become fixed.

Not everyone can break free from stereotypes. Is this a special skill, or does it take effort?

L

It's probably not a special ability. I also rely more on endurance than I seem to. If you ask where creativity comes from, I can say that it comes from persistently holding on to the possibilities, asking if there is something else out there, and constantly searching for something interesting. It's like a loach trying to break through a blocked channel. Persistence is the important thing to find new solutions. Naturally, the studio process is lengthy. The amount of research or sketching is huge, and if another company draws 100, we draw 200, or even 1,000. There is no way we can't find a way.

K

But effort alone is not enough. I think the images are spread about in the brain and rise to surface when
I am in good condition.

L

The word inspiration is often used, but I think that being inspired does not mean that a new image suddenly appears, but more about opening up possibilities. An inspired state is a state of calm, naturalness, and freedom to think of more possibilities. If you're not in good physical condition, you only have negative thoughts and your thinking narrows. When I am comfortable, many things feel positive and I can open my mind. Even when I saw in 2016 the exhibition held by Thomas Heatherwick and Heatherwick Studio, *New British Inventors: Inside Heatherwick Studio*, I ended up with not only appreciation for the beauty of the design, but also for the way of thinking. I just like it when a concept of mine becomes real.

K

The work process is a series of judgments. Judgment intervenes when seeing a new form, and it must be a judgment that feels unfamiliar. First, how do you judge the shape?

L

When you tweak the shapes, you find clues in the new elements that emerge. The source of these tweaks are the images in your head. The ability to see is important in judging clues, and

you need to see a lot to gain this ability. You have to see enough to know what is good and what is bad, and you have to be able to see again. You have to gain the concept that doing this is good or doing this is bad. If you ask me to give you a standard, I can't answer easily. In the past, images that people often used were tweaked, so a form similar to the existing one came out. Now I try to get the things I like from within me. There is a limit to coming up with newer ideas from what others already like.

K

It's hard to put into words because it's something that can't really be explained, but I believe designers already know. Just because it can't be expressed doesn't mean you don't know. If the designer does not know it himself, it cannot be expressed outwardly whether it's a sketch or a design. Although it's difficult, I think the creative process of a designer can be explained.

L

Even if you experience a sudden burst of inspiration, it comes from something you've seen at some point. The thought of designing a clock while working on the disaster kit project was possible because the feeling of the moment when I saw the free space of an opened old clock was still there. I unintentionally opened the watch and remember saying, "There's nothing." That experience left an impression on me. At that time, I recognized that it was a space where I could put things in, and that experience was mixed with various memories, and it came out as a project later. A designer can be said to be a person who is good at archiving these pieces and who finds a suitable method by substituting them for the problems he is currently facing. He has good image memory, so he is adept at intuitively judging, combining, and transforming things. I'm not the type to memorize, but I can remember situations, moments, and images well. I think the ability to perceive space, judge an image, or quickly recognize things is also useful. Designers quickly see and remember well shapes, colors, and even blurry objects. I think this kind of ability that is sensitive about perceiving with our eyes can be expressed as 'visual smartness'.

K

It's really interesting to say 'I remember'. Why does it happen when I am doing nothing?

L

We often experience a state of mindfulness. As soon as I open my eyes in the morning, while walking down the street carelessly, or even just zoning out. It may be unconscious, but it may be that the body and mind are aiming for new things. It's one of the most amazing human abilities.

K

Imaging is only part of the creative process. It's all about finding similar memories. Even if you were able to image up something, you still need the process of refinement. Usually when I'm still, I don't think about anything, but I have to concentrate to think. You have to think with willpower. The situation doesn't matter. You are thinking about the process of applying what to do. If you are in good shape, you will remember more things. If you are feeling bad, you can think of it as bad and create something else. Brainstorming projects also have this process. You are trying to think. Sometimes it comes up spontaneously, but usually, it takes all day of hard work to figure out how to solve and do it. For the medals of the PyeongChang Winter Olympics, we decided to change the manufacturing method from the beginning and go in a different direction. Is there anything new? Should we make it out of metal? It could end up different from the original shape. How about hollowing out the metal and using extrusion moulding[11] technology? For me, technology is also an image. I am imagining the final product made from metal.

L

I would like to hear more about the medal design for the PyeongChang Winter Olympics.

K

It is a work that I wanted to create a completely different form. Since we tried to change the way the form looked, the beginning of my thinking was different first. Existing medals are made by forging[12], but our work used 3D printing technology. We were trying to create a fundamentally different shape by changing the manufacturing process itself. I wanted to avoid the traditional way of making medals such as adding shapes or mother-of-pearl material. In the end, it was sorted by coining[13] method. When we talk about the process of creation, we are twisting conventional wisdom. In the past, I was

hesitant about whether to do this or not, whether it was a good or bad idea, but now I just go with it. If you're on, you will start to see. We are in the process of embodying this method naturally.

L

In brain science, it is said that humans have the ability to categorize basic cognitive systems. It is called mapping and one of the basic ways humans become conscious. And creativity has to do with the ability to categorize the world.

K

You have to simultaneously break categorization while categorizing. Of course this is difficult. Categorization makes the process more efficient, more quantifiable, and recognizable, but it is just as inflexible. I believe that the ability to cross categories lies in the realm of emotion, not reason.

L

Hongik University's graduation exhibition work *Lighting the Music and Touching the Light* in 2004, as a creation of a new shape category. That project is still known as a good exhibition. Even though it was just a speaker, the interface was not in the interior but handing down from the top. The shape was simply innovative.

K

At the time, I liked the emotional part of light and sound. That was the period when Nokia phones came out. It was a time when electronic products were pouring out with the development of IT so I was very interested in technology, and I wanted to create something that combined technology and emotion. So I decided to make something that involved light and sound. At first, the object looked like a desk stand, but I didn't like it. Then, by reversing two opposing concepts, I came up with 'lighting the music and touching the light.' The way the interface appears inside the light was new to me. The idea that was so vague at first was finally concretized. It was from that moment I've been thinking about tweaks.

L

Creating an original form is perhaps the most fundamental role of a designer.

K

The original form means the state with the least

clutter. If we had to explain Earth objects to an alien, what would you bring? If it's a cell phone, you would bring the iPhone, and if it's soap, the Dove brand. We would take the most refined and complete items. If there is too much clutter, it would interfere with the explanation. Naoto Fukasawa describes himself as "a person who organizes shapes." He is a master at doing so, and this is possible because he contemplates the basic form. I think his way of thinking is fundamentally unique. I've been trying to think like this since I was in school, and I was greatly influenced by him.

L

Is there any difference in the work process compared to that of the past?

K

Life has become regular and stable. I get up at 6 am, go for a walk, and walk to work. I sometimes sketch by myself from 8:00 to 10:00, but that's the best time. It's fun. Through this life, I have learned how to control myself. In the past, I couldn't get up in the morning at all, and I pushed myself too hard. I was too desperate. Now, I am relieved of that burden and the compulsion is gone. If you are too rigid or anxious, your work or sketches will not be very good. When your mind is at ease, your work will be much better.

L

There are many studies that show that excessive stress or excessive cravings are not conducive to creativity. So, under what conditions do you work best?

K

It should be fun. To have fun, there has to be no stress, and when there is stress, humor does not appear properly. When I feel comfortable and in a good mood, my work goes well. You can't look at everything negatively just because you're blocked once. What doesn't work just doesn't. I think that emphasizing playfulness is not as simple as you think. If you look in many ways at the reasons why humans live, reproduction and play are probably the most important. When someone asks you to go out and play, you should just literally enjoy the moment instead of forcing yourself in a productive activity. That's play. Playing like that definitely affects your imagination.

3D 렌더링
3D rendering

아이디어 스케치
Idea sketch

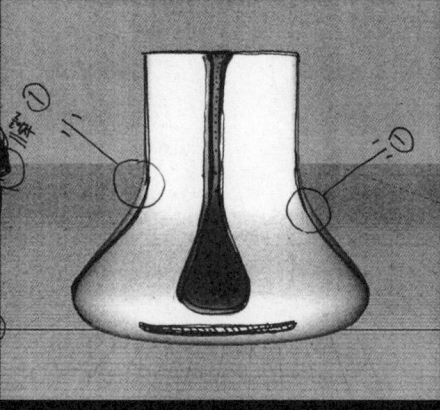

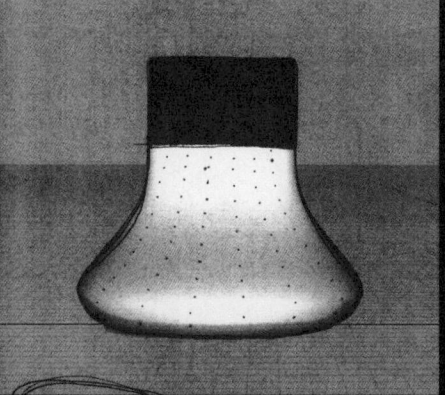

음악을 비추고 빛을 만지다
Spotlight the Music and Touch the Light

음악과 빛의 물리적 특성을 이해하고 두 요소를
결합해 새로운 사용성을 제시했다. 이종교배를
통해 탄생한 인터페이스는 제품의 물리적 특성에만
집중되어 있던 기존의 사용자 경험 자체를 새롭게
제공한다. 디바이스와 기술을 통한 감성적인
인터랙션이 가능해진 것이다.

The physical characteristics of music
and light were well understood and the
two elements were combined to present
a new usability. The interface created
through crossbreeding provides a new
user experience that used to be focused
only on the physical characteristics of the
product. Emotional interaction is possible
through devices and technologies.

허들 조명
Hurdle Light

2005년 이탈리아 밀라노 디자인 위크에서 돌아오는
비행기 안, 조명이 물에 반사되는 것을 본 이석우가
빛의 직진과 반사를 생각하며 스케치했다. 여느 때
같으면 스쳐 지나갔을 텐데 당시에는 아직 전시의
여운이 남아 있었다. 한국에 돌아와서도 그 힘을
유지하며 디자이너 변동진과 협업해 완성했다.

On the plane returning from Milan Design
Wook in Italy in 2005, Lee Sukwoo, who
saw the light reflecting off the water,
made a sketch while thinking about the
straightness and reflection of light. Like
most times, such thoughts would have
passed, but at that moment, the afterglow
of the exhibition still remained. So even
after returning to Korea, he maintained that
feeling and completed the Hurdle Light in
collaboration with designer Byeon Dongjin.

워킹 목업 작업 도구
Working mockup making tool

워킹 목업 제작 과정
Working mockup production process

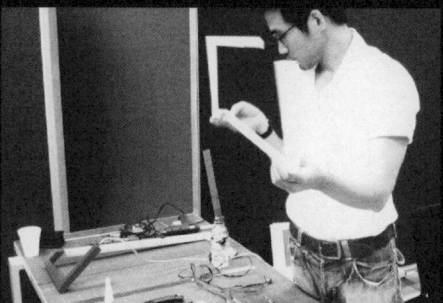
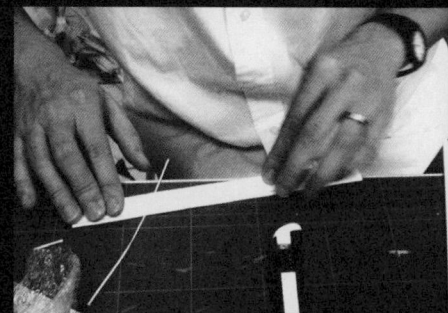

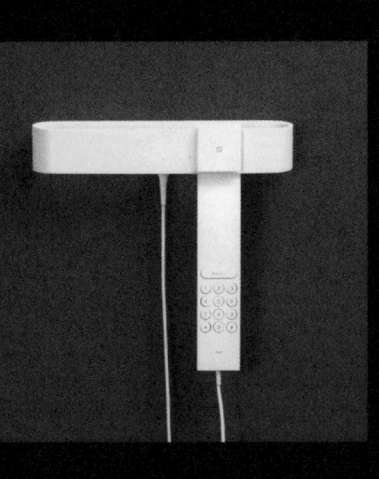

프린트한 디자인 목업
print of design mockup

사물의 일상
Ordinariness of Object

사물의 본질을 찾기 위해 사람과 사물 사이에서
일어나는 인터랙션을 관찰했다. 이 인터랙션의
물리적 특성을 고려해 오브제로 발전시키는
디자인에 관한 고민이 많았다. 사물과 사물,
사물과 사람 등 보이지 않는 상호작용에서 출발한
디자인 콘셉트이다.

To find the essence of objects, Lee Sukwoo
observed the interactions between people
and things. By considering the physical
characteristics of this interaction, he put in
a lot of thought into the design to develop
it into an object. It is a design concept that
begins from invisible interactions between
object and object and object and people.

촉감 폴더블 핸드폰
Tactile Foldable Mobile Phone

이석우가 대학교 졸업 후 삼성전자를 거쳐
미국 시애틀에 위치한 디자인 컨설팅 회사 티그의
산업 디자이너로 일할 때 디자인한 LG전자의
폴더블폰 콘셉트다. 마커 스케치와 2D 포토샵
렌더링을 통해서 디자인했다.

This is LG Electronics foldable phone
concept designed by Lee Sukwoo who
after graduating from university and
working at Samsung Electronics, then
became an industrial designer at TEAGUE,
a design consulting firm in Seattle, USA.
It was designed through marker sketches
and 2D Photoshop rendering.

디테일 스케치
Detail sketch

3D 프린트 후 그립감 체크
Grip test post 3D print

한 송이의 꽃을 위한 꽃병
Vase for Just One Flower

석고를 통한 3D 프린팅 방식을 활용했다. 많은
모델을 저해상도로 출력해 최적의 디자인을 찾아낸
것이다. 일반적인 화병 형태에서 시작해, 점점 형상을
허물고 변화를 주며 콘셉트를 발전시켰다. 제작에는
산업통상자원부와 한국디자인진흥원의 디자이너
육성 프로그램인 차세대디자인리더의 도움을 받았다.

The 3D printing method with plaster was
used. Many models were printed at low
resolution to find the optimal design.
Starting with a general vase shape, the
concept was developed by gradually
breaking down and changing the shape.
The production was supported by the
Ministry of Trade, Industry and Energy
and the Next Generation Design Leader,
a designer training program of the Korea
Institute of Design Promotion.

우뭇가사리 시리즈
Agar-agar Series

철망과 스티로폼을 이용해 만든 실물 레이어를
다양하게 포개며 실험한 뒤 콘셉트를 정리했다.
이를 기반으로 알리아스에서도 3D 레이어 포개기를
반복해 원하는 패턴과 구조를 찾아 나갔다.

After experimentation with various layers
made using wire mesh and Styrofoam, the
concept was finalized. Based on this, Alias
also repeated 3D layer superimposition to
find the desired pattern and structure.

알리아스 소프트웨어를 통한 모델링
Modeling with Alias software

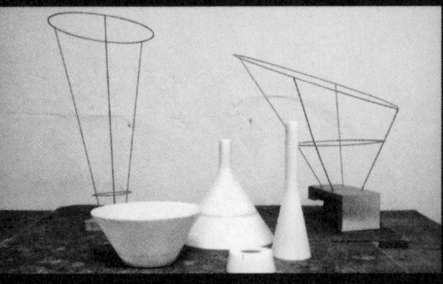

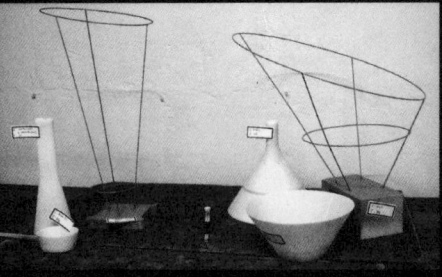

목업 제작 과정
Mockup production process

무중력 조명 시리즈
Zero-G Light Series

시리즈 중 하나인 라디오는 조명등의 형태를 다듬어
잡는 방법도 조작 사용성도 랜턴과 유사하다.
소리가 디바이스에서 발산되는 모양으로 디자인해,
라디오를 '음악을 비추는' 개념으로 재해석했다.

One of the series, the radio, is similar to
a lantern in terms of how to refine the
shape of the lighting and how to use it. The
radio was reinterpreted as the concept of
'lighting up music' by designing the sound
as emanating from the device.

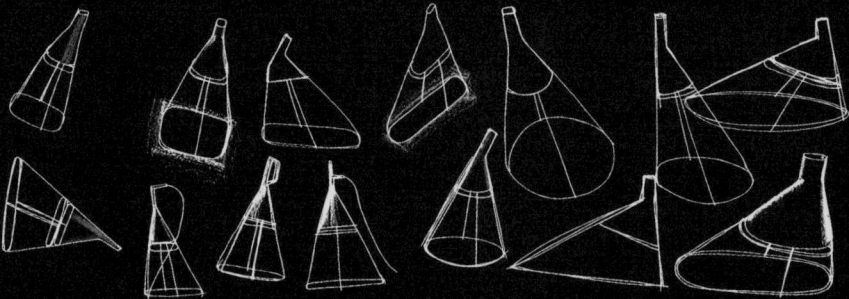

아이디어 스케치
Idea sketch

아파트 제품 아이덴티티
Apartment Product Identity

정사각형 디자인을 적용하려면 아파트 건축
도면에서 전기설비 부분을 바꿔야 했다. 이에 따라
전기설비팀과 긴밀하게 협력한 작업이다. 2D 렌더링
디자인을 1:1로 출력해 종이에 붙이고, 스케일을
가늠하면서 실제 감각과 사용성을 확인했다.
이런 작업은 디지털에서 구현 및 제조 과정으로
넘어갈 때 생기는 오차를 줄여준다.

In order to apply the square design, we
had to change the electrical equipment
part in the apartment building layout.
Accordingly, it was a work that required
close cooperation with the electrical
installation team. The 2D rendering design
was printed 1:1 and pasted on paper,
and the actual feeling and usability were
confirmed while measuring the scale. This
process reduces missteps and errors in
usability and in the process of moving from
digital to manufacturing.

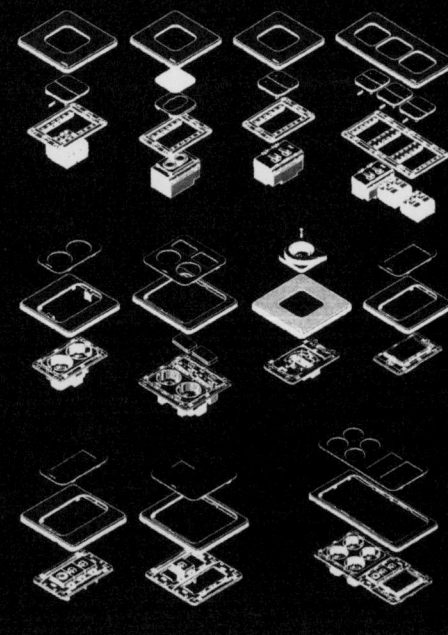

스위치 종류별 모듈 분해도
Module division by switch type

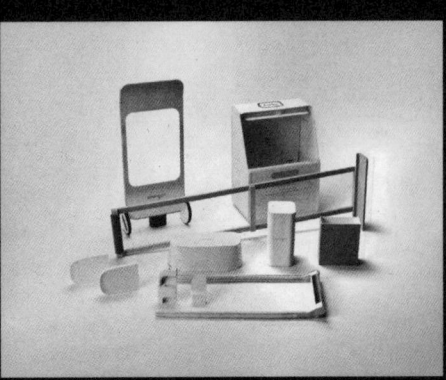

나무와 종이로 만든 초기 프로토타입
Early prototypes made of wood and paper

물병
Water Bottle

내부 이해 당사자 간의 관계를 분석해 비즈니스를
파악하고, 각 주체의 업무를 효과적으로 시스템화해
서비스 공급자의 업무 효율을 높였다. 이를 위해
마케팅, 제품 개발, 서비스, CS 조직과 워크숍
및 아이데이션을 전개했다. 공급자와 소비자의
접점에서는 여러 사용자 경험이 일어난다. 그중 가장
의미 있고 서비스 가치가 잘 드러나는 디자인을
채택했다.

The business side was understood by
analyzing the relationship between internal
stakeholders, and the work of each
entity was effectively systematized to
increase the work efficiency of the service
provider. To this end, we went forth with
marketing, product development, service,
CS organization, workshop, and ideation.
Many user experiences occur at the point
of contact between the supplier and the
consumer. The design that was the most
meaningful and showed the value of
service was chosen.

레그 퍼니처 시리즈
Leg Furniture Series

짬 날 때마다 의자나 조명등, 꽃병 같은 것을 노트에 자잘하게 그려왔다. 노트를 기반으로 다리에서 아이디어를 얻은 의자를 스케치했다. 슬슬 재미가 붙어 종이와 나무로 미니어처도 만들고, 내친김에 프로토타입[14]까지 제작하게 되었다. 이것이 매터&매터의 첫 컬렉션인 레그 체어의 원형이다. 스케치를 모델링해 입체로 만들고, 입체를 1:1로 확대한 도면을 만들어서 불완전하더라도 종이로 제작 가능하게 출력했다.

Whenever I had spare time, I drew small things like chairs, lights, and vases in my notebook. Based on the notes, I sketched a chair inspired by the leg part. Gradually, it became fun and we made a miniature out of paper and wood, and even made a prototype[14] with my own hands. This is the prototype of Matter & Matter's first collection, the leg chair. We modeled the sketch and made it three-dimensional, and printed in paper the enlarged three-dimensional sketch 1:1 so that it could be created even if incomplete.

←
061

스케치 목업 제작 과정
Sketch mockup production process

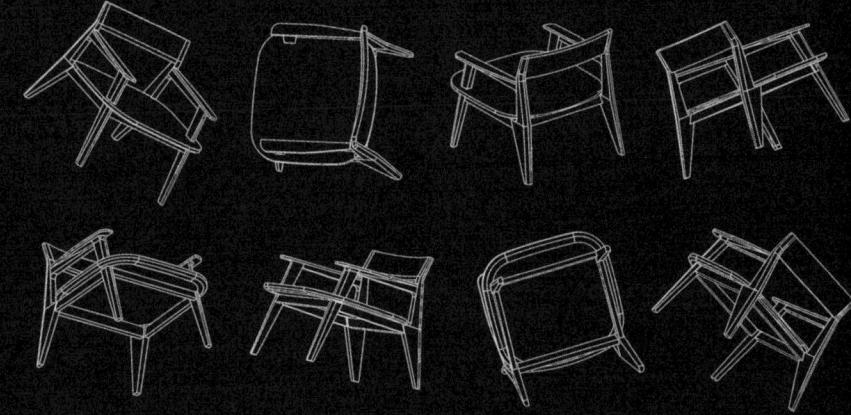

3D 모델링
3D modeling

인도네시아 현지 마스터 샘플 작업
Master sample work in Indonesia

노말 체어
Normal Chair

한국에서 만든 프로토타입과 도면을 인도네시아에
보내고, 인도네시아 공장에서 일차적으로 만든
프로토타입을 확인했다. 원하는 대로 조형이
만들어졌는지 검토한 뒤 수정사항이 있으면
현장에서 자르고 붙이고 가다듬었다. 변형된
프로토타입을 다시 검토하고 현장에서 수정사항
반영하기를 반복했다. 이 과정을 많이 거칠수록
디자인의 질이 높아진다.

Prototypes and drawings made in Korea
were sent to Indonesia, and prototypes
made primarily at the Indonesian factory
were confirmed. After reviewing whether
the model was created as desired, if there
were any corrections, we had the chair cut,
pasted, and refined on the spot. This was
repeated to review the modified prototype
again and reflect the modifications in
the field. The more you go through this
process, the higher the quality of the
design.

오리가미 체어
Origami Chair

노말 체어와 마찬가지로 도면을 인도네시아에
보내고 프로토타입을 확인하는 과정을 거쳤다.
인도네시아 현장에서 장인들이 바로 프로토타입에
표시해 크기나 비례를 바꾸면 몇 분 만에 수정된
디자인을 검토하고, 다시 수정한 디자인을 장인들과
함께 검토하는 방식으로 최종 마스터 모델을
만들었다.

As with the Normal Chair, the drawings
were sent to Indonesia and the prototype
was checked. On site in Indonesia, the
craftsmen marked the prototype right
away and reviewed the changed design
as soon as the size or proportion were
changed. Then the craftsmen reviewed the
revised design until the final master model
was made.

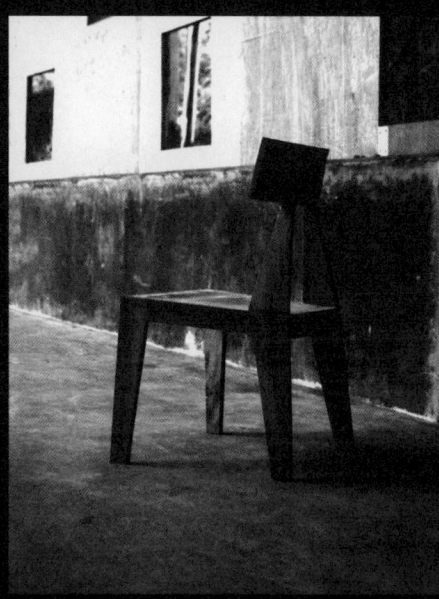

인도네시아 현지 마스터 샘플 작업
Master sample work in Indonesia

인도네시아 현지 가구 작업장
Indonesian local furniture workshop

윙 테이블
Wing Table

구조의 디자인에서 출발한 테이블이다. 스케치,
3D 모델링, 종이 목업 등의 과정을 거치며 구조를
확인하고 형태를 잡아갔다. 앉았을 때 편한지,
비례가 맞는지, 구조에 문제가 없는지 여러 일차적인
테스트를 거쳤다.

The Wing Table is a table that started from
the design of the structure. Through the
process of sketching, 3D modeling, and
paper mockup, we checked the structure
and developed the shape. It went through
several primary tests to see if it was
comfortable to use, if the proportions
were correct, and whether there were any
problems with the structure.

←
073

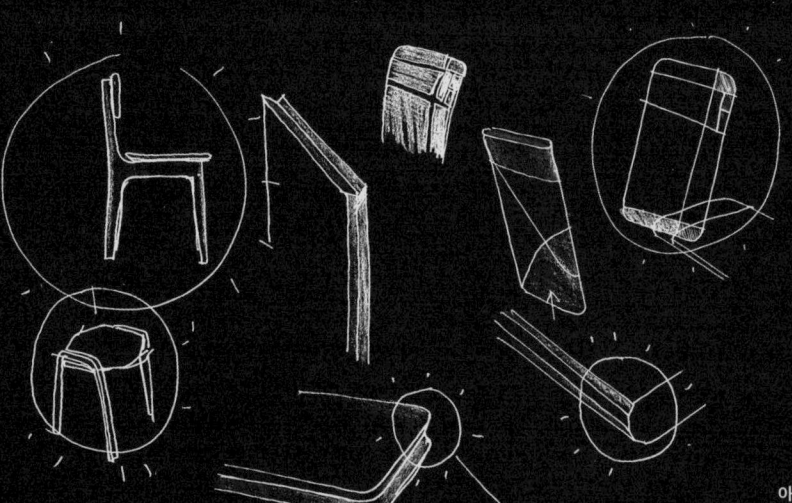

아이디어 스케치

도트 테이블
Dot Table

스티로폼을 잘라 빠르게 1:1 프로토타입을 먼저
만들고, 스케치를 나중에 하며 디자인 조형을 잡아
나갔다. 일반적인 프로세스를 거꾸로 전개한 것이다.
비례와 입체 구조의 최적화를 위해 많은 시간을
보냈다.

The shape design came into being by first
cutting Styrofoam into a 1:1 prototype first
and then sketching afterwards. This is the
reverse of the normal process. Much time
was spent on optimization of proportions
and three-dimensional structures.

인도네시아 현지 마스터 샘플 작업
Indonesian local master sample work

 ← 077

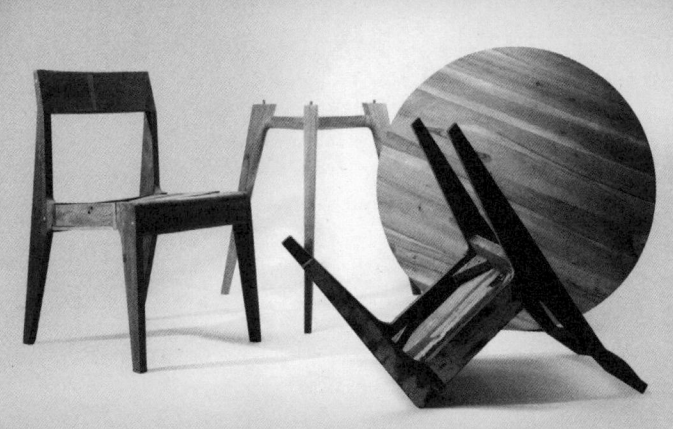

마스터 샘플 스튜디오 촬영
Master sample studio shoot

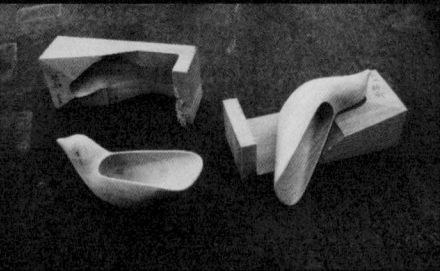

CNC 커팅 작업 과정
CNC cutting work process

트로피칼 버드
Tropical Bird

기존의 밋밋한 사각형 펜 트레이에서 벗어나고 싶어
새 모양으로 디자인했다. 날개와 등 부분에 놓은 펜이
새의 깃털을 형상화하도록 구성해, 사용자가 담은
펜에 따라 다른 분위기로 연출이 가능하다.

We designed a new shape to break away
from the existing plain square pen tray.
The pen placed on the wings and back is
configured as the shape of bird feathers,
so it is possible to create a different
atmosphere depending on the user's pens.

← 081

양산 공정
Mass production process

오래된 미래 테이블과 벤치
An Old Future Table & Bench

구 서울역사를 해체하면서 나온 폐목을 매터&매터의 레그체어 시리즈에 접목해 재해석했다. 가구를 만든 뒤 남은 자투리 목재는 CNC 가공해 서울역사 전체의 실루엣을 미니어처로 제작했다.

The wood from the demolished former Seoul Station was reinterpreted by grafting it into Matter & Matter's leg chair series. The scrap wood left over from the completed furniture was made with the CNC to create a miniature silhouette of the entire Seoul Station.

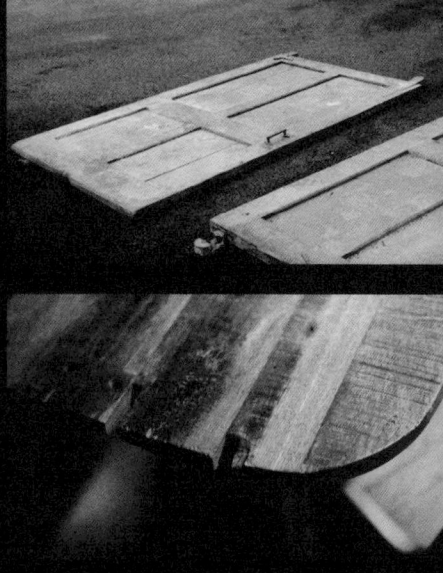

건조 중인 폐목
Wood that is drying

←
085

나무 수집 및 선별
Wood collection and sorting

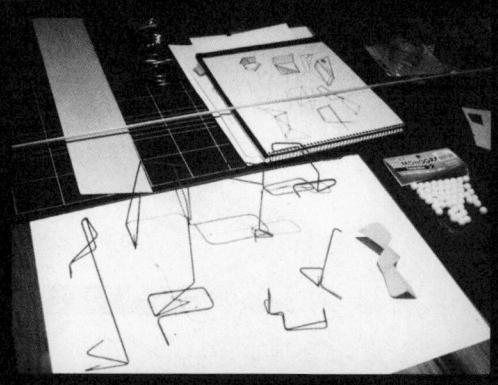

철사를 이용한 입체 스케치 과정
Three-dimensional sketching process using wire

프로토 벤치
Proto Bench

일반적으로 평면에 스케치를 하지만, 사실 우리가 생활하는 환경은 입체다. 입체를 생각하며 평면에 입체를 그리는 프로세스와 입체를 생각하며 바로 입체를 그리는 프로세스는 조금 다르다. 그리고 새로운 프로세스는 뜻밖의 결과물을 만들어낼 때가 많다. 프로세스를 어떻게 디자인하는지에 따라 결과물의 모습도 달라진다.

In general, sketches are made on a flat surface, but in reality, the environment we live in is three-dimensional. The process of drawing a three-dimensional object on a flat plane while thinking three-dimensionally is slightly different from the process of drawing a three-dimensional object while three-dimensional thinking. These new processes often produce unexpected results. Depending on how you design the process, the appearance of the result will also change.

← 089

입체 스케치를 종이 위로 옮긴 평면 스케치
A paper sketch of a three-dimensional sketch

숨쉬는 타일
The Respirer

종이는 평면에 가까운 재료지만 접거나 구부려서
입체를 만들 수 있다. 이런 속성에서 사물의
살갗이나 껍질, 껍데기와 유사한 느낌을 받았다.
갑옷과 물고기의 비늘을 상상하며 종이로 입체
스케치를 시작했다. 하나하나 접어서 형태를 만든
다음 연결하거나 잘라 붙이면서 모양새를 정리했다.
자연스레 종이의 재질적 특성을 반영하게 됐다.
디자인을 형태적으로 만들어간 것이 아니라, 과정에
사용한 재료의 특성이 조형에 나타난 것이다.

Paper is a near-flat material, but it can be
folded or bent to create a three-dimensional
shape. Because of these characteristics, it
is similar to the skin or shell of an object.
We imagined the scales of an armor and
that of a fish, and we started making
three-dimensional sketches using paper.
Each was folded to form a shape, then
connected or cut and pasted to form a
shape. I was naturally reflected the material
characteristics of paper. The design
was not developed into a form, but the
characteristics of the material used for the
created the form.

←
093

타일 아이디어 스케치
Tile idea sketch

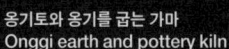

옹기토와 옹기를 굽는 가마
Onggi earth and pottery kiln

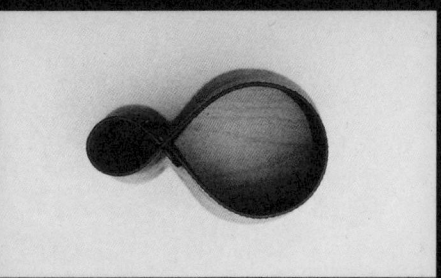

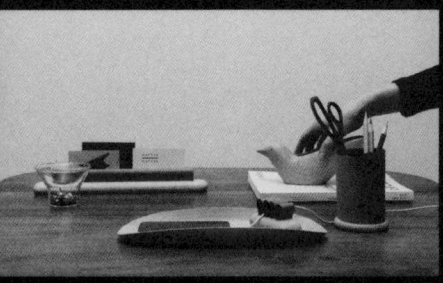

연출 사진 촬영 과정
Process of exhibit photo shoot

데스크 액세서리 시리즈
Desk Accessories Series

어떤 사람들은 재활용 소재에 거부감을 느낄 것이다.
업사이클 소재를 이용하면서도 최종 결과물은 기존
공산품과 유사하게 접근해 완성도를 높이기로 했다.
완전히 새로운 오브제로 재탄생하도록 소재를 전부
해체하고 다시 조합했다. 디자인을 진행하는 중에도
기초 소재에 관한 리서치를 꾸준히 병행했다.

Some people may feel reluctant to use
recycled materials. While using upcycled
materials, we decided to approach the
final product similarly to already existing
industrial products to improve the degree
of perfection. We disassembled and
reassembled all the material so the final
product could be reborn as a completely
new object. During the design process,
research on basic materials was carried
out in tandem.

←

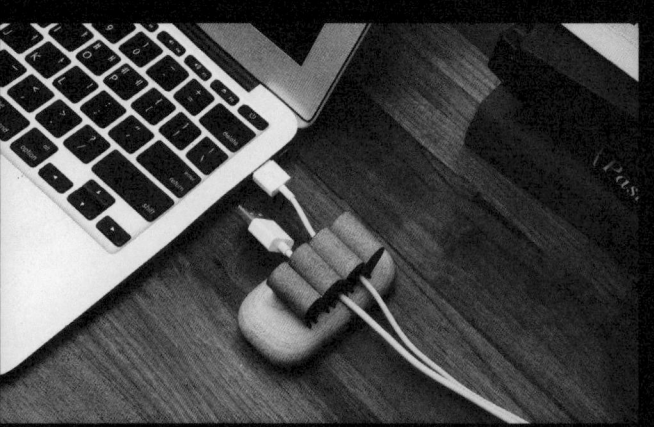

가죽 사이로 케이블을 정리하며
사용성 테스트
Usability test after
organizing cables through
leather

TV 리모컨
TV Remote Control

리모컨은 다양한 연령이 다양한 공간에서
사용한다. 본격적으로 디자인하기 전에 어떤 사용자
시나리오가 있을지 먼저 상상했다. 리모컨은 버튼의
정의가 중요하기에 초반부터 스크린의 UX를 고려해
버튼 디자인과 레이아웃까지 구체적으로 스케치했다.
처음 버튼을 디자인할 때는 스티로폼 바에 출력한
키패드를 붙이고 직접 눌러보는 등, 우리가
버튼을 어떻게 사용하는지 점검하며 레이아웃을
수정해나갔다.

The remote control is used by people of
various ages in various spaces. Before
designing in earnest, we first imagined
what kind of user scenario there could
be. Since the definition of the buttons is
important for the remote control, from
the beginning, the button design and
layout were sketched in consideration of
the UX of the screen. When we designed
the button for the first time, we modified
the layout by checking its utility such as
attaching a printed keypad to a Styrofoam
bar and directly pressing it.

← 101

사용성 향상을 위한 초기 프로토타입
Early prototypes for improved usability

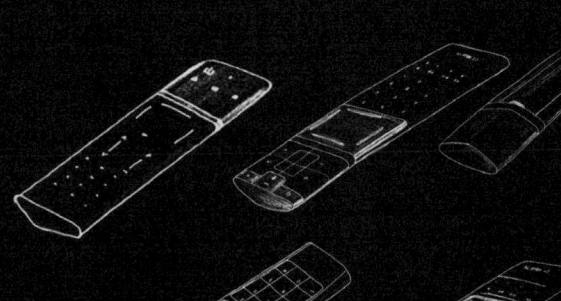

아이디어 스케치
Idea sketch

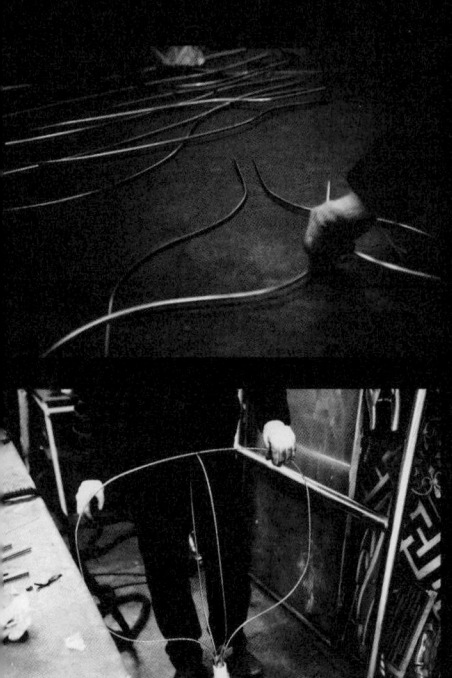

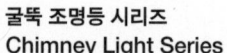

굴뚝 조명등 시리즈
Chimney Light Series

스타킹 천, 철사, 폼보드 등을 이용해 조형을 만들어 보면서 다방면으로 실험했다. 이런 과정에서 나온 형태는 순수한 조각으로 접근했다. 여러 가지 소프트 목업[15]을 나열하고 관찰하는 동안 모티브가 되는 디자인의 특징을 찾고, 이를 좀 더 정밀한 1:1 프로토타입으로 제작했다. 제작에 들어가면 조명등의 광원과 조도 등 여러 가능성을 한층 현실적으로 타진하게 된다.

We experimented in various fields while making the model using stocking material, wire, and foam board. The form that emerged from this process was approached as a pure sculpture. While listing and observing various soft mockups[15], we found the characteristics of the design that became motifs, and produced them as a more precise 1:1 prototype. During production, you will be able to more realistically explore various possibilities such as the light source and intensity of illumination.

←
105

청계천 철사점에서 만든 프로토타이핑
Prototyping at a Cheonggyecheon wire shop

입체 스케치 모델
Three-dimensional sketch model

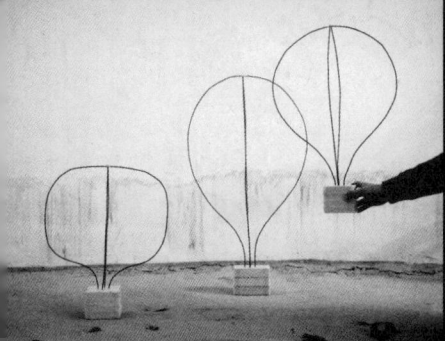

전자책 단말기
eBook Reader

전자책 단말기는 스마트폰 및 태블릿과 경쟁해야
한다. 기기 가장자리에 한 손으로 책장을 넘길 수
있는 인터페이스를 적용하자, 전자책 사용자 환경에
최적화 된 전자책 단말기만의 디바이스를 만들 수
있었다. 여기에 나만의 서재를 강조하는 GUI[16]를
적용했다.

E-book readers must compete with
smartphones and tablets. By applying
an interface that allows users to turn the
bookshelf with one hand on the edge of
the device, we made possible the creation
of a device optimized for the e-book
reader's environment. Here, we applied
GUI[16] that emphasizes "my book shelf."

UX 시나리오 계획
UX scenario planning

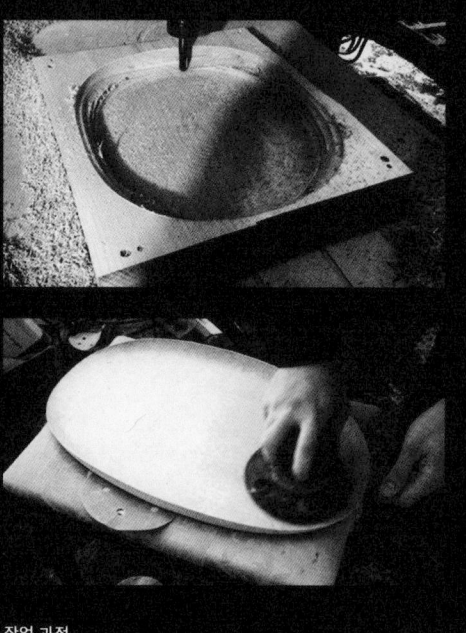

잎사귀 트레이
Leaf Tray

단순하게 조형할수록 비례와 디테일이 중요하다.
또한 CNC 가공을 통한 제작은 기계 작업과
수작업이 조화를 이루어야 한다. 디테일을 가장
최적화해 제조할 수 있도록, 디자인과 제조 시스템
사이에서 많이 고민한 프로젝트다.

The simpler the shape, the more important
proportion and detail are. In addition,
in CNC machine manufacturing, it is
important to balance machine work and
hand craft. It is a project that involves a
lot of thought between the design and the
manufacturing system so that the details
could be optimally manufactured.

작업 과정
Work process

← 113

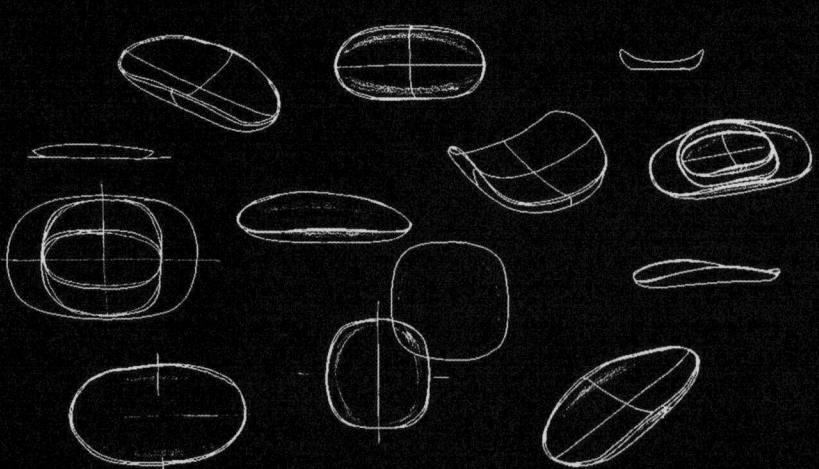

아이디어 스케치
Idea sketch

TV 셋톱 박스
TV Set-top Box

클라이언트만의 조형성을 고려해 이유 있는
디자인을 끌어내는 작업이었다. 사용자의 환경과
개성에 잘 어울릴 디자인을 고민하는 과정에서
아이디어를 찾고, 이를 기반으로 다시 제품을 분석해
새로운 관점에서 도출한 조형이 결정되었다.

It was project where the design was
developed upon deliberation of the "shape"
of our client, SK Broadband. The idea
was found while considering the user's
environment and personality and based on
this, we analyzed the product again and
decided upon a design with a renewed
perspective.

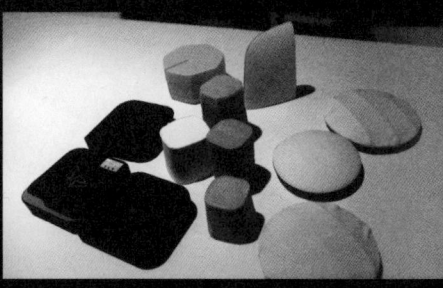

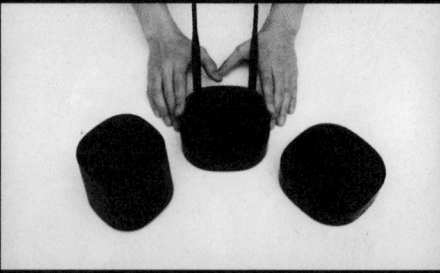

다양한 종이 목업 및 더미 목업을 통한 형태 연구
Research on shapes through various paper
And dummy mockups

117

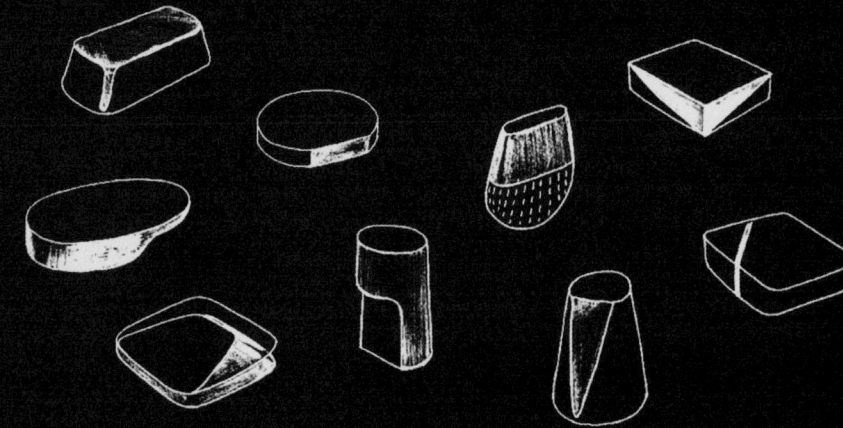

아이디어 스케치
Idea sketch

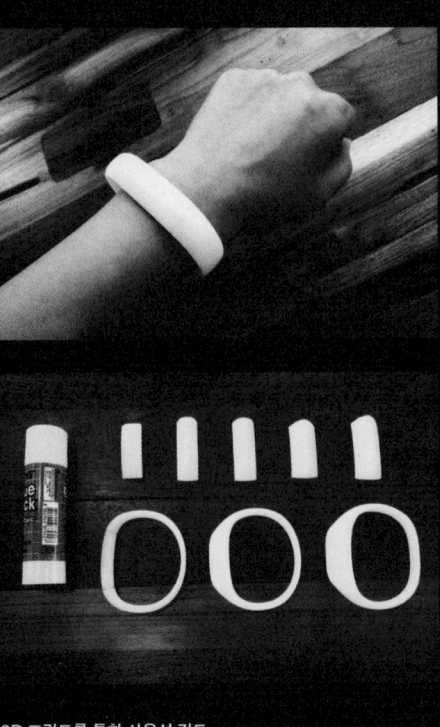

3D 프린트를 통한 사용성 검토
Review of usability through 3D print

스마트 밴드
Smart Wristband

웨어러블 디바이스는 개개인의 개성과 사이즈를
포용해야 하며, 최소한의 구조를 합리적으로
제조하는 게 관건이다. 설계 부분에서
엔지니어링과의 협업이 중요한 프로젝트였다.
여러 사람의 손목을 실측하고 성향별로 분리해
다양한 디자인의 스트랩을 구현할 수 있도록 했다.

The important point of wearable devices is
the production of a design that considers
individual personality and size with a
minimalist form that is reasonable. The
collaboration with engineers in the layout
was very important. We analyzed wrists of
various people and divided by preference
in order to generate diversified designs.

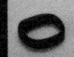
←

3D 모델링
3D modeling

오피스 가구 시리즈
Office Furniture Series

오피스마다 그들만의 업무 방식과 문화가 있다.
시나리오 스케치를 진행하며 업무 환경의 문제점과
개선점을 찾고 이것을 모티브로 삼았다. 디자인을
발전시키는 과정에 선택된 몇 가지 안으로 1:1
스케일의 목업을 만들어 사용성을 검증하고, 구현
가능성 및 양산성 평가를 진행했다.

Each office has its own way of working
and office culture. As we proceeded with
the scenario sketch, we found problems
and parts for improvements in the work
environment and took these as a motif.
We made a 1:1 scale mockup of some
designs we selected in the process of
improving the design to verify usability,
and proceeded with feasibility evaluation
and mass production.

아이디어 스케치
Idea sketch

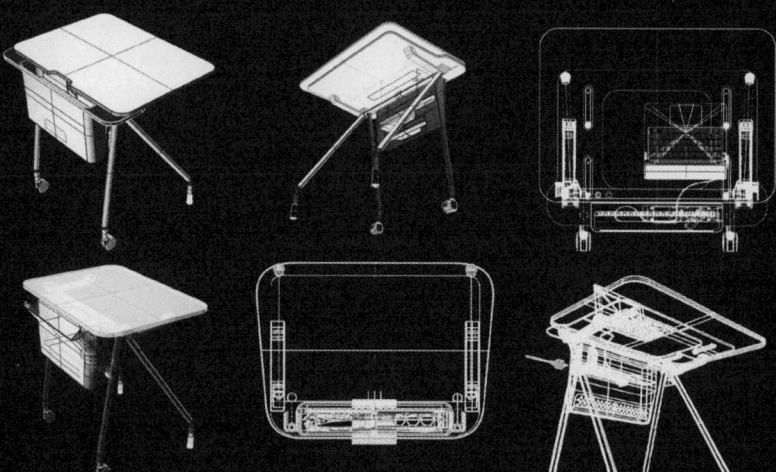

3D 모델링
3D modeling

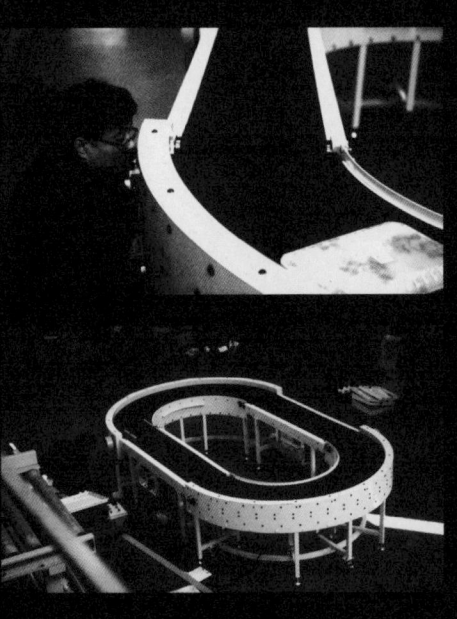

브랜드 스토어
Brand Store

클라이언트인 CJ의 역사와 문화를 반영하기 위해 과거에서 많은 모티브를 가져왔다. 컨베이어 벨트가 실제로 돌아가게 하기 위해 제작 업체와 협의하면서 디자인을 구체화했다. 기업 심볼 마크를 단순하게 패턴화해 기념품과 패키지에 적용하기도 했다.

Many motifs were taken from the past to reflect the history and culture of the client, CJ. To make the conveyor belt go round, the design was refined in consultation with the manufacturer. The corporate symbol was simply patterned and applied to souvenirs and packaging.

컨베이어 벨트 설치 과정
Conveyor belt installation process

아파트 인테리어 조명 시리즈
Apartment Interior Light Series

초창기에는 다목적 공간을 고려했다. 광원을
다양하게 연출할 수 있도록, 조명등 자체에
집중하기보다 광원의 설정이 용이한 디자인에
초점을 맞춰 아이디어를 전개했다. 진행하면서
광원을 LED로 교체했고, 이에 따라 광원의 색상과
밝기 및 무드가 전자적인 느낌으로 연출되었기에,
점점 더 단순하고 본질적인 형태로 다듬어졌다.

Initially, rather than focusing on the lighting
itself, we developed the idea by focusing
on a design that allows easy setting of
the light so that the light source could be
displayed in a variety of ways depending
on multi-purpose spaces. As we
progressed, the light source was replaced
with an LED, and the color, brightness, and
mood of the light source were produced
electronically, so that the form was refined
to be simpler and more essential.

종이 소프트 모델로 조도 및 조형 테스트
Illumination and sculpture testing with
paper soft models

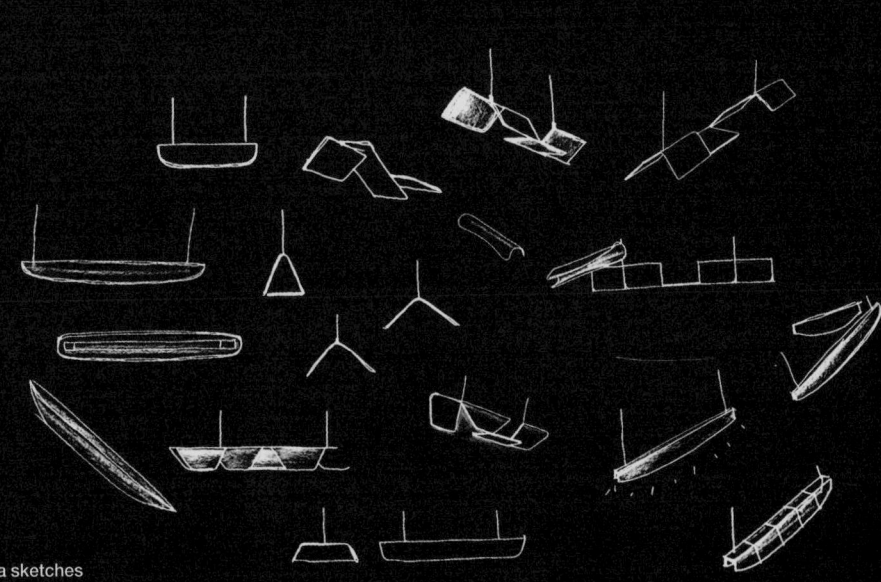

다양한 실내등 아이디어 스케치
Various interior lighting idea sketches

3D 모델링으로 엔지니어링 검토
Review of engineering with 3D modeling

스마트 스피커
Smart Speaker

스피커가 가장 안정적으로 서면서도 사운드 효율이 제일 좋은 각도로 조형했다. 구부린 알루미늄 타공판을 적용해 소재감을 살리고, 안쪽에 듀얼 트위터와 듀얼 우퍼를 장착했다. 모서리 상단에는 터치 센서를 적용해 직관적인 조작이 가능하도록 디자인했다.

The speaker was created to stand at the most stable angle and with the best sound efficiency. A curved aluminum perforated plate was applied to enhance the texture, and in the interior a dual tweeter and dual woofer were installed. The speaker was designed to enable intuitive operation by touch sensor at the top corner.

우산
Umbrella

스케치만으로는 디자인하는 대상의 결과를
구체적으로 판단하기 어려울 때가 있다.
우산 손잡이도 팔에 걸 수 있는 다양한 형태를
만들어 비교했다. 그러는 동안 점점 원형에
가까운 형태로 진화했다.

Sometimes it is difficult to judge the
results of the design object in detail with
sketches only. Umbrella handles were also
compared by making various shapes that
could be hung on the arm. In the meantime,
the Umbrella gradually evolved into its
original shape.

손잡이 스케치
Handle sketch

사용성을 고려한 손잡이 스케치
Handle sketch considering usability

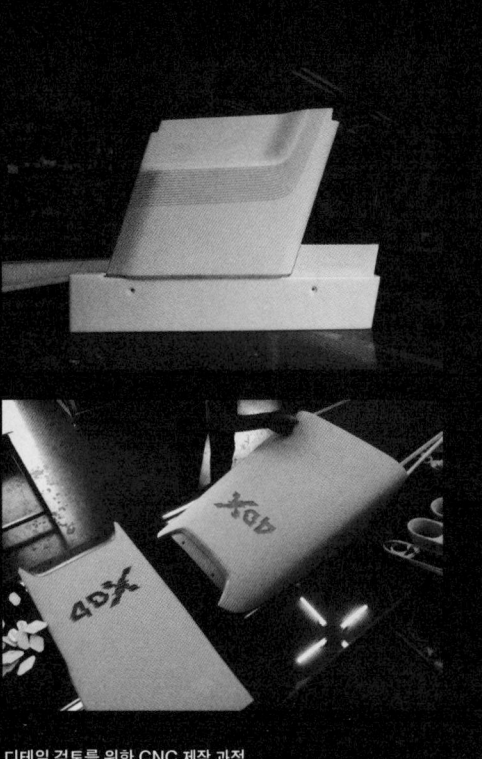

디테일 검토를 위한 CNC 제작 과정
CNC production process for detail review

4D 영화관 의자
4D Theater Chair

사이드 커버와 백 커버에는 바닥을 향해 빛나는
LED 조명등을 달고, 아래면에 위치한 반사광이
이를 받쳐주도록 했다. 눈부심을 방지하는 동시에
자기 자리를 편하게 찾을 수 있도록 해주는 유도등
역할을 한다. 또 하나의 특징은 세 방향에서
입체적으로 감싸는 쿠션이다. 사용자에게 편안한
감상을 제공하기 위해 설계했다. 다양한 연령
및 성별에 걸친 대상군의 데이터를 분석해 만든,
인체공학의 총체적 결과물이라고 할 수 있다.

On the side and back cover, we attached
LED lights that shone toward the floor,
and the at the bottom were reflected
lights. These acted as a guide light that
prevents glare and makes it easier to find
seats. Another unique feature is a cushion
that wraps three-dimensionally in three
directions. It was designed to provide a
comfortable movie experience to users.
The 4D Theater Chair can be said to be the
overall result of ergonomics created by
analyzing the data of the test subjects by
various ages and gender.

플록 벌브
Flock Bulb

원형, 반원형, 활꼴, 부채꼴 등 여러 조합을 실험했다.
크로키 노트에 펜과 색연필로 거칠게 스케치한
이미지를 토대로 끈을 직접 천장에 걸어서 형태를
다듬으며 작업했다.

Several combinations were tested, such
as circular, semicircular, arcuate, and
sectoral. Based on the rough sketches
with a pen and colored pencils in a croquis
notebook, the bulb's shape was refined by
actually hanging objects on a string from
the ceiling.

149

실제 설치 전 끈을 달아보는 과정
Process of attaching the string before actual
installation

샘플 제작 과정
Sample
production
process

컬러 팔레트 테스트
Color palette test

라이프 클락 재난 키트
Life Clock Disaster Kit

가장 중요한 건 '재난 상황이 발생했을 때 쉽게 찾아
사용할 수 있는가'였다. 시계는 집에 두고 자주 보는
사물 중 하나다. 언젠가 건전지를 교체하기 위해
열어보니 의외로 내부에 여유가 많았고, 사용할
수 있는 특별한 공간이라고 생각했다. 필수 제품을
선택하는 과정에는 SWNA 디자인팀뿐 아니라
응급대원, 소방관, 의사, 간호사, 재난 전문가 등 많은
사람의 인터뷰와 정성 조사를 진행했다.

The most important question was, "Is the
product easy to find and use in case of
a disaster?" A clock is an object that we
keep at home and look often. One day,
when I opened a clock to replace the
battery, there was surprisingly plenty of
space inside. I thought this was a special
space that could be utilized. In the process
of selecting essential products, not only
the SWNA design team but also first
responders, firefighters, doctors, nurses,
and disaster experts were interviewed and
research done.

스마트 충전기
Smart Charger

처음부터 충전하며 음악을 들을 수 있는 형태를
고민했다. 소리가 잘 증폭되는 뿔 형태로도
만들어보고, 힌지를 넣어 기능적으로도 접근해보고,
조명등이나 거치 형태를 새롭게 해보기도 했다.
각 형태는 스케치하고 실물을 만들어 검증했다.

From the beginning, we thought about
a form in which music could play while
charging. We made it into a horn shape
that amplified the sound well, added a
hinge to for functionality, and also tried
a new lighting or mounting shape. Each
form was checked by sketching and being
made.

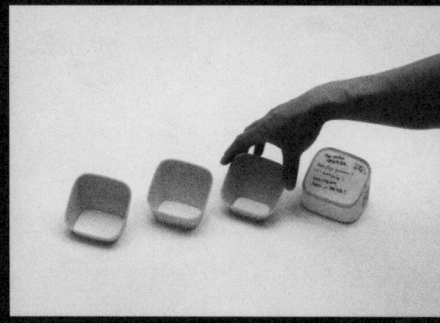

다양한 소재를 이용한 1:1 소프트 목업
1:1 Soft mockup using various materials

157

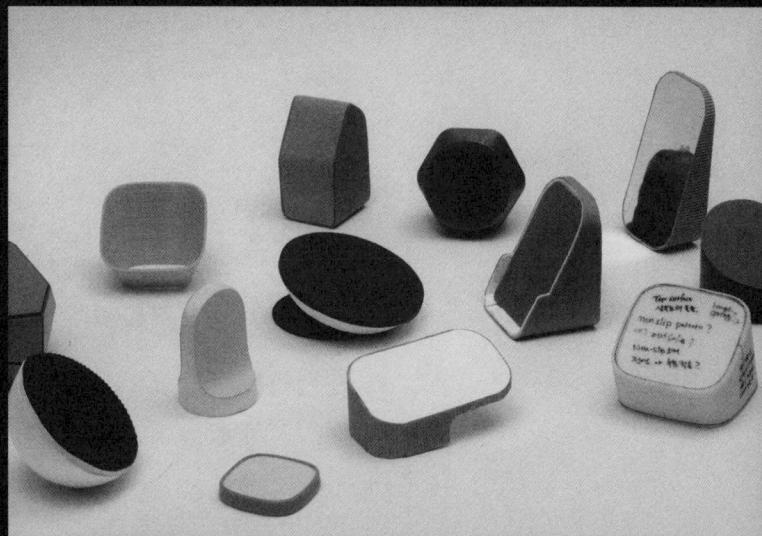

여러 모양의 소프트 목업을
통한 형태 연구
Formal studies through soft
mockup of different shapes

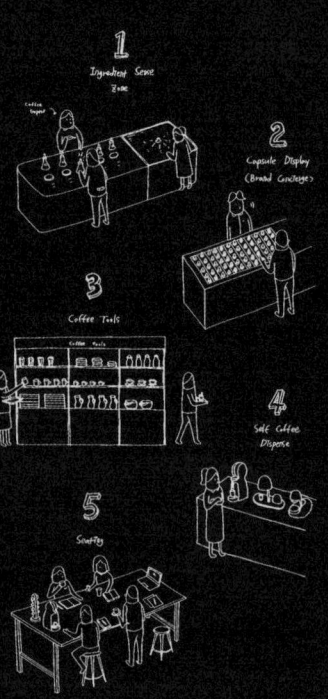

플래그십 스토어 카페
Flagship Store Cafe

공간 디자인은 가구와 테이스팅 오브제를 기반으로 마감재와 조명 구조를 결정했다. 먼저 소비자의 경험 지도를 그려보고 거기에 맞는 오브제 디자인을 진행했다. 이후 경험 지도를 공간에 반영하는 방식으로 서비스 존을 정의해 공간 디자인을 발전시켰다.

For the space design, the finishing materials and lighting structure were decided based on the furniture and tasting objects. First, we drew a map of the consumer's experience and proceeded to design an object to match these experiences. Afterwards, we developed the space design by defining the service zone that reflected the experience map to the space.

소비자 경험 지도 스케치 1
Consumer experience map sketch 1

161

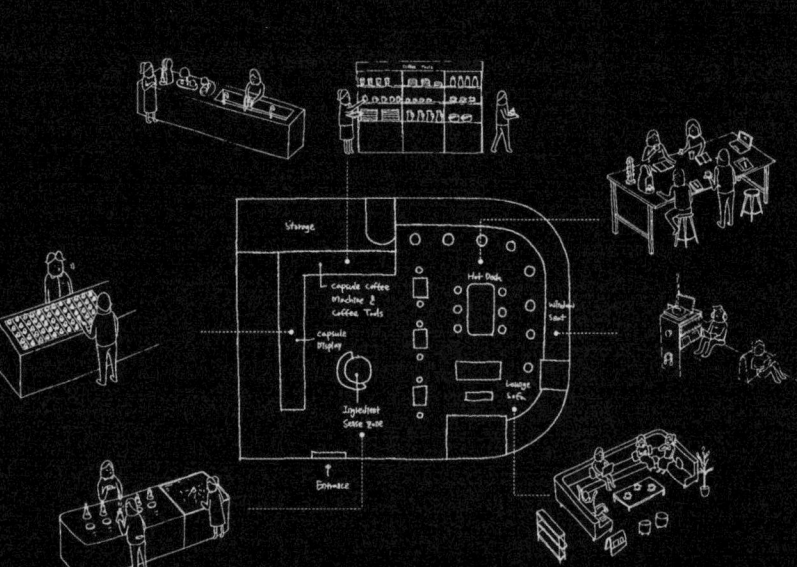

소비자 경험 지도 스케치 2
Consumer experience map sketch 2

그래피컬 조명
Graphical Light

한때 한국 근대화의 주역이었던 을지로는 기술이
빠르게 발전하면서 쇠퇴했다가, 최근 많은 예술가와
디자이너가 다시 모여든 지역이다. 제조업 장인과
창작자들이 자아낸 시너지 효과 덕분에 창조의
중심지로 주목받았다. 이 프로젝트는 잠재력을
가진 을지로 조명 상가와 디자이너가 상생하는 시장
구조를 만들려는 노력의 일환이라고 할 수 있다.

Euljiro, once a leader in Korea's
modernization, went through decline
due to rapid technological development,
but recently many artists and designers
have gathered there again. Thanks to
the synergy created by manufacturing
craftsmen and creators, it drew attention
as a center of creativity. This project can
be said to be part of an effort to create a
market structure in which the potential of
the Euljiro lighting district and designers
can coexist.

수수깡을 이용한 2D 스케치 입체화
3D rendering of 2D sketch using
sorghum straws

←
165

청계천 용접집에서 용접 작업
Welding work at a welding shop
by Cheonggyecheon

1차 3D 프린트 테스트
First 3D print test

2018 평창 동계 올림픽 메달
2018 PyeongChang Winter Olympic Medal

한글을 길게 늘인 형태가 과연 메달이 될 수 있을지 확인하고자 먼저 3D 프린터로 프로토타입을 만들어보았다. 그 덩어리에서 가능성을 얻어 조형을 다듬어나가며 형태를 시험했다. 제품을 양산하기까지 3D 프린팅을 비롯해 여러 디자인 목업[17], 프로토타입 작업을 거쳤다. 특히 목에 거는 리본 부분은 샘플의 색상과 패턴이 주는 느낌을 양산 과정까지 유지하는 게 매우 어려웠다. 열 번도 넘는 샘플 제작을 거치고, 갑사 기법을 사용한 최종 메달 스트랩 디자인이 나왔다.

To check whether the elongated shape of Hangeul could become a medal, we first made a prototype with a 3D printer. We obtained possibilities from the mass, refined the form, and tested the shape. Before mass production of the product, the medal went through various design mockups[17] and prototypes, including 3D printing. Especially, for the ribbon part, it was very difficult to maintain the feeling of the color and pattern of the sample until the mass production process. After making more than ten samples and from this, we used the Gapsa technique for the final ribbon design.

한글을 3D에 입히는 과정
The process of displaying
Hangul on 3D

서클 피콕과 테일 버드
Circle Peacock & Tail Bird

클라이언트의 인스턴트 냉면 전용 조리도구를
제작해 소비자의 편의성을 높이고 스토리 있는
브랜드로 만들고 싶었다. 두 달 남짓 개발을 진행하는
동안 수많은 냉면을 직접 조리해 먹으며 사용성을
연구하고, 20개가 넘는 프로토타입을 만들었다.

By creating a cooking tool for the client's
instant naengmyeon, we wanted to
increase the convenience of consumers
and make a brand with a story. During
the development of the product for about
two months, we cooked and ate a lot of
naengmyeon while studying the usability,
and made more than 20 prototypes.

프로토타입을 통해 실제 조리 테스트
Real cooking tests with prototypes

설치 시뮬레이션과 천 샘플
Installation simulation and fabric
samples

버클 조명 시리즈
Buckle Light Series

광원 부분에 천을 걸쳐 빛이 직접적으로 보이지
않게끔 의도했다. 천의 재질은 빛 투과가 용이한
것으로 선택해, 빛이 천에 가려 너무 어두워지지
않게 했다. 사용자의 기호에 따라 공간 분리 역할도
할 수 있도록 디자인했다.

We intended that the light would not be
seen directly by placing a fabric over the
light source. The material of the cloth was
chosen to allow light to pass through so
that the light did not become too dark by
being covered. The series was designed to
act as a space partition according to the
user's preference.

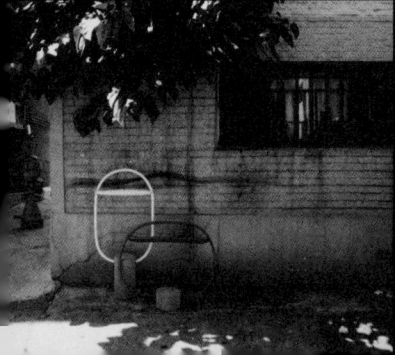

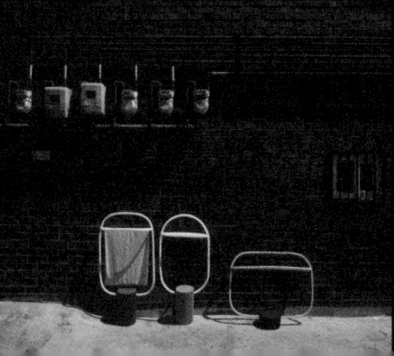

1:1 소프트 모델 촬영
1:1 soft model
shooting

문화역서울284 굿즈 시리즈
Culture Station Seoul 284 Souvenir Series

서울역 곳곳의 계단은 각자의 쓰임새뿐 아니라
그에 따른 형태도 모두 달랐다. 계단 한 칸의 폭과
높이, 난간 형태, 크기까지 천차만별이었다. 그 많은
계단의 단면을 자르면 또 다른 형태가 나타났다.
때로는 균형을 깨야 새로운 균형을 찾을 수 있다.

Stairs throughout Seoul Station differed
not only in their use, but also in their shape.
The width and height of each stairwell,
the shape of the balcony, the size… all
were different. Another shape appeared
when the side of the many stairs was cut.
Sometimes the existing balance needs to
be broken in order to find a new one.

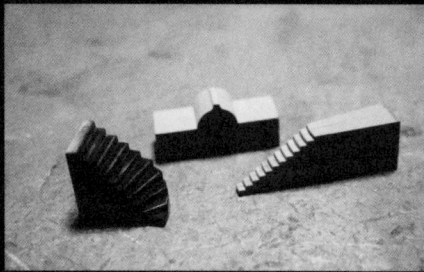

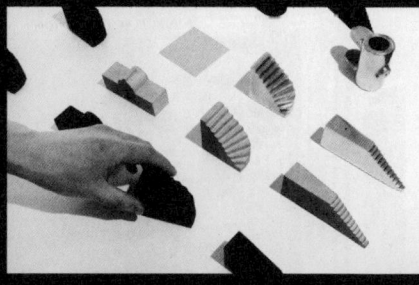

알루미늄 후가공
Aluminum post-processing

사형 주조 과정
Sand mold casting process

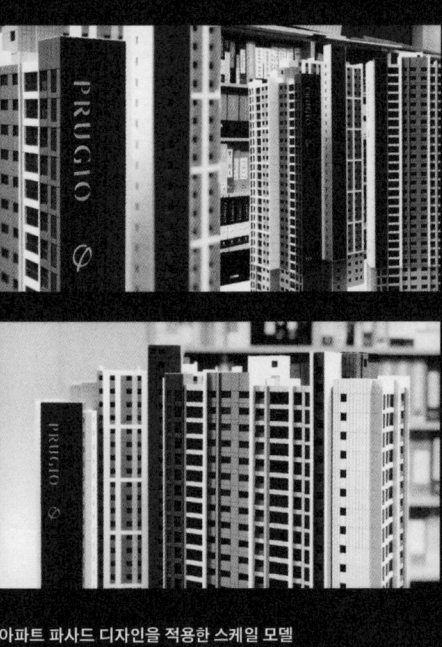

아파트 브랜딩 및 마스터플래닝
Apartment Branding & Masterplanning

아파트도 아름다운 건축물이 될 수 있다는 것을
보여주기 위해 형태에서부터 변화를 꾀했다.
평면 구조에 컬러만을 이용해 입면을 치장했던
단편적 변화에서 탈피하는 게 그 시작이었다. 옥상
구조물을 강조하거나 창의 구조를 뒤틀고, 파사드에
입체적인 면을 더하는 등 평면의 단조로움을
벗어나기 위해 다채롭게 시도했다.

In order to show that an apartment can
also be beautiful architecture, the form
has to change. This was the beginning
of breaking away from the fragmentary
changes that used only color to
decorate the façade on a flat structure.
Various attempts were made to escape
the monotony of the flat surface by
emphasizing the roof structure, tweaking
the structure of the window, and adding
a three-dimensional aspect to the façade.

아파트 파사드 디자인을 적용한 스케일 모델
Scale model with apartment façade design applied

←
185

다양한 렌더링 초안
Various rendering drafts

리그 오브 레전드 트로피
Trophy LOL

알루미늄은 정교한 제작이 가능하고, 무게를 줄일
수 있으며, 그 고유의 특성이 잘 나타난다. 트로피의
각 라인에 명도와 휘도를 다르게 적용하기 위해
알루미늄 3D 프린터로 아노다이징[18]과 부분 도장을
진행했다. 이를 통해 빛의 각도에 따라 이미지가
달라지는 트로피를 완성했다.

Aluminum can be elaborately
manufactured, can reduce weight, and
exhibit its unique properties well. In order
to apply different brightness and its
distribution for each line of the trophy,
we performed anodizing[18] and partial
painting with an aluminum 3D printer.
Through this, we completed a trophy
whose image changes depending on the
angle of light.

←
189

디테일 3D 프린트 테스트
Detail 3D print test

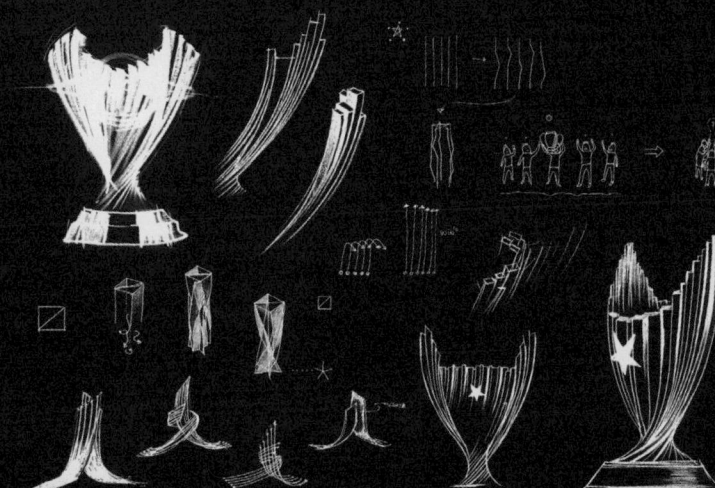

아이디어 스케치
Idea sketch

실제 오브젝트 제작 과정
Real object creation process

스테이션 지오메트리
Station Geometry

구 서울역의 기둥, 지붕, 계단 등 건축적인 요소의
형태를 관찰하고 기록했다. 요소의 부분을 확대해
강조하기도 하고, 전체를 기하학적인 형태로
재해석하는 등의 변형을 거치는 동안 추상적인
형태를 갖춘 오브제로 스케치했다. 목재나
아크릴부터 시작해 종이, 타공판 등 주변의 재료를
활용해 여러 질감을 표현했다.

We observed and recorded the forms
of architectural elements such as pillars,
roofs, and stairs in the former Seoul
Station. Abstract sketches of objects were
done with elements that were expanded
and emphasized and whole geometric
shapes reinterpreted. Starting with
wood and acrylic, various textures were
expressed using surrounding materials
such as paper and perforated boards.

백상예술대상 트로피
Trophy Baeksang

은박 종이를 이용해서 만든 곡선에 칼집을 낸 후
앞뒤로 접어서 기둥 형태를 만들었다. 다각도로
촬영해 이미지화하고, 이를 기반으로 3D 모델링을
정리해 조형을 다듬어 나갔다.

After a cut was made on the curve made
from silver foil paper, the trophy model
was folded back and forth to create a
column shape. We took pictures from
various angles and imaged them, and
based on this, we organized 3D modeling
and refined the final model.

3D 모델링을 통한 조형 테스트
Model testing using 3D modeling

스케치 목업과 스케일 모델
Sketch mockup and scale model

콘크리트 커튼
The Curtained Wall

가상 3D 시뮬레이션으로 바람을 일으켜 휘날리는
커튼을 상황별로 캡쳐하고, 이를 디지털 모델링으로
옮겨 다섯 개의 커튼 벽을 디자인했다. 이 과정에서
스스로 서 있을 수 있도록 구조 연구를 병행했다.
콘크리트 3D 프린터 회사와 협업해, 3D 프린터의
두 가지 노즐이 서로 다른 분사액을 분사하는
방식으로 적층해 완성했다.

Five curtain walls were designed by
capturing curtains blowing in the wind
in different situations using a virtual 3D
simulation and transferring them to digital
modeling. In the process, structural studies
were carried out so that it could stand on
its own. In collaboration with a concrete
3D printer company, the art was created
by using two nozzles of the 3D printer that
stacked-sprayed different liquids.

←
201

콘크리트 3D 프린트 과정
Concrete 3D printing process

한글 2.5
Hangeul 2.5

평면의 한글에 3D 모델링 툴을 이용했다.
XYZ 축의 중력을 바꾸어가며 입체화하는 과정을
거쳐, 다양한 조형 실험을 통해 1차 모델링을
정리했다. 이를 스케일 모델로 3D 프린트해 검토한
후 다시 3D 모델링 수정을 반복해 조형을 다듬어
나갔다.

A 3D modeling tool was used for flat
Hangeul. By going through the process of
three-dimension by changing the gravity
of the XYZ axis, we organized the primary
modeling through various modeling
experiments. After reviewing the 3D
printing of the scale model, we continued
the process of refinement through 3D
modeling.

사형 주조를 위한 목형 제작
Mold making for sand casting

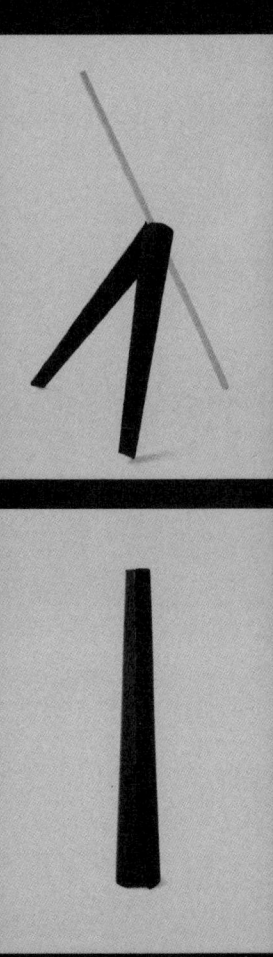

태극기함
Korean Flag Case

트라이포드로 세울 수 있으면서도 퀄리티 높은 외관을 구현하기 위해 구조 설계와 금형 수정을 반복했다. 디자인을 시작한 후 6개월 만에 안정된 초기 샘플을 제작했다. 네이버 해피빈을 통해 펀딩을 진행했으며, 2019년 10월 20일 기준으로 한 달 만에 1만 9,772%를 달성해 총 7만 개가 팔렸다. 수익금은 독립 유공자들에게 기부되었다.

We repeated structural design and metal mode modification to achieve a high-quality appearance while being able to stand as a tripod. A stable initial sample was produced six months after starting the design. Funding was gathered through Naver Happy Bean, and as of October 20, 2019, it achieved 19,772% in one month and sold a total of 70,000 cases. Proceeds were donated to national independence fighters.

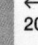

←
209

구조 검토를 위한 테스트
Test for structural review

작업 초기의 다양한 형태 연구
Research on various shapes in the early stages of work

화장품 용기
Cosmetic Bottle

효과적인 스케치를 위해 먼저 펜으로 그린
다음 디지털로 옮겨왔다. 여기에 리터칭을 하거나
재질을 입혀 보는 등 다양하게 실험했다.
이를 통해 3D 스케치 렌더링으로 나아갔다.

For effective sketching, I first drew with a
pen and then transferred it digitally. And
then through various experiments such as
retouching or coating materials, I moved
on to 3D sketch rendering.

디지털로 옮긴 펜 스케치
Digitally transferred pen sketches

골판지 모델을 통한 비례와 조형성 연구
Research on proportion and shape through
corrugated cardboard modeling

공기청정기
Air Purifier

골판지 종이의 단순한 세로 패턴은 공기의 흐름을
연상케 한다. 골판지를 다양한 원기둥 형태로 말아서
비례와 조형성을 연구하고, 여러 모델을 비교하며
다듬고, 내부 컴포넌트에 적용하는 작업을 거쳤다.

The simple vertical pattern of corrugated
paper is reminiscent of the flow of air.
Corrugated cardboard was rolled into
various cylindrical shapes and proportions
and form were researched. Many models
were compared and refined and then
applied to internal components.

암 체어
Arm Chair

암체어는 의자에 앉았을 때 자세가 편안한 게
중요하다. XPS[19]로 다양한 레이어를 만들어 붙이고,
각도별로 직접 앉아보았다. 최소의 공간을 차지하며
최적의 자세가 가능한 구조를 잡는 데 시간을 많이
보냈다.

It is important to have comfortable posture
when sitting in an armchair. We made and
pasted various layers with XPS[19], and sat
down at different angles. A lot of time was
spent figuring out a structure that takes up
the least amount of space and also allows
for the best posture.

실제 착석을 위한 1:1 구조물
1:1 structure for actual sitting

←
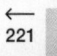
221

구조 연구를 위한 종이 목업
Paper mockup for structural
research

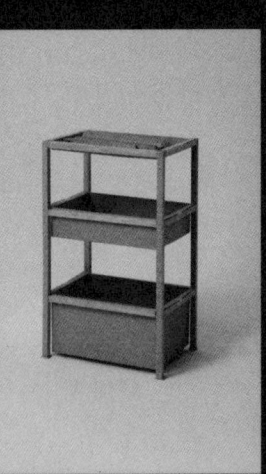

목재로 만든 프로토타입
A wooden prototype

트롤리
Trolley

가구를 디자인할 때는 다양하게 프로토타이핑하기 위해 넓은 공간이 필요하다. 수납 공간의 깊이나 높이, 그리고 들어가는 오브제의 특성을 고려해서 처음부터 나무와 골판지 등을 이용해 실물 크기로 만들어 보았다. 가구가 일상에서 효과적으로 쓰이도록 만들기 위해 노력했다.

When designing furniture, you need a lot of space for prototyping in a variety of ways. By considering the depth and height of the storage space and the characteristics of the object to be entered, we tried to make the trolley in life size using wood and corrugated cardboard from the beginning. Efforts were made to make furniture effectively used in everyday life.

트레이
Tray

골판지를 이용해 사이즈와 비례감을 다양하게
연구했다. 그래픽적으로 안정적인 비율을 찾는 동안,
이런저런 소품을 직접 수납해보며 기능적으로도
알맞은 사이즈를 찾아갔다. 기본 도형으로 이루어진
단순한 형태의 제품이기에 트레이의 깊이, 두께 등
디테일한 부분을 더욱 세심히 디자인했다.

Using corrugated cardboard, we studied
the size and sense of proportion in various
ways. While looking for a graphically
stable proportion, we directly tried to
store various small items and found a
functionally appropriate size. Since it is
a simple product made of basic figures,
detailed parts such as the depth and
thickness of the tray were designed more
carefully.

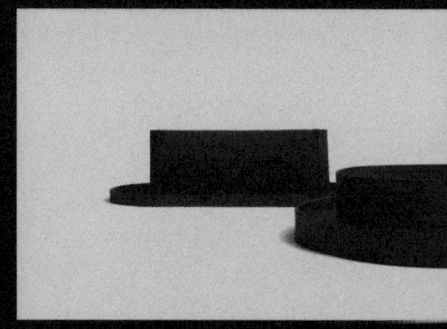

사용성 테스트
Usability test

다양한 형태 연구
Research on various shapes

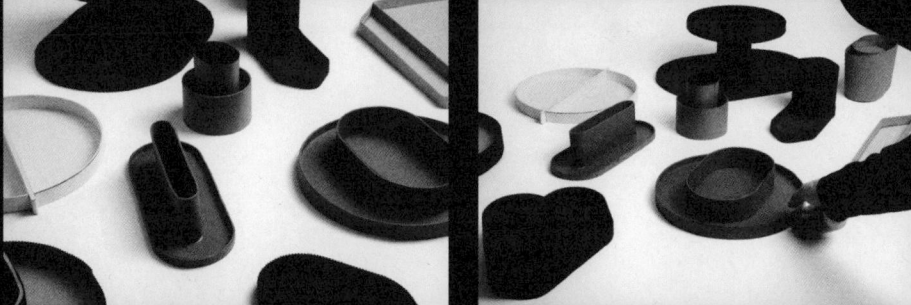

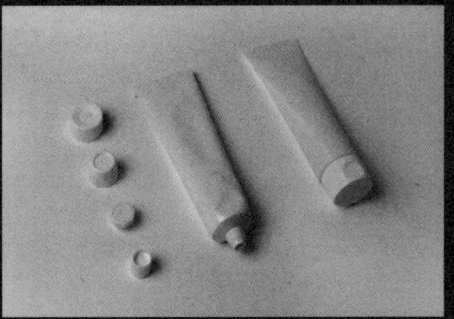

치약 뚜껑 형태 연구
Research on toothpaste cap shape

치약
Toothpaste

치약 패키지의 재질은 신문지를 재활용한 펄프로 구성했다. 종이로 먼저 프로토타입을 만들어 보고, 3D 프린터를 이용해 안을 좁혀 나갔다. 이 상자는 다른 용도로도 재사용 가능하다.

The toothpaste package is made from recycled newspaper pulp. We made a prototype with paper first, and then used a 3D printer to narrow it down. This box can be reused for other purposes as well.

←

치약 패키지 구조 실험 및 연구
Experiment and research on toothpaste package structure

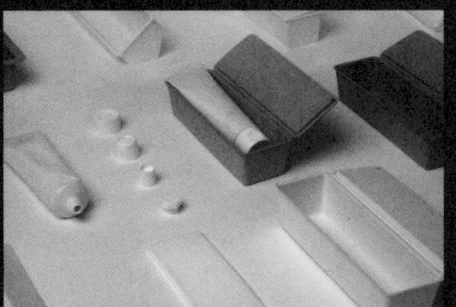

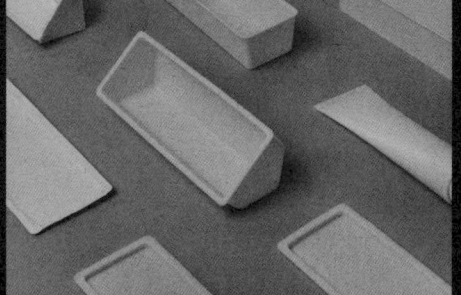

클러스터 오브 라이트
Cluster of Light

렌티큘러 필름은 독특한 특성이 있다. 처음에는
이 필름을 '가지고 논다'는 가벼운 마음으로
실험했는데, 그러다 광학 효과가 탁월한 것을
발견했다. 이런 속성을 조명등과 연결해 다양하게
연출하는 과정에서 상들리에의 모듈 디자인을
찾아갔다.

Lenticular films have unique properties.
At first, we "played around" with this film
with a light mind, and then we discovered
that the optical effect was excellent. In the
process of connecting these properties
with lighting and creating various displays,
we came upon the Chandelier's module
design.

광학 효과 테스트
Optical effect test

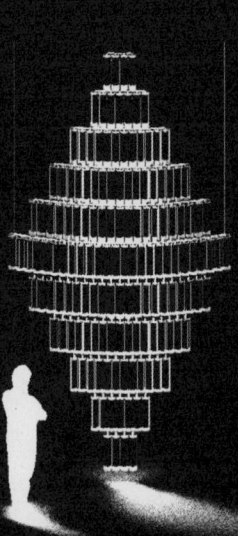

설치 형태 검토를 위한 렌더링
Rendering for review of
installation

구조 검토 아이디어 스케치
Structural review idea sketch

LED 헤어 디바이스
LED Hair Device

머리에 쓰는 디바이스는 사이즈의 정의가 중요하다.
최적의 구조를 찾기 위해 다양한 인종 및 성별의
머리 사이즈를 평균 낸 후, 종이로 반구를 제작하고
3D 프린터를 통해 형태를 좁혀 나갔다.

For devices worn on the head, the
definition of the size is important. After
averaging the head sizes of various races
and genders to find the optimal structure,
we made the hemisphere with paper and
the shape was narrowed using a 3D printer.

스마트폰 UV 충전기
Smartphone UV Charger

제품 양산까지의 과정 중 플라스틱의 경우, 금형을
위한 디자인과 사출물의 관리가 중요했다. 초반에
콘셉트를 잡을 때부터 양산성을 고려해야 한다.
그 틀을 깨면서 한 걸음씩 나아가는 것이다.

During the process up to mass production,
design for molds and management of
injection moldings were important for
plastics. From the initial conception, we
had to consider mass production while
breaking the frame and moving forward
step by step.

양산성 검토 및 수정
Mass production review and correction

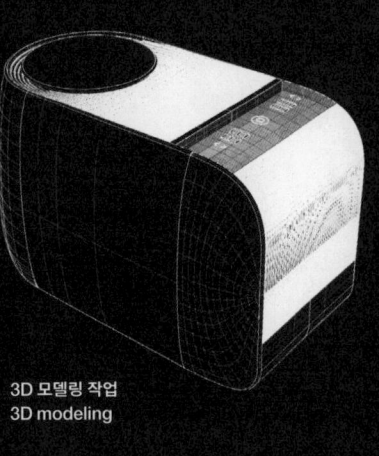

3D 모델링 작업
3D modeling

온수 매트 보일러
Hot Water Mat Boiler

기존 형태의 보일러는 디자인의 한계가 많았다.
엔지니어와 협의해서 빠르게 스케치 후 3D로 새로운
형태를 만들었다. 3D 상에서 컴포넌트를 이리저리
이동해 외형에 적용하면서 한정된 형태라는 제약
조건을 극복했다.

Existing boilers have many limitations
in design. Through collaboration with an
engineer, a sketch was quickly done and
a new 3D shape was created. Through
the movement of components around in
3D and applying them to the exterior, the
constraint of a limited form was overcome.

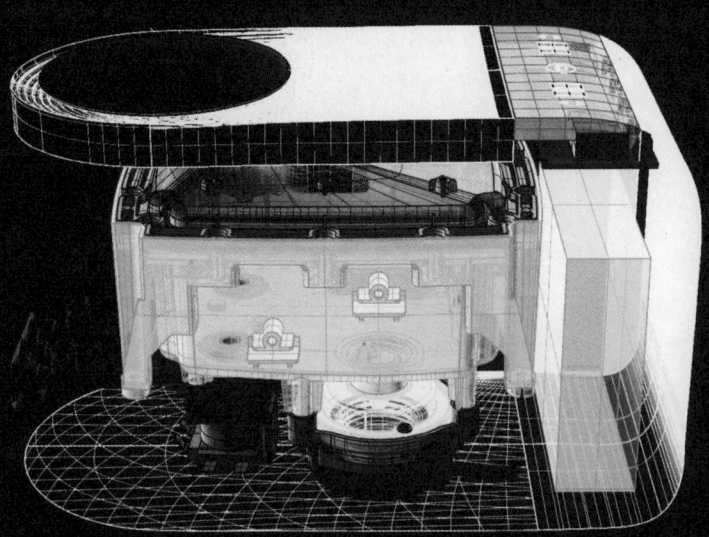

구조 설계를 위한 3D 모델링 작업
3D modeling for structural design

노트북 파우치
Notebook Pouch

천은 다른 소재와 달리 플렉서블한 특성이 있어 스케치나 모델링을 해도 온전히 구현되지 않을 때가 잦다. 또한 재봉이나 바느질을 통해 실제 최종 제품에 가까운 프로토타이핑이 가능하기에, 디자인 과정에서 아날로그적 수작업을 자주 하게 된다.

Unlike other materials, fabric has a flexible characteristic, so even after sketching and modeling, it is often not fully expressed in form. In addition, since the final product is possible by prototyping the product through sewing or needlework, analog manual work is often done in the design process.

천 소재 샘플 검토 및 선별, 봉제 작업
Fabric material sample review and selection and sewing work

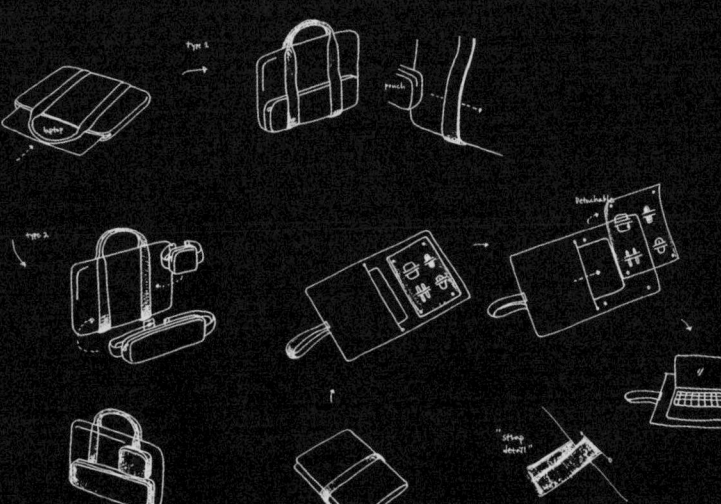

아이디어 스케치
Idea sketch

워킹 프로토타입 검토
Working prototype review

NPT 전동 킥보드
NPT Electric Scooter

스케치를 통해 빠르게 생각을 가다듬고, 매력적인
콘셉트를 골라 스케일 모델로 만들었다. 그중 가능성
있는 것을 선별하고 만들기 간단한 여러 소재를
이용해 1:1로 테스트했다. 이 과정을 반복할수록
디자인이 더 세련되게 가다듬어진다.

Through sketches, ideas were quickly
reorganized, and an attractive concept
was selected and made into a scale model.
Among them, testing 1:1 by using a number
of simple materials was done to find
materials with potential. The more this kind
of process is repeated, the more refined
the design becomes.

음악의 패턴
Pattern of Music

종이와 나무를 잘라서 미니어처 모델을 만들며
조형의 모티브를 잡아 나갔다. 입체로 스케치하는
것과 평면에 스케치하는 것은 차이가 크다.
입체 스케치는 구조적인 접근이 가능해 본질적인
해석이 가능하다. 또한 실제로 재질의 촉감을 느끼며
자르고 붙이는 행위 자체에서 영감을 받기도 한다.

A miniature model was made by cutting
paper and wood to capture the form's
motif. There is a big difference between
sketching three-dimensionally and
sketching on a plane. A three-dimensional
sketch can be approached structurally
and so enables essential interpretation.
Also, you can actually feel the texture of
the material and be inspired by the act of
cutting and pasting.

←
261

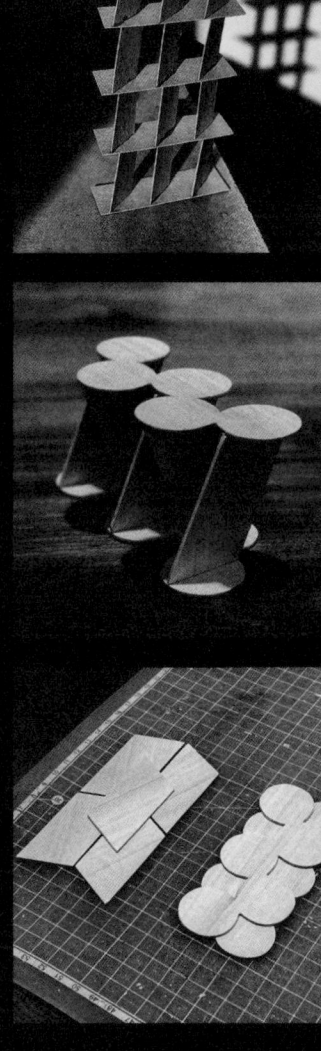

미니어처 스케치를 통한 조형 실험
Model experiment through miniature
sketches

3D 모델링
3D modeling

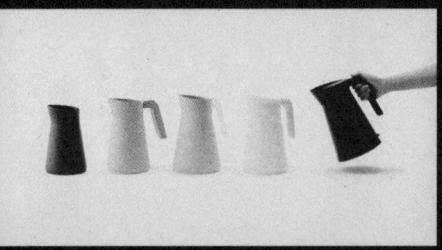

3D 모델링을 통한 조형 테스트
Formative testing with 3D modeling

무선 전기 주전자
Wireless Electric Kettle

초기 아이데이션에서는 여러 형태를 스케치로
제안하고 실루엣별로 정리해 다듬어갔다.
이를 토대로 빠르게 3D 모델링을 하고 스케치
렌더링 및 리뷰를 거쳐 가장 안정된 디자인을 종이로
만들었다. 테이블에 실물 종이 모델을 늘어놓고
검토하기도 하고, 다시 3D 데이터로 만든 종이
모델을 비교하기도 하는 등 여러 각도에서 보았다.

In the initial idealization, various shapes
were suggested in sketches and refined
by silhouette. Based on this, 3D modeling
was done with speed, and the most stable
design was made from paper after sketch
rendering and review. Various angles were
looked at such as reviews of models made
from paper examined on the table and
comparisons of paper models made again
with 3D data.

← 265

다양한 형태의 1:1 종이 모델들
Various forms of 1:1 paper models

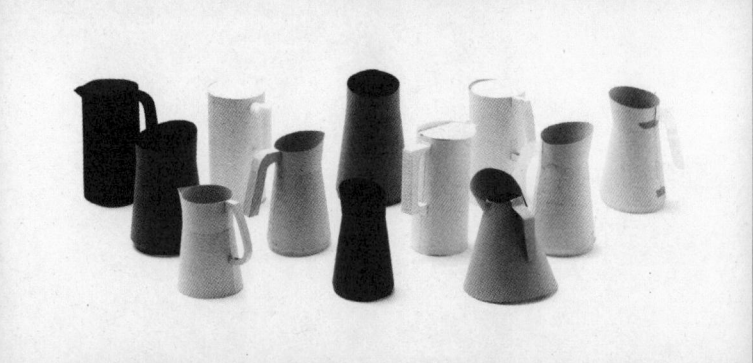

10 퍼스낼리티 10 체어
10 Personalities 10 Chairs

바닥에 원형 가공한 스테인레스 스틸을 설치해 의자 구조가 반사되도록 했다. 눈에 보이는 외형뿐 아니라 어떻게 만들어졌는지까지 잘 볼 수 있도록 유도한 것이다. 과정과 결과물을 비교할 수 있도록 종이 모델도 전시했다. 이 전시에는 4,000여 명의 관람객이 다녀갔다.

A round stainless steel was installed on the floor to reflect the structure of the chair. It was planned so that people could see not only the visible outer appearance but also the structure of the chair as it was made. A paper model was also displayed so that the process and results could be compared. About 4,000 visitors attended this exhibition.

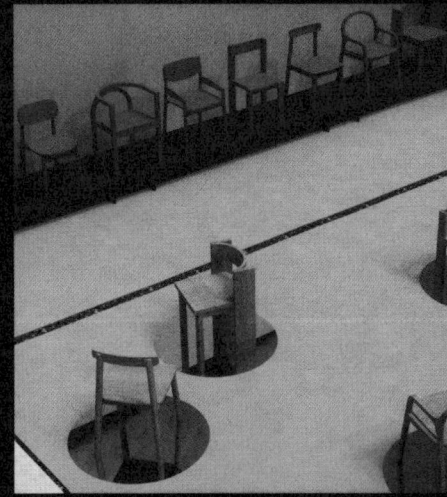

전시 설치를 위한 렌더링
Rendering for an exhibition installation

1:1 종이 모델과 전시장 렌더링
1:1 Paper model and exhibition rendering

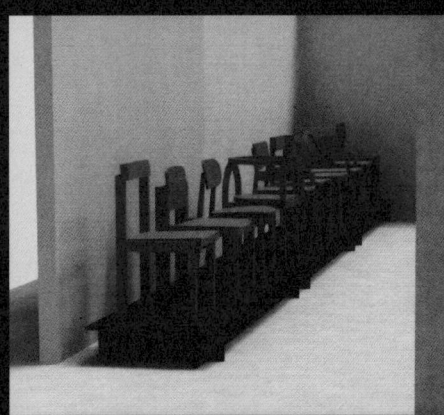

인덱스
Index

분류 Type	정보 Informetion
재료 Material	클라이언트 Client

음악을 비추고 빛을 만지다
Spotlight the Music and Touch the Light
→025
→290
2004

ⓣ 전자제품 | electronics
ⓜ 아크릴, 천, 플라스틱, 혼합매체, LED |
acrylic, fabric, LED, mixed media, plastic
ⓘ IDEA 어워드 금상(2005) | International Design
Excellence Awards, Gold Prize (2005)

사물의 일상
Ordinariness of object
→033
→292
2006

ⓣ 소품, 조명, 테이블 | accessory, light, table
ⓜ 나무, 아크릴, 플라스틱, 혼합매체, LED |
acrylic, LED, mixed media, plastic, wood
ⓘ 〈사물의 일상〉, BMH 갤러리 | Ordinariness of
Object, BMH Gallery

한 송이의 꽃을 위한 꽃병
Vase for just one flower
→041
→294
2007

ⓣ 소품 | accessory
ⓜ 금속(스테인리스 스틸) | metal (stainless steel)
ⓘ KIDP 차세대디자인리더 | KIDP Next Generation
Design Leader

무중력 조명 시리즈
Zero-G Light Series
→049
→296
2009

ⓣ 조명 | light
ⓜ 금속(스틸), 플라스틱, LED |
LED, metal (steel), plastic
ⓘ 슈퍼스튜디오 피유 전시(2010) |
Exhibited at the Superstudio Più (2010)

물병
Water Bottle
→057
→298
2012

ⓣ 전자제품 | electronics
ⓜ 금속(알루미늄), 아크릴, 천, 플라스틱, 혼합매체 | acrylic,
fabric, metal (aluminium), mixed media, plastic
ⓒ 코웨이 | Coway

노말 체어
Normal Chair
→065
→300
2011

ⓣ 의자 | chair
ⓜ 나무(티크) | wood (teak)
ⓒ 매터&매터 | Matter & Matter

윙 테이블
Wing Table
→073
→302
2012

ⓣ 테이블 | table
ⓜ 나무(티크) | wood (teak)
ⓒ 매터&매터 | Matter & Matter

허들 조명
Hurdle Light
→029
→291
2005

ⓣ 조명 | light
ⓜ 아크릴, 플라스틱, LED | acrylic, LED, plastic
ⓘ 라이터치 국제 조명상 스페셜 멘션 | Lightouch
International Lighting Award, Special Mention

촉감 폴더블 핸드폰
Tactile Foldable Mobile Phone
→037
→293
2007

ⓣ 전자제품 | electronics
ⓜ 플라스틱, 혼합매체 | mixed media, plastic
ⓒ LG전자 | LG Electronics

우뭇가사리 시리즈
Agar-agar Series
→045
→295
2008

ⓣ 의자, 조명 | chair, light
ⓜ 플라스틱(3D 프린트) | plastic (3D print)

아파트 제품 아이덴티티
Apartment Product Identity
→053
→297
2010~2012

ⓣ 생활잡화 | sundries
ⓜ 금속(스테인리스 스틸), 천, 플라스틱 |
fabric, metal (stainless steel), plastic
ⓒ e편한세상 | ePyeonhansesang

레그 퍼니처 시리즈
Leg Furniture Series
→061
→299
2011

ⓣ 의자 | chair
ⓜ 나무(티크) | wood (teak)
ⓒ 매터&매터 | Matter & Matter

오리가미 체어
Origami Chair
→069
→301
2011

ⓣ 의자 | chair
ⓜ 나무(티크) | wood (teak)
ⓒ 매터&매터 | Matter & Matter

도트 테이블
Dot Table
→077
→303
2012

ⓣ 테이블 | table
ⓜ 나무(티크) | wood (teak)
ⓒ 매터&매터 | Matter & Matter

트로피칼 버드
Tropical Bird
2012
→081
→304

T 소품 | accessory
M 나무(티크) | wood (teak)
C 매터&매터 | Matter & Matter

프로토 벤치
Proto Bench
2012
→089
→306

T 의자 | chair
M 나무, 천 | fabric, wood
C 〈프로토_라이트〉, 아트클럽1563(숨프로젝트) |
PROTO_LIGHT, artclub1563(SUUM project)

데스크 액세서리 시리즈
Desk Accessories Series
2013
→097
→308

T 소품 | accessory
M 나무(오크), 재생가죽, 천 |
fabric, regenerated leather, wood (oak)
C 매터&매터 | Matter & Matter
O 메종&오브제 한정판매 | Sold at Maison & Objet

굴뚝 조명등 시리즈
Chimney Light Series
2013
→105
→310

T 조명 | light
M 금속, 나무(오크), 전구, 천(라이크라) |
bulb, fabric (Lycra®), metal, wood (oak)
C 매터&매터 | Matter & Matter
O 메종&오브제 한정판매 | Sold at Maison & Objet

잎사귀 트레이
Leaf Tray
2013
→113
→312

T 소품 | accessory
M 나무(오크) | wood (oak)
C 매터&매터 | Matter & Matter

스마트 밴드
Smart Wristband
2014
→121
→314

T 전자제품 | electronics
M 아크릴, 폴리우레탄, 플라스틱, 혼합매체, LED |
acrylic, LED, mixed media, plastic, polyure███
C SK텔레콤 | SK telecom

브랜드 스토어
Brand Store
2015
→129
→316

T 공간 | space
M 금속, 나무(나왕), 혼합매체, LED |
LED, metal, mixed media, wood (lauan)
C CJ

스마트 스피커
Smart Speaker
2015
→137
→318

T 전자제품 | electronics
M 아크릴, 플라스틱, 혼합매체, LED |
acrylic, LED, mixed media, plastic
C SK텔레콤 | SK telecom

오래된 미래 테이블과 벤치
An Old Future Table & Bench
2012
→085
→305

T 의자, 테이블 | chair, table
M 나무(소나무) | wood (pine)
O 〈오래된 미래〉, 문화역서울284 |
An Old Future, Culture Station Seoul 284

숨쉬는 타일
The Respirer
2012
→093
→307

T 오브제 | objet
M 옹기토 | onggi pottery
O 〈설화문화전: 흙, 숨쉬다, 옹기〉 |
Sulhwa Cultural Exhibition: Soil, Breathe, Onggi

TV 리모컨
TV Remote Control
2013
→101
→309

T 전자제품 | electronics
M 플라스틱, 혼합매체 | mixed media, plastic
C CJ헬로비전 | CJ Hellovision

전자책 단말기
eBook Reader
2013
→109
→311

T 전자제품 | electronics
M 금속, 아크릴, 플라스틱 | acrylic, metal, plastic
C 예스24 | YES24

TV 셋톱 박스
TV Set-top Box
2013
→117
→313

T 전자제품 | electronics
M 아크릴, 플라스틱, 혼합매체 | acrylic, metal, plast█
C SK브로드밴드 | SK broadband

오피스 가구 시리즈
Office Furniture Series
2014
→125
→315

T 의자, 테이블 | chair, table
M 금속, 나무(합판) | metal, wood
(plywood & MDF)
C 네이버 | NAVER

아파트 인테리어 조명 시리즈
Apartment Interior Light Series
2015
→133
→317

T 의자 | chair
M 금속(알루미늄), 아크릴, 혼합매체, LED |
acrylic, LED, metal (aluminium), mixed media
C e편한세상 | ePyeonhansesang

우산
Umbrella
2015
→141
→319

T 생활잡화 | sundries
M 플라스틱 | plastic
C KT

4D 영화관 의자
Theater Chair
2016
→ 145
→ 320

🆃 의자 | chair
Ⓜ 천, 플라스틱, LED | fabric, LED, plastic
Ⓒ CGV

생존 시계 재난 키트
Life Clock Disaster Kit
2016
→ 153
→ 322

🆃 생활잡화 | sundries
Ⓜ 천, 플라스틱, 혼합매체 |
fabric, mixed media, plastic
Ⓒ 경기도주식회사 | Korea
Gyeonggido Company

플래그십 스토어 카페
Flagship Store Cafe
2017
→ 161
→ 324

🆃 공간 | space
Ⓜ 금속, 나무(나왕), 천, 혼합매체, LED | fabric,
LED, metal, mixed media, wood (lauan)
Ⓒ 네스카페 | Nescafe

2018 평창 동계 올림픽 메달
2018 PyeongChang Winter Olympic Medal
2017
→ 169
→ 326

🆃 오브제 | objet
Ⓜ 금속(구리, 금, 동, 은), 나무, 천(감사) | fabric (gapsa),
metal (bronze, copper, gold, silver), wood
Ⓘ 평창 동계 올림픽 | PyeongChang Winter Olympic

버클 조명 시리즈
Buckle Light Series
2018
→ 177
→ 328

🆃 조명 | light
Ⓜ 금속, 돌, 천, LED | fabric, LED, metal, stone
Ⓘ 《By 을지로: 디자인 컬래버레이션》 |
By Euljiro: Design Collaboration

아파트 브랜딩 및 마스터플래닝
Apartment Branding & Masterplanning
2019
→ 185
→ 330

🆃 공간 | space
Ⓜ 금속, 나무, 돌, 유리, 콘크리트, 혼합매체 |
concrete, glass, metal, mixed media,
stone, wood
Ⓒ 푸르지오 | PRUGIO

스테이션 지오메트리
Station Geometry
2019
→ 193
→ 332

🆃 오브제 | objet
Ⓜ 금속, 나무, 아크릴, 종이, 천, 플라스틱 | acrylic,
fabric, metal, paper, plastic, wood
Ⓘ 문화역서울284 전시 | Exhibited at the
Culture Station Seoul 284

콘크리트 커튼
The Curtained Wall
2019
→ 201
→ 334

🆃 오브제 | objet
Ⓜ 콘크리트(3D 프린트) | concrete (3D print)
Ⓘ 광주디자인센터 전시 | Exhibited at the
GWANGJU design center

플록 벌브
Flock Bulb
2016
→ 149
→ 321

🆃 조명 | light
Ⓜ 광섬유, 금속 | metal, optical fiber
Ⓒ 3M

스마트 충전기
Smart Charger
2016
→ 157
→ 323

🆃 전자제품 | electronics
Ⓜ 고무, 아크릴, 플라스틱, 혼합매체, LED |
acrylic, LED, metal, mixed media, plastic, rub█
Ⓒ 3M

그래피컬 조명
Graphical Light
2017
→ 165
→ 325

🆃 조명 | light
Ⓜ 금속, 전구, 혼합매체 |
bulb, metal, mixed media
Ⓘ 《By 을지로: 디자인 컬래버레이션》 |
By Euljiro: Design Collaboration

서클 피콕과 테일 버드
Circle Peacock & Tail Bird
2018
→ 173
→ 327

🆃 주방용품 | kitchenware
Ⓜ 플라스틱 | plastic
Ⓒ 농심 | Nongshim

문화역서울284 굿즈 시리즈
Culture Station Seoul 284 Souvenir Series
2019
→ 181
→ 329

🆃 오브제 | objet
Ⓜ 금속(알루미늄) | metal (aluminium)
Ⓘ 문화역서울284 전시 | Exhibited at the
Culture Station Seoul 284

리그 오브 레전드 트로피
Trophy LOL
2019
→ 189
→ 331

🆃 오브제 | objet
Ⓜ 금속(3D 프린트) | metal (3D print)
Ⓒ 리그 오브 레전드 | League of Legends

백상예술대상 트로피
Trophy Baeksang
2019
→ 197
→ 333

🆃 오브제 | objet
Ⓜ 금속(금) | metal (gold)
Ⓒ 백상예술대상 | Baeksang Arts Awards

한글 2.5
Hangeul 2.5
2019
→ 205
→ 335

🆃 오브제 | objet
Ⓜ 금속(알루미늄) | metal (aluminium)
Ⓘ 국립한글박물관 전시 | Exhibited at the
National Hangeul Museum

태극기함
Korean Flag Case
2019
→ 209
→ 336

T 생활잡화 | sundries
M 플라스틱 | plastic
C MBC

화장품 용기
Cosmetic Bottle
2020
→ 213
→ 337

T 생활잡화 | sundries
M 플라스틱 | plastic
C LG생활건강 | LG H & H

공기청정기
Air Purifier
2020
→ 217
→ 338

T 전자제품 | electronics
M 플라스틱, 혼합매체 | mixed media, plastic
C JAJU

암 체어
Arm Chair
2020
→ 221
→ 339

T 의자 | chair
M 금속, 나무, 천 | fabric, metal, wood
C JAJU

트롤리
Trolley
2020
→ 225
→ 340

T 생활잡화 | sundries
M 금속, 플라스틱 | metal, plastic
C JAJU

트레이
Tray
2020
→ 229
→ 341

T 소품 | accessory
M 플라스틱 | plastic
C JAJU

치약
Toothpaste
2020
→ 233
→ 342

T 생활잡화 | sundries
M 금속(알루미늄) | metal (aluminium)
C 닥터노아 | Dr.NOAH

클러스터 오브 라이트
Cluster of Light
2020
→ 237
→ 343

T 조명 | light
M 렌티큘러 필름, LED(T5) |
LED (T5), lenticular film
I 문화역서울284 전시 | Exhibited at the
Culture Station Seoul 284

LED 헤어 디바이스
LED Hair Device
2020
→ 241
→ 344

T 전자제품 | electronics
M 플라스틱, 혼합매체, LED |
LED, mixed media, plastic
C TS트릴리온 | TS Trillion

스마트폰 UV 충전기
Smartphone UV Charger
2020
→ 245
→ 345

T 전자제품 | electronics
M 플라스틱, 혼합매체, LED |
LED, mixed media, plastic
C KT하이텔 | KTH

온수 매트 보일러
Hot water mat boiler
2020
→ 249
→ 346

T 전자제품 | electronics
M 플라스틱, 혼합매체, LED |
LED, mixed media, plastic
C 나비엔 | Navien

노트북 파우치
Notebook pouch
2020
→ 253
→ 347

T 소품 | accessory
M 천 | fabric
C 로우로우 | RAWROW

NPT 전동 킥보드
NPT Tire Electric Scooter
2020
→ 257
→ 348

T 전자제품 | electronics
M 금속, 플라스틱, 혼합매체, LED, NPT |
LED, metal, mixed media, NPT, plastic
C 한국타이어 | Hankook Tire

음악의 패턴
Pattern of Music
2020
→ 261
→ 349

T 오브제 | objet
M 나무(MDF) | wood (MDF)
I 〈레코드284―문화를 재생하다〉, 문화역서울284 |
Record284―Culture on a Turntable,
Culture Station Seoul 284

무선 전기 주전자
Electric Kettle
2021
→ 251
→ 350

T 전자제품 | electronics
M 금속, 플라스틱, 혼합매체, LED |
LED, metal, mixed media, plastic
C 하이마트 | HIMART

10 퍼스낼리티 10 체어
10 Personalities 10 Chairs
2021
→ 269
→ 351

T 의자 | chair
M 나무(오크) | wood (oak)
I 〈맥락 속의 오브제〉, 코사이어티 서울숲 |
Objects in Context, Cociety Seoulsup

미주
Endnotes

1 워킹 목업
Working mockup

생산 전 최종적으로 제품의 기능과 성능을 검증하고 테스트할 목적으로 제작하는 목업이다. 실제 양산할 제품과 동일하게 기능할 수 있게 제작한다.

It is a mockup that is produced for the purpose of verifying and testing the function and performance of the product before actual production. The mockup is manufactured so that it can function similarly to the product that is to be mass-produced.

2 CNC

컴퓨터 수치 제어. 선반이나 절삭기 같은 공작 기계를 컴퓨터로 제어하는 시스템이다. 마이크로프로세서가 내장된 덕분에 프로그램을 자유롭게 변경할 수 있어, 기계 가공 능력이 비약적으로 향상된다.

Computerized Numerical Control. A computer-controlled system for machine tools such as lathes and cutters. Thanks to the built-in microprocessor, the program can be freely changed, which greatly increases the machining capability. Processes often produce unexpected results. Depending on how you design the process, the appearance of the result will also change.

3 스판덱스
Spandex

나일론과 두세 가지 섬유를 혼합하여 만든 소재. 활동하기에 편하고 신축성, 내구성, 발한성 및 건조성이 뛰어나 여러 용도로 다양하게 쓰이지만, 가격이 비싸고 열에 약하며 정전기가 일어난다는 단점이 있다.

A material made by mixing nylon and two or three fibers. It is easy to use and has excellent elasticity, durability, sweating and drying properties, so it is used for various purposes, but it has the disadvantages of high price, low heat tolerance, and generation of static electricity.

4 광섬유
Optical fiber

광학 신호를 빛의 손실 없이 전달하는 가느다란 유리 또는 플라스틱 섬유. 통신뿐 아니라 다양한 분야에 활용되며, 흔히 자동차 무드등으로도 자주 쓰인다.

A thin glass or plastic fiber that transmits an optical signal without loss of light. It is used not only in communication but also in various fields, and is often utilized as a mood light for automobiles.

5 힌지
Hinge

경첩. 다른 부품에 연결된 장치가 상하로 움직이거나 회전할 수 있도록 하는 조임 장치.

A fastener that allows a device connected to another component to move up and down or rotate.

6 사형 주조법
Sand mold casting

모래나 주물사를 사용해 만든 주형 공간에 용해한 금속을 주입한 후 굳혀 제품을 만드는 주조 공법. 오래 전부터 가장 많이 쓰인 전통적이고 범용적인 방법으로, 복잡한 형상의 제품이나 다품종 소량 생산에 적합하다.

A casting method through which molten metal is poured into a mold space made with sand or molding sand and then hardened to complete the product. It is the oldest traditional and general use method and suitable for small volume production of products with complex shapes or products of various types.

7 렌티큘러 필름
Lenticular film

렌티큘러의 사전적 의미는 '수정체' 또는 '볼록렌즈'로, 렌티큘러 필름은 여러 개의 볼록렌즈를 나열한 필름이라고 할 수 있다. 보는 각도에 따라 다른 그림이 나와 화폐 위조 방지 장치 등으로도 쓰인다.

The dictionary meaning of lenticular is 'crystalline lens' or 'convex lens', and lenticular film can be said to be a film in which several convex lenses are arranged. Depending on the viewing angle, a different picture appears and is used as a currency counterfeit prevention device.

8 T5 램프
T5 lamp

직경이 5인치, 즉 15.875밀리미터인 형광 램프. 일반적으로
16밀리미터 램프라고 한다. 아파트의 간접 조명이나 백화점
매장의 인테리어 조명 등으로 자주 사용한다.

A fluorescent lamp with a diameter of 5 inches
(15.875 millimeters). It is commonly referred to
as a 16mm lamp. It is often used for indirect lighting
of apartments or interior lighting of department
stores.

9 NPT

비공기압 타이어. 공기압이 아닌 구조적 형상만으로 차량
하중을 지지해, 타이어 손상시에도 정상적인 주행이 가능하고
공기압을 관리할 필요가 없다.

Non-Pneumatic Tires. By supporting the vehicle
load only with the structural shape instead of air
pressure, normal driving is possible even when the
tire is damaged, and there is no need to manage
the air pressure.

10 MDF

중밀도 섬유판. 나무를 고운 입자로 잘게 갈아서, 접착제와 섞은
후 이를 압착해 만든 목재 합판이다.

Medium Density Fiberboard. It is a wooden
plywood made by grinding wood into fine particles,
mixing it with adhesive, and then pressing it.

11 압출 성형
Extrusion moulding

금속이나 플라스틱 등의 원료를 압출하고 냉각해 성형하는
가공법. 압출성형기에 공급하고 금형에서 밀어내 일정한
모양의 단면을 가진 연속체로 변환한다.

A processing method in which raw materials
such asmetal or plastic are extruded, cooled,
and molded. Thematerial is fed into the extruder
moulder and extractedfrom the mold and
transformed into a continuum with acertain
shape on its surface.

12 단조
Forging

소성 가공의 일종. 해머 등으로 금속 가공물을 두드려 원하는
형태로 성형하는 방법이다.

A kind of plastic processing. It is a method of
forminga desired shape by beating a metal
workpiece with ahammer.

13 압인
Coining

재료를 밀폐된 금형 속에서 강하게 눌러 금형과 같은 모양을
재료의 표면에 만드는 정밀 단조 가공.

Precision forging processing that creates a mold-
likeshape on the surface of a material by pressing
thematerial strongly in a closed mold.

14 프로토타입
Prototype

본격적인 상품으로 나오기 전에 제작하는 시제품. 제품을
검증하고, 발견한 문제점이나 약점을 개선·보완해 사용자에게
가장 적합한 형태를 제공하는 것이 목적이다.

A prototype is produced before it becomes the
complete product. The purpose is to provide the
most suitable form to users by verifying the product
and improving or supplementing the problems or
weaknesses found.

15 소프트 목업
Soft mockup

설계 오류를 검증하거나 제품의 형상, 크기 등을 확인하기 위한
목적으로 제작하는 간단한 목업. 가시적인 느낌을 볼 수 있도록
크기나 구조를 단순화해 만든다.

A simple mockup created to verify design errors or
check the shape and size of a product. It is made
by simplifying the size or structure so that you can
have a visual impression.

16 GUI

그래픽 사용자 인터페이스. 사용자가 편리하게 사용할
수 있도록 입출력 등의 기능을 알기 쉬운 아이콘 따위의
그래픽으로 나타낸 것이다.

Graphical User Interface. Functions such as input
and output are displayed in graphic form such as
icons that are easy to use for users.

17 디자인 목업
 Design mockup

콘셉트 목업. 제품의 디자인을 확인하기 위해 도면에 따라 실제 양산품과 흡사한 형상을 구현한다. 형상, 구조, 색상 등 외관을 구성하는 요소를 중점으로 범용적인 활용이 가능하게 제작한다.

Concept mockup. In order to conrm the design of the product, the shape similar to the actual massproduced product is implemented according to the drawing. It is manufactured so that it can be used universally, focusing on the elements that make up the appearance, such as shape, structure, and color.

18 아노다이징
 Anodizing

양극 산화 처리. 금속 재질의 표면을 의도적으로 산화·부식하는 가공법. 산화막 자체가 외부의 영향으로부터 제품을 보호하고, 다공성 표면 위에 착색도 가능하다.

A processing method that deliberately oxidizes and corrodes the surface of a metal material. The oxide lm itself protects the product from external inuences, and coloring is possible on the porous surface.

19 XPS

압출 폴리스틸렌. 일반적으로 상품명인 아이소핑크라고 부른다. 가볍고 독성이 없어 인체에 무해하며 보온 단열 성능과 내구성이 우수하다. 단열 시공, 완충제, 모형 제작 등에 사용한다.

eXtruded PolyStyrene. Generally called by its brand name Isopink. It is light and non-toxic, so it is harmless to the human body and has excellent thermal insulation performance and durability. It is used for insulation construction, buffer, and model making.

이석우 Lee Sukwoo

홍익대학교를 졸업하고 삼성전자, 미국 퓨즈프로젝트와 티그를 거쳐 한국
구글-모토로라에서 글로벌 크리에이티브 리드 및 수석 디자이너로 활동했다.
2011년 산업 디자인 오피스 SWNA 설립에 이어 자체 오브젝트 브랜드인
리버럴 오피스를 설립했다. 2015년 레드닷 어워드 디자인 콘셉트 부문
글로벌 탑 10 디자인 스튜디오로 선정되었으며, 2018년 대한민국디자인대상
산업통상자원부장관 표창과 2019년 오늘의 젊은 예술가상 디자인 부문을
수상했다. 2021년 삼성디자인멤버십 자문교수로 활동했고, 같은 해 독일
iF 어워드 및 브라운 어워드 심사위원으로 선정되었다.

After graduating from Hongik University, Lee Sukwoo worked
for Samsung Electronics in South Korea, Fuse Project and
Teague in the US, and acted as a global creative leader and
chief designer at Google-Motorola, Korea. Following the
establishment of the industrial design office SWNA in 2011,
he established his own object brand, The Liberal Office,
In 2015, he was selected as one of the top 10 Global Design
Studios in the design concept category at the Red Dot Awards
and received the Minister of Trade, Industry and Energy
commendation at the 2018 Korea Design Awards and the Young
Artist of the Day award in 2019 in the design category. In 2021,
he was worked as an advisor-professor to Samsung Design
Membership, and in the same year, was selected as
a judge for Germany's iF Award and the Brown Award.

SWNA와 함께한 사람들
SWNA Crews

이석우, 이정연, 박채지, 김규창, 권균환, 이영빈, 이윤재, 이효정, 장준혁, 이의주, 이연주, 천다혜, 이동현, 장다정,
양다예, 조영진, 박민지, 유하연, 박지선, 이지혜, 최영우, 김동현, 박채지, 천강일, 윤일섭, 이원경, 이승목, 윤성웅,
백승기, 최현우, 김정아, 박정언, 임현정, 전혜림, 한상국, 이한뉘, 이민진, 조나단 고메, 윤미리, 강수정, 배지혜,
변한별, 정일윤, 김수언, 조아라, 카즈아키, 박윤형, 박기쁨, 이은정, 유재훈, 강문선, 김유정, 정재운, 조교상,
양정모, 이지선, 최지영, 지현영, 김이도, 김동겸, 김유성, 스카디 스툼, 장 클라크, 박재훈, 김진아, 김소영, 김성진,
강원향, 정영근, 진선욱, 최지율, 강영은, 김유정, 김경민, 고소영, 김규석, 서지원, 박정준, 김린, 신지현, 장유진,
유지훈, 권오현, 사라애밍거, 맹유민, 김혜일, 손하은, 오지훈, 이정춘, 강희주, 김예진, 유나연, 이지민, 최희,
최평국, 김은지, 목승수, 장원, 윤지원, 서현석, 이수현, 이하영, 박진우, 이한각, 김영지, 이승협, 진효정, 임재혁,
연태권, 김명년, 고나현, 우민섭, 정희경, 김영빈, 장희재, 이수빈, 김일, 김혜진, 김종건, 김하영, 김연규, 김효중,
서예지, 홍동현, 임희주, 김연수, 허보윤, 노시은, 한세영, 정효선, 신동민, 곽제헌, 최지영, 김종승, 오승빈

Lee Sukwoo, Lee Joungyeon, Park Chaejee, Kim Gyuchang, Kwon Gyuenhwan, Lee
Yeongbin, Lee Yunjae, Lee Hyojeong, Jang Junhyeok, Lee Euiju, Lee Yeonju, Cheon Dahae,
Lee Donghyeon, Jang Dajeong, Yang Daye, Cho Youngjin, Park Minji, Yoo Hayeon, Park
Jisun, Lee Jihye, Choi Youngwoo, Kim Donghyun, Cheon Kangil, Yoon Ilsub, Lee Wonkyung,
Lee Seungmok, Yoon Sungwoong, Beak Seungki, Choi Hyunwoo, Kim Junga, Park Jungeon,
Lim Hyunjung, Jeon Hyerim, Han Sangguk, Lee Hannwi, Lee Mijin, Jonadan gome, Yoon
Miri, Kang Soojung, Bae Jihye, Byun Hanbyeol, Jung Ilyun, Kim Sooeon, Cho Ara, Kazuaki,
Park Yunhyung, Park Kippeum, Lee Eunjung, Yu Jaehoon, Kang Moonsun, Kim Yujung,
Jung Jaewoon, Cho Kyosang, Yang Jungmo, Lee Jisun, Choi Jiyoung, Ji Hyunyoung, Kim
Yido, Kim Dongkyum, Kim Yusung, Skadi Stum, Jean Clark, Park Jaehoon, Kim Jina, Kim
Soyoung, Kim Sungjin, Kang Wonhyang, Junh Younggeun, Jin Sunwook, Choi Jiyun, Kang
Youngeun, Kim Yujung, Kim Kyungmin, Ko Soyoung, Kim Gyuseok, Seo Jiwon, Park Jungjun,
Kim Rin, Shin Jihyun, Jang Yujin, Yu Jihoon, Kwon Ohyun, Saraemingeo, Maeng Yumin, Kim
Hyeil, Son Haeun, Oh Jihoon, Lee Jungchun, Kang Heeju, Kim Yejin, Yu Nayeon, Lee Jimin,
Choi Hee, Choi Pyungguk, Kim Eunji, Mok Seungsoo, Jang won, Yoon Jiwon, Seo Hyunseok,
Lee Soohyun, Lee Hayoung, Park Jinwoo, Lee Hangak, Kim youngji, Lee Seunghyub, Jin
Hyojeong, Lim Jaehyuk, Yeon Taekwon, Kim Myungyoen, Ko Nahyun, Woo Minsub, Jung
Heekyung, Kim Yeongbin, Jang Heejae, Lee Soobin, Kim Il, Kim Hyejin, Kim Jonggun, Kim
Hayoung, Kim Yeonkyu, Kim Hyojoong, Seo Yeji, Hong Donghyun, Lim Heeju, Kim Yeonsoo,
Heo Boyoon, No Sieun, Han Seyoung, Jung Hyosun, Shin Dongmin, Kwak Jeheon, Choi
Jiyoung, Kim Jongseung, Oh Seungbin